# THE POETICS OF
# INFORMATION OVERLOAD

Gertrude Stein at the Teletype. Gertrude Stein and Alice B. Toklas Papers, YCAL MSS 76, Box 149, Folder 3528, Beinecke Rare Book and Manuscript Library, Yale University.

# THE POETICS OF INFORMATION OVERLOAD

## FROM GERTRUDE STEIN TO CONCEPTUAL WRITING

Paul Stephens

University of Minnesota Press
Minneapolis • London

An earlier version of chapter 1 appeared as "'Reading at It': Gertrude Stein, Information Overload, and the Makings of Americanitis," *Twentieth-Century Literature* 59, no. 1 (2013): 126–56. An earlier version of chapter 2 appeared as "Bob Brown,'Inforg': The'Readies' at the Limits of Modernist Cosmopolitanism," *Journal of Modern Literature* 35, no. 1 (2011): 143–64; copyright Indiana University Press. An earlier version of chapter 3 appeared as "Human University: Charles Olson and the Embodiment of Information," *Paideuma* 39 (August 2012): 181–208; reprinted with permission from the National Poetry Foundation. An earlier version of chapter 6 appeared as "Vanguard Total Index: Conceptual Writing, Information Asymmetry, and the Risk Society," *Contemporary Literature* 54, no. 4 (2013): 752–84; copyright 2013 by the Board of Regents of the University of Wisconsin System; reproduced courtesy of the University of Wisconsin Press.

The poem "Asphodel, That Greeny Flower," by William Carlos Williams, is from *The Collected Poems: Volume II, 1939–1962*, ed. A. Walton Litz and Christopher MacGowan (New York: New Directions, 1986); copyright 1944 by William Carlos Williams; reprinted by permission of New Directions Publishing Corporation.

Published by the University of Minnesota Press
111 Third Avenue South, Suite 290
Minneapolis, MN 55401-2520
http://www.upress.umn.edu

Library of Congress Cataloging-in-Publication Data
Stephens, Paul.
The poetics of information overload : from Gertrude Stein to conceptual writing /
   Paul Stephens.
   Includes bibliographical references and index.
   ISBN 978-0-8166-9439-6 (hc : acid-free paper)—ISBN 978-0-8166-9441-9
(pb : acid-free paper)
   1. American poetry—20th century—History and criticism. 2. American
poetry—21st century—History and criticism. 3. Poetry, Modern—History and
criticism. 4. Literature and technology. 5. Poetics. 6. Modernism (Literature)—
United States. 7. Information technology in literature. I. Title.
   PS310.M57S74 2015
   811'509112—dc23

                                                      2014019916

Printed in the United States of America on acid-free paper

The University of Minnesota is an equal-opportunity educator and employer.

20 19 18 17 16 15        10 9 8 7 6 5 4 3 2 1

*This book is dedicated to*
Adrienne Whitehead, Allison Stephens,
Amy Stephens, Andric Stephens, Chris Davey,
Jay Davey, *and* Scott Ryno Stephens

# CONTENTS

# PREFACE

## STARS IN MY POCKET
## LIKE BITS OF DATA

Everybody gets so much information all day long that they lose their common sense.

—Gertrude Stein, "Reflection on the Atomic Bomb" (1946)

It is a very sad thing that nowadays there is so little useless information.

—Oscar Wilde, "A Few Maxims for the Instruction of the Over-Educated" (1894)

There are 3.5 million stars in my pocket—stored in the SkyVoyager app, and mapped instantaneously relative to my position on the Earth's surface. All 924 North American bird species and their songs are included with iBird Explorer Pro. I have nearly unlimited access to music; I can audio-record my entire day; I can record high-definition video and send it wirelessly. There are over forty thousand messages in my Gmail inbox. The world's major newspapers are continually updated by the minute. Thanks to my mobile web browser, I have access to more words than were contained in the National Library of Ireland on June 16, 1904.[1] On that day Leopold Bloom carried the following items in his pocket:

Potato
Kidney
1 ½ pounds Denny's sausage
Letter to Henry Flower from Martha Clifford (and later the crumpled envelope of this letter)
Lemon soap
Card (Henry Flower)
*Freeman's Journal*
Handkerchief

Pocket watch (stops before 8)
French Letter (slang for condom)
Bread
*Agendath Netaim* advertisement
Chocolate
*Sweets of Sin* (book)
Pocketbook
Photo of Molly
Assorted monies[2]

It is an eclectic, messy, symbolically laden catalog—leaning heavily toward food and text. Over a century later, an updated version of modernism's iconic everyman would likely carry fewer physical sources of information. The letter, the newspaper, the card, the advertisement, the book, the photo, and the pocket watch could all be supplanted by a four-ounce iPhone (available in Ireland and over two hundred other countries). Bloom's money could easily be replaced with plastic (credit cards of course did not exist in 1904; we are never told whether Bloom has any identification on him). The *Freeman's Journal* Bloom carries contains news of the *General Slocum* disaster in New York Harbor on June 15. Even in 1904, news traveled quickly. Since the introduction of the telegraph, words have traveled with near instantaneity across long distances. In *The Victorian Internet*, Tom Standage quotes the *Daily Telegraph*'s claim in 1843 that "time itself is telegraphed out of existence."[3] F. T. Marinetti claims similarly in his epochal 1909 "Futurist Manifesto," "Time and space died yesterday."[4]

A century later, the statistics are nonetheless astonishing. The problem of information overload is often described as a spreading and dangerous epidemic, although much disagreement exists as to its causes and its cures. According to a recent study by the Global Information Industry Center at the University of California, San Diego, the average American "consumed" one hundred thousand words per day in 2008.[5] Print accounted for only 8.51 percent of words consumed. Television accounted for 44.85 percent while computers accounted for 26.97 percent (not including games). The same study made its biggest headlines by estimating that the average American encounters a total of 36 gigabytes of information daily. The neologism "exaflood" has recently been coined to describe conditions under which "between 2006 and 2010 the

global quantity of digital data will have increased more than six-fold from 161 exabytes to 988 exabytes."[6] To put this in perspective, "in 2003, researchers at Berkeley's School of Information Management and Systems estimated that humanity had accumulated approximately 12 exabytes of data (1 exabyte corresponds to $10^{18}$ bytes or a 50,000 year–long video of DVD quality) in the course of its entire history until the commodification of computers."[7] More data has been created and stored since the turn of millennium than in the entire history of humanity. The metaphors for the phenomenon—flood, torrent, tsunami, overflow, glut, inundation, saturation—are consistently liquid.[8] James Gleick's recent best seller *The Information: A Theory, a History, a Flood*, for instance, deploys the metaphor in its title.[9] A selection of books published on the topic give a good sense of the life and death, sink or swim, stakes involved: *Data Smog: Surviving the Information Glut*; *Distracted: The Erosion of Attention and the Coming Dark Age*; *Media Unlimited: How the Torrent of Images and Sounds Overwhelms Our Lives*; *The Overflowing Brain: Information Overload and the Limits of Working Memory*. The preceding titles, it should be noted, are all published by reputable university or trade presses. Far more examples could be drawn from popular self-help literature, as well as from management culture (in the form of books, seminars, proprietary reports, and consulting programs). A brief glance at the covers of information-overload self-help books (Figure 1) gives an idea of the range of issues at play. With perfect postmodern irony, information overload has even created its own self-propelled industry. The consulting firm Basex, which specializes in helping large corporations deal with the phenomenon, routinely grabs headlines in major newspapers with its claim that information overload costs the U.S. economy $900 billion per year (the data on which they base these claims is considered proprietary and is not made public).[10] Basex has even helpfully declared August 12 an annual "Information-Overload Awareness Day."

Science fiction did not prepare us for this—nor did avant-garde poetry, although many of the central aesthetic and political questions with regard to information overload are addressed or anticipated within twentieth-century avant-garde writing. Time and space may have died over a century ago, but information has increasingly taken on a life of its own—literally, according to some, who would ascribe a kind of global noetic consciousness or mathematical sublimity to the vastness of the Internet. In his 1984 novel *Stars in My Pocket Like Grains of Sand*,

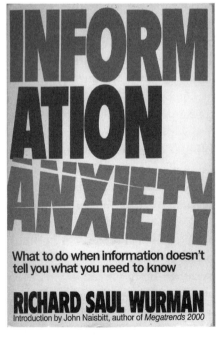

*Figure 1.* Four examples of information-overload self-help books.

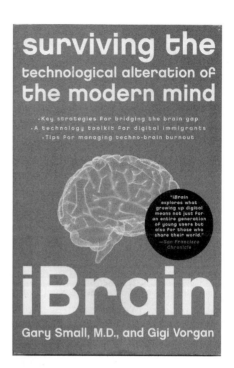

**surviving the technological alteration of the modern mind**

· Key strategies for bridging the brain gap
· A technology toolkit for digital immigrants
· Tips for managing techno-brain burnout

*"iBrain explores what growing up digital means not just for an entire generation of young users but also for those who share their world."*
—San Francisco Chronicle

# iBrain

**Gary Small, M.D., and Gigi Vorgan**

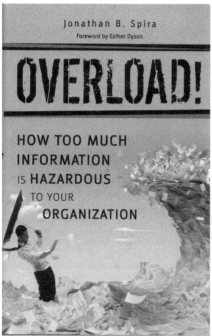

Jonathan B. Spira
Foreword by Esther Dyson

# OVERLOAD!

## HOW TOO MUCH INFORMATION IS HAZARDOUS TO YOUR ORGANIZATION

Samuel Delany presciently described a futuristic communication "web" a decade before Tim Berners-Lee coined the term "World Wide Web."[11] Delany foresaw a future in which there is radical information inequality, but in which it is also possible to travel to six thousand worlds. Delany's novel suggests that more words may not necessarily mean that we will have access to more worlds. For now we only have one world—and we have no choice but to come to terms with instantaneous global flows of information.

The philosopher Bernard Stiegler has recently suggested that we should rethink the pervasive effects of information technology through the lens of what he calls "psycho-power." Although I find this designation problematically vague, I also find it suggestive of the larger range of issues that surround questions of information saturation. For Stiegler, "psycho-power is the systematic organisation of the capture of attention made possible by the psycho-technologies that have developed with the radio (1920), with television (1950) and with digital technologies (1990), spreading all over the planet through various forms of networks, and resulting in a constant industrial canalization of attention which has provoked recently a massive phenomenon of the destruction of this attention that American nosologists call attention deficit disorder. This destruction of attention is a particular case, and an especially serious one, of the destruction of libidinal energy whereby the capitalist economy self-destructs."[12] A number of modern and postmodern narratives coalesce in this passage: the mass media is envisioned as a predatory organism, and technocratic capitalism is seen as essentially at odds with the genuine acquisition of knowledge and experience. Technology in this model essentially holds out innumerable lures that distract us from our real desires. While there is much to be said for Stiegler's provocations, there are also qualifications to be made. Despite reservations about some of Stiegler's more extreme formulations (discussed at greater length below, in the introduction, under the subheading "The Economics of Attention"), I share his concern that the increasing rapidity of capitalism's "creative destruction" process takes a severe toll on individual psyches, as well as exacerbating unequal patterns of information distribution globally.

In a recent commencement address, even the president of the United States referred to the problem. Speaking at the historically black Hampton University, Barack Obama told students that they were "coming of

age in a 24/7 media environment that bombards us with all kinds of content and exposes us to all kinds of arguments, some of which don't always rank that high on the truth meter. And with iPods and iPads; and Xboxes and PlayStations—none of which I know how to work— (laughter)—information becomes a distraction, a diversion, a form of entertainment, rather than a tool of empowerment, rather than the means of emancipation. So all of this is not only putting pressure on you; it's putting new pressure on our country and on our democracy."[13] What is most surprising about this passage is Obama's use of the word "emancipation." As the president noted in his address, Hampton was founded by ex-slaves in 1861. Obama is in a sense presenting a version of what might be called the "dialectic of information": greater access to information does not necessarily lead to increasing enlightenment. The implication would be that both information excess and human bondage are fundamentally antithetical to individual autonomy, and at odds with an "informed" citizenry. Even if this is the case, the moral problem of slavery would seem to be of an entirely different order than that of information overload—one would not, for example, casually refer to "information slavery." The direct target of Obama's concern may be right-wing news outlets such as Fox, but he also expresses a larger generational concern that new information technologies are regressive in their effects on the young. Other than counseling old-fashioned self-control, the president had no practical solutions to offer.

Avant-garde poetry may have a small role to play in our understanding of global information flows; on the other hand, the avant-garde has always aspired to be predictive, to keep up with the present, to stay ahead of history. The avant-garde's attempts to maintain critical distance from mainstream bourgeois values may be grandiose and hyperbolic—but the questions raised by avant-garde movements should not be dismissed as nihilistic or as unrepresentative of larger social developments. To adapt a question posed by Lyn Hejinian—"Isn't the avant-garde always pedagogical?"—I would ask, "Isn't the avant-garde always technological?"[14] Much of the work of the twentieth-century avant-garde was extremely self-conscious of the rapid changes in technologies of communication and data storage. From Dada photomontage to hypertext poetry, avant-garde methodology has been deeply concerned with remediation and transcoding—the movement from one technological medium or format to another.[15] As Brian Reed has recently written,

"Poetry is a language-based art with a penchant for reflecting on its channels of communication."[16] For Reed, poetry "offers unparalleled opportunities for coming to grips with the new media ecology. Poets, as they experiment with transmediation, serially bring to light each medium's textures, contours, and inner logic."[17] While poetry may seem the most non-technological of literary genres, I show that poets were often obsessed by the changing nature of information and its dissemination in the twentieth century. The news that there is more news than we can process is not so new: while avant-garde poetry may not figure prominently in the global information glut, the global information glut figures prominently in avant-garde poetry. However marginal it may seem, poetry will long outlast our current media platforms:

> Look at
> what passes for the new.
> You will not find it there but in
> despised poems.
> It is difficult
> to get the news from poems
> yet men die miserably every day
> for lack
> of what is found there.
> Hear me out . . .[18]

# INTRODUCTION

Relevant information's hard to come by. Soon it'll be everywhere,
unnoticed.

    —John Cage, *A Year from Monday*

A human being takes in far more information than he or she can put out.
"Stupidity" is a process or strategy by which a human, in response to
social denigration of the information she or he puts out, commits him-
or herself to taking in no more information than she or he *can* put out.
(Not to be confused with ignorance, or lack of data.)

    —Samuel Delany, *Stars in My Pocket Like Grains of Sand*

## The Aesthetics of Information Overload

Anyone surveying the topic of information overload is bound to run
headlong into the phenomenon him- or herself. The topic has attracted
the attention of media theorists, futurologists, sociologists, librarians,
historians, computer scientists, psychologists, neuroscientists, popular
pundits, management theorists—as well as, this book argues, poets.

*The Poetics of Information Overload* explores twentieth- and twenty-
first-century literary works that partake of, as well as parody, the informa-
tion glut that characterizes modernity. Although information technology
has typically been figured as hostile or foreign to poetry, I suggest that
avant-garde poetry has been centrally concerned with technologies of
communication, data storage, and bureaucratic control—not simply re-
jecting those technologies, but also adopting and commenting on them.
Much of the poetry discussed in this book has been dismissed as "non-
referential" or unreadable; by reading this poetry through the lens of
information systems and data practices, I show that the poetry of the
past century has had much to say about the effects of new media. Rather
than being antithetical to technological change, avant-garde poetry has
been closely tied to it.[1] Although scholars from other fields have devoted
considerable attention to information overload, this book is the first to

account for the phenomenon in relation to modernist and contemporary poetry.

As detailed in my historical survey below, I understand information overload broadly as a range of phenomena relating to the limits of cognition, perception, and memory (both personal and collective). Rather than passively observing an end of history, or drowning in information, avant-garde writers have swum within and against the currents of information flows—demonstrating not only agitation but also absorption. If one replaces the word "art" with "poetry" in the following sentence, it is possible to get an idea of what I mean with respect to poetry: "Data art reflects a contemporary worldview informed by data excess; ungraspable quantity, wide distribution, mobility, heterogeneity, flux."[2] Poetry "informed by data excess" has been with us at least since the emergence of modernism. Virtually the same transposition could be performed on the following sentence from Victoria Vesna's *Database Aesthetics: Art in the Age of Information Overflow*, in which she suggests, "In an age in which we are increasingly aware of ourselves as databases, identified by social security numbers and genetic structures, it is imperative that artists actively participate in how data is shaped, organized, and disseminated."[3] This active participation in the shaping, organization, and dissemination of information has been an important, though underappreciated, ongoing concern of avant-garde poetics on the levels of both form and content.

This study takes modernism as its point of departure because so many of the key concerns surrounding information saturation were first articulated in the late nineteenth century, long before the advent of the computer or the Internet. As Tim Wu has shown, the first all-powerful American "information empires" were not IBM, Microsoft, Apple, Amazon, or Google—but rather Western Union (telegraphy), the Bell System (telephony), and RCA (radio and television).[4] Before there was a "mimeograph revolution" in the 1960s, there was a "magazine revolution" that began in the 1890s.[5] Mark Morrisson succinctly identifies the conditions that brought about such a revolution: "Cheap paper, the rotary press, the Linotype machine—at the most mundane level, these inventions led to the explosion of mass market print publications and advertising at the end of the nineteenth century in Britain and America."[6] As early as his 1926 *One-Way Street*, Walter Benjamin would locate the origins of poetic modernism in Mallarmé's reaction to unprecedented

"locust swarms of print" in the 1890s.[7] Benjamin worried that ever-cheaper means of reproduction would lead to literary writing being "pitilessly dragged out into the street by advertisements and subjected to the brutal heteronomies of economic chaos."[8] But he also foresaw that poets—"the first and foremost experts in writing"—would have a central role to play in the creation of a revolutionary new "picture-writing."[9]

In chapter 1, I explore Gertrude Stein's importance as an inaugural figure in a tradition of sprawling works which, in her own words, cannot be read, but can only be "read at." Kenneth Goldsmith, perhaps the most influential of contemporary appropriation poets, places his writing in the Stein tradition. Stein, he suggests, "often set up a situation of skimming, knowing that few were going to be reading her epic works straight through (how many people have literally read every word of *The Making of Americans?*) . . . Much of Stein's writing was never meant to be read closely at all, rather she was deploying visual means of reading. What appeared to be densely unreadable and repetitive was, in fact, designed to be skimmed, and to delight the eye (in a visual sense) while holding the book. Stein, as usual, was prescient in predicting our reading habits."[10] Goldsmith (himself trained as a sculptor) shifts the literary value of Stein's saturated writing from narrative or semantic levels to visual and aural levels. Whereas visual pleasure in reading is often associated with minimalist works, or with concrete or visual poetry, Goldsmith suggests that there can be an equivalent pleasure in skimming large quantities of text. In surveying Stein's writing in relation to technology over the course of her career, I suggest that Stein was concerned with the effects of information saturation from her early writing in the 1890s until her very last written composition, "Reflection on the Atomic Bomb" in 1946. As Mark Goble writes in *Beautiful Circuits: Modernism and the Mediated Life*, "Stein exemplifies the new mode of writing that Friedrich Kittler calls 'the discourse network of 1900,' which understands the medium of words as powerfully challenged by the ability of film and other 'technological media' to record and store experience of every kind."[11]

In chapter 2, I show how Bob Brown, in claiming that Stein inspired him to create his reading machine, also read Stein's work in relation to technological change. Without using the term proper, Stein and Brown both thematize information overload in ways starkly at odds with the Pound/Eliot/Joyce model of obsessively cataloging cultural history.

Stein's resistance to proper names and to direct quotation suggests a radical break between history and lived memory, as well as between stored information and immediate sensory data. With regard to Joyce, Stein claimed, "You see it is the people who smell of the museums who are accepted, and it is the new who are not accepted. You have got to accept a complete difference. It is hard to accept that, it is much easier to have one hand in the past. That is why James Joyce was accepted and I was not. He leaned toward the past, in my work the newness and difference is fundamental."[12] The museum, like the archive and the library, preserves the data of the past. From Stein's perspective, Joyce's writing is profoundly paleonymic—that is, it preserves proper names rather than interrupting the patriarchal process of genealogical affiliation. Both *Ulysses* and *The Making of Americans* are supremely overloaded (or overflowing) works—but it would be impossible to list the contents of the pockets of the latter's protagonist, David Hersland, much less to map his information intake on a particular day.[13]

Charles Olson, I argue in chapter 3, modified the Pound/Williams model of the poet as prolific autodidact. Williams's late-1920s *Embodiment of Knowledge* is indicative of modernist hostility toward universities as well as toward the growing specialization of knowledge. As rector of Black Mountain College, Olson championed a radically interdisciplinary curriculum. As early as 1949, he incorporated the language of cybernetics into his poem "The Kingfishers," which would go on to be the opening poem in Donald Allen's *New American Poetry*, the most influential poetry anthology of the postwar period. Olson champions an insatiable desire to embody information; at the same time, his attempt to synthesize vast bodies of information from disparate fields culminates in *The Maximus Poems'* failure to communicate that information to the townspeople of Gloucester, Massachusetts (the putative addressees of Olson's epic). Olson, I suggest, is both a hero and a victim of information overload—tragically, as well as self-parodically, at various points in his career.

The fourth chapter, "'When Information Rubs/Against Information': Poetry and Informatics in the Expanded Field in the 1960s," discusses the writing of John Cage, Bern Porter, Bernadette Mayer, and Hannah Weiner, all of whom refer to information overload in the mid to late '60s. Influenced in large part by Marshall McLuhan, they increasingly incorporated informatic motifs and issues into their writing—demonstrating

a recurring fascination with what the art historians Hannah Higgins and Douglas Kahn describe as the "mainframe experimentalism" of the 1960s.[14] Although pre-digital, the "mimeograph revolution" of the 1960s lowered barriers to publication and enabled poets (often in the company of artists) to experiment with visual and found texts in journals such as *0 To 9*. Cage, Porter, Mayer, and Wiener (all of whom were published in *0 To 9*) exhibit a keen interest in new telecommunications and data-storage technologies, and their writing explores a rich array of issues related to the emergence of a postindustrial "information society."

Language poets who came of age as writers in the 1970s, such as Lyn Hejinian and Bruce Andrews, produced new kinds of saturated poetic texts, which I explore in chapter 5. In *My Life* and *The Cell*, Hejinian offers a dense mix of immediate personal sensory data and public information (or misinformation). Likewise, Andrews recycles the linguistic detritus of consumer culture into radically paratactic poems. Works such as Andrews's *I Don't Have Any Paper, So Shut Up (or Social Romanticism)* ask us to reconfigure our notions of personhood and communicative agency. In response to an information-saturated world, Andrews fights saturation with more saturation. Hejinian employs similar strategies—but whereas there is practically no sense of personal recollection in Andrews's poetry, Hejinian routinely interjects seemingly insignificant personal memories into her poems. "Memory is the money of my class," she writes in *My Life*, drawing our attention to the value accorded to information within different contexts.[15] Nostalgia reifies bourgeois conceptions of family and identity; information saturation threatens to undermine such markers of origin.

Drawing on the legacy of conceptual art, recent works of conceptual writing by poets such as Goldsmith, Robert Fitterman, Vanessa Place, and Tan Lin—which I discuss in chapter 6—have been consistently engaged with new media and with questions of appropriation and remediation. Goldsmith's *Day* could well stand as an answer to a rhetorical question posed by Basex's 2007 report on information overload: "What is a knowledge worker to do in a world where the Sunday edition of the *New York Times* has more information than the amount of information an average person alive 400 years ago might have come across in his lifetime?"[16] While Basex Inc. hyperbolically stresses the existential threat of information overload, Goldsmith sanguinely engages it by retyping, without any semantic alteration, an entire day of the *New York*

*Times.* Retyping the *Times* significantly reconfigures our sense of its context and meaning. "All the news that's fit to print"—but from whose perspective? "Fit" in the sense of size? Or "fit" in the sense of appropriate? In book form, the September 1, 2000, edition of the *New York Times* Late Edition takes up 836 pages. Yet *Day* does not feel encyclopedic in the manner of *Ulysses*. *Ulysses* demands that we pay attention to the specificity of its allusions; *Day* does not. As readers, we cannot possibly master the mostly forgettable and/or immediately obsolete information of the national paper of record. While the management culture writing on information overload continually stresses that workers and knowledge consumers need to exert more careful control over information, Goldsmith and other conceptual writers suggest that we can only exert such control with great difficulty. As a writer, Goldsmith voluntarily gives up control over many aspects of his process. From Goldsmith's perspective, there were few variables involved in producing *Day*—and little or no skill or craft was required. I suggest that Goldsmith's work, along with other recent works of conceptual writing, can be situated in the context of the emergence of cognitive capitalism and the intensification of the "risk society," particularly in the wake of the 2008 financial crisis.

Although I express reservations about the term "information overload"—due primarily to its potential for technological determinism— I think it is here to stay, and I follow the lead both of popular usage, as well of scholars from diverse disciplines, in adopting the term to refer to a range of phenomena related to information abundance. A chart (Figure 2) produced by Google's Ngram Viewer gives an idea of the increasing frequency with which the term appears in the Google Books database. "Information overload" first began to appear in journals of psychology and organizational management around 1960. The term is sometimes traced to Bertram Gross's 1964 *The Management of Organizations*, but it clearly circulated in a number of contexts prior to this.[17] The term appears in Marshall McLuhan's writing for the first time in the 1964 talk "Cybernetics and Culture": "Today, the ordinary child lives in an electronic environment; he lives in a world of information overload. From infancy he is confronted with the television image, with its braille-like texture and profoundly involving character. . . . Any moment of television provides more data than could be recorded in a dozen pages of prose."[18] Here, television is considered the primary culprit and

children the primary victims. McLuhan's later writings would expand considerably on the theme of information overload (as I detail in chapter 4), but perhaps the greatest credit for popularizing the term should to go to Alvin Toffler's 1970 *Future Shock*, which drew on Gross's work.[19] Gross in turn cited Vannevar Bush's 1945 "As We May Think" as the earliest theorization of the problem. The rise of information theory in the 1940s, accomplished by figures such as Bush, Alan Turing, Norbert Weiner, John von Neumann, Claude Shannon, and Warren Weaver, brought with it far-reaching implications. Like the computer itself, the postwar notion of information overload could be said to emerge at the complex intersection of military, corporate, and educational interests.[20]

The emergence of the term proper in the early 1960s can be most closely linked to the need among management theorists to achieve greater efficiency, and among psychologists to assess the impact of new technologies. But beyond this, there is little consensus when it comes to the history of the larger phenomenon. Reputable scholars have variously located the origins of information overload in the library at Alexandria, in medieval scriptoria, in the printing revolution of early modern Europe, in the Enlightenment's "reading revolution," in the late-nineteenth century's "control revolution," in the post-1945 development of computers, as well as in the post-1990s growth of the Internet.[21] Others have argued that the problem of information overload has been greatly exaggerated—

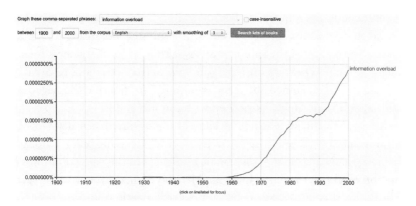

*Figure 2.* The Google Books Ngram Viewer is still in the beta stage of development and remains unreliable in terms of producing precise results. I reproduce this chart mainly to demonstrate broadly the post-1960 proliferation of the term "information overload."

either out of elitist fear of mass culture, or out of misunderstanding the nature of information and its dissemination. Using the term "information overflow" to describe artworks that incorporate databases, Victoria Vesna has suggested another approach in her *Database Aesthetics*. While I find her substitution of "overflow" for "overload" suggestive in that it shows the response of artists and writers to information saturation not to be an exclusively negative one, I retain the terminology of "overload," in part because it describes conditions of exhaustion common to "knowledge workers" (a term first coined by the management guru Peter Drucker in 1959). Among the most consistently articulated concerns of those who have written on the subject has been the sense that workers, readers, and computer users experience fatigue. Unlike the more general "overflow," "overload" more forcefully takes account of how often the phenomenon is linked to questions of "infostress" or "information anxiety."[22] Both "overload" and "overflow" convey a strong sense of the limitations of the human capacity to absorb data, but "overflow" may put a more favorable spin on the phenomenon by eliding the sense of agitation implicit in "overload." "Overflow," particularly in the context of poetry, connotes the sublime, an important aesthetic analogue of information abundance. Recent critics have variously used the terms "digital sublime," "information sublime," and "bureaucratic sublime" to describe twentieth- and twenty-first-century conditions of information abundance.[23] Wordsworth famously spoke of poetry as the "spontaneous overflow of powerful feelings," but insisted that it be found in "tranquility." A key aspect of the sublime, according to Kant, is that "the feeling of the sublime carries with it, as its character, a mental agitation."[24] Drawing on Kant (and with direct reference to Stein), Sianne Ngai has coined the term "stuplimity" to describe the negative affects, or "ugly feelings," associated with the sublime.[25]

Many of the major aesthetic debates of the twentieth century—over, for instance, perception, style, technological reproducibility, cultural memory, and canonicity—take on new valences in the context of information overload. Primarily following the lead of media theorists and art historians, this book rereads the avant-garde poetic tradition through the lens of its engagement with information overload. Sven Spieker goes so far as to "view early-twentieth-century modernism as a reaction formation to the storage crisis that came in the wake of Beniger's [control] revolution, a giant paper jam based on the exponential increase in

stored data, both in the realm of public administration and in large companies whose archives were soon bursting at the seams."[26] Spieker claims ingeniously that "Dadaist montage functions as an anti-archive that . . . reacts to the traumatizing paper jam that occurred in the wake of the First World War (no other event in history generated as much paperwork)."[27] The approach taken by Spieker suggests the rich interrelation between twentieth-century aesthetic form and new data-storage techniques.

Jean Baudrillard maintains that "we live in a world where there is more and more information, and less and less meaning."[28] This I find a reductive formulation. More information does not necessarily lead to less meaning (and properly speaking, Baudrillard would be better off using the term "data" rather than the term "information," since information, at least as understood by information theory, must by definition convey meaningful data).[29] The claim that information overload is at odds with narrative fiction could be understood as a version of the complaint that more information leads to less meaning. David Shields's recent *Reality Hungers*, for instance, argues that "we're overwhelmed right now by calamitous information. The real overwhelms the fictional, is incomparably more compelling than an invented drama."[30] Walter Benjamin claims similarly in his 1936 "The Storyteller" that "if the art of storytelling has become rare, the dissemination of information has played a decisive role in this state of affairs. Every morning brings news from across the globe, yet we are poor in noteworthy stories."[31] For Benjamin and Shields, information excess is opposed to authentic experience and to our ability to impose narrative coherence on the world. In response, both Benjamin and Shields practice collage/appropriation techniques in order to recuperate lost meaning. In so doing, they create new (and often surprisingly personal) narratives that decry information excess at the same time that they thrive on guiding readers through that excess.

When T. S. Eliot asks in the 1934 "The Rock" "Where is the wisdom we have lost in knowledge? / Where is the knowledge we have lost in information?" he is articulating a key high modernist anxiety.[32] A surplus of data threatens access to cultural tradition as well as to reliable political information. Max Weber's main thesis in the 1919 "Science as a Vocation"—which would go on to be the central claim of Adorno and Horkheimer's *Dialectic of Enlightenment*—is that "the increasing

intellectualization and rationalization of the world do not . . . indicate
an increased and general knowledge of the conditions under which one
lives."[33] The culture industry, in Adorno and Horkheimer's terms,
thrives off the overproduction of sensory data. As theorized by Sieg-
fried Kracauer and Walter Benjamin, the masses are distracted by mass
culture's dazzling ornamentalism.[34] They lose control over knowledge;
by succumbing to mass culture they surrender their very ability to make
informed political decisions.[35]

High modernism's relation to mass culture has been amply discussed
elsewhere—what should be particularly noted here is the degree to which
modernist writers were preoccupied by the profusion of information
brought about by new technologies of communication and storage.[36]
Near the opening of his first essay collection, *The Sacred Wood*, Eliot
writes:

> The vast accumulations of knowledge—or at least of information—
> deposited by the nineteenth century have been responsible for an equally
> vast ignorance. When there is so much to be known, when there are so
> many fields of knowledge in which the same words are used with different
> meanings, when every one knows a little about a great many things, it
> becomes increasingly difficult for anyone to know whether he knows what
> he is talking about or not. And when we do not know, or when we do not
> know enough, we tend always to substitute emotions for thoughts.[37]

Eliot's concern with information abundance, this passage shows, was
related to his theory of emotions and individual expression—the sub-
ject of his most famous essay, "Tradition and the Individual Talent," also
included in *The Sacred Wood*. Eliot's worries about the effects of "vast
accumulations of . . . information" were widely shared by his contempo-
raries. Modernist poets demonstrate a keen preoccupation with guiding
the tastes of the "average reader"—works such as Pound's *ABC of Read-
ing* or Louis Zukofsky's *A Test of Poetry* function as primers on what
and how to read. Every anthology or great books list could be said to
be an attempt to contain a flood of possibilities—Pound's attempt to
condense and synthesize general culture for his readers is explicitly
couched in terms of rescuing the modern autodidact from the research
library. Pound is routinely apologetic about the limitations of his antho-
logical and pedagogical projects, as for instance in the *Guide to Kulchur*:

"Despite appearances I am not trying to condense the encyclopedia into 200 pages. I am at best trying to provide the average reader with a few tools for dealing with the heteroclite mass of undigested information hurled at him daily and set to entangle his feet in volumes of reference."[38] As he writes in the *ABC of Reading*, "We live in an age of science and abundance.... The weeder is supremely needed if the Garden of the Muses is to persist as a garden."[39] In some sense Pound spent his entire career trying to condense his own personal mental encyclopedia for his readers—from his early writings on troubadour poetry to the late *Cantos*, Pound's writings (with the important exception of his Imagist poems) are overloaded with historical detail. I. A. Richards famously claimed that T. S. Eliot was able to make *The Waste Land* "equivalent in content to an epic" through his use of allusion.[40] Could *The Cantos* and *The Waste Land* be considered epics of sampling or of data compression? Perhaps designating them as such undervalues their contents. On the other hand, in some sense both are elaborate pastiches which thematize their own fragmentation as well their own inability to make tradition(s) "cohere."

*The Cantos* and *The Waste Land* present versions of a world overburdened by factual history, and yet threatened at the same time by a loss of authentic cultural tradition. Pound especially had a tortured relation to emergent media forms, most notoriously radio. On one wartime broadcast, he claimed, "The press, your press, is a machine for destroying the memory, the public memory."[41] As it was for Eliot, for Pound the mass media was generally antithetical to "tradition." Eliot's "dissociation of sensibility" occurs in the seventeenth century when poets find themselves no longer capable of "constantly amalgamating disparate experience."[42] Like the metaphysical poet in Eliot's account, the contemporary knowledge worker who suffers from overload proves incapable of "constantly amalgamating disparate experience." Increasingly over the course of the century, the poet was a white-collar office worker, sometimes even thematizing conditions of work and distraction in the workplace.[43] As JoAnne Yates and Alan Liu have shown, Taylorist procedures were introduced into white-collar offices not long after they were introduced in factories.[44] The primary obstacle to white-collar efficiency, to employ an anachronism, was what we would think of as "multitasking." The Taylorist/Fordist response to the distracted worker is to reduce the number of tasks assigned to each worker. The distracted knowledge

worker is typically an insufficiently specialized knowledge worker; the non-specialized (and hence distractible) worker became increasingly anathema over the course of the twentieth century. Concomitantly over the course of the century, as the conceptual artist Ian Burn noted in the early 1980s, intellectuals and artists underwent a process of "deskilling."[45] From the ready-mades of Marcel Duchamp to the *Statements* of Lawrence Wiener, art arguably became information as opposed to craft.

If high modernist poets could envision themselves as critics as well as victims of the discontinuous time of distraction in the workplace, it became more difficult for postwar writers to position themselves outside the continuous stream of data and distraction.[46] Whereas high modernist poets tended to quote high cultural sources in discrete units, more recent techniques of appropriation suggest that such selective methods of quotation have lost their force within contemporary media culture. Rob Fitterman describes his writing practice as follows:

> For me, using appropriation—either wholesale or in smaller sampled units (no hierarchy here)—intersects several current conversations about consumerism, art and technology, readership, etc. . . . By replacing or meshing "authentic" text with found text, I hope to highlight a parallel disparity between the object and the commodified object (Buchloh). *Significantly reduce eDiscovery processing costs by culling and reducing the amount of data collected prior to submission to costly processing.* This is, in part, why I do what I do—not to replicate or exploit the original, but to turn up the volume on its difference as we drag these materials into our own expressions and carve our paths through the informational morass.[47]

Fitterman's appropriation technique calls into question the authenticity of any text in a society dominated by information. But although Fitterman describes our current condition as "the informational morass," he does not nihilistically suggest that there is nothing we can do about it. On the contrary, he suggests that updated defamiliarization techniques might allow for recognizing new ways of navigating an increasingly commodified infosphere.

Perhaps the most iconic avant-garde poem of information overload is Raymond Queneau's 1961 *One Hundred Million Million Poems*, in which ten sonnets can be combined to form $10^{14}$ possible sonnets. According to François Le Lionnais, "Queneau calculated that someone reading the

book 24 hours a day would need 190,258,751 years to finish it."[48] This works out to 2.7 million human life spans at seventy years each. So demanding was the project of writing the poem(s) that Queneau sought the assistance of Le Lionnais, a mathematician, thereby inaugurating the Oulipo (or *Ouvroir de littérature potentielle*, the influential Paris-based literary collective that remains active to this day). Queneau's poem participates in the information sublime at the same time that it adheres to most of the conventions of the classical sonnet. In accomplishing this fusion of the finite sonnet with the infinitude of the machine, Queneau literalizes two of William Carlos Williams's most famous statements: "A poem is . . . a machine made of words," and "To me all sonnets say the same thing of no importance."[49] No final meaning can be assigned to a poem whose very parameters exceed the attentional capacities of its readers. But this is not to say that the poem is without meaning. In a 1938 essay, "Wealth and Limit," Queneau expressed strong concerns about an overabundance of information: "A finite individual cannot, in a finite amount of time, amass an infinite quantity of knowledge (facts)."[50] For Queneau, "By reading many books one can accumulate wealth, but in order to be truly rich you must renounce wealth; you must renounce what Goethe called 'infinite detail.'"[51] One means by which Queneau aspired to renounce the wealth of information to be found in poetry and in literary history was to undertake to "haikuify" a sonnet of Mallarmé, preserving only its rhyming words. Although *One Hundred Million Million Poems* at first appears to be a limitlessly expansive work, one might also read it as focusing the reader's attention on the most fundamental attributes of the sonnet form. Reduction and multiplication both function in Queneau's work as responses to a culture in which "to consult [the *Larousse de XXe Siècle*], or any catalogue, or any bibliography, is to learn nothing. . . . No one reads the original works any longer, and if they do glance at them, it's only for a quick look at the index or the table of contents."[52]

In common with the writers discussed at greater length in the individual chapters of this book, Queneau sees the accumulation of specialized information as having reconfigured the ways in which literary texts are created and experienced. He does not, however, react to this transformation with nostalgia, but rather with *a renewed attention to poetic form*. It is important to stress that this is a book about information overload in relation to the forms taken by avant-garde writing; this is not a

comprehensive study of information overload as a general phenomenon,
nor does this study engage with the "mainstream" tradition in American
poetry. Marjorie Perloff offers a succinct rationale for why more tradi-
tional poets do not fall under my purview: "The most cursory survey of
contemporary poetics would show that, at least as far as what Charles
Bernstein calls 'official verse culture' is concerned, technology, whether
computer or the video, audio, and print media, remains, quite simply
the enemy, the locus of commodification and reification against which a
'genuine' poetics discourse must react."[53] This dichotomy between a
media-philic poetic avant-garde and a media-phobic "official verse cul-
ture" is perhaps overstated. Nonetheless, after much searching I have
found very little mainstream poetry that engages issues of information
saturation, either on the level of form or content. As this study argues,
one of the distinguishing features of the poetic avant-garde has been its
ongoing engagement with changing technologies of information and
communication. That engagement has taken many forms, arguably even
reshaping our understanding of what qualifies as poetry.

## The Case Against Information Overload

A number of strong objections have been made to the term "information
overload." The most common objection is made from the perspective of
what Bruce Sterling calls "the Whig theory of technological history,"
in which "all technological developments have marched in progressive
lockstep ... to produce the current exalted media landscape."[54] Along
these lines, the graphic design guru Edward Tufte succinctly rejects the
term on organizational grounds: "It is not a matter of how much infor-
mation there is, but rather how effectively it is used.... Information
overload? ... Clutter and confusion are failures of design, not attributes
of information."[55] The extraordinary growth of Apple, Microsoft, and
Google over the past two decades would lend considerable credence to
Tufte's claim: the success of these three iconic corporations resulted in
large part from their ability to make computers more user-friendly. By
creating powerful, easy-to-use interfaces, they became among the larg-
est and most influential American multinational firms within a remark-
ably short time. In his book *Interface Culture*, Steven Johnson presents
a particularly Whiggish late-1990s view of the power of interfaces to
combat information overload: "The great surge of information that has

swept across our society in recent years looks genuinely innocuous next to the meticulous anarchy of real bit-space . . . But we see almost nothing of that universe because we have built such sturdy mediators to keep it separate from us . . . What differentiates our own historical moment is that a symbolic form has arisen designed precisely to counteract . . . fragmentation and overload with synthesis and sense-making. The interface is a way of seeing the whole."[56] Johnson does not offer a direct refutation of the term "information overload," but his point is clear: well-designed interfaces largely negate the problem of information overload. Johnson suggests that we need blinders to function efficiently, and he optimistically concludes that interfaces can restore to us a quasi-Hegelian organic wholeness. How information is filtered may be the key question surrounding information overload—I am unconvinced, however, that improved interfaces can address all, or even most, of the epistemological and aesthetic issues that surround information overload.[57]

In his *The Wealth of Networks*, Yochai Benkler terms information overload "the Babel objection." Benkler champions a collaborative reception version of the wiki model when he suggests that "the Babel objection is partly solved . . . by the fact that people tend to congregate around common choices."[58] A greater amount of information should bring with it a greater array of choices, but it should also provide metadata on the popularity and utility of those choices. Benkler places primary importance on editing and filtration, and notes, "The core response to the Babel objection . . . is to accept that filtration is crucial to an autonomous individual."[59] Benkler suggests a related paradox in that perhaps the most effective way to counteract information overload would be to increase Internet concentration—that is, reduce the number of filters or content providers. This would however generally be antithetical to the liberal democratic desire for a diversified media and telecommunications sector. For Benkler, this suggests that "to the extent that concerns about Internet concentration are correct, they suggest that information overload is not a deep problem."[60]

An exemplary display of pro and contra positions concerning information overload took place in 2005 when the playwright Richard Foreman wrote in a statement for his play *The Pancake People; or, The Gods Are Pounding My Head* that "we are becoming 'pancake people'—spread wide and thin as we connect with that vast network of information

accessed by the mere touch of a button."[61] A somewhat unlikely defender of the Western humanistic tradition, Foreman lamented the loss of "a tradition of Western culture in which the ideal (my ideal) was the complex, dense and 'cathedral-like' structure of the highly educated and articulate personality—a man or woman who carried inside themselves a personally constructed and unique version of the entire heritage of the West."[62] By contrast, Foreman wrote, "today, I see within us all (myself included) the replacement of complex inner density with a new kind of self-evolving under the pressure of information overload and the technology of the 'instantly available.'"[63] In response, the computer scientist and pioneering artificial intelligence researcher Marvin Minsky scoffed at such claims:

> Mr. Foreman complains that he is being replaced (by "the pressure of information overload") with "a new self"... I think that this is ridiculous because I don't see any basic change; there *always* was too much information. Fifty years ago, if you went into any big library, you would have been overwhelmed by the amounts contained in the books therein....
>
> So, in my view, it is not the gods, but Foreman himself who has been pounding on his own head. Perhaps if he had stopped longer to think, he would have written something more sensible. Or on second thought, perhaps he would not—if, in fact, he actually *has* been replaced.[64]

Minsky is in some sense correct to point to the long history of information overload, as well as to point to the comical implications of Foreman having been replaced by something like an "inforg" avatar. Nonetheless, Minsky is surprisingly tone deaf to the increasing urgency of claims such as Foreman's. That information overload has always existed, or has been nearly coterminous with literacy, should not necessarily lead us to ignore the more recent history of the term over the past several decades. The digitally networked human may be far from a cyborg or an automaton—and yet surely the quantity of data available instantaneously has radically changed human behavior, particularly when it comes to accessing and producing cultural artifacts and literary texts.

The strongest objection to the term information overload, in my view, is that it implies an inherently antidemocratic attitude toward the production of information at the same time that it suggests a rejection of popular and mass culture. According to Mark Poster, "Complaints

that the net inundates everyone with information overload should be understood as the statement of those who are comfortable with earlier restrictions on who speaks, to whom, when, as well as with the content of what may be said. . . . It is pointless to bemoan or to celebrate the new conditions; one must instead work to comprehend critically their limits and affordances."[65] While I agree with Poster that information overload should not necessarily be seen in utopian or dystopian terms, I am less certain that the problem can so simply be attributed to anxieties about the masses gaining a voice. Complaints about the inundation of books have existed at least since the advent of print culture. It represents an epochal shift that most Internet users can at a moment's notice publish their opinions globally on a blog. But historically the term information overload would seem to be much more closely connected to another of Poster's objections to the term: "The discourse of the data flood, we might call it, presumes a psychophysiological model that is questionable: humans must have a limited ability to absorb external sensations, and the Internet is hogging too much brain space."[66] Here we encounter a considerable difficulty, since there is much disagreement among neuroscientists, management experts, and humanists as to the limits of our cognitive ability to process large quantities of information.

## Attention: The Limits of the Human Processor

Jonathan Crary, following the lead of Beniger and others, has suggested that in the late nineteenth century new technologies of reproduction and communication—as well as the professionalization of fields such as psychology within research universities—created a cultural crisis surrounding questions of attention and distraction: "It is in the late nineteenth century, within the human sciences and particularly the nascent field of scientific psychology, that the problem of attention becomes a fundamental issue. It was a problem whose centrality was directly related to the emergence of a social, urban, psychic, and industrial field increasingly saturated with sensory input. Inattention, especially within the context of new forms of large-scale industrialized production, began to be treated as a danger and a serious problem, even though it was often the very modernized arrangements of labor that produced inattention."[67] Although he does not use the term "information overload," Crary suggests that a powerful conflux of social and technological factors coalesced

around the issue of attentiveness. In doing so, Crary largely negates or sidesteps neuroscientific arguments about the limitations of our brain's processing power. For Crary, it is social pressures, rather than the inherent limitations of the human processor, that define normative patterns of concentration and consciousness. He is particularly outspoken in his suspicion of the diagnostic category of ADHD (or ADD):

> Over the last few years we have been reminded of the durability of attention as a normative category of institutional power, in the form of the dubious classification of an "attention deficit disorder" (or ADD) as a label for unmanageable schoolchildren and others. Without entering into the larger issue of the social construction of the illness, what stands out is how attention continues to be posed as a normative and implicitly natural function whose impairment produces a range of symptoms and behaviors that variously disrupt social cohesion. . . . Of course, one distinction that separates contemporary discussions from those of a century ago is the insistence that ADD is not linked to any weakness of the will, and there is no personal responsibility involved.[68]

Crary is right to suggest that the ongoing attention crisis and the problem of information saturation have in a sense become self-fulfilling prophecies of the era of industrial (or postindustrial) production. Basex, for instance, demonstrates that those who attempt to remedy the problem are often major players in hyping the problem. But even if the same is true with regard to ADHD, there exists a considerably greater body of research on the side of psychiatrists and neuroscientists than on the side of those humanists and others (e.g., members of the Church of Scientology) who have cast aspersion on the diagnostic category. Crary describes ADHD as a "dramatic expansion of another layer of disciplinary technology—the sweeping use of potent neurochemicals as a strategy of behavior management."[69] As much as I admire the writing of Crary and Stiegler, I question their hasty dismissal of a condition that is generally said to affect at most between 3 percent and 5 percent of the population. According to the psychiatrist Thomas Brown, whose book on the topic is fairly representative of the mainstream medico-scientific perspective, "The medications used for ADD are among the best researched for any disorder."[70] In his *Overflowing Brain: Information Overload and the Limits of Working Memory*, the Swedish neuroscientist

Torkel Klingberg notes that "attention is the portal through which the information flood reaches the brain," and that "working memory is essential for controlling the attention. We have to remember what it is we are to concentrate on."[71] According to Klingberg and others, drugs such as Adderall and Ritalin have been shown to improve working memory by as much as 10 percent. Even if these drugs are overprescribed, particularly to children, it seems excessive to make ADHD a central front in the war against what Stiegler labels as "psychopower."

In his most extensive treatment of ADHD, Bernard Stiegler suggests that attention-destroying technologies and "media-rich environments" have produced "an organological revolution of the life of the mind," and suggests that "in the course of just three generations, this mutation has become literally colossal, an almost unimaginable worldwide change."[72] Recent psychological research has suggested that cognitive behavior has adapted since the widespread adoption of the Internet. Preliminary experiments conducted by a team led by the psychologist Betsy Sparrow suggest that "processes of human memory are adapting to the advent of new computing and communications technology. Just as we learn through transactive memory who knows what in our families and offices, we are learning what the computer 'knows' and when we should attend to where we have stored information in our computer-based memories."[73] Sparrow and colleagues acknowledge that there are innate limitations to human memory, but they also argue that the cognitive benefits of the Internet far outweigh the costs. They conclude that "we are becoming symbiotic with computer tools, growing into interconnected systems that remember less by knowing than by knowing where the information can be found. This gives us the advantage of access to a vast range of information, although the disadvantages are constantly being debated. It may be no more than nostalgia at this point, however, to wish we were less dependent on our gadgets."[74]

N. Katherine Hayles has written extensively on ADHD and reading practices, and suggests that educators should differentiate between "hyper" and "deep" attention. According to Hayles, "Deep attention, the cognitive style traditionally associated with the humanities, is characterized by concentrating on a single object for long periods (say, a novel by Dickens), ignoring outside stimuli while so engaged, preferring a single information stream, and having a high tolerance for long focus times. Hyper attention is characterized by switching focus rapidly

among different tasks, preferring multiple information streams, seeking a high level of stimulation, and having a low tolerance for boredom."[75] Hayles suggests that "hyper attention" poses a threat to traditional methods of education—but she does not claim that "hyper attention" is an unmitigated evil, or a conspiracy to destroy the attention of the world's youth. Like the mainstream tradition in management theory, what Hayles is primarily suspicious of is essentially multitasking.[76] She does not offer a blanket critique of the entire psychiatric establishment, and her views are backed by scientific sources. What seems to be most at stake in Hayles's assessment is the continuing value of the contemplative experience of reading. Hayles offers the example of a Dickens novel to illustrate her case for "deep attention," but she does not specify a particular Dickens novel. Here perhaps an analogy can be made to the avant-garde writing I discuss under the rubric of information overload. At least in their initial periodical forms, Dickens's writings must often have competed with other works in something like a "hyper attention" mode. Surely *A Christmas Carol* is a page-turner, but what of the notoriously unfinishable *Bleak House*? It seems to me that despite its length, *Bleak House* is not, at least in a formal sense, a text that Dickens meant to be "read at" rather than read.

The speed at which texts are read is an important corollary of the information overload debate—particularly in the context of literary writing. "Reading may be classified according to the time it takes up," Georges Perec writes in his supremely classificatory *Species of Spaces*.[77] Tan Lin (discussed in chapter 6) has recently written that "all reading is format-dependent scanning i.e. controlled forgetting."[78] Such claims made about poetry have been controversial. Dale Smith and others have recently advocated "Slow Poetry" in response to conceptual writing. Smith and Goldsmith's 2009 exchange "The Tortoise and the Hare: Dale Smith and Kenneth Goldsmith Parse Slow and Fast Poetries" offers an excellent overview of this debate.[79] Both Goldsmith and Smith see the Internet as profoundly altering reading practices; the premises on which they construct their polemics are particularly revealing. According to Goldsmith (who, to be fair, is operating in a provocateur mode), "Any notion of history has been leveled by the internet."[80] In response, Smith argues, "The only difference between a digital archive and a library is found in the different storage capacities and the greater accessibility offered by digital formats. A 'truly digital immersion' doesn't seem to answer anything

more or less than print immersions—or the speeded up way of life after airplanes and cars or whatever. The human psyche remains at best a kind of Paleolithic thing, and there's a lot of brain research and evolutionary biology etc that talks about this."[81] Goldsmith's notion of an end of history brought about by the Internet is clearly overstated, as is Smith's invocation of the prehistoric limitations of human cognition. At the same time, their starkly divergent positions reveal a shared emphasis on adapting poetry either to embrace, or to resist, the acceleration of reading.

The Claudius App: A Journal of Fast Poetry, edited by Jeff Nagy and Eric Linsker, provides a platform for contemporary poetry that engages new forms of reading and writing. The journal's fourth issue takes the form of an ingenious parody of Poetry Magazine's iPhone app. In effect, Poetry's app (see Figure 3) is a relational database that allows readers to choose poems based on moods (e.g., sadness) and topics (e.g., youth). The Claudius App IV (Figure 4) uses the same categories, but leads readers to its own content. The Claudius App IV is not in fact a mobile application written for the iPhone, but instead a webpage written in HTML that is designed to look like an app. Clicking on the Poetry app's "More Info" button leads to the banally humanistic statement that "This application was created to introduce new audiences to the world of poetry." Clicking on The Claudius App's "More Info" button leads to an absurdist mash-up text that begins "The system was marking down," which any diligent reader of postwar American poetry will recognize as a parody of the opening line of John Ashbery's 1970 "The System": "The system was breaking down."[82] While The Claudius App may be something of an inside joke, it is also reflective of larger phenomena related to the ubiquitous availability of poetry online. Poetry's app presumes that what draws new readers to poetry are primarily affective and personal considerations. The Claudius App's parody would seem to suggest that it is unlikely that readers will read traditional poetry on their phones. Poetry's app is, in a sense, built on a paradox: it aims to draw casual mobile readers to poetry that can be quickly consumed, and yet the poems it draws readers to, for the most part, are traditional contemplative lyrics that seem out of place on an iPhone screen.

Joshua Clover (whose poetry is included in the first issue of The Claudius App) claims that "modern poetry, and free verse in particular, is indeed faster" than its pre-twentieth-century antecedents.[83] For Clover, this acceleration suggests an ongoing engagement with technological

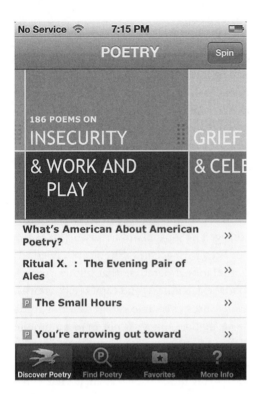

*Figure 3.* Poetry Foundation app (2013).

*Figure 4. The Claudius App IV: A Journal of Fast Poetry* (2013).

change, as well as with increasingly intensified forms of capitalism. The historian Sue Currell has shown that from the late nineteenth century onward it became apparent that new technologies would alter the nature and speed of reading. Slow reading came to be seen as a contemplative luxury (and/or a pedagogical necessity); speed reading came to be viewed as a modern necessity. Currell describes how speed reading was typically disparaged until the 1890s, when new psychological research argued that attention was "shown not to decrease with acceleration but to sharpen and improve."[84] From the turn of the century to the 1950s, speed reading manuals proliferated. While traditionalists might maintain that reading quickly was antithetical to literature, even conservative modernist critics such as I. A. Richards felt compelled to experiment with speed reading. With his reading machine, Bob Brown (as discussed in chapter 2) was arguably parodying the speed reading movement. The introduction of mechanized or accelerated forms of reading has, not surprisingly, alarmed many.[85] For others, such as Brown, new technologies of reading and writing have also held forth the promise of radically altering the nature of poetic language, which need not be created and received within the confines of a contemplative state free from the attractions and distractions of new communications technologies.[86]

Drawing primarily on the examples of Stein and Cage, the poet and critic Joan Retallack suggests that both were centrally concerned with reconfiguring the attention of their viewers. In *The Poethical Wager*, she argues that the "role of the arts seems positively urgent" because "in this age of Attention Deficit Disorder, how rare an informed, intense, not to say pleasurable connection with anything in our daily lives can be—the effects that this distractedness has on possibility and aspiration."[87] Thus, drawing attention to attention, in Retallack's terms, is akin to an ethical (or "poethical") act. Retallack's defense of avant-garde writing as an antidote to distraction ingeniously allows the writing to retain its capacity to shock at the same time that it acknowledges that poetry must compete with countless distractions.

## The Economics of Attention

In his book (whose lengthy title itself seems designed to frustrate direct attention!) *plagiarism/outsource, Notes Towards the Definition of Culture, Untitled Heath Ledger Project, a history of the search engine, disco OS, Tan*

Lin writes, "An attention span produces things that interest us and not the other way around. Thus every attention span is a form of labor whose aim is to produce surplus value. We own our own capacities for producing attention, in the way that workers once owned arms and legs and with them produced iron hoops or steel forks."[88] In fact, Lin is quoting without attribution an article by Jonathan Beller titled "Paying Attention."[89] Have we as readers been paying attention? Did we just *pay* our attention to Lin? Or to someone else? Did we derive something in return from the transaction? A quick web search, as every professor knows, is the fastest way to catch a plagiarist. Perhaps Lin alludes to this phenomenon with his ambiguous titular phrase "a history of the search engine." One effect of Lin's appropriation tactic is to demonstrate that we have very limited ownership when it comes to owning our own attention. To "surf" the web is perhaps to use our attention in ways that are not necessarily productive. Even so, the waves on which we surf would seem to be overwhelmingly located on private beaches.

The management theorist Herbert Simon was perhaps the most influential thinker on the economics of attention of the postwar period. Simon's *Administrative Behavior: A Study of Decision-Making Processes in Administrative Organizations* (first published in 1945 and subsequently expanded and updated) declares in its most recent, 1997 edition, "The central lesson that the computer should teach is that information is no longer scarce or in dire need of enhanced distribution. In contrast with past ages, we now live in an information-rich world. . . . The main requirement in the design of organizational communication systems is not to reduce scarcity of information but to combat the glut of information, so that we may find time to attend to that information which is most relevant to our tasks."[90] Even before the rise of the personal computer, it was clear to Simon that corporations were dedicating a significant proportion of their resources to information management. For the most widely praised management text of its kind to make information overload a central concern gives an idea of the threat perceived by the managers and corporations. In a much-quoted passage, Simon claimed in 1971 that "what information consumes is rather obvious: it consumes the attention of its recipients. Hence a wealth of information creates a poverty of attention, and a need to allocate that attention efficiently among the overabundance of information sources that might consume it."[91] Simon coined the term "satisficing" to describe "a bounded rationality" in which

in the interest of maximizing utility and efficiency it makes sense not to investigate all possible outcomes of a decision. Daniel Kahneman and Amos Tversky (who, like Simon, also won the Nobel Prize in Economic Sciences) suggested further that a greater number of life choices would not necessarily make people happier.[92] Barry Schwartz terms this the "paradox of choice": when we are confronted by a hundred possible varieties and sizes of toothpaste in the supermarket, we are likely not to benefit from devoting extensive attention to our selection process.[93] Happiness, in Schwartz's view, largely results from the proper allocation of attention.

Attention economics, the rhetorician Richard Lanham has recently argued, is so fundamental to our contemporary world that rhetoric deserves to be utterly redefined as a field: "[Rhetoric] has traditionally been defined as the art of persuasion. It might as well, though, have been called the economics of attention. In a society where information and stuff have changed places, it proves useful to think of rhetoric precisely as such, as a new economics."[94] Lanham and others are grappling with a number of complex, interrelated issues. In a society of mass consumption, both of material products as well as of entertainment and information, it is often unclear who owns what when it comes to attention. How should we quantify attention? According to the psychologist Mihaly Csikszentmihalyi, attention can be quantified on the level of the life span:

> It seems that we can manage at most seven bits of information—such as differentiated sounds, or visual stimuli, or recognizable nuances of emotion or thought—at any one time, and that the shortest time it takes to discriminate between one set of bits and another is about 1/18 of a second. By using these figures one concludes that it is possible to process at most 126 bits of information per second, or 7,560 per minute, or almost half a million per hour. Over a lifetime of seventy years, and counting sixteen hours of waking time each day, this amounts to about 185 billions bits of information. It is out of this total that everything in our life must come— every thought, memory, feeling, or action.[95]

For Csikszentmihalyi, it is essential to human happiness that we find "flow," which he defines as sustained concentration. Excessive sensory input inhibits flow, and detracts from our quality of life. Csikszentmihalyi

generally assumes that individuals can create "flow" through effortful self-control—presuming that individuals are the owners of their own attention. Others, who link attention and distraction more closely to technology, are less sure that individuals are in control of their attention. At stake are not only issues of who owns information, but who controls the attention required to process information.

If, in a crude version of the Marxist model of exploitation, capitalists continually appropriate the surplus value produced by the physical labor of workers, it remains unclear what rights knowledge workers have over the products of their intellectual labor. Knowing what rights consumers of information have, if any, is even less clear. Whether individuals have rights to be protected from advertising, data collection, and information saturation seems an open question in an era where intellectual property is in flux. Attention, rather than labor, may have become the general equivalent—but the two are of course closely related.[96] In *The Human Motor: Energy, Fatigue, and the Origins of Modernity*, Anson Rabinbach chronicles how in the postwar period, "with the declining significance of industrial work as a paradigm of human activity and modernity, the body no longer represents the triumph of an order of productivism."[97] Gradually replacing the industrial age metaphor of the human motor were any number of information age metaphors: the cyborg, the global brain, the human word processor.[98] Such analogies are so ubiquitous and generalized as to defy comprehensive description here; in the context of information overload what is perhaps most important to note is that these analogies almost always have political implications in terms of the potential for technology to supplement or to supplant human agency.

## An Eco-nomics of Memory:
## Archive Pandemic/Archive Panacea

Despite the pervasive rhetoric of dematerialization that surrounds the information age, the topic of information overload seems repeatedly to return to questions related to the archive, typically imagined in physical terms. Who authorizes its contents? Who filters? Who and what is preserved within? Who has access? Who can forget? The purported anarchy of the Internet-as-mega-archive suggests to many that a crisis of epic proportions is underway in terms of literary valuation. In his *Gutenberg*

*to Google: Electronic Representations of Literary Texts*, Peter Shillingsburg writes of e-texts that "already information overload has set in. The comprehensiveness of the electronic archive threatens to create a salt, estranging sea of information, separating the archive user from insights into the critical significance of textual histories."[99] In a recent essay, Kenneth Goldsmith writes that "the blizzard of language is amnesia-inducing; these are not words to be remembered."[100] Goldsmith's concern is not new among poets. As early as 1962, John Ashbery would write cryptically in his influential *Tennis-Court Oath* that

> In America the office hid
> archives in his
> stall . . . [101]

Whatever this personified "America the office" is hiding is unclear, as if the poet were lost in an infinitely mysterious bureaucratic sublime. As is often the case in Ashbery's poetry, the referents are vague; the poet toggles back and forth between fragmentary memories and the immediate present, and seems forgetful or distracted.[102]

This book suggests that poets have not been passive victims of the proliferation of information, but rather have actively participated in—sometimes benefiting from, sometimes implicitly advocating, sometimes resisting—that proliferation. Poetry's engagement with information technologies constitutes its own emergent textual history. As Derrida reminds us, archives are not simply about preserving the past—they are about continuously reconfiguring the future. In Derrida's terms, the archive is really a giant filter, not unlike (in Freudian terms) a colossal superego, wherein a culture authorizes its past. Derrida frames the question of the archive in economic terms, with recourse to the etymological sense of the word: "Every archive . . . is at once institutive and conservative. Revolutionary and traditional. An *eco-nomic* archive in this double sense: it keeps, it saves, but in an unnatural fashion, that is to say by making the law (*nomos*) or in making people respect the law. . . . It has the force of law, of a law which is the law of the house (*oikos*), of the house as place, domicile, family, lineage, or institution."[103] The question of the archive, then, is fundamentally a question of the economics of memory. What constitutes "an unnatural fashion" of memorialization? Is the technicization of memory by itself unnatural? Alluding to

Aristotle's distinction between the natural production and accumulation of wealth within the household (economics) and the unnatural production and accumulation of wealth outside the household (chrematistics) through finance capital and other means, Derrida would seem to suggest that insofar as the archive redefines memory through technicizing it, then the process of archivization is unnatural. The salient point here would be that the archive is not a neutral space of accumulation: rather, the archive is to cultural capital what the investment bank is to finance capital. The archive is a space of endless revaluation, which both preserves and produces memories far in excess of the interpretive capacities of any one archivist or "market maker."

At the opposite extreme from "archive fever," there is what could be called an "archive panacea" countermovement. The Global Consciousness Project at Princeton could be understood as one such incarnation of the notion that the World Wide Web is an evolving "noosphere" (in Teilhard de Chardin's terms).[104] Proponents of "archive panacea" tend to see the web as a radical social leveler, distributing information to the many with few adverse consequences. This might be seen as an extreme version of the Whig theory of technological development, which infuses the progressive model of information technology with a healthy dose of evolutionary fervor. Those who stress the dangers of information overload often invoke the "Cro-Magnon brain" as an analogue to the modern human brain.[105] Those who champion the advantages of unlimited access to information often suggest that in the course of a few generations human consciousness has been utterly transformed. From the standpoint of evolutionary science, both of these positions seem premised on questionable sociobiological assumptions. By any respectable measure, it should take many generations for the effects of information technology to affect the genetic traits of human beings.[106]

The idea of a totalizing digital archive, however, rather than inspiring utopian optimism, generally seems to inspire suspicion, if not paranoia. A poem such as Mel Nichols's "I Google Myself" describes, as well as performs, the now-common narcissistic experience of locating oneself within the global archive of the web.[107] (The poem takes the form of a parody of the lyrics to the popular song "I Touch Myself" by Divinyls.) The global archive offers the possibility that every literate person can become an archivist whose archive is available to all with the requisite technological means. Craig Dworkin has recently applied the term

"hypermnesia" to the conditions facing the publication and valoriza-
tion of contemporary poetry. Hypermnesia involves exceptionally vivid
memories, and yet it also implies a pathological overvaluation of certain
memories at the expense of others. The archetypal literary hypermnesic
is Borges's Funes the Memorious.[108] Like "The Library of Babel," the
story of Funes has become a central point of reference in discussions
of information overload. "The certainty that everything has already
been written annuls us, or renders us phantasmal," Borges writes in
"The Library of Babel."[109] Funes's total memory annuls his ability to
create anything new, so overwhelmed is he by the complexity of his
total recall.

   Freud, as in the famous analogy of the layers of the city of Rome in
*Civilization and Its Discontents*, suggests that in effect we never really
forget, but rather repress, past experiences. Information overload, we
might say, results partly from the sense that the archive, like the globe
itself, is hopelessly overpopulated with memories.[110] Around the same
time that information overload was becoming a widely circulated term
in the late 1960s and early 1970s, concern about overpopulation also
began to take on new urgency.[111] Even earlier, Stein, Brown, and Olson
all demonstrated concern with human overpopulation—or at least with
overpopulation's sociological corollary, the problem of anomie. French
curator and art critic Nicholas Bourriard has placed under the banner
of "postproduction" art a body of work that specifically engages a world
overpopulated with art objects:

> Since the early nineties, an ever increasing number of artworks have been
> created on the basis of preexisting works; more and more artists interpret,
> reproduce, re-exhibit, or use works made by others or available cultural
> products. This art of postproduction seems to respond to the proliferating
> chaos of global culture in the information age, which is characterized by an
> increase in the supply of works and the art world's annexation of forms
> ignored or disdained until now. These artists who insert their own work
> into that of others contribute to the eradication of the traditional distinc-
> tion between production and consumption, creation and copy, readymade
> and original work. The material they manipulate is no longer *primary*. It is
> no longer a matter of elaborating a form on the basis of a raw material but
> working with objects that are already in circulation on the cultural market,
> which is to say, objects already *informed* by other objects.[112]

The archive, as we know, is continually expanding and can never be total. As defined by Foucault, the archive is more like a living language than it is like a dead one:

> The archive ... defines a practice that causes a multiplicity of statements to emerge as so many regular events, as so many things to be dealt with and manipulated. It ... does not constitute the library of all libraries, outside time and place; nor is it the welcoming oblivion that opens up to all new speech the operation field of its freedom: between tradition and oblivion, it reveals the rules of a practice that enables statements both to survive and to undergo regular modification. It is the general system of the formation and transformation of statements.[113]

What Hal Foster has called the "archival impulse" does not, then, imply an end of history, but rather a proliferation of histories. It is to Foucault that we largely owe the critical–theoretical notion of the singular "archive," and yet Foucault was careful to avoid the conventional polarity of the archive-as-total-oblivion versus the archive-as-total-memory. To define the archive as "a general system of the formation and transformation of statements" is admittedly vague, but as a definition it fits well with the notion of an electronic archive that is continually expanding. One of Bourriard's most crucial claims is that postproduction art goes beyond appropriation art in that the works are premised on an ideal of sharing rather than of individual ownership. Postproduction art is drawn from what is in effect a giant global archive of images, ideas, and sounds. Such an archive is open to all who know where to look, and how to borrow without stealing (or without getting caught).

Among the archive's paradoxes is that it preserves memories in bulk, but that very bulk threatens to alter, if not obviate, the significance of those memories. The hypermnesiac archive, in Dworkin's description, "remains a destructive accumulation, a bibliographic potlatch in which the survival of books—books and not merely their 'content'—can only be guaranteed by their destruction."[114] Archive fever, as a version of information overload, results from a hypertrophy of stored data, and forces us to continually bridge the distance between data and knowledge, perception and meaning, lived memory and artificial memory. Nietzsche is conspicuously absent from *Archive Fever*, although he is perhaps Derrida's central philosophical influence. In many respects, Nietzsche's

"Utility and Liability of History" is more prescient of current debates about information saturation than are the texts of Freud—given that the unconscious generally plays a small role in contemporary discussions of information overload, and given also Freud's tendency to assume that it is internally stored memory, as opposed to external written memory, that overwhelms our sensorium. In the immediate aftermath of the Franco-Prussian War, Nietzsche noted that the war had "already been transformed into a hundred thousand pages of printed paper."[115] For Nietzsche, the increasing availability of historical data was anathema to heroic individualism, indeed to individualism of any kind: "The modern human being drags around with him a huge number of indigestible stones of knowledge, which then on occasion, as in the fairy tale, make quite a racket inside his stomach. This racket betrays the fundamental characteristic of this modern human being: the remarkable antithesis between an interior that corresponds to no exterior and an exterior that corresponds to no interior—an antithesis unknown to peoples of the ancient world. Knowledge consumed in excess of hunger—indeed, even contrary to one's need—now no longer is effective as a shaping impulse."[116] Stuffed with knowledge, the human being is bloated to the point of shapelessness. Nietzsche's metaphors are of food, not of drowning, and the message is that the inwardness we take to be founded on historical knowledge is in fact no inwardness at all. Rather than the individual devouring knowledge in the archive, the individual is devoured by the archive.

According to the ideals of classical humanism, one could never know too much. But perhaps at the very moment God died, He returned with infinite technologies to preserve all human knowledge, whatever its actual worth. For Nietzsche, information inundation is a matter of life and death: "Historical knowledge constantly flows into [modern man] from inexhaustible sources; alien and disconnected facts crowd in upon him; his memory opens all its gates and is still not open wide enough; nature struggles as best it can to receive, order, and honor these alien guests, but they themselves are involved in a struggle with one another, and it seems necessary to overpower and subdue them all if he himself is not to perish as a result of their struggle."[117] Whereas for Nietzsche, the flood threatens to overwhelm us with historical data, for most contemporary observers information overload threatens to overwhelm us with present data, with the latest news rather than with ancient history. Nietzsche personifies facts themselves; in the process of moving from

data to knowledge, facts effect the opposite movement in humans: abundant facts turn each person into a mere factoid among factoids. Nietzsche's remark that "our writing tools are also working on our thoughts" is frequently cited in support of arguments that imply technological determinism.[118] But it is also true that our thoughts are working on our writing tools; the tools have allowed us to produce works of art that would not have been possible (or perhaps even conceivable) otherwise.

With electronic memory now ubiquitous, it requires more conscious agency to organize and/or delete memories than it does to preserve them in bulk.[119] Total memory is rapidly becoming our default mode. Bernard Stiegler writes that "we are in constant relation with mnemotechnological apparatuses of all kinds, from televisions and telephones to computers and GPS navigation systems. These cognitive technologies, to which we consign a greater and greater part of our memory, cause us to lose ever-greater parts of our knowledge."[120] For Stiegler, this exteriorization of memory results in a situation analogous to the process of proletarianization described by Marx: the factory worker needs no skills or knowledge of his own to perform his tasks; likewise, the consumer or producer of knowledge need not retain a personal store of knowledge. The pocket-size archive fundamentally reconfigures the experience of acquiring publicly available information; what its overall effects on literature and general human knowledge will be, it seems too early to say. The very magnitude of the changes taking place in terms of communication and data storage make elaborate prognostications impossible. Physical letters, which often constituted the most important source of historical information about writers, effectively no longer exist as evidence of the beliefs and methods of younger writers. Derrida notes the transformation brought about by e-mail:

> Electronic mail today . . . is on the way to transforming the entire public and private space of humanity, and first of all the limit between the private, the secret (private or public), and the public or the phenomenal. It is not only a technique, in the ordinary and limited sense of the term: at an unprecedented rhythm, in quasi-instantaneous fashion, this instrumental possibility of production, of printing, of conservation, and of destruction of the archive must inevitably be accompanied by juridical and thus political transformations. These affect nothing less than property rights, publishing and reproduction rights.[121]

E-mail is both infinitely retrievable as well as radically intangible—in the sense that it carries with it little or no "aura" in Benjamin's terms. At least in part, Derrida was obsessed with the archive in his late writing because he was being meticulously archived while still alive—a situation common to many well-known late twentieth-century intellectuals and poets, but a situation that seems increasingly unlikely in an era where there are fewer and fewer physical traces of the writing process (in the form not just of letters, but also of drafts, notebooks, etc.). At the same time, nearly every action one undertakes with a word processor or a web browser leaves behind a considerable trail of metadata (time saved, time accessed, etc.). How much value are we to place on minutely recorded data that has hitherto not been considered worth preserving? As with so much else, questions of memory and interpretation ultimately come down to questions of control and meaning. The unit of the book remains the preeminent literary filter—whether that will remain the case in the future is a question beyond the scope of the printed document you hold before you.

## The Copiousness of Metadata and the Convergence of Media

In *The Making of Americans*, Stein envisions a kind of modernist Total Information Awareness to be brought about by the sheer comprehensiveness of her epic novel: "Soon there will be a history of every kind of men and every kind of women and every way one can think about them. Soon there will be a history of every man and every woman and every kind of being they ever have or could have in them."[122] Her words bring to mind the conceptual artist Douglas Huebler's claim that "one of the great things that holds a culture together is redundancy of information."[123] Character, for Stein, is deeply based in habit, which is to say in repeated actions and behaviors. Typically we understand repeated, habitual activities in pejorative terms. But as Huebler suggests, in information theoretical terms redundancy is necessary to convey meaning. Other influential modernists, such as Flaubert, were more alarmed at the growing redundancy of stored information and its effects on human character.

If there were an ur-text of information overload, it would have to be *Bouvard and Pécuchet*. In Raymond Queneau's words, "Our helpless

autodidacts are flummoxed by tides of contradictory information, competing theories, and unverifiable assertions."[124] Flaubert, as is well-known, read fifteen hundred volumes as background research. Bouvard and Pécuchet are invoked so frequently in discussions of appropriated writing that referencing them in that context is a cliché in itself. If there were an entry for "information overload" in the *Dictionary of Received Ideas* (inventing new definitions for it is almost another cliché!), it might read, "An affliction from which this author suffers greatly." Bouvard and Pécuchet bear witness to a vicious circle of exponentially expanding textuality from which they and their creator cannot escape ("Printing press" is defined as "A marvelous discovery. Has done more harm than good").[125] In their failure to complete their classification scheme, our heroes are, in the words of Craig Dworkin, like "interfaces to the proliferating database of printed matter in the Troisième République."[126] In the fragmentary Chapter 11 (the last Flaubert wrote) of *Bouvard and Pécuchet*, our heroes undertake to "copy haphazardly, whatever falls in their hands, all the papers and manuscripts they come across, tobacco packets, old newspapers, lost letters, believing it all to be important and worth preserving."[127] The copyists return to their original vocation with even greater gusto now that it is an avocation. "But soon they feel the need to make some sort of classification."[128] Presumably the two believe they will someday be able to retrieve their data—and thus they begin to construct a classification system, to undertake a "Dictionary of acquired ideas. Catalogue of fashionable ideas." Even poetry (which is defined as "Utterly useless. Out of fashion") is to be reduced to the level of mere bureaucratic data: "The manuscripts of Marescot's clerk = poetic passages."[129]

The ease with which text and music can now be produced, copied, and exchanged has spawned an important body of recent critical writing which places in question the nature of intellectual property. Kenneth Goldsmith's preface to *Against Expression: An Anthology of Conceptual Writing* claims, convincingly to my mind, that the recent surge in appropriation writing is a response to unprecedented textual abundance. "Why are so many writers now exploring strategies of copying and appropriation?" he asks. "It's simple: the computer encourages us to mimic its workings. If cutting and pasting were integral to the writing process, we would be mad to imagine that writers wouldn't explore and exploit those functions."[130] For Goldsmith, "With the rise of the Internet, writing is

arguably facing its greatest challenge since Gutenberg. What has happened in the past fifteen years has forced writers to conceive of language in ways unthinkable just a short time ago."[131]

Marcus Boon's *In Praise of Copying* (which was originally envisioned as a collaboration with Goldsmith, and is incidentally being given away for free online by Harvard University Press) links copying to *copia*, the abundant style. Boon suggests that copies are "markers of the dangers of an excess that needs to be controlled."[132] For Boon, "Copia involves a movement of forms and energies that is antithetical to that of private property—from the point of view of form—inherently multiple, excessive, and abundant."[133] Boon argues for a complete overhaul of the existing global understanding of copyright and intellectual property, and he suggests that copia has a role to play in that process. For Erasmus, copia is synonymous with variety and plenitude. According to Ann Blair, "References to the abundance of books appeared well before the early modern period, whether cast favorably (as cornucopian abundance) or unfavorably (as overabundance)."[134] Copia recasts information abundance in favorable terms; famously, Erasmus offers two hundred variations on a single sentence. However much irony may have gone into his project, Erasmus was confident that language could be artfully constructed and systematically taught, in part by means of exercises. Erasmus values both *inventio* and *imitatio*, encouraging the artful use of commonplaces. Copia, in the sense of constrained variation, could also be considered an important technique of twentieth-century avant-garde writing, with Raymond Queneau's *Exercises in Style* serving as perhaps its best-known example.

As Bouvard and Pécuchet discover, archiving the results of their copying requires that they create a classification scheme: effective data storage necessitates the creation of effective metadata protocols. Drawing on Derrida, Dworkin writes that "by archiving books, the archive itself adds to their bibliographic information."[135] As Dan Graham's "Schema" (discussed in chapter 6) shows, every iteration of a text alters (if ever so slightly) its form—as well as creating (perhaps largely insignificant) new metadata about the conditions of its reception. In Derrida's description, the archive is ever expanding: "By incorporating the knowledge deployed in reference to it, the archive augments itself, engrosses itself, it gains in *auctoritatis*. But in the same stroke it loses the absolute and meta-textual authority it might claim to have. One will never be able to

objectivize it with no remainder. The archivist produces more archive, and that is why the archive is never closed."[136] This ever-expanding archive, I would suggest, has elicited an appropriately copious variety of responses. Contra Stein, there never will be "a history of every man and every woman," although it is conceivable that there is now recorded data about every American presently living—indeed, one might suggest that being an American citizen is legally the antithesis of being *sans papiers* (or the digital equivalent).[137] Stored data by itself does not constitute history, however. Stein's total history can only exist in a projected future, and Stein's notion of such a copious history requires a genius figure (herself) to process and filter historical information.

The technicization of memory—as in Kittler's description of an undifferentiated optical/digital media that will absorb all others—is sometimes taken to signal the death of the author as well as the death of literature.[138] Kittler writes that "under conditions of high technology, literature has nothing more to say. It ends in cryptograms that defy interpretation and permit only interception."[139] Against Kittler's pronouncement, poetries of information overload—by which I mean poetries (and poetics texts) that relate either formally or historically to information saturation—demonstrate an extraordinary range of innovative responses to changing technological conditions. Rather than accept posthistorical pessimism, the poetics of information overload show that there are many possible forms, as well as frames of reference, available to contemporary poetry. The kinds of poetry discussed in this book ask us to rethink our commonly held notions of literary meaning (what was there to say that can no longer be said?), our notions of communicative transparency (what is the difference between a difficult literary work and a cryptogram?), as well as our notions of personhood (how are we defined by our access to, and ownership of, information?). Much depends on our answers to these questions.

Poetry, that is, continues to have much to say—too much perhaps . . .

# 1

# "READING AT IT"

## GERTRUDE STEIN, INFORMATION OVERLOAD, AND THE MAKINGS OF AMERICANITIS

There is no grammar in opposition but there is if there is omnipresent successful intermediation.
—Gertrude Stein, *How to Write*

There are so many things to say at one time and this is one of them.
—Gertrude Stein, *Narration: Four Lectures*

In the final paragraph of her last completed composition, "Reflection on the Atomic Bomb," Gertrude Stein wrote, "Everybody gets so much information all day long that they lose their common sense. They listen so much that they forget to be natural. This is a nice story."[1] It is difficult to see how in 1946 the atomic bomb could have been "a nice story," and "Reflection on the Atomic Bomb" has typically been considered a peripheral late work. But I would counter that, despite its brevity and its opacity, it is an important final statement of Stein's attitudes toward technology, information, and epistemology. For Stein, the bomb "is not at all interesting, not any more interesting than any other machine, and machines are only interesting in being invented or in what they do, so why be interested. . . . That it has to be secret makes it dull and meaningless."[2] Stein's response to the bomb is quiescent, but it is also skeptical, in the sense of suspending judgment (and consequently fear) in the face of a multiplicity of unforeseeable outcomes. In the immediate aftermath of Hiroshima, Nagasaki, and the Holocaust, Stein refrains from apocalyptic pronouncements. Rather than make a direct

proclamation on the nature of the bomb, she offers a reflection on how
saturated the world is not only with information, but also with fear:
"There is so much to be scared of so what is the use of bothering to
be scared."[3] Though it may now sound like something of a truism,
Stein's statement "Everybody gets so much information all day long that
they lose their common sense" bears a complex relation to her life and
work. After exploring Stein's attitudes toward information abundance
at length, I return to "Reflection on the Atomic Bomb" at the conclusion
of this chapter.

It is tempting to imagine Stein having read Vannevar Bush's influen-
tial "As We May Think" in the July 1945 issue of the *Atlantic Monthly*.
"As We May Think" is the most significant and widely read article on
the growing problem of information saturation in the immediate post-
war period.[4] The *Atlantic* figured prominently in Stein's career—its
serial publication of the *Autobiography* introduced her to a mass audi-
ence. The *Atlantic* also published B. F. Skinner's attack on her in 1934,
as well as publishing her "The Winner Loses: A Portrait of Occupied
France" in 1940. Stein might also have encountered an abridged version
of Bush's article in the September 10, 1945, issue of *Life*; eerily, Stein's
article "Off We All Went to See Germany" appeared a month earlier,
in the August 6, 1945, issue.[5] "As We May Think" explores the role of
scientists in the war, and suggests "it is the physicists who have been
thrown most violently off stride" by "the making of strange destructive
gadgets."[6] The last sentence of Bush's introduction in the *Atlantic* had
originally read "Now, as peace approaches, one asks where [scientists]
will find objectives worthy of their best."[7] The *Life* version omitted the
phrase "as peace approaches." What preoccupied Bush most centrally
were the new requirements and possibilities for information storage and
retrieval that emerged from the war effort. Bush proposed the "Memex,"
a proto-computer filing system, as a means by which scientific and prac-
tical knowledge might be indexed in order to address the problem of
information overload.[8] The central problem facing researchers is that
"there is a growing mountain of research. But there is increased evidence
that we are being bogged down today as specialization extends. The
investigator is staggered by the findings and conclusions of thousands of
other workers—conclusions which he cannot find time to grasp, much
less to remember, as they appear."[9] Though there is no evidence that
Stein was aware of the emergence of modern computing within the

military projects supervised by Bush, Alan Turing, Norbert Weiner, and others, "Reflection on the Atomic Bomb" suggests that Stein, too, recognized the increasing difficulty of sorting through vast amounts of information in the immediate postwar period.

"Information" is an uncharacteristic word in Stein's earlier writing, occurring only three times in *The Making of Americans,* and rarely thereafter. More typically, Stein speaks of knowledge or of knowing. Stein's use of the word "information" in "Reflection" slightly prefigures the changing nature of the word in the late 1940s. The philosopher of technology Albert Borgmann has argued that "information led an inconspicuous semantic life until in the second half of the twentieth century it gradually and at first hesitantly moved to center stage. The birth certificate of information as a prominent word and notion is an article published in 1948 by Claude Shannon ["The Mathematical Theory of Communication"]."[10] Even before Shannon's article appeared, and a mere five months after Stein's death, Norbert Wiener published an eloquent letter, also in the *Atlantic,* which clearly suggested the link between scientific information and atomic destruction: "In the past, the comity of scholars has made it a custom to furnish scientific information to any person seriously seeking it. However, we must face these facts: The policy of government itself during and after the war, say in the bombing of Hiroshima and Nagasaki, has made it clear that to provide scientific information is not necessarily an innocent act, and may entail the gravest consequences."[11] Wiener's statement is far more direct and politically charged than Bush's; there is no indication that Stein felt so dire a sense of loss or emergency with the atomic bomb, nor that she was so concerned about preserving the secrecy of scientific information. If Stein saw information in less apocalyptic terms than Weiner, she nonetheless was centrally concerned with questions of cognition and epistemology; issues of "what one knows" are central to her writing. Barbara Will employs the term "epistemophilia" to describe Stein's aspiration to depict "everything in my knowledge" in works such as *The Making of Americans.*[12] There is much in Stein's biography, as well as in her views of history and industry, to substantiate reading her work through the lens of technological change. Steven Meyer has admirably and exhaustively described "the correlations of writing and science" in Stein's work, as the subtitle to his *Irresistible Dictation* would have it. Drawing in part on his research, in what follows I explore the correlations of writing and

information in her work. I suggest that Stein's interest in questions
of attentiveness and information saturation informs her writing from
the 1890s to the 1940s. I argue further that Stein resists the gendered
pathologization of inattention prevalent in late nineteenth- and early
twentieth-century experimental psychology. I make these claims with
the proviso that Stein's engagement with questions of attentiveness and
technological change is multifaceted, and cannot be reduced to a single
formula. Stein's writing does not, as is sometimes claimed, reject refer-
entiality altogether in favor of acontextual information (as opposed to
meaningful knowledge); nor does Stein's use of repetition emerge solely
in reaction to new industrial and communications technologies. Stein,
in short, was not a technological determinist, and yet the influence of
emergent technologies such as the assembly line, telegraphy, radio, and
film can be widely felt throughout her writing.

## The Makings of Americanitis

Over four decades before "Reflection on the Atomic Bomb," Stein began
*The Making of Americans*—a work that could be said to inaugurate a
tradition of books that are in some sense impossible to read in a conven-
tional manner due to the demands they make on readers. Stein was to
remark in *Everybody's Autobiography* that "*The Making of Americans* is a
very important thing and everybody ought to be reading at it or it."[13] To
read "at it," rather than to read "it," is indicative of Stein's larger engage-
ment with the growing proliferation of information that characterizes
the transition to the twentieth century. Sianne Ngai uses *The Making of
Americans* as a touchstone in the "Stuplimity" chapter of her *Ugly Feel-
ings* precisely because it is "an experiment in both duration and endur-
ance."[14] *The Making of Americans*, in describing a country "it has taken
scarcely sixty years to create," portrays a nation already fatigued by its
extraordinary industrial success.[15] Ngai writes of the experience of read-
ing it: "As any reader of *The Making of Americans* in its entirety can
attest, the stakes of this astonishing 922-page narrative are the exhaus-
tion it inevitably induces."[16] For Ngai, in Stein's writing, "astonishment
and fatigue, when activated in tandem, come to organize and inform
a particular kind of relationship between subjects and language."[17] A
significant component of that "relationship between subjects and lan-
guage," I want to suggest, is the experience of technological modernity.

In a generalized sense, Stein lived through what James Beniger calls the "control revolution" of the late nineteenth and early twentieth centuries, and she did so in the company of some of the period's most influential thinkers on questions of knowledge and epistemology—not only her teachers William James and Hugo von Münsterberg, but also her friends Bertrand Russell and Alfred North Whitehead.

In 1903, the year that Stein began *The Making of Americans*, the Rexall drug company introduced the patent medicine "Americanitis Elixir."[18] According to the bottle, the solution was "RECOMMENDED BY US for Neurasthenia, Nervous Exhaustion and other Conditions of Debility arising from Nerve Over-Strain" (see Figure 5). William James is sometimes credited with having coined the term "Americanitis" as a synonym for neurasthenia (literally "tired nerves"). In fact, neither James nor Stein ever specifically used the term "Americanitis" in print, although James can be credited with popularizing a book that did use the term, Annie Payson Call's 1891 *Power Through Repose*.[19] Whereas previous writers using the term "Americanitis" had suggested the phenomenon was primarily climatic, Call and James suggested that neurasthenia had more to do with the rapid pace of modern life.[20] James praised Call profusely in two reviews and in his 1895 talk "The Gospel of Relaxation," in which he wrote, "The American over-tension and jerkiness and breathlessness and intensity and agony of expression are primarily social, and only secondarily physiological, phenomena. They are bad habits, nothing more and nothing less, bred of custom and example, born of the imitation of bad models and the cultivation of false personal ideals."[21] Among the bad habits induced by neurasthenia was inattention. Jonathan Crary notes that in the 1870s and 1890s, "contemporary research on newly invented nervous disorders, whether hysteria, abulia, psychasthenia, or neurasthenia, all described various weakenings and failures of the integrity of perception."[22]

As a student of James and Münsterberg in the 1890s, Stein was ideally situated to witness the widespread pathologization of inattention described by Crary:

> It is in the late nineteenth century, within the human sciences and particularly in the nascent field of scientific psychology, that the problem of attention becomes a fundamental issue. It was a problem whose centrality was directly related to the emergence of a social, urban, psychic, and industrial

field increasingly saturated with sensory input. . . . It is possible to see one crucial aspect of modernity as an ongoing crisis of attentiveness, in which the changing configurations of capitalism continually push attention and distraction to new limits and thresholds, with an endless sequence of new products, sources of stimulation, and streams of information, and then respond with new methods of managing and regulating perception.[23]

James, true to his radical empiricism, was reluctant to blame neurasthenia on physiology or innate character. Like Call, and like the coiner of the term "neurasthenia" George Miller Beard, James considered the inexorable acceleration of modern American life primarily to blame. Rather than using their newfound prosperity to float gently down James's "stream of consciousness," Americans, particularly those of what Beard called the "brain-working class," were drowning in a flood of

*Figure 5.* Americanitis elixir, circa 1903.

overstimulation.[24] Beard considered neurasthenia so prevalent a disorder as to hardly require detailed empirical evidence: "The development of nervousness and the increase of functional nervous diseases, under whatever names they may be known, have been so great in modern times, especially in the Northern portions of the United States, that there is no need of statistics."[25] Oddly proud of the uniquely American nature of the disorder, Beard wrote, "For years, the philosophers of both continents have been asking, and in various and inconsistent ways have been answering this question, Are nervous diseases increasing? and they have gone to the most distant regions and to the far away ages for arguments which, when found, did not aid them on either side. There is no need of this search, the proofs are all about us; we are overloaded, weighed down with excess of evidence; the proof shines so strong that our eyes are blinded by its light; it irritates and teases us until we are benumbed, and can feel no more."[26] By means of a curious circularity, the researcher saturated with evidence becomes the most compelling example of the existence of the disorder. It is almost as if to recount the "excess of evidence" would be to risk neurasthenic consequences in the reader.

Like James, Beard considered himself to suffer from neurasthenic symptoms. James was particularly concerned about the effects of overstimulation on workers: "It is your relaxed and easy worker, who is in no hurry, and quite thoughtless most of the while of consequences, who is your efficient worker; and tension and anxiety, and present and future, all mixed up together in our mind at once, are the surest drags upon steady progress and hindrances to our success."[27] Americanitis (or neurasthenia), in this description, poses something of a conundrum: how can the "dull, unhurried worker" in fact be more productive than the "intense, convulsive worker"?[28] In James's proto-Taylorist account, neurasthenia implies that a sustained excess of concentration can paradoxically result in an inability to concentrate. As Maria Farland writes in "Gertrude Stein's Brain Work":

> Insofar as an economy increasingly based on knowledge-work required workers with particular mental and psychical traits, its emergence precipitated a corresponding emphasis on the hearts, souls, and minds of these new mental workers. In this context, as Michel Foucault has pointed out, the focus of attention was no longer the manual laborer—"the future

worker who had to be taught the disciplines of the body"—but the aspiring brain worker, "the schoolboy . . . who was in danger of compromising not so much his physical strength as his intellectual capacity." As the normative gaze shifted its focus from the corporeal body to the inculcation of "intellectual capacity," the primary concern was their mental, rather than physiological, attributes.[29]

Stein's undergraduate research allowed her to witness firsthand the emergent field of scientific psychology's near obsession with questions related to fatigue and inattention. Retrospectively surveying his field in the 1913 *Psychology and Industrial Efficiency*, Münsterberg wrote that "the various kinds of fatigue and exhaustion [are] the one field which has been thoroughly plowed over by science and by practical life in the course of the last decades."[30] The experiments Stein conducted, however rudimentary, introduced her to the difficult problem of quantifying human attention, in "normal" as well as in fatigued circumstances. As early as her essay "Cultivated Motor Automatism" of 1898, Stein began to depart from the empirical scientific methods she had been taught and to become interested instead in character psychology; it was there that Stein first claimed that "habits of attention are reflexes of the complete character of the individual."[31] Stein considered the claim important enough that she quoted herself verbatim (without noting the direct quotation of herself) in "The Gradual Making of *The Making of Americans*."[32] Stein's dedication to character psychology—due in large part to her subsequent devotion to the theories of Otto Weininger—has been much lamented by critics.[33] Such criticism is justified as it pertains to Stein's understanding of sexuality and race—particularly her depiction of Melanctha.[34] But critics have not, in my view, given sufficient credit to Stein's attempt to deploy character as a means by which to resist the normativizing tendencies of a technocratic society—particularly in terms of resisting the highly gendered discourse of neurasthenia.

Among the most fundamental assumptions of the earlier 1896 "Normal Motor Automatism" (nominally authored by Stein and Leon Solomons, but in fact written entirely by Solomons) is that "whatever else hysteria may be . . . it is a disease of the attention."[35] Solomons and Stein used themselves as the control group in the experiment, claiming to "stand as representatives of the perfectly normal—or perfectly ordinary—being, so far as hysteria is concerned."[36] Although Stein and

Solomons considered hysteria a disease of the attention, they also saw that inattention might play a role in normal cognition as well as in pathological cases: "Our problem was to get sufficient control of the attention to effect [the] removal of attention."[37] Before she left for Johns Hopkins, Stein's notion of "bottom nature," or innate character, had already placed her at odds with the empiricism of James: "One of the things I did was testing reactions of the average college student in a state of normal activity and in the state of fatigue induced by their examinations. I was supposed to be interested in their reactions but soon I found that I was not but instead that I was enormously interested in the types of their characters that is what I even then thought of as the bottom nature of them."[38] By the time she had reached Johns Hopkins much of the research she had participated in was already outdated. Steven Meyer notes that "in 1897, the year Stein entered medical school, the English neurophysiologist Charles Sherrington introduced the concept of the synapse as 'an anatomical and functional explanation for the mechanism by which the individual neuronal units could communicate with each other.' Hence Stein, in her first two years at Johns Hopkins, much of the time spent conducting laboratory research, found herself in the midst of a paradigm shift if ever there was one."[39] In learning of the internal workings of the brain, Stein was far ahead of her contemporaries in conceiving of it as an information processor. As Meyer describes the importance of her exposure to the concept of the synapse, "The crucial thing to note here is that in taking neurons, as described by the neuron doctrine, as paradigmatic of organic life (and thereby presuming that nerve cells, like other cells, don't form 'actual unions,' or organic unities, but are only exceptional in that they 'do something very different from other cells of the body,' namely, they 'process information'), it becomes necessary to reconceive organicism as a function of contact or contiguity, rather than of organic connection."[40] Stein's medical studies allowed her to rethink the nature of consciousness and perception in far more mechanistic terms than her contemporaries—though she largely rejected such explanations, and refrained from using technical scientific language. What she retained, according to Meyer, was an understanding of an organicism that emphasized "contiguity" rather than "connection"—a distinction that emphasizes that knowledge acquisition is an empirical, as opposed to an intuitive, process. Ironically, perhaps, Stein began her scientific work by studying the

problem of attention, using herself as a case study in normalcy—and yet through the course of her graduate studies found herself becoming increasingly distracted. Whether Stein herself suffered from American-itis, she in effect partook of the remedy that the disease's very name suggested: she departed for Europe. Tom Lutz's excellent *American Nervousness, 1903: An Anecdotal History* takes the year in question to be indicative of the peak of neurasthenia as a phenomenon. This was an important year for Stein: she completed her first novel, *Q.E.D.*; she set-tled into 27 Rue de Fleurus in Paris; she bought her first Cézanne; and she began *The Making of Americans.*

*Q.E.D.* opens with Adele, the Stein character, described as having mild neurasthenic symptoms: "The last month of Adele's life in Balti-more had been such a succession of wearying experiences that she rather regretted that she was not to have the steamer all to herself. It was very easy to think of the rest of the passengers as mere wooden objects; they were all sure to be of some abjectly familiar type."[41] The American types Adele encounters seem to have no identity or bottom nature. Midway on her transatlantic passage Adele is transformed by meeting Helen, who immediately counteracts Adele's tendency to yield "to a sense of physical weariness and to the disillusionment of recent failures."[42] When Adele returns to New York later in the novel, she has a new apprecia-tion for the pace of American life. Despite the pain of her failed rela-tionship with Helen, Adele, according to Lutz, "comes to reject the false advertising of neurasthenic self-presentation."[43] In part through over-coming the symptoms of Americanitis, Adele becomes more masculine: "I always did thank God I wasn't born a woman," she remarks, scandal-izing her friend Mabel.[44] As Mabel and Adele find themselves increas-ingly able to enjoy the "habit of infinite leisure," Helen becomes more and more overcome by her "exhausted nerves."[45] And as Adele grows stronger and more independent, her relationship with Helen becomes increasingly untenable: "When together now they seemed quite to have changed places. Helen was irritating and unsatisfying, Adele patient and forbearing."[46] Toward the conclusion of *Q.E.D.*, Helen's "attitude" is described as "a triumph of passivity."[47] Part of what is demonstrated in *Q.E.D.* is the growing force of Stein's personality: Adele comes to dominate her homosocial milieu, leaving behind the frenetic material-ism of her native Baltimore and its habit of infinite exhaustion. Thirty years later, in *The Geographical History of America; or, The Relation of*

*Human Nature and the Human Mind,* she was to write, "I have been told that I have always been nervous and unoccupied, that I have never cared to fill my time with the things that fill it and as a result I am not likely to remember or forget and therefore have I a human mind. Is it because of this that I have a human mind."[48] In common with the character of Adele, Stein also considered herself to demonstrate systems of neurasthenia, and saw it as (to some extent) constitutive of her character.

Even more so than *Q.E.D.,* Stein's later expatriate reflections on American history demonstrate her attitudes toward the increasing pace of American life. Her account of modernity in many respects substantiates Crary's correlation of attention with the growing disciplinary requirements of the late nineteenth century. According to Stein, "The eighteenth century began the passion for individual freedom, the end of the nineteenth century by conceiving organization began the beginning of a passion for being enslaved not so much for enslaving but for being enslaved."[49] As it pertains to the Enlightenment, Stein's account is fairly conventional, but as pertains to the late nineteenth century, it is somewhat counterintuitive. Stein seems to be describing the rapid growth of bureaucratic knowledge (including perhaps the crucial transformation of the two research universities she attended) as a "passion for being enslaved." Stein was wary of an overly bureaucratized culture, as she later saw it manifested in the New Deal, and saw the United States as the most highly organized of all societies: "Spain because of its lack of organization and America by its excess of organization were the natural founders of the twentieth century."[50] Stein was concerned that the expansion of organizational knowledge threatened individualism, or as she put it, "vital singularity." In an oft-quoted passage from *The Making of Americans,* she writes:

> I say vital singularity is as yet an unknown product with us, we who in our habits, dress-suit cases, clothes and hats and ways of thinking, walking, making money, talking, having simple lines in decorating, in ways of reforming, all with a metallic clicking like the type-writing which is our only way of thinking, our way of educating, our way of learning, all always the same way of doing, all the way down as far as there is any way down inside to us. We are all the same all through us, we never have it to be free inside us. No brother singulars, it is sad here for us, there is no place in an adolescent world for anything eccentric like us, machine making does not

turn out queer things like us, they can never make a world to let us be free each one inside us.[51]

Stein characterizes American industrial homogenization as utterly stultifying, and yet she implies that individualism itself is a product, rather than being innate. The notion of "brother singulars" in the plural verges on the oxymoronic; this passage has often been read as a defense of same-sex relationships, which it most certainly is. But it is also an expression of Stein's ambivalence toward the standardization imposed by technology. The habitual clicking of the typewriter suggests a complete mechanization of all thought. As is well-known, Alice B. Toklas typed all of Stein's mature manuscripts (most likely including the above words), which would make it a scene of writing literally produced by two "queer things like us." Stein beautifully plays off two opposing exaggerations—"we are all the same" and yet at the same time we, as "brother singulars," cannot be made by machine. "Queer things like us" cannot be identical in the way of machine-produced objects. Barbara Will aptly remarks of *The Making of Americans* and Stein's notions of history and its relation to the family and individualism," "'History,' 'progress,' and 'making' [as terms in Stein's writing] ask us to see ourselves, fundamentally, as our fathers' daughters and sons, as their replicable parts within the great generational machine."[52] Stein was fascinated by generations as a defining unit of historical and personal temporality: the very process of human reproduction is made into a mechanistic process in Stein's account of generational change. What fascinated Stein about the American "great generational machine" was its comparative newness, as well as its comprehensive effectiveness—especially in shaping character and in directing the attention.

Stein was both attracted to, and repelled by, American industrial production and the increasing organization and standardization it required. In *Everybody's Autobiography*, she positions her project as anticipatory of the assembly line: "In *The Making of Americans* I was making a continuous present a continuous beginning again and again, the way they do in making automobiles or anything."[53] And yet in the same work she writes of the utter dullness of mass production: "I detach myself from the earth being round and mechanical civilizations being over and organization being dull."[54] Stein was deeply proud of her Americanness,

especially as embodied in her two assembly-line produced Fords, Aunt Pauline and Godiva. In his "Bride of the Assembly Line," Barrett Watten has proposed a strong connection between Stein's compositional methods and Fordist production: "Stein's Ford . . . is equally a product to be consumed and a mode of production, as a new technology, that may be admired for its capacity to gain access to and even produce experience, not just to reify it. Technology partakes of authorship, and not just in terms of a pattern of consumption."[55] Watten suggests further that "Stein elaborates a theory of American identity as stemming, not from state structures, but from its modern capacity to produce."[56] Watten's reading accounts well for Stein's fascination with the continuous present of industrial production. Stein had the greatest admiration for the American capacity for making, and although she seems to have feared the effects of such a tremendous capacity for production, she also saw it in favorable terms as the central distinguishing feature of the modern United States. Germans might be methodical, but they could not, for Stein, be either truly modern or truly organized, as she puts it in The Autobiography of Alice B. Toklas: "Gertrude Stein used to get furious when the english all talked about german organization, they had method but no organization. Don't you understand the difference, she used to say angrily, any two Americans, any twenty Americans, any millions of Americans can organize themselves to do something but germans cannot organize themselves to do anything."[57] Stein presents Americans as the most flexible of all peoples in terms of their capacity to organize and to reorganize in large numbers—and yet remains concerned about the effects of such organization on the "bottom nature" of Americans. In questioning the science, as well as the pseudo-science, of her day, Stein was arguably making room for more kinds of American "bottom nature."

## "Act so that there is no use in a center": The Continuous Present of Partial Attention

One means by which Stein aspired to overcome the complete organization of society was to induce states of distraction in her readers.[58] As she writes in How to Write, "When a dog is no longer a lap dog there is a temporary inattention."[59] Or as she puts it in Stanzas in Meditation:

I have lost the thread of my discourse.
This is it it makes no difference if we find it
If we found it . . .[60]

Ellen Berry writes that "Reading Stein's texts . . . requires a paradoxical
or split act of attention—a relaxed hyperattention, an unconscious
hyperconsciousness, a borderline state of awareness a little like insom-
nia."[61] Barbara Will refers to this as "attentive inattentiveness."[62] The
reader cannot help but daydream or lose their train of thought when
confronted by a passage such as the following: "He certainly might have
been one completely listening to any one explaining this thing why each
one is doing what each one is doing. He was pretty nearly completely
listening to any one who was one explaining this thing. He was then one
sometimes explaining something. He was then sometimes wanting to be
needing to be needing being one completely explaining everything. He
certainly listened very much and very often and certainly he very nearly
completely listened when he listened to very many who were explaining
everything."[63] David Hersland, rather than *listening to*, is, in effect, *listen-
ing at*. We as readers cannot help but be caught up in the rhythmic repeti-
tion of the aspiration to listen—but we, too, cannot "completely" read.
Linda Stone has recently coined the term "continuous partial attention"
to describe "keeping tabs on everything while never truly focusing on
anything."[64] According to the neuroscientist Gary Small, "When paying
continuous partial attention, people may place their brains in a height-
ened state of stress. They no longer have time to reflect, contemplate,
or make thoughtful decisions. Instead, they exist in a sense of constant
crisis."[65] For the most part in Stein's writings, the state of continuous
partial attention is celebrated, and produces not stress or crisis, but
rather pleasure and possibly contemplative absorption.

James's *Principles of Psychology* presents a theory of attention that is
largely unsympathetic to "continuous partial attention." James recognized
that one's variety of attention might change from instant to instant, and
according to James, "There is no such thing as voluntary attention sus-
tained for more than a few seconds at a time. What is called sustained
voluntary attention is a repetition of successive efforts which bring back
the topic to the mind."[66] But, as Lisa Ruddick points out, "it is a mistake
to think of James's thoughts on the stream of consciousness as offer-
ing an implicit model for a diffuse or wandering literary style. That is to

confuse his descriptive and his prescriptive aims. . . . In James's scheme of things, wandering is the meanest possible use of the mind."[67] It is suggestive to compare a subtitle of James's "Attention" chapter, "The Ideational Excitement of the Centre," with one of Stein's most famous statements, "Act so there is not use in a center."[68] Quoting a passage describing David Hersland, Steven Meyer writes that "Stein aligned herself with those for whom, as she described them in *The Making of Americans,* 'spirituality and idealism have no meaning excepting as meaning completest intensification of any experiencing'; radical empiricists all, for whom 'any conception of transcending experience' was meaningless."[69] "Completest intensification" for Stein would not be identity (a thing in relation), but rather entity (a thing not in relation). Stein sought to make her writing "really exciting," but to privilege the "ideational excitement of the centre" would be to risk losing sight of the larger picture—to privilege a transcendental moment of identification (as Joyce perhaps did with his notion of the "epiphany") over the continuity of a present that has no center.

Stein's notion of the genius's extraordinary powers of sustained attention corresponds closely to the view of genius found in *Principles of Psychology*: "Geniuses are commonly believed to excel other men in their power of sustained attention. In most of them, it is to be feared, the so-called 'power' is of the passive sort. Their ideas coruscate, every subject branches infinitely before their fertile minds, and so for hours they may be rapt. But it is their genius making them attentive, not their attention making geniuses of them."[70] With the chiasmus of the last sentence, James carefully avoids a deterministic equation of genius and attention. The central claim of Steinian epistemology that "when you know anything, memory doesn't come in" further radicalizes James's radical empiricism by privileging immediate sense data over remembered or secondhand data. Barbara Will astutely describes the significance of Stein's notion of a "consciousness without memory," which

> describes a state of immediate, present-tense distraction where one is "watching what one produces only as it is produced." This is radically opposed to what Stein would refer to as a "nineteenth-century" tradition of epistemological inquiry, where the achievement of "knowledge" is predicated upon a temporally progressive process of experience and appropriation of the "known" on the part of an objective "knower." In Stein's reformulation

of this relationship in the 1930s, "knowledge" based on memory and a domination of knower by known has been replaced by a continuously present process that keeps in play at once two very different activities: production ("motor automatism") and watchful "knowing" or attentive inattentiveness.[71]

Will's reading favorably emphasizes the stakes involved in Stein's radical (re)writing of a present in which knower and known, writer and reader, are placed in more equitable relation to one another. In his *American Literature and the Destruction of Knowledge: Innovative Writing in the Age of Epistemology*, Ronald Martin claims, "No writer did more in the business of knowledge destruction than Gertrude Stein."[72] Such a reading of her as the most radical of epistemoclasts would likely have dismayed Stein. Though she may have cherished dismantling received knowledge, "attentive inattentiveness" (or "continuous partial attention") does not deny that we can have access to knowledge; rather, it challenges the pathologization of states in which we have imperfect access to knowledge.

Taylorism, we might recall in this context, was in large part designed to prevent worker distraction; to get each thing done as quickly as possible, it was necessary to focus worker attention on as few tasks as possible.[73] According to Münsterberg (a qualified admirer of Taylor), "Psychological laboratory experiments have shown in many different directions that simultaneous independent activities always disturb and inhibit one another."[74] Stein's use of "continuous partial attention" effects precludes such an instrumentalization of direct attention; she forces us to lose our train of thought. In effect, we as readers must overcome our tendency to dismiss repetition and distraction as exclusively fatiguing. Distraction can also create effects of surprise and pleasure; distraction will not lead to greater efficiency, but it may (contra James) lead to greater autonomy. To put this in mildly flippant terms, for Stein distraction builds character. The following passage from *Useful Knowledge*'s "Wherein the South Differs from the North" ingeniously plays on the rhyming pair inattention/intention:

In the middle of attention.
Any more as to the north.
In the middle of inattention.
Any more as to the north.
In the middle as an attention.

Any more as to the north.
In the middle as in attention.[75]

It is impossible to hear these variations aloud exactly as they are written. By the mere variation of a pronoun, or by the rearrangement of syntax, Stein is able to make it impossible for us to pay full attention. Neurasthenia, according to Beard and others, was a distinctly northern phenomenon. Even so, we cannot locate attention in this passage—*in* the middle, *in* the north or *in* the south. We can, however, compare states of attention to our present state or to past states:

Is it settled.
Settled is it.
In attention as to the south.
Settled is it.
In attention as to the north.
It is settled is.
In attention as to the south.
In attention in intention.[76]

It—if *it* is our attention to attention—is not a "settled" matter. Attention must have something to do with intention—with our ability to effect change upon external circumstances. As soon as we stand "in the middle of attention," the middle has shifted. Joan Retallack describes how "Stein's geometry of attention . . . creates a fractal coastline of repetitive/permutative linguistic forms whose semantic shape (following the permeable, fluid dynamic of any coastline) is constantly shifting in the emotional, social, intellectual weather of interpretive space."[77] Retallack's coastline metaphor is helpful in that it emphasizes how fluid the effects of Steinian repetition can be; long stretches of the coastline may seem dreary and redundant, until one finds oneself lost "in the middle of attention," most likely as the result of some unforeseen event (or perhaps nonevent in the case of a momentary distraction).

## "Enormous Publicity": Overpopulation, Media, and the Destruction of Attention

Stein tended to view mass communications technologies as antithetical to the creation of a "continuous present": "Think of any news that is fit

to print it all did happen the day before and once it is the day before it might just as well be the week or the month before or the year before."[78] The time lag in the newspaper's delivery of news makes it uninterestingly redundant, as opposed to interestingly repetitious: "Well and what should the newspaper do, well sooner or later they will have to rediscover to-day and realize that yesterday is not to-day."[79] Worse, the newspaper conveys far too much to too many people indiscriminately: "This as I say has been the great problem of our generation, so much happens and anybody at any moment knows everything that is happening that things happening although interesting are not really exciting. And an artist an artist inevitably has to do with what is really exciting."[80] The role of the writer is to elevate the ambient information of the media, that which is merely interesting, to the level of that which is truly exciting: the immediacy of the masterpiece. The instantaneous global transmission of information only conveys a kind of pseudo-continuous present— "the false sense of time of the newspaper world."[81] According to Stein, the reason why "the novel as a form has not been successful in the Twentieth Century" is that "no individual you can conceive can hold their own beside life. There has been so much in recent years . . . there was not this enormous publicity. People now know the details of important people's daily life unlike they did in the Nineteenth Century. Then the novel supplied imagination where now you have it in publicity."[82] Publicity, about which Stein knew a great deal by the 1940s, is for her generally antithetical to imagination.[83] The newspaper makes the past and present available, but it has little to say about individual character: "The newspapers are full of what anybody does and anybody knows what anybody does but the thing that is important is the intensity of anybody's existence."[84] Stein saw radio as particularly antithetical to individualism and to genuine experience: "To the Twentieth Century events are not important. Events have lost their interest for people. You read them more like a soothing syrup, and if you listen over the radio you don't get very excited."[85]

Among the indications that Stein considered information excess to be a serious problem in the twentieth century is the concern she repeatedly expressed about overpopulation, particularly in *Everybody's Autobiography*. Stein is eerily prescient of the era of global positioning technology when she writes, "Anyway nobody can get lost any more because the earth is all so covered with everybody and everybody is always moving

around."[86] Not being able to get lost conveys a loss of mystery as well as a loss of the possibility for unique discovery. Stein goes as far as to suggest that "the only thing that really bothers me is that the earth now is all covered over with people and that hearing anybody is not of any particular importance."[87] Surely more than this must have been bothering Stein in 1937, and yet she places a singular emphasis on overpopulation and its supposedly deafening effects. She also seemingly alludes to the rise of fascism, communism, and the New Deal when she returns to the theme of organization: "The world is completely covered with people and these people would like to be completely organized to live."[88]

Stein's ultimate conceptual antagonist is in some sense memory, insofar as it is an obstacle to the creation of "the continuous present." This also informs her understanding of the role of technology in American history: "The Twentieth Century, which America created after the Civil War, and which had certain elements, had a definite influence on me. And in *The Making of Americans* . . . I gradually and slowly found out that there are two things I had to think about; the fact that knowledge is acquired, so to speak, by memory; but that when you know anything, memory doesn't come in. At that moment that you are conscious of knowing anything, memory plays no part. You have the sense of the immediate."[89] Stein elaborates elsewhere on the industrial organization that makes possible a kind of wholesale eradication of historical memory. For Stein, the American psyche is Taylorist in its conception of time: "The assembling of a thing to make a whole thing and each one of these whole things is one of a series, but beside that there is the important thing and the very American thing that everybody knows who is an American just how many seconds minutes or hours it is going to take to do a whole thing."[90] Stein's use of repetition makes the reader extremely self-conscious of the rhythmic nature of language, and runs generally counter to the Taylorist notion of a discrete, normative duration for "the assembling of a thing." The constant use of present tense and participial forms—*The* Making *of Americans*—makes it difficult to remember one's place within a linear succession of events, whether or not those events are presented as narrative. Steven Meyer notes that "in her neuroanatomical investigations Stein was examining several of the structures implicated in the innermost mechanisms of close reading, or of 'reading in slow motion.'"[91] It is also possible to suggest that Stein was examining the innermost mechanisms of distracted reading, or of reading at an

accelerated pace. Meyer cites Wittgenstein's *Culture and Value* in support of his claim: "I really want my copious punctuation marks to slow down the speed of reading. Because I should like to be read slowly."[92] But Stein's approach is arguably often the inverse—by minimizing the role of commas, for instance, she in effect speeds up reading, particularly when reading on the page as opposed to reading aloud. What is at issue is not necessarily the actual speed of reading, but the ability to create "a continuous present" in the mind of the reader. The reader who reads at a consistent pace may encounter plenty of "interesting" information; the reader who is truly excited will be more likely to vary her reading speed. As Stein puts it in the penultimate stanza of *Stanzas in Meditation*, "Thank you for hurrying through."[93]

Crary argues that in the late nineteenth century, research on attention almost invariably led to an impasse, wherein the capacity to pay attention revealed itself to be primarily context-dependent rather than immutably fixed in the individual psyche: "Scientific psychology never was to assemble knowledge that would compel the efficient functioning of an attentive subject, or that would guarantee a full co-presence of the world and an attentive observer. Instead, the more one investigated, the more attention was shown to contain within itself the conditions for its own undoing—attentiveness was in fact continuous with states of distraction, reverie, dissociation, and trance. Attention finally could not coincide with a modern dream of autonomy."[94] Stein's insistence on character psychology places in doubt any attempt to construct a normative, attentive subject. Crary notes that it "was through the new imperatives of attention that the perceiving body was deployed and made productive and orderly, whether as a student, worker, or consumer."[95] Stein's texts make such a model of the perceiving body difficult, if not impossible, to sustain. Even if Stein presents herself as an ideally attentive observer, it is not possible to attend perfectly to her writings—at least not in the manner required by the scientific testing of Stein's day. For Crary, "attention as a process of selection necessarily meant that perception was an activity of exclusion, of rendering parts of a perceptual field unperceived."[96] What Stein insists on is a radically inclusive perceptual field: "anybody at any moment knows everything."[97] This is not to say that Stein's politics are always so inclusive; it is to say that Stein continually presents us with a perceptual field that refuses to exclude on our behalf as readers. For Stein, the closest approximation of

such an inclusive perceptual field was the cinema, for her the best embodiment of the very American principle of *e pluribus unum*: "In *The Making of Americans*, I was doing what the cinema was doing. I was making a continuous succession of the statement of what that person was until I had not many things but one thing."[98] Through the repetition of words and images—or to use Stein's term, through "insistence"—character is revealed. It is our character as readers ultimately that will determine how we perceive the inclusive perceptual field. The best way to view that inclusive field (as well as to view ourselves within that field) might be to fall into the inevitable experience of continuous partial distraction.

## "Making Americans American": The Liberation of Linguistic Excess

Early in 1944, Stein offered an account of the "decided liberation" that led her to her mature style that differs considerably from the accounts presented in *The Autobiography* and "The Gradual Making." Expecting that the liberation from German occupation was imminent, Stein describes how the Spanish–American War

> was another big step in making Americans American. . . . We knew then that we did not need Europe to tell us what to do what we wanted to do . . . It was a decided liberation, that was when I began to write, and I found myself plunged into a water of words, having words choosing words liberating words feeling words and the words were all ours and it was enough that we held them in our hands to play with them whatever you can play with is yours, and this was the beginning of knowing all America.[99]

Earlier in the same piece, Stein presents a narrative of the late nineteenth century in which among the most important consequences of "the enormous industrial development of the United States from coast to coast" was that "there never was a country who read and wrote so much, the daily newspapers alone in the United States in one month could fill a fairly large sized library what could they do about it how can you change a language when it is being read so much so continuously any and every day."[100] Stein's answer to this self-proposed question is to respond that because of the very quantity of language produced in the United States, American writers could not in fact "change the language":

So what could they do. They could not change the language it was written too much every day and so from the beginning they began to see if by putting a sort of hydraulic pressure on the language they could not force it to become another language even if all the words were the same, the grammatical construction the same, and the idioms the same. So slowly by conscious choice of words making some words come closer to each other than they ever had been before, in the use of language, making a movement of the language that was steadily clearer more monotonous and fresher by thinning out the thicknesses, by pressure steady pressure they did not change the language but they did succeed they are succeeding in making it feel different very very different.[101]

This extraordinary passage—though it never made it into print in Stein's lifetime—deserves to be better known. Stein's language alternates between the mechanistic ("hydraulic pressure") and the domestic ("thinning out the thicknesses"). "More monotonous and fresher" in this sense is a quintessential Steinian paradox—in much the same way that the title *Tender Buttons* can convey (almost oxymoronically) an inseparable blend of mechanistic, organic, sexual, and emotional meanings.

Approaching Stein's writings simply as reactions to information overload would obscure the very complexity of the "movement of language" they insistently seek to represent.[102] Information abundance might very well threaten "common sense," but Stein was hardly an unconflicted apologist for common sense. Among Stein's most perceptive contemporaries with respect to the increasing pace of the "movement of language" was William Carlos Williams, who in his 1930 essay on Stein writes, "Movement (for which in a petty way logic is taken), the so-called search for truth and beauty, is for us the effect of a breakdown of the attention. But movement must not be confused with what we attach to it but, for the rescuing of the intelligence, must always be considered aimless without progress."[103] Williams, who himself had extensive scientific training, appreciated Stein's ability to effect "a breakdown of attention," but he did not, in the manner of Skinner, reduce Stein's writings to a caricature of science. Williams saw something far more significant in Stein's writing, and he viewed her writing as epistemologically superior to the science of the day: "What are philosophers, scientists, religionists, they that have filled up literature with their pap? Writers, of a kind. Stein simply erases their stories, turns them off and does without

them, their logic (founded merely on the limits of the perceptions) which is supposed to transcend the words, along with them. Stein denies it. The words, in writing, she discloses, transcend everything."[104] But perhaps the words do not "transcend everything," but rather *everything transcends everything*—by which I mean to suggest that, for Stein, there is no transcendental knowledge and there is no singular word. As Stein wrote to Ellery Sedgwick in 1934, "No [my writing] is not so automatic as [B. F. Skinner] thinks. . . . If there is anything secret it is the other way. . . . I think I achieve by xtra consciousness, excess."[105]

Referring to the following passage in *Everybody's Autobiography*, Steven Meyer suggests that there is a strong relationship between Stein's resistance to organization and her interest in the profusion of "verbal flux": "Pictures have been imprisoned in frames, quite naturally and now when people are all all peoples are asking to be imprisoned in organization it is quite natural that pictures are trying to escape from the prison the prison of framing. For many years I have taken all pictures out of their frames, I never keep them in them, and now that I have let them out for so many years they want to get out by themselves, it is very interesting."[106] For Meyer, "Typically . . . human beings remain only vaguely aware of the language-inflected voices they are continually setting in motion, despite passing much of their waking lives in the midst of verbal flux. By contrast . . . not only did [Stein] seek to recreate the experience in hundreds of ways and hundreds of compositions, but she also found that writing functioned readily as a medium for investigating how 'organization' might be reconceived as something other than a 'prison of framing.'"[107] The prison house of framing in many ways is more accurate than Nietzsche's "prison house of language"—at least as a description of the conditions of representation. The "prison house of language" invites linguistic determinism; Stein, in Marjorie Perloff's terms, instead engages in linguistic indeterminism—or perhaps we might even say she engages in linguistic overdeterminism.[108] "Reflection on the Atomic Bomb" suggests that information excess might counteract the liberating power of linguistic excess that Stein continued to celebrate so forcefully a little over a year earlier in "American Language and Literature."

"Reflection on the Atomic Bomb" is, however, a bleaker work than it first appears. Troublingly, the address of Bernard Faÿ's country home is written on the cover of the manuscript cahier.[109] Faÿ had at this point been imprisoned for twenty-three months and had been stripped of his

chair at the College de France. Five months later, he would be convicted of *dégradation nationale* as a Nazi collaborator. At the very least, Stein ignored a good deal of the information she had about Faÿ's activities— particularly concerning his role in crushing the Freemasons. There is good reason to read the "Reflection" as a document that operates by means of what it refuses to say, rather than what it does say. "Reflection" makes no mention of the suffering of civilians, nor does it give any sense of the scale of the Holocaust. Barbara Will's *Unlikely Collaboration* has given us the most detailed portrait to date of Stein's late work— somewhat surprisingly, however, *Unlikely Collaboration* makes no mention of "Reflection on the Atomic Bomb."[110] In an earlier essay, Will describes "Reflection" in a footnote as "naïve and disingenuous."[111] John Whittier-Ferguson, by contrast, reads it as a kind of retraction:

> Stein . . . realizes that, in the wake of the second world war, she has very little to say. It is essentially a problem of scale of calibrating words and things. If the Great War, with its ten million dead, brought us into modernity, what do the fifty million dead in its sequel bring? Why should she continue her demanding, risky search for an appropriate register in which to write about this new form of modernity? The history of her own art ends not with Hitler after all, but with Harry Truman and the invention he authorizes for use. Her last reflection on art is almost as simple as saying nothing.[112]

In Whittier-Ferguson's account, by saying little, Stein is in effect speaking volumes. While that may in part be the case, we might also recall that Stein's tone is confident, and "Reflection" doesn't seem to indicate that Stein felt her search for an appropriate register had failed. Unlike the immediate postwar writing of Beckett, Blanchot, and Celan, Stein's postwar writing does not cultivate tropes of silence. Stein eagerly returned to a life in the public eye at war's end. With the exception of the occupation years, Stein's later life was lived entirely in the media spotlight, and she was a prodigious producer and consumer of information.

Setting aside for a moment the complexities of Stein's personal experience of the war, I want to suggest that "Reflection" may reveal another set of contradictions. How does getting too much information make us unnatural or irrational? Would Stein's writing itself qualify as information? Stein seems to blame everyone getting too much information

for instilling an irrational fear of the bomb. But does too much informa-
tion also lead to the creation of the bomb? "Reflection" implies that the
masses of information we get all day long (presumably primarily through
newspapers and radio) are as dangerous as the weapons that ended the
war. While this may be simple hyperbole, it is also an epistemological or
even an ideological claim. Too much information clouds our common
sense: could this be what happened to those in thrall to Fascist propa-
ganda (perhaps even including Stein herself)? But what does Stein mean
by common sense in this context? So much of Stein's writing seems to
celebrate the conditions produced by "too much information"—distrac-
tion, uncertainty, polysemy—and yet "Reflection" seems to suggest that
the inability to process large quantities of information leads to irratio-
nal fear. Stacy Lavin writes of "Reflection" that "the vagueness of Stein's
reference to *information* (information about what? Where does "every-
body" get it?) throws into relief the sense of sheer *quantity* conveyed by
the sentence."[113] Lavin, it seems to me, is exactly right to suggest that the
very vagueness of Stein's declaration in part accounts for its rhetorical
power. Stein is of course thinking more of radio and newspapers than
she is about emergent information technologies such as the computer
or microfilm. Stein's 1945 *Wars I Have Seen*, for instance, could just as
easily be titled *Wars I Have Heard* since much of the book describes the
experience of listening to the radio under occupation. For Stein, per-
haps the crucial difference between the first and second world wars is
the increasing role of the mass media. In *Mrs. Reynolds*, for instance, she
describes how "suddenly in September 1940 the United States of Amer-
ica instead of being a part of a big land illimitably flat, the land against
which Christopher Columbus bumped himself in 1492 became a part of
the round world that goes around and around."[114] In "Reflection," at
least, "information" is not medium-specific. We might even read "Reflec-
tion" as embodying a postwar zeitgeist where, in Mark Goble's words,
"history becomes a problem not of loss but excess and even abundance,"
with the result that "the material status of the mediums that bear [his-
tory]" becomes "impossible to manage."[115]

Despite its vagueness, I do not think "Reflection" is a naïve text. For
Barbara Wineapple, it is "interesting not only for what it says but what
it represents: the occlusion of Gertrude Stein and other women—men
too, primarily modernists—as political beings who respond to elec-
tions, wars, economics, law, jurisprudence, and those nefarious gadgets

we, these days, have christened weapons of mass destruction."[116] For Wineapple, this occlusion is largely self-chosen by Stein, and thus the "Reflection" is a conscious statement of political disengagement. To this I would add that Stein achieves this distance from history and everyday politics, in part, by means of her nebulous invocation of information. "Reflection" can be read as employing a "blame the media" strategy— but it can also be read as a calculated, albeit brief, appraisal of some of the most important developments of the postwar era: the transition to a post-Fordist economy increasingly dominated by advertising and information; the emergence of a cold war culture of secrecy; the anxiety induced by the overwhelming vulnerability of civilians to violence. By the very nature of its emphatic disavowal of the bomb's power, "Reflection" invites readers to be perplexed and discomfited.

Marshall McLuhan famously described the bomb as "pure information," the ultimate marker of the transition from the "mechanical age" to the "electronic age."[117] In the same 1964 talk, McLuhan used the term "information overload" for the first time in his writing. In describing the bomb as "pure information," McLuhan meant that it marked the triumph of "big science," the nation-state and the research university. But in another sense, the bomb is a kind of summation of information that negates the collective pursuit of progressive knowledge. It is impossible even to "read at" the effects of the bomb. Stein's last words spoken to Toklas—"What is the question?"—are justifiably famous; but the parting words of Stein's last written composition may be just as significant for what they have to say about the historical changes Stein witnessed over the course of her lifetime: "This is a nice story."[118] But it is also not a nice story. It is too many stories at once. As she writes in *Wars I Have Seen*, "There are so many stories so many stories and so much confusion."[119]

# 2

# BOB BROWN, "INFORG"

## THE "READIES" AT THE LIMITS OF MODERNIST COSMOPOLITANISM

As soon as my reading machine becomes a daily necessity certainly it will be out of date. Pocket reading machines will be the vogue then, reading matter will radioed as it is today to newsies on shipboard and words perhaps eventually will be recorded directly on the palpitating ether.

Reading from books is an anachronism in this Airplane Age. . . . The readies are the only suitable form of airplane reading, they are in time with the age.

—Bob Brown, *Readies for Bob Brown's Machine*

"I was almost a book myself," the American writer Bob Brown (1886–1959) recalls characteristically of his younger self.[1] "Books are I are one," reads the colophon to his *1450–1950*—as if he had finally achieved the metamorphosis by embodying the entire history of printed books since the time of Gutenberg. Brown's 1930–31 reading machine, I argue, hyperbolically attempts to eradicate the difference between human and book, as well as between local reading and global reading. Brown could thus be described somewhat anachronistically as an example of what Luciano Floridi refers to as an "inforg." Floridi suggests that in the information age, "we are not standalone entities, but rather interconnected organisms, or inforgs, sharing with biological agents and engineered artifacts a global environment ultimately made of information, the infosphere."[2] Brown's reading machine, I suggest most provocatively, fashions readers and writers as global word processors *avant le lettre*, or rather *post le lettre*. The reading machine implies that electronically transmitted language will alter the nature of literary form; at the same time, it parodies

the Americanization of the wor(l)d brought about by new technologies of communication. Kenneth Goldsmith has recently declared "I am a word processor."[3] Alan Liu similarly describes how he "went to sleep one day a cultural critic and woke the next metamorphosed into a data processor."[4] Brown anticipates such claims. Moreover, as an inveterate traveler and expatriate, he projects such claims onto a backdrop of increasing global interconnectedness.

Brown remained largely forgotten by scholars of modernism until Jerome McGann declared of *Readies for Bob Brown's Machine* in 1993, "When the afterhistory of modernism is written, this collection . . . will be recognized as a work of signal importance."[5] Published in France in 1931, *The Readies* anthology included texts by Gertrude Stein, William Carlos Williams, Ezra Pound, F. T. Marinetti, Kay Boyle, and Eugene Jolas. Since McGann made this claim, increased critical attention has been paid to Brown—by Michael North, Craig Dworkin, and Craig Saper, among others—and the recent republication of *The Readies* (although, alas, not the full anthology) and *Words* by Rice University Press should generate additional scholarly interest. Little attention has been paid, however, to Brown's other writings or to his life—much of which he spent in Brazil.[6] I argue that Brown's reading machine should be considered in the context of modernist cosmopolitanism, and that behind Brown's machine lurks an ambivalent response to the global spread of American financial and technological supremacy. Michael North notes, "The very extremity of Brown's claims and the eccentricity of his machine are valuable in exposing certain inevitable blind spots in the machine vision of transatlantic modernism."[7] Despite its cosmopolitan aims, Brown's "Optical Writing" remains indicative of white American expatriate narratives, and its persistent use of dialect is at odds with Brown's aspirations to create a universal optical language. In this vein, North has shown how Brown's *Readies* texts are based on racialized notions of American culture and language.[8] This chapter builds on that account by arguing that Brown's "readies" are significant not only for what they have to say about the racialization of language, but also for what they have to say about the limits of modernist cosmopolitanism. Many of Brown's contemporaries recognized him as a fundamentally parodic writer (indeed, few of them took him seriously).[9] But recent critics have tended to read him much more literally—and in doing so, they have tended to overlook the cosmopolitan dimensions of

his writing.[10] Brown may remain a "minor" modernist, but he is a revealing figure for the "afterhistory of modernism" now being written—an afterhistory that has focused increased scrutiny on the hyperbolic universalizing claims of high modernism (many of which were subject to scrutiny and ridicule even as they were being formulated). It may be that an important facet of "bad modernism" is the work of noncanonical modernists, whose writing—if indeed it is of a second-rate, imitative, "hanger-on" nature—can reveal as much about modernism's internationalist aspirations as that of canonical writers like Joyce and Woolf.[11] In writing what he calls a "minor history" of Tony Conrad, the art historian Brandon Joseph suggests that "to designate and examine Conrad as 'minor' . . . is to acknowledge the manner in which he problematizes the terms 'musician,' 'composer,' 'artist,' 'filmmaker,' and so on."[12] Brown, like Conrad, worked in many genres (and even in many professions), but his writing—even if we acknowledge its "minority"—"does not lack all relation to major categories, historical transformations, movements, or individuals."[13] On the contrary, Brown's writing (and *The Readies* anthology in particular) may bear a closer relation to the major categories and historical currents of transatlantic modernism than the writing of his better-known friends and peers.

## Sitting on Top of the World-as-Oyster

Brown's first published optical poem (see Figure 6) appeared in 1917 in an auspicious location, the second issue of *The Blind Man* (edited by Marcel Duchamp, Beatrice Wood, and Henri-Pierre Roché) on the page immediately preceding Alfred Stieglitz's famous photo of Duchamp's *Fountain* (the urinal he signed as R. Mutt). Brown's optical writing thus emerges at a key moment of self-definition for what is arguably the first American avant-garde, New York Dada, described by Marjorie Perloff as both "a European invention and intervention."[14] The son of a Chicago rare-book dealer, Brown was a dedicated traveler, a prolific writer, and an avid book collector. Brown wrote roughly thirty books, at least five of which—*Gems: A Censored Anthology*, *Words*, *Demonics*, *1450–1950*, and *The Readies*—were closely allied with *transition's* "Revolution of the Word." He was published in some of modernism's most influential journals: *Others*, *The Blind Man*, and *transition*; he was close enough to Gertrude Stein to have merited a portrait from her in 1928; he assisted

in editing Nancy Cunard's *Negro* anthology in the early 1930s; for his *Readies* anthology he was able to assemble many of high modernism's most prominent writers; in the 1950s the Brazilian concrete poet Augusto de Campos produced a version of Brown's *1450–1950* for a Brazilian audience (without knowing that Brown spoke Portuguese and had lived for many years in Brazil).[15]

Critics have tended to dismiss outright Brown's post-*Readies* projects, which mostly center on culinary and travel writing.[16] There is, however, a continuity between Brown's later "nonliterary" projects—such as *Let There Be Beer!* (an anti-prohibition global history of beer) and *The Complete Book of Cheese* (a global primer on cheese)—and his earlier poetic writing. From the teens to the 1950s, Brown mounted a critique of American culture from something of a global Epicurean perspective. He spent a significant portion of his life outside the United States—living in Brazil from 1919 to 1928 and France from 1930 to 1934 and again returning to Brazil for most of the 1940s—and his writing often comments on the global influence of American culture. While in Brazil, Brown edited a weekly newspaper titled the *Brazilian American*; he founded corresponding journals, *The Mexican American* (in Mexico City) and *The British American* (in London). By his own account, Brown was a prolific reader, writer, eater, and drinker—reveling in a kind of aesthetic and sensual omnivorism.

The visual and aural punning of "Eyes on the Half-Shell" would culminate in Brown's *1450–1950*, published by Harry Crosby's Black Sun Press in 1929, the year before Brown proposed the reading machine. In the self-portrait (Figure 7) with which Brown concluded *1450–1950*, he again recycled the "Eyes on the Half-Shell" motif (as he would also in the *Readies* anthology). In the self-portrait he places the optical poem at the center of the globe with himself as a stick figure on top. As crude and frivolous as the drawing may seem, it is nonetheless indicative of Brown's attempt to portray himself as both a writer and as a living embodiment of the history and afterhistory of books. In this self-portrait (which to the best of my knowledge has never received scholarly treatment), Brown figures himself as a writing machine and a reading machine. Nearly *every* aspect of the drawing is doubled—through its head, the figure takes in images and sounds; through its "PAINFULLY PLEASANT PLACE," the figure presumably defecates (or generates) newly digested sounds and images. At the upper right corner we

Eyes

My god †

what eyes

Eyes on the

Half shell

Robert Carlton Brown.

A RESOLUTION MADE AT BRONX
PARK

*Robert Carlton Brown*

I'M GOING TO GET
A GREAT BIG
FEATHER-BED
OF A PELICAN
AND KEEP HIM
IN THE HOUSE
TO CATCH THE
FLIES, MOSQUITOES AND MICE,
LAY EGGS FOR ME
TO MAKE OMELETTES OF,
AND BE MY DOWNY COUCH AT NIGHT.

*TALE BY ERIK SATIE*

I had once a marble staircase which was
so beautiful, so beautiful, that I had it
stuffed and used only my window for get-
ting in and out.

Elle avait des yeux sans tain
Et pour que ca n'se voie pas
Elle avait mis par-dessus
Des lunettes a verres d'ecaille.

S. T., E. K.

*Figure 6.* Bob Brown, in *The Blind Man*, no. 2, p. 3, 1917.

see "BOOKS" and correspondingly at the lower left corner "MY READING MACHINE," and apposite to these, "1450" and "1950." At the center of Brown's body is his "STOMACH FOR EVERYTHING." On one side of his chest is his "ART" and on the other his "ROSE RIB" (Rose being the name of his wife). One of Brown's feet rests on China, the other on Brazil. If Brown is a world conqueror, he is decidedly self-deprecatory (or self-defecatory) about his accomplishment.

Brown's optical poems appear less haphazard when one recalls the original proximity of "Eyes on the Half-Shell" to Duchamp's "Case of R. Mutt," arguably modernism's most dramatic challenge to traditional aesthetics, as well as to prevailing notions of artistic agency. *The Blind Man* was deliberately an exercise in bathroom humor; Brown's optical poems are correspondingly crude in content and in execution. The most humorous aspect of Brown's self-portrait may be his substitution of the entire globe with "Eyes on the Half-Shell." Brown is literally sitting on his own refuse—a slippage between text and image, past and present. The picture seems to suggest that you are not only what you eat, but also what you read and see. Like Duchamp's "Boîte-en-Valise" (which would recycle Duchamp's oeuvre in portable form, and the first of which wasn't completed until 1940), Brown's portrait is a microcosmic advertisement for the artist and his art. The self-portrait is an unapologetic repackaging of Brown's earlier work. The central bifurcation of the sketch would seem to be between a material past of books-as-objects and an immaterial future in which optical writing transcends nation, tradition, and speech. Next to the opposed "1450" and "1950" are what Brown elsewhere refers to as "FLY SPECKS / ON YELLOWED PAGES," which take on the shape of hearts or chili peppers. The fly specks are the self-conscious mark of the minor writer, or of the book collector. At the heart of Brown's writing is a defense of the unremunerated love of the amateur. The fly, one might infer, is also "the flitting Money Fly," the term Brown uses for money changers (without anti-Semitic overtones) in his poem "American Eagle Broadcast" (discussed below).[17] The fly cannot remain simply a fly, but must be metamorphosed through visual and textual punning. Otherwise the fly would be an image of death; thus, "there are no flies on me" in the final version of the self-portrait both embraces and defies Brown's obscurity. Like so many of Brown's visual puns, the fly speck is absurdly literal—which is to say that it disguises its complexity from all but the most diligent reader–viewers.

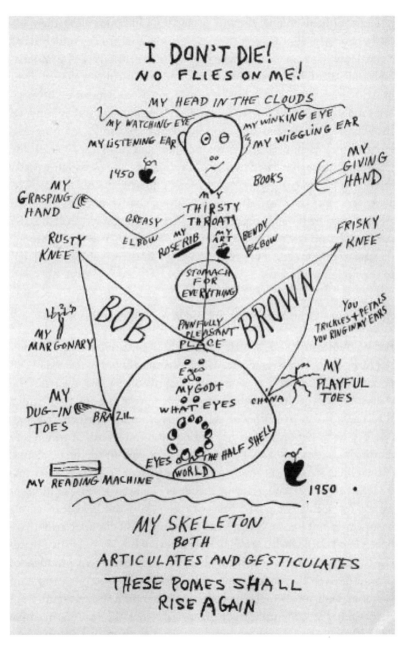

Figure 7. Bob Brown, "Self-Portrait" (1929) in 1450–1950, n.p. ["I DON'T DIE! / NO FLIES ON ME!" and "THESE POMES SHALL / RISE AGAIN" added by Brown in 1950.] Courtesy of Phoebe Brown.

If it is difficult to take Brown's projections and puns altogether seri-
ously, herein I would suggest there is a critical opportunity rather than a
critical impasse—in that Brown's parodic interventions can be fascinat-
ingly polyvalent. Brown traffics in the racialized discourses characteristic
of white high modernism, but he is also consistently hostile to Ameri-
can capitalism, as well as to the spread of American cultural dominance.
Brown's metaphors and substitutions continually shift, resulting in a
literalization of himself as both a product and producer of texts and
images within a globalized marketplace. In *1450–1950* (see Figure 8), we
read "THE WORLD IS MY OYSTER," but underneath this are "MOUN-
TAIN OYSTER," "PRAIRIE OYSTER," and "OYSTER OF THE SEA."[18] What
all these oysters have in common—the world, the testicle, the hangover
cure drink, and lastly the "literal" oyster—is that they are seen through
American oyster eyes, awestruck and naïve in their ambitious attempt
to consume the foreign.

## Bob Brown Graphomaniac/Bob Brown Bibliomaniac

Brown frequently refers self-deprecatingly to his prolific verbal output,
but he does not similarly regret his copious consumption of words. "Our
potential consumption of words through all the senses is terrific," he
writes. "Words gush through our minds at a great rate and we hesitate,
slow them down to stutter or stammer them out."[19] Brown describes
two key points of origin for the reading machine—both of which the-
matize his saturation as a writer and as a reader. In the first account,
Brown links it to his experiences as book collector: "The machine came
directly out of my pioneering in the ideas business, writing millions of
words, foreseeing the possibilities of the movies and living exclusively
with words and books. Since I was sixteen I had bought and sold rare
books and handled with growing interest every kind of published mate-
rial from papyrus through incunabula to the most recent products of
private presses. I attended books auctions in Chicago, New York and
London as religiously as some people go to church."[20] Brown argues from
an entirely plausible utilitarian perspective that the reading machine
will save time, paper, transport costs, and so forth—but he also argues
that the machine will rehabilitate reading and give new life to literature.
The reading machine, in a sense, has the power to make it possible for
all readers to partake of the collector's mania for words.

*Figure 8.* "The World Is My Oyster," from *1450–1950*, n.p. Courtesy of Phoebe Brown.

In the second account of the machine's origin, Brown recounts how in 1914 he "read Gertrude Stein and tape-tickers in Wall Street."[21] McGann's groundbreaking reading of Brown makes much of Brown's interest in Stephen Crane, but does not mention his interest in the ticker tape, which figures more prominently in Brown's account of the genesis of the machine: "The Wall Street ticker is a reading machine. I didn't know it then, but you know it already. We read the tape. It passed before our eyes jerkily, but in a continuous line. Endlessly, at any speed, jerk, jerk, jerk, when the Market's pulse was fast, click, click, when it was slow."[22] The reading machine, like the ticker, is in effect a perpetual motion machine of language: "My mind ticked words, I wanted to help it tick them on for eternity."[23] The aspiration here is much like that described in N. Katherine Hayles's account of the posthuman subject: "If we can become the information we have constructed, we can achieve effective immortality."[24]

Brown continually describes himself as overwhelmed by data, but he also describes himself as invigorated by that same excess. The reading machine somewhat implausibly provides an antidote by giving the reader more control over the speed of reading. The ability to vary the tempo of reading constitutes the single greatest attribute of the reading machine:

> Why wasn't there a man-made machine like the running tape-of-thought device in the mind which would carry words endlessly to all reading eyes in one unbroken line, a reading machine as rapid and refreshing as thought, to take the place of the antiquated word-dribbling book? I wanted a reading machine to bring the words of others faster into my mind. I wanted a reading machine to carry my words faster and farther into the minds of others. I conceived that with such a machine to represent them fully, writers might find a new urge to write more vividly, or at least differently, to approach closer to the hieroglyphic mysteries that have streamed across their gossamer braintapes from the beginning of time to infinity. Such a machine would provide an outlet for things of my own. With it maybe I wouldn't have to write any more crap, with it perhaps I wouldn't have to read any more crap.[25]

By drawing on the dream of optical writing, Brown provides himself a platform for his own writing, as well as a way in which to eliminate the traditional restrictions of printed media. Optical writing is universally

legible (at least to the initiated) and full of endless potential energy—
like the ticker tape, like Esperanto, like C. K. Ogden's Basic English, and
like the almighty dollar (all of which thrived in the 1920s).
Optical writing is also a response to what could be called the Taylori-
zation of the word. Brown's extraordinary run-on paragraphs should be
quoted in full to give a sense of their odd mix of exhaustion and energy.
Brown recounts his early years as a writer in which he labors endlessly
in literary assembly lines, calling himself "a factory of fiction." Such mass
production of the word eliminates any true authorship, and leaves be-
hind only the husks of hackneyed genres:

> At twenty-nine I had written and sold 1,000 short and long fiction stories,
> one every 3 and 6/10ths days, counting 100,000 word typewriter busters
> and 3,000 word playful finger-tip type-ticklers. I had written a best seller,
> and a successful book of detective stories "The Remarkable Adventures of
> Christopher Poe," jingles, sketches, monologues, serials, digests, slogans,
> advertisements, feuilliton, reports, memoirs, confessions, tales, narratives,
> guides, monographs, descriptions, obituaries, wise-cracks, legends, jour-
> nals, lives, plays, adventures, experiences, romances, fairy tales, parables,
> apologues, circulars, doggerel, sonnets, odes, episodes, lyrics, thrillers,
> dime novels, nickel novels, society verse, essays, rondelets, biographies and
> codexes. My stories were published sometimes as many as five or six in
> a single issue of a pulp magazine, under my own name Robert Carlton
> Brown and under a dozen nom-de-plumes.[26]

Brown translates his grueling experience of speed writing immediately
onto his experience of reading. All genres have united in his mastery of
their kitsch versions. *Tender Buttons* is precisely so revolutionary for
him because it teaches him how to read all over again. To "read in a man-
ner as up-to-date as the lively talkies," one has to find a way to revolu-
tionize reading as well as writing. Rather than allowing technology to
desensitize the reader, Brown had to find a way to make technology
resensitize the reader. Brown can hardly be taken entirely at his word
on the first page of his original *transition* article when he proposes "a
simple reading machine which I can carry or move around and attach to
any old electric light plug and read hundred thousand word novels in ten
minutes if I want to, and I want to."[27] Brown's ideal of reading sounds
much like Marinetti's ideal of cuisine in the 1932 *Futurist Cookbook*. To

reduce the meal to a pill or the novel to ten-minute experience of infor-
mation retrieval is to mount a challenge to tradition that alters our
notions of the entire experience of either reading or eating. If these pills
are hard to swallow, they should be taken with a grain of salt—the death
of the page-turner, it turns out, can only be facilitated by the death of
the page.

The reading machine is an antidote to the fatigue of writer and reader,
both of whom can only fight overstimulation with more overstimula-
tion. The white-collar worker is too tired to read a conventional book;
he falls asleep with it in bed:

> Now shift this tiresome book in your hand, prop up your eyelids with
> match sticks and move your eyes wearily back and forth over another three
> thousand lines or so. When you have a reading machine to bring the type
> right up before your eyes you won't need to prop them open, or search for
> words from one side of the page to the other; words will be brought right
> up flush with your vision and the reading intake of your mind.
>
> At the time I had written myself out I read Gertrude Stein's *Tender But-
> tons*. I didn't know what it was about then any more than I know what's
> about anything she's writing today, but I can still read it when I haven't
> anything more stimulating, and get a kick out of it. At the time *Tender But-
> tons* was published I had to read it because positively there was nothing
> else in America to read.[28]

Rather than prop our eyes open with match sticks, we can prop them
open with reading material that is more interesting in its mode of deliv-
ery as well as in its content. Brown implicates his reader in a sort of
*Clockwork Orange* scene wherein the tired reader must continually fight
sleepiness and distraction through artificial means. Stein breaks the cycle
of redundancy by drawing attention to repetition. Like the character
Data (who reads at superhuman speed) on *Star Trek: The Next Genera-
tion*, Brown's idealized reader becomes one with information. It is impos-
sible for a human to keep up, "to continue reading at today's speed."
The solution to the problem can only be to go beyond the technology
of reading, to get rid of "useless words," to get rid of useless languages, to
view words as vectors and images rather than as mundane combina-
tions of letters.[29] Commas and periods only slow readers down, whereas
arrows, equals signs, and hyphens—like flashing cursors—accelerate the

transformation of symbols into thought. The dream of the reading machine is cybernetic (to cite a coinage made only seventeen years after the reading machine was proposed): the reading machine counters the entropic decay of local languages by means of something like a Maxwell's demon of reading, a demon who implants ideas directly in the brain of the globalized reader. The field of vision is limitless, the second law of thermodynamics is nullified—the reading machine, like the stock market, is premised on infinite expansion, barring some unforeseen apocalyptic event. Through optical writing human beings would have a surer basis for communication, and there would be no need for translation—or so Brown's hyperbolic boosterism might lead us to believe.

As the 1930s wore on, Brown increasingly sympathized with the internationalist aspirations of the Popular Front. Brown wrote for both *The Masses* and *The New Masses*, and in 1940 published *Can We Co-Operate?* which ends with a somewhat belated paean to Soviet communism (he had visited the Soviet Union twice, in 1936 and 1937). By 1935 Brown is extolling Theodore Dreiser and Mike Gold at the expense of Pound and Stein, whom he labels as "dying bourgeois writers."[30] In discussing an upcoming writers' congress, he notes, "Americans of all political colors will convene to organize a single body to fight against fascism in defense of culture. And here the liquidation of the Ezra Pounds and Gertrude Steins will be duly celebrated."[31] Brown's use of "liquidation" in this context is chillingly cavalier—but once again he is likely exaggerating for effect. The juxtaposition of the plural Pounds and Steins is intriguing (particularly since Brown knew both personally). At least in this context, Brown's communist allegiances seem to have led him to group Pounds and Steins together as writers whose work could be considered retrograde only in terms of its political content. As Stein and Pound drifted rightward in the 1930s, Brown drifted left—no longer as confident in the technophilic modernism he had championed only a few years earlier.

One primary effect of American technological dominance in the twentieth century—and an effect particularly strongly felt whenever the word is technologized—is the spread of global English.[32] Manuel Komroff notes in his contribution to *The Readies*, "Supposing you have made a new fiddle, and supposing we admit it is as good as a classical Stradivarius. But the tune you play is after all only Yankee Doodle!"[33] In referring to this most trite and jingoistic of American songs, Komroff is perhaps inadvertently pointing out that while the reading machine may

revolutionize the form taken by the word, it may not revolutionize the content. The language of the readies has yet to be invented—the danger is that the language of the readies will be a financialized American language, without new words and forms suited to the new world produced by the spread of faster communications technologies. Brown proposes a kind of myth of origin where mother tongues inevitably come under the purview of Holy Rollers (Pentecostals) who resemble the high rollers of American finance:

> Bawling creative Babes in the Word continue the struggle to shatter the filmy caul they were born with and get at the rosy nourishing nipples of their mother, the Sphinx-like Reader. Manifestos have been broadcast in all tongues in all times, dating from the one God issued at the Tower of Babble, which carries on today in the Unknown Tongue by which the Holy Rollers commune. Maybe when we lift our creative writing heads too high again through the unexpected outlet of the Reading Machine God will come along and pie the type and we'll have to begin all over again.[34]

Not only will the reading machine allow readers to overcome their mother tongue, the reading machine will allow readers to overcome all tongues. If we take Brown at his word, the ambitions of the reading machine—like the ambitions of technocratic American capitalism—are limitless. The "Reading Machine God" is a striking incarnation of what the historian of technology David Nye calls a "second creation" narrative—a particularly American mythology of reversing the fall of man through technological means.

## The Cosmoparodic; or, The Ambivalence of Cosmopolitan Style

Italo Calvino's 1965 *Cosmicomics* opens with a fable of the earth having once been so close to the moon that people were able to jump back and forth. An absurd premise surely—but also an intriguing reversal of the typical world-is-getting-smaller account of globalization's ever-accelerating pace. Calvino's fable is in some sense one of prelapsarian innocence—but it could also be read as demonstrating considerable skepticism toward the idea that the contraction of space and time is anything new. My neologism "cosmoparodics" is intended to describe

a similarly fanciful, parodic ambivalence toward cosmopolitanism in Brown's writings.

In her *Cosmopolitan Style: Modernism Beyond the Nation*, Rebecca Walkowitz argues that "the tricks, the ruses, and the insistent pleasures of 'living' are the necessary conditions of a truly critical cosmopolitanism."[35] The description is apt in describing Brown's travel-suffused poetry, which retools the clichés of the tourist in the service of a conflicted internationalism. It may be that parody, through its insistent repetitions, is particularly well suited to undermine notions of authenticity and cultural specificity—and yet at the same time parody risks reductively mimicking that which it parodies. Simon Dentith defines parody as "any cultural practice which provides a relatively polemical allusive imitation of another cultural production or practice."[36] "Relatively polemical" gets at the kinds of ambiguities involved in parodic (not to mention self-parodic) literary works. To the extent that Brown is polemical, many of his aims would seem to align with those Walkowitz associates with "critical cosmopolitanism":

> By speaking of a critical cosmopolitanism, I mean to designate a type of international engagement that can be distinguished from "planetary humanism" by two principle characteristics: an aversion to heroic tones of appropriation and progress, and a suspicion of epistemological privilege, views from above or from the center that assume a consistent distinction between who is seeing and what is seen. When added to an ideal or method in cultural theory, the adjective "critical"—as in "critical cosmopolitanism," "critical heroism," "critical internationalism," and "critical globalization," to name just a few recent examples—tends to imply double consciousness, comparison, negation, and persistent self-reflection: an "unwillingness to rest," the attempt to operate "in the world . . . [while] preserving a posture of resistance," the entanglement of "domestic and international perspectives," and the "self-reflexive repositioning of the self in the global sphere."[37]

Brown's writings (both before and after his communist turn) are certainly skeptical of planetary humanism, of heroic authorship, and of the tourist's epistemological privilege (or lack thereof). But it would be going too far to call Brown a critical cosmopolitan—to call him an ambivalent cosmopolitan suggests that his cosmopolitanism is fraught with paradox and contradiction. Brown's ambivalent cosmopolitanism reveals that

among the lesser-known figures of expatriate modernism there was both deep skepticism of American capitalism and considerable self-awareness about being an American abroad. At the same time, Brown could embrace a *Metropolis*-like vision of something along the lines of a global "megapolitan" sublime made possible by relentless technological acceleration.

The title poem of *Globe-Gliding*, for instance, presents a futurist-type account of an endless global city; the poem is also suffused with a parody of the Deweyan formula of "locality is the only universal":[38]

Our Globe is but a
twinkling constellation of cities
Our Great City of Cities
perhaps not as big or important as
Hoboken
in celestial trans-Neptunian circles
but to us who know no other
our own little world is a great
international metropolis[39]

Brown might at first seem to be championing what Paul Virilio calls the "ominipolis," an all-encompassing global metropolis.[40] But as is so often the case with Brown, his futuristic projections can be read as comic displacements on the part of a deracinated subject. In shifting from "globe-trotting" to "globe-gliding," Brown introduces a reconfigured global proximity brought about by air travel. The cover of *Nomadness* (Figure 9) gives a sense of the cosmopolitan kitsch aesthetic that Brown seems to have sought. Airplane, train, and ocean liner vie for position with pyramids, mosques, and an Eiffel Tower. To complement these are wine and champagne glasses emblematic of the bohemian expatriate. *Globe-Gliding* is hardly innovative in its free-verse form; its poems are "talky" as opposed to optical. The majority of poems in *Globe-Gliding* are titled after places; the book is in fact the record of a lifetime of travel.

An unpublished and undated poem, "Salute to All the Bob Browns," demonstrates well Brown's self-deprecatory style. In its collapsing of names, the poem makes an implicitly Steinian case about the interchangeability of identities. The poem verges on the kind of "planetary humanism" that Walkowitz would differentiate from "critical cosmopolitanism":

I know 7 of the 700 Bob Browns
Or is it 7,000, 700,000
I hope 70,000,000
And of these I know
3 are writers (1 black, 1 white, 1 red)
Marx bless the whole
7-come-11 rainbow of Bob Browns
2 are artists (1 paints in St. Paul,
the other draws in Greenwich Village)
2 big businessmen (a radio announcer in Chi.
and a mortician in Okla)
That's all the Bob Browns I know personally
And allowing for dainty differences
In shape of ears, color of eyes and epidermis
We're all exactly alike[41]

The Popular Front humanism of the poem is immediately apparent; the poem also interestingly deracinates Brown, both in the sense of thematizing his anonymity as a minor writer and in terms of making his name transcend place and race. Even so, all of these Bob Browns remain distinctly American.

Like many of Brown's post-1920s writings, *Let There Be Beer!* (1932) is a global cultural survey that offers a targeted critique of American exceptionalism. The argument of *Let There Be Beer!* is simple: "Let America know that she has traded her birthright for a pot of near-beer."[42] In order to make this argument, Brown takes readers with him on a world tour of beers. He is particularly fixated on the disappearance of the American free lunch with prohibition: "Mention the old U.S.A. to a traveled German, Britisher, Frenchman, or even to a Singapore coolie, and he will come right back at you with some wise-crack about free lunch."[43] The free lunch is the ultimate dream of the unapologetic bohemian, for it prioritizes the cost of drink over the cost of food and provides a universal standard for hospitality: "All over the world, eyes pop and mouths water at the memory of Uncle Sam's free lunch counter. To allow such a revered institution to fall into decay is an international disaster of effect more far-reaching than England's going off the gold standard—a crime as unspeakable as the speak-easy itself. . . . Free lunch is America's one outstanding achievement. . . . Nothing on earth

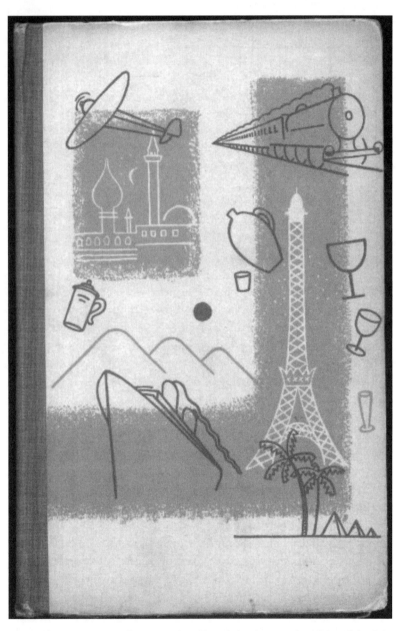

*Figure 9.* Cover, Bob Brown, *Nomadness* [English edition title, *Globe-Gliding*] (1931). Courtesy of Phoebe Brown.

makes such a universal appeal as something for nothing, anything for nothing."[44] It is one thing to go off the gold standard, but entirely another thing to go off the free lunch standard. If Horace's famous poetic dictum in the *Ars Poetica* had been *aut prodesse aut delectare*, to delight and instruct, Brown's poetic dictum is simply "Prosit! and more power to you," "prosit" being the German toast deriving from the Latin *prosit*, may it benefit, the third-person singular subjunctive of *prodesse*. The *delectare*, one may presume, goes without saying. Or at least the *delectare* part need not be apologized for—especially during the only free interval during the day left to the worker.

Brown's *Gems: A Censored Anthology* again critiques American prudery, by taking poems from Palgrave's *Golden Treasury* and suggestively blocking out portions. Brown foregrounds the figure of the philistine American abroad: "All forbidden books are sold in shops adjoining American Banks and Express Offices the world over. . . . 'Ulysses' they know as the modern American Bible, a sort of Science and Health for tourists in horn-rimmed specs who eagerly plank down ten gold dollars in payment; they don't know that ninety-five percent of the buyers of Joyce's classic read only the last forty pages at a cost of about twenty-five cents a page, but that would surprise them, Americans are notoriously crazy and lavish with their money."[45] The suppression of vice would seem to succeed only in drawing more attention to it. Ever the book dealer, Brown quantifies the amount spent on books by the American abroad in terms of the cost per page. The literary value of *Ulysses* for the American abroad is completely subsumed by its pornographic lure. "Book-legging," like "boot-legging," Brown makes clear, is a profitable trade premised on American isolationism.

If many of Brown's books (especially *Globe-Gliding, Let There Be Beer!* and *Gems*) attempt speedy round-the-world tours in terms of their content, *The Readies* anthology attempts a speeded-up round-the-world revolution in literary form. The contributions to the "readies" run the gamut in terms of content, but they tend to conform to Brown's notion of accelerating language either through altering or omitting punctuation, or through the ellipsis of words. The sequential juxtaposition of Pound's, Williams's, and Kreymbourg's seemingly perfunctory contributions to *The Readies* cannot be accidental. Pound's "Highbrow's Translation" is more of a lowbrow translation of Horace:

HIGHBROW'S TRANSLATION FROM HORACE

(*Periscos odi*)
The Persian buggahs, Joe
Strike me as=a=rotten show,
Stinking of nard and=musk
Over the whole of their rind and husk;
Wearing their soft=shell clothes
Whichever way the wind blows,
The Persian buggahs, Joe,
Strike me as=a=rotten show.[46]

Pound's poem is hardly "highbrow," but rather doggerel—homophobic, Orientalist, and resentful. Perhaps to suit the context of the anthology, Pound transforms the original Horace poem condemning luxury into a modernist condemnation of ornate language. The equals signs in the poem seem not to be integral to the poem's meaning—but instead perhaps almost to parody the reading machine as not introducing something new into the field of poetics, as not in fact revolutionizing the word.

The Williams poem that follows seems not to treat the reading machine seriously—or rather to treat the machine as the reduction of poetry to exact rhyme, producing a meaningless total equivalence between words:

READIE POME

Grace-face: hot-pot: lank-spank: meat-eat: hash-cash: sell-well: old-sold: sink-
wink: deep-sleep: come-numb: dum-rum: some-bum[47]

Like Pound's "translation," Williams's "Readie Pome" would seem to venture into primitivist/futurist territory, benignly rhyming itself into mnemonic numbness. "lank-spank: meat-eat: hash-cash." These are masturbatory mnemonics—undermining any sort of collective "logo-cinematic" (Jolas's term) idealism that the project of *The Readies* might entail. Williams's poem enacts the getting rid of "useless words" advocated by Brown: but why rhyme individual words, other than to create

doggerel?[48] The words that should precede rhyme-endings in any traditional verse structure are presumably removed, creating an effect of radical ellipsis. Even the two syllables of the word "poem" are compressed into one. The reading machine is here understood as introducing a kind of optical and sonic shorthand: evoking a verbal intensity through sonic mirroring or through pure rhyme. Like Williams's poem, Kreymbourg's poem that follows thematizes its own suspicion of the reading machine. Kreymbourg's contribution is an iambic tetrameter couplet with a feminine ending, formulaic and parodic at the same time:

REGRETS

Old man Kreymbourg has grown too seedy
To write Bob Brown a speedy readie.[49]

Kreymbourg, the editor of the influential (by then defunct) journal *Others*, poeticizes his own inability to contribute a poem. Kreymbourg is too slow to match the speed demanded of a readie writer. In the face of a radical transformation of reading, he, too, can only fall back on the most traditional of forms.

Stein's contribution to *The Readies* is a witty rejoinder to Brown's exaltation of erasure and linguistic acceleration. Stein had already in 1929 composed her portrait of Brown titled "Absolutely as Bob Brown or Bobbed Brown." Sent to Brown in 1930, Stein's readie, "We Came. A History," arrived "in two parts that together fill one cahier.... The second part appears to be the readie proper, although Brown published both parts as she obviously sent them to him."[50] In contrast to Pound's homophobic "translation," Stein's contribution is remarkably insightful into the processes by which victors write history:

Historically there=Is no disaster because=Those who make history=Cannot be overtaken=As they will make=History which they do=Because it is necessary=That every one will=Begin to know that=They must know that=History is what it is=Which is as they do=Know that history is not=Just what every one=Does who comes and=Prefers days to more . . .[51]

The identity of the "we" in the poem is left indeterminate. Whereas Pound's translation parodically presumes that "Joe," his assumed everyman reader, will share his suspicion of "Persian buggahs," Stein's "We

Came" offers a flexible "we." Whoever "we" are, we are presumably a collectivity because of a shared migration. Stein's poem is eminently cosmopolitan in its inclusiveness, whereas Pound's is chauvinistic in its demonization of a presumed other. Stein's "readie," so far as I am able to ascertain, is the only instance in her writing in which she employs equals signs as a mark of punctuation. For Stein (who was so extraordinarily self-conscious in her use of punctuation) to use equals signs, we might surmise, was not only a way to speed her writing, but also a way of suggesting a radical grammatical equivalence that would recognize that "history is not=Just what every one=Does."

## Coda: Beyond the Paper Principle/Beyond National Poetries?

Jacques Derrida's description of the effects of the word processor sounds remarkably like a description of the reading machine:

> [The computer] restores a quasi immediacy to the text, a desubstantialized substance, more fluid, lighter, and so closer to speech, and even to so-called interior speech. This is also a question of speed and rhythm: it goes faster—faster than us; it surpasses us. . . .
> The dematerialized letter moves faster than sound, faster than cognition—it crosses borders without needing its papers in order.[52]

The reading machine speeds cognition—in fact, it aspires to overcome sensory overload through placing the desubstantialized word directly into the mind of the reader, who is now more of a seer, who through sheer power of will, along with the prosthetic powers of the reading machine, can absorb vast amounts of information instantaneously.

Such would be a utopian/futurist projection of the reading machine's potential to overcome speech and the local. But Brown, I have argued, is more conflicted. He wants to preserve the exotic, and yet his machine eliminates all barriers to communication by transmitting language directly into the mind of the reader. The French writer Jacques Roubaud has recently posed a somewhat analogous parodic program that would eliminate the need for translation. Each paragraph of Roubaud's essay on poetry in translation begins with an @, as if to mimic the immediacy

of the e-mail address's equation of the personal name and the institutional address:

@10.4 The general opening of markets ... is going to put poetry in an even more precarious position. . . .

@10.6 For poetry encounters very unusual customs obstacles. . . . I am talking about the language border, and the need for translation, which makes the cost of transportation from one language to another truly prohibitive. . . .

@10.6 There are two radical solutions to this problem. The first is radical: *eliminate* dominated language poetry.

@10.7 The second solution is similar to the first, or even further: eliminate the difficulties of translation through general standardization, and adapt the modes of poetic expression of the dominant universal language, which is English.[53]

Roubaud, like Mallarmé, admits to being an Anglophile—and thus his program is not only parodic, it is self-parodic. As a poet who writes in French, Roubaud is advocating the elimination not only of his medium but of his native language. Since he has access to English, and since much of his poetry has been translated into English, Roubaud might not in fact suffer from his advocacy of Global English. He is not optimistic about the fate of poetry in languages other than English—but the point of his parody, as I take it, is that poetry preserves the local and resists translation, and that poetry is particularly worth preserving in an age of instantaneous global communication. Like Brown, Roubaud employs parody in part to resist an unreflective nostalgia. The reading machine parodies both a utopian desire for a universal language and a dystopian mistrust of language as a medium. Brown's machine implies a "translation app," to use the most up-to-date lingo of the iPhone (which can wirelessly access virtually limitless quantities of poetry in multiple languages in over two hundred countries). And yet perhaps poetry is still, as the cliché (often attributed to Robert Frost) would have it, "what gets lost in translation"—from language to language as well as from voice to page to screen. Perhaps poetry remains a particularly stubborn ghost in the machine—an untranslatable otherness hidden within even the ghostliest American projections of the word of the future.

# 3

# HUMAN UNIVERSITY

## CHARLES OLSON AND THE
## EMBODIMENT OF INFORMATION

There is no limit to what you can know. Or there is only in the sense that
you don't find what you don't seek to know. There is no truth at all, of
course, in the modern velleity (the lowest degree of desire) that you can't
know everything.

    —Charles Olson, *The Special View of History*

His attention was constantly changing focus, from the rods and cones in
a pigeon's eye to the drift of the continents. . . . Olson wanted his students
to achieve vertically the entire horizon of human knowledge.

    —Guy Davenport, *The Geography of the Imagination*

From the 1949 "Kingfishers" to the later *Maximus Poems*, Charles
Olson personifies the technological and epistemological pressures
of a postwar United States whose information production and stor-
age capacities had grown exponentially within a few decades.[1] Olson's
work—perhaps more so than any other poet of the period—bears wit-
ness to the glut of information at mid-century. Olson's field poetics are
premised on the idea that the "poet–pedagogue" must expose him- or
herself to the broadest possible range of information—for Olson, this
results in a sharpening rather than a diminution of the poet's atten-
tion. Contemporaries often described Olson as both an intellectual and
a physical giant (he was six feet six), remarkable in his capacity to absorb
information. Steve McCaffery has recently described him as "the exem-
plary poet of the Cybernetic Age," and suggested that "with the earth
on the brink of ecological disaster and language enmashed in the age
of information, Olson appears as a prophet and perhaps a destroying

angel."[2] Olson was among the first to use the term "postmodern," and his conflicted embrace of cybernetics was closely tied to his understanding of the new postwar epoch.[3] Olson himself wrote dramatically that he had "sacrificed every thing" in his "attempt to acquire complete / concentration."[4] This chapter explores how Olson fashioned himself as both a hero and a victim of information overload, and suggests that his engagement with information is key to his poetics.

Olson's two central poetic influences, William Carlos Williams and Ezra Pound, had both thoroughly indicted the system of American education before the war.[5] Olson follows in the footsteps of Pound and Williams in leaving behind an unfinished epic poem—but whereas Pound and Williams sought forms of modernist knowledge, I suggest that Olson resigns himself instead to the less epistemologically certain category of information. For Robert von Hallberg, "Olson the poet is not a maker but an expositor; what matters to him is the poem's last word: information."[6] Like Olson, Williams believed that poetry could fulfill a unique epistemological function, serving to unify otherwise disparate and/or overly institutionalized forms of knowledge. Williams was never able to complete *The Embodiment of Knowledge*, his searing late 1920s indictment of American higher education. For Williams, "We are in that stage: 'the more you study the less you know'; which is perfectly true—unless you go through—to what?—to stillness, to that basis on which the modern excellence of the best new poetry is founded."[7] Poetry, as "the only articulate form," serves for Williams as a means by which to see the world more clearly.[8] For Williams, "data should be present in activities, which, in particular, have newly organized their material, such as, let us say, in poetry. How better than in poetry, that has undergone a revolution."[9] By the mid-1940s, Williams had increasingly turned toward chronicling the local by way of historical and found documents. In part as a reaction to the dehumanization of the war, a poem had become for Williams a "machine made of words," as he put it in the 1944 preface to *The Wedge*.[10] The citizens of Williams's Paterson, New Jersey, like the citizens of Olson's Gloucester, Massachusetts, "because they neither know the sources nor the sills of their / disappointments walk outside their bodies aimlessly."[11] *Paterson* and *Maximus* could both be said to counter rootlessness through the creation of epic (perhaps even partly mock epic) protagonists who are mythically connected to their respective townscapes. In both cases, embodied (or internalized)

information about the local arguably becomes a means by which local citizenship can be made universal, bypassing the triumphant nationalism of the postwar United States.

During the decade from the early 1940s, when he worked at the Office of War Information, to the early 1950s, when he was rector of Black Mountain College, Olson repeatedly described an aspiration to overcome conditions similar to those that Theodor Adorno and Max Horkheimer contemporaneously referred to as the dialectic of enlightenment, wherein the domination of nature by rational means—but not to rational ends—had led to the exponential growth of the culture industry and a corresponding decline of general knowledge regarding true sociopolitical conditions. Olson's political views were less fervently leftist than those of Adorno and Horkheimer, and the comparison should not be overstated; nonetheless, the three thinkers share a sense of profound frustration at the general state of knowledge within American universities and the mass media in the war's immediate aftermath. The war affected Olson deeply.[12] It was, in some sense, Olson's revision of Williams to turn himself, as poet, into a machine made of information. As Don Byrd writes, Olson "does not imagine the poet as an artisan as Pound or Williams do, but as a biological machine."[13] With its direct quotations from Norbert Weiner's *Cybernetics*, Olson's 1949 "Kingfishers" most clearly reveals the poet's interest in information theory. For a generation of poets, it took on additional resonance as the opening poem of Donald Allen's *New American Poetry* anthology. Although the term "feedback" (or "feed-back") had been used in the context of radio and electronics since the 1920s, according to the *OED* it only began to be used in relation to social organization or to biological organisms in the 1940s. "The Kingfishers" features the concept of feedback prominently:

Not one death but many,
not accumulation but change, the feed-back proves, the feed-back is
the law . . .

We can be precise. The factors are
in the animal and/or the machine the factors are
communication and/or control, both involve
the message. And what is the message? The message is

a discrete or continuous sequence of measurable events distributed in
time[14]

Under the banner of Heraclitean flux—"Into the same river no man
steps twice"—Olson is able to reconnect mind and body by way of re-
course to Wiener's *Cybernetics*.[15] Invoking Wiener's concept of feedback
enables Olson to envision the (re)embodiment of information within a
postwar context in which scientific knowledge seemed to have over-
whelmed all possibility of its being humanely controlled. "The message"
is a continuous one, and it is overpowering, particularly given the poem's
earlier reference to the war ("not one death but many"). For Olson the
"will to change" can impede the onslaught of death and indifference. As
Olson's "anti–*Waste Land*,"[16] "The Kingfishers" does not deny the chaos
into which Western civilization has fallen, but contra Eliot, Olson does
not suggest that his readers can reclaim that lost coherency through
recourse to Anglo-American cultural or religious tradition: for Olson
"the field" of cultural information must be far wider.

Within the typescript of *Cybernetics*, which he first encountered at
Black Mountain College in 1947 in advance of its publication, Olson
found a grim prognosis for the postwar era: "This is the world of Bel-
sen and Hiroshima," Wiener declared. "I write in 1947, and I am com-
pelled to say that [to have a society based on human values] is a very
slight hope," he continued.[17] "The present time is the age of communi-
cation and control."[18] It was during this period (the Macy Conferences
ran from 1943 to 1953) that information theory took shape, and, as
N. Katherine Hayles and Mark Hansen have argued, that information
came to be constructed as a disembodied medium.[19] For Hayles, "the
post–World War II era ... was ripe for theories that reified information
into a free-floating, decontextualized, quantifiable entity."[20] Within
recent new media scholarship, there has been fairly broad consensus
that, in Bernadette Wegenstein's words, "the body is our most funda-
mental medium of knowledge and experience," or as Hayles puts it,
"information is never disembodied ... messages don't flow by them-
selves, and ... epistemology isn't a word floating through the thin, thin
air until it is connected up with incorporating practices."[21] Despite his
sexism (discussed below), Olson, in common with many contemporary
feminist scholars of new media, was suspicious of the dematerialization
and disembodiment of information. Olson consistently championed an

embodied consciousness that valued self-reflexivity. The persona Olson created—that of an "infovore" struggling to process information continually within an outsized, ungainly body—insisted on a cybernetic subjectivity. Olson had always been an omnivorous gatherer of information, keenly interested in the nature and transmission of knowledge. As early as 1931 he writes, "Everything absorbs my attention. It is a tendency I have to fight against."[22] F. O. Matthiessen brought Olson to Harvard in 1934 because Olson had collected valuable primary-source Melville documents. Finding himself under the influence of Edward Dahlberg and unable to assimilate his considerable knowledge of Melville into a conventional dissertation, Olson left Harvard, and repeatedly expressed frustration at the stultified nature of conventional mid-century academia. Olson would have concurred wholeheartedly with Williams's assessment that "no student nowadays is given to understand the meaning of knowledge (or of college)—a necessary view of the field—but is lost—brutalized by facts, brutalized by a sleet of information—deafened into a general language—dwarfed in understanding—made into a cock-eyed grotesque of a man to perform a given task."[23] Olson echoes this complaint about specialization on many occasions, particularly during his time at Black Mountain College. Olson, like Williams, believed that "everything should always be taught at once."[24] Poetic education, Williams makes clear, is an antidote to information saturation: "Mountains of dead words, cemeteries of words befog the mind. . . . If he has written poetry it may help. He knows at least something of the difficulties of form. Style he takes to be a word like the others. It is all one thing."[25] The way to cleanse the words was not simply to strip them of their debased mass-cultural meanings, but to revivify them through poetic arrangement. Form, in other words, could serve as a means by which to filter language that had lost its referential specificity.

Rather than loosely connecting history and myth through what he labeled the faulty "ego-system" of Pound in the *Cantos*, Olson's "proprioceptive" method is meant to create a more immediate, vital sense of the poet engaged with unprocessed data.[26] Logic and categorization are in effect counter-cybernetic for Olson—they interrupt the immediacy of the interchange between organism and environment, between poet and perception: "Logic and classification . . . intervene at just the moment they become more than the means they are, are allowed to become ways

as end instead of ways to end, END, which is never more than this instant, than you, figure it out."[27] The body, as well as the voice, of the poet must be perfectly attuned to its surroundings, as well as to its part in what Marx would call "species-being." Don Byrd recalls Robert Duncan in 1983 claiming that "Olson and I are cybernetic poets. It is what distinguishes us the others of our generation, even Creeley."[28] What Duncan seems to have meant was that his, and Olson's, interest in mythography and measure had found an important epistemological analogue in cybernetics.

According to the philosopher of technology Albert Borgmann, "Information led an inconspicuous semantic life until in the second half of the twentieth century."[29] The rise of information theory in the late 1940s— in the work of figures such as Wiener, Claude Shannon, and Vannevar Bush—reinforced the distinction to be made between "knowledge" and "information."[30] By way of an anecdote, Borgmann exemplifies the period from the late 1940s to the early 1960s when the word "knowledge" could still be used somewhat interchangeably with "information": "In 1960, Fritz Machlup published *The Production and Distribution of Knowledge in the United States*, a title that sounds odd today. It is information, we would think, that can be produced and distributed. The thought did not occur to Machlup. He acknowledged the rise of information and considered its inclusion in his title, but in the end he clung to the tradition that began with Plato wherein the grand and explicit topic is knowledge while information is dimly perceived as trouble."[31] Paradoxically, Olson's narrative of intellectual history, while seemingly Platonic in its emphasis on human universals, is in fact deeply anti-Platonic, locating the essential decline of the Western polis within Athenian rationalism—in Olson's terms, this is the transition in method from Herodotus to Thucydides, in which *muthos* or myth (with its cognate sense of "mouth") had been denounced in favor of *logos* (in Olson's terms, disembodied literate reason). In championing a fusion between muthos and logos, Olson was able, at least partly, to reconcile historical and mythographic speculation. In epistemological terms, the "mytho-logic" synthesis allows Olson to maintain a healthy respect for primary historical facts (analogous to "information") at the same time that it allows him to resist what he considers the false objectivity of Thucydides and Plato (whose writing, for Olson, excessively purports to be rational "knowledge").

Olson was not an unequivocal champion of Wiener's *Cybernetics*, although he did successfully recruit Wiener as a trustee of Black Mountain College. In a remarkable 1951 letter to Robert Creeley, he goes so far as to link cybernetics to fascism:

> Sometime quite recently a door went bang shut, and a "box" of history can be seen as such, and put away—say, the box 500BC–1950AD
>
> (that is—to stay on the best known ground—biochemistry is postmodern. And electronics, now, is already a science of communication—the "human" is already the "image" of the computing machine, and the lesson (by the substitution of the binary for the decimal in its operation) of its better workings[32]

In Olson's metanarrative, the pre-rational (500 BCE) and the post-rational (1950 CE) are the grand bookends of history. There are apocalyptic Cold War overtones to Olson's account, but there is also a hopefulness that future advances in biochemistry and electronic communication might result in new forms of embodiment—so long as humans are not remade in the image of computers.[33] Olson's initial enthusiasm for cybernetics as a theoretical grounding for an emergent postliterate world was tempered by a deep suspicion of cybernetics as an amoral outcome of evolutionary processes. Olson's letter to Creeley continues:

> all these effects, of course, or movements apparently forwarded are "blind," in the sense that they go without any recourse to a series of sanctions, as did the previous or modern, philosophy, ethics, and science
>
> an evidence of this, open to all, is the stupidities & dangers of "Cybernetics," which, so far as the noticeable absence in it of grounded human sanction goes, most resembles that side of collectivism which we loosely call fascism[34]

Olson at this point seems to have been unaware of Wiener's 1950 *Human Use of Human Beings* (though he later owned the book), in which Wiener expressed similar concerns.[35] Olson suggests to Creeley that "THE ENGINEER is the HERO of the system we call the WEST," and that as a result of the heroic elevation of technical man, matter became divided from what "'spirit' or whatever word you use to denominate the organic force which [is] the human."[36] Olson's organicism manifests

itself not only in his descriptions of his own body, but also in his descriptions of the two communities in which he felt most at home: Black Mountain College and Gloucester. Olson called Black Mountain "the biggest city he had ever known. He described it as more 'like a human individual than it is like anything else. . . . Black Mountain's secret is a combination as ineluctable as that of the human organism— bones, and the breathing apparatus of flesh, the pores.'"[37] The relation of bodily organism to social organization (or *polis*) is a main concern of Olson's mature writing; he recurrently described himself (and/or Maximus) as incorporating Gloucester and Black Mountain within himself (and vice versa).

For Olson, written language is radically reductive of the total experience of the "human universe," in large part because writing externalizes information, delimiting the field of discursive possibility: "For any of us, at any instant, are juxtaposed to any experience, even an overwhelming single one, on several more planes than the arbitrary and discursive which we inherit can declare."[38] The introduction of technicized memory in the form of writing is catastrophic: "The moment you exaggerate the function of discourse in the plane of knowledge or the intellect— the moment you remove memory from the human organism, or, make it merely an agent of knowledge instead of an agent of re-projection— you make energy mechanical by removing from its direction & end the very participant which can demand that content can serve a purpose other than a material one."[39] For Olson, when *hypomnesis* (Bernard Stiegler's term for technically stored media, including writing) displaces *anamnesis* (Stiegler's term for embodied memory) there results a radical narrowing of the range of human thought—hypomnesis detracts from our ability to perceive the physical world around us, as when Olson compares Thucydides to "the latest finest tape recorder."[40] As he puts it in *Human Universe*, "We have lived long in a generalizing time, at least since 450 B.C." Hence the need for a recuperation of spoken language: "Logos, or discourse, for example, in that time, so worked its abstractions into our concept and use of language that language's other function, speech, seems so in need of restoration that several of us go back to hieroglyphs or to ideograms to right the balance. (The distinction here is between language as the act of the instant and language as the act of thought about the instant.)"[41] Even if Olson did not harbor as deep a confidence as did Pound in the transparent power of the ideogram,

Olson nonetheless saw linear, alphabetical writing as inimical to spontaneity. The classificatory and bureaucratic functions of Western writing concerned him even more than the actual writing system. For Olson, the arrival of Greek rationalism led to a disembodied consciousness incapable of fully perceiving the natural and historical world. Olson's ideal of embodied knowledge insists on an intimate relation between primitive facts and the most current of events. In his "Starting from Where You Are" course at Black Mountain in 1954, he proposed to study the present by way of the most immediate materials on hand, such as local newspapers. In a 1956 "Draft Plan for the College," he writes, "Knowledge, at Black Mountain, in that usual sense is also fixed as what we take it to be, what in the 20th century it has become: news, hot news. So we don't treat it as something called a 'body' of knowledge, canned like Army food, to be fed out like a spam."[42] A "body of knowledge" for Olson could not be an independent, abstract entity. If it became that, it would merely mimic the mass-produced ideologies of the twentieth century.

Olson's pre-*Maximus* attempts to write a long poem in the late 1940s reveal him struggling to reconcile poetry, mythography, and historical data.[43] In a 1948 outline for the long poem he intended to call *West*, he proposed that he would "reverse the motion of Homer, Dante, Melville, start in Asia with . . . Lao-Tse (and the horizontal, anthropological Am Indian society)."[44] Olson even seems to have considered naming the poem's central character "Orpheus West." The impracticalities of such a sweeping epic soon become apparent. "Is it possible to write a long poem called WEST?" he wondered. "Or is the American experience too stiff, too unfabled for use?"[45] In a way, Olson had already answered this question in the concluding pages of *Call Me Ishmael*. The stiffness of American subject matter was not the problem; rather, the problem was selecting from a vast quantity of fabled materials without becoming the exclusive arbiter of those materials' universal significance. In a 1953 fragment describing his decision to abandon the poem, he writes, "I begin to think that [*West*] better be something as wide and stupid as AMERICA. But in either case it was never meant to be 'history.' And so it presents the usual problem: how to do it in what way to make it, like they used to say, univoisal."[46] The answer was, as he had suggested in "Projective Verse" in 1950, to reject the conventional "ego position" of the epic poet: "MYSELF, then, in this poem, excluded as person to the POEM, no personal memory,

quite the opposite, *archetypal memory.*"[47] In 1947, Olson wrote that he wanted his poetry to "put everything back in the box of facts."[48] The parodically overextended character of *Maximus* represents Olson's attempt to do justice the vastness of his materials. Maximus, as Butterick has suggested, is fundamentally a figure meant to test "what size man can be once more capable of, once the turn of the flow of his energies that I speak of as the WILL TO COHERE is admitted, and its energy taken up."[49] At the same time, the figure of Maximus demonstrates the impossibility of finding total coherence through a single epic persona.

One of the overriding questions of *The Maximus Poems* (posed by Maximus to himself) is "Where shall you listen / when all is become billboards, when, all, even silence, is spray-gunned?"[50] It is no accident that the first song of *Maximus* notes the pressures of advertising culture on the landscape:

> Colored pictures
> Of all things to eat: dirty
> Postcards
>          And words, words, words
> All over everything
>                No eyes or ears left
> To do their own doings (all
> Invaded, appropriated, outraged, all senses
> Including the mind, that worker on what is[51]

Olson consistently represents modern man as overcome by a deluge of language and information. The deluge is not only delivered by means of television and other mass-mediated means; Olson is fiercely critical of almost all mid-century bureaucratic institutions, and their role in accumulating disinterested data. For Olson, facts have no meaning unless they are qualitatively (re)constituted within a body or polis. The state, like the university, generally obstructs the individual's access to knowledge, not through scarcity but through profusion.

In the "Bibliography of America for Ed Dorn," Olson refers obliquely to quantity as "King Numbers" and to quality as "King Shit."[52] Quantity for Olson can have the effect of either focusing the attention (if a law can be derived) or dispersing it (if the information remains undigested, or lawless). In the main, however, Olson was suspicious of quantity (not

to be confused with "measure") and associated it with postwar American mass consumption. Olson wanted to temper his tendency toward being an intellectual and sensual omnivore (a lover of quantity) by being what he referred to as an "amorvore" (a lover of quality):

                    All,
has no honor as quantity.
            And the attention
in each of us,
is that one, not the other
not the perfect one. Beauty,
is too quick
for time

            If man is omnivore,
and he is, he eats anything
every so often, he is also
amorvore
as well[53]

Olson felt that virtually every aspect of American society in the twentieth century had become overcome by these dual monarchs, King Numbers and King Shit. From the postal service in which his father had worked for most of his life to the emergent Melville "industry" (as he calls it in 1950), Olson saw himself at odds with a culture that valued quantity of data over quality of information. Nevertheless, Olson prized many of the products of specialized American research, and liked, for instance, to consider Black Mountain a more humane, more embodied version of Princeton's Institute for Advanced Study. Olson recognized that the American research university, particularly in the sciences, had contributed to revolutionizing knowledge within the span of his own lifetime. "Look, one of the reasons why I stress American scholarship," he writes to Cid Corman,

   IS, that the American PUSH is not at all all machines and engineers
      THE FACT is, that, Americans are putting out a body of research ROUND
   the WORLD, which is the kind of grounding on which that culture of
   Europe rested rests is now buried in here lies the anthill[54]

Not only has the flood of American information all but drowned Europe, it has also drowned out the ability of the American intellectuals who produced it to process it. Olson recognized that the expatriate auto-didactic vision of Pound was anachronistic in the postwar period. The American technocratic worldview, for better and for worse, had entirely suffused the "body of research" being spread "ROUND the WORLD."

Olson's critique of American universities is unsparing, and often reveals him at his most didactic. As he emphatically puts it in the opening of "The Gate and the Center," "KNOWLEDGE either goes for the center or it's inevitably a State Whore—which American and Western education generally is, has been, since the beginning."[55] Olson insisted so strongly on the primacy of the "poet–pedagogue" that some, such as von Hallberg, have suggested that his poetry was always subservient to his larger polemics. Ben Friedlander writes, "Olson was not literary in orientation: that is, he was not interested in making finished, free-standing works of art, objects to be appreciated or consumed as ends in themselves. He was, instead, engaged in writing as an activity subservient to the production of knowledge."[56] Though I largely concur with Friedlander's and von Hallberg's emphasis on Olson as a producer of knowledge (or more specifically, "information") as opposed to a poetic perfectionist, I wonder if readers need to choose between the two. Olson clearly believed in a poetry informed by history, but he also described improvisation as central to his poetics, and acknowledged that "it is very difficult, to be both a poet, and an historian."[57] Friedlander also points out that "Olson produced texts as a way of sharing his findings and participating in a community of writers and researchers . . . the larger shape of his writings is only discernible in his total output, which is not a matter of books alone. In his final years, Olson abandoned the book as ultimate horizon and worked instead to produce an archive."[58] Olson's archival method can be said not only to apply to Olson's continual search for primary information, but also to his attempt to manage his own body of work. Olson seems to have known the truth of Friedlander's suggestion that his work is best approached as a "total output."

In Olson's most direct account of the mind–body relation, he defines "proprioception" as "the data of depth of sensibility / the 'body' of us as object which spontaneously or of its own order produces experience of, 'depth' Viz SENSIBILITY WITHIN THE ORGANISM / BY MOVEMENT OF ITS OWN TISSUES."[59] Proprioception allows the new culture of

unlimited, but non-located, information to find a home within the human universe of the bio-cosmo-logical (I choose this awkward locution to suggest that Olson considers his universe to be a mortal one, but nonetheless still a universe). In the well-known lines that lend their title to the film *Polis Is This*, Olson cribs directly from Alfred North Whitehead's *Adventures of Ideas*. Olson's gestures during a filmed reading of the poem in 1966 suggest that the "this" in "polis is this" is Olson's own body:

> An American
> is a complex of occasions,
> themselves a geometry of spatial nature.
>
> I have this sense,
> that I am one
> with my skin
>
> Plus this—plus this:
> that forever the geography
> which leans in
> on me I compel
> backwards I compel Gloucester
> to yield, to
> change
>
> Polis
> is this.[60]

Proprioception allows us to become one with our surroundings, to get back to "our own primary," as he puts it in *Call Me Ishmael*. Olson is at one with his skin at the same time that he is at one with his poem. The antidote to a limitless universe of knowledge is not a renunciation of universal themes, but rather an intensification of attention, or as he sometimes puts it, concentration. For Olson, concentration must be a fully embodied act, a never-ending "plus this." "I compel" is repeated twice. Olson is undoubtedly thinking of the etymological sense of "compel" as "to drive together" or to "bring together in one place." The landscape of Gloucester leans against Maximus, to which he responds by himself leaning back against the town.

As the embodiment of human/polis reconciliation, Olson must open himself to as many phenomena as he is humanly able. Olson (or by proxy Maximus) is never quite at home in the tragically flawed polis of Gloucester. As much as he loathed Aristotle in other contexts, Olson would have approved of his notion that a man must be either super-human or a beast to live outside of the polis. Often the phenomena to which Olson must expose himself are profoundly dislocating:

> It could be put this way: any phenomenon, to be experienced, takes precise engagement; and that the experience of several phenomena increases the precision brought to bear. My own sense is that there can't be enough, and that one of the extraordinary virtues of a human being is (a), that he can take so much, and (b), the more that he takes the more he can, and the more he can give—that is the greater, by intensity, is his precision. And the reason is very much tied to field—to that which I have called the virtue of totality: that experience is such (is so rich), that the more kinds of experience one includes (the more phenomena and actions) the finer and faster is the attention brought to bear on all succeeding ones, and, by the brilliance of memory, on what has been known. This constellating of experience and attentions is such a breeder of values that one can say that just here is the gain which has undone all hierarchy—that just here is where the discovery of value can be said to lie, in this increase in the precision of attention by the width and depth of the phenomena allowed in to demand attention.[61]

Contrary to what we might expect, the "virtue of totality" does not entail a fixed system of belief—rather Olson suggests that "field" is anti-hierarchical. We cannot know our own perspective unless we derive our knowledge from outside-in (from totality to cogito), rather than, as in Olson's understanding of Descartes, seeking our knowledge from inside-out (from cogito to totality).

Concentration is a key word for Olson, as in "Letter 6" of the *Maximus Poems*:

Eyes,
& polis.
fishermen.
& poets

            or in every human head I've known is
            busy
      both:
      the attention, and
      the care
            however much each of us
            chooses our own
            kin and
            concentration[62]

For Olson, the community (the polis) and care are coextensive—they
arose with the first cities, rather than emerging from the rationalistic
culture of post-Thucydidean Greece. One must concentrate on some
form of place and people in order to have an identity. Concentration
for Olson is profoundly autopoetic, as he suggests near the ending of
*The Maximus Poems*:

                        Concentrate
            one's own form, holding
            every automorphism[63]

For Olson, an automorphic self-consciousness was the means by which
one could transform copious data into meaningful information. In the
comprehensive notion of "field" which dominates Olson's poetics from
"Projective Verse" onward, what allows the perceiver to assimilate dis-
parate facts is precise concentration. Olson sometimes referred to the
totality of concentration (or attention) as "stance," as in the "Chiasmus"
lectures: "Stance is very much a source and result of such maximal
attention. And space could be called the inclusion of all the possible
stances to all the possible facts or objects or acts which I am here in-
sisting is the phenomenal man is required [sic] to include within him-
self."[64] Space, then, like its counterpart "field," is not only physical, but
also mental—an ability to hold together abundant thoughts. Olson was
fond of Keats's "negative capability"; it suggested that the poet could
be a nexus of contradictory ideas, held in place by the poet's unique
embodied perspective, his "stance." As he put it elsewhere in the same
lectures, "What I know is the experience of bringing all to bear on
anything."[65]

The late poem "The Telesphere" is sometimes taken to be a crude expression of Olson's loneliness in Gloucester after the death of his wife, but the title suggests that we might also read the poem as part of his larger desire to embrace what we might now think of as the "infosphere":

Gather a body to me
like a bear. Take it on
my left leg and hold it off
for love-making, man or woman
boy or girl in the enormity
of the enjoyment that it is
flesh, that it is to be loved, that
I desire it, that without it
my whole body is a hoop
empty and like steel
to be iron to grasp
someone else in myself
like those arms which hold
all the staves together
and make a man, if now as cold and hot
as a bear, out of me.[66]

Olson was hardly shy in making his body the parodic subject of his poems—here his desire is literally omnivorous as a bear's, desiring any sort of body with which to commune. Indeed, the body of Maximus often takes on the proportions of a parodic analogue for imperial over-stretch. The hoop cannot contain the staves: the man cannot retain his loved ones; the man cannot restrain himself; his country cannot restrain itself. Such sentiments are echoed loudly in the concluding page of *The Maximus Poems*. Although Olson was certainly a misogynist and a homophobe—who favored almost exclusively homosocial surroundings—he also, as in "The Telesphere," presents himself as something of a Whitmanic pansexual being. "The Telesphere" demonstrates that "stance," or concentration, incorporates (in the literal sense of the word) sexual desire. Olson's sacrifice of himself to knowledge, as Michael Davidson points out, is not only a sacrifice of his own sexuality, but also of the agency of the women of the polis or of the sphere of learning. Of the lines "I've sacrificed every thing, including sex and woman / —or

lost them—to this attempt to acquire complete / concentration," Davidson writes, "If this is a confession of vulnerability and limit on Olson's part, it is no less a statement of personal resistance by which 'sex and woman' are kept out of a city they had yet to occupy."[67]

Davidson is right to note the exclusionary and gendered nature of Olson's polis, whether at Black Mountain or at Gloucester. Another, more proximate observer of Olson's gender politics, Robert Duncan, was more sympathetic to Olson's self-sacrificial claims. Duncan's extraordinary account of Olson's death demonstrates that Olson retained his self-parodic maximalist persona to the very end. In a letter to Jess Collins, Duncan describes in intimate detail conversations he had with Olson as he was dying of liver cancer. The liver/"live-her" itself becomes a gendered organ, as Olson reflects on the disease (if we take its root cause to be alcoholism) that cost him "my wife   my car   my color   and myself "[68] Duncan recounts him saying:

> "You put it on me . . . I was not Zeus, but Prometheus . . . I want you to tell me what to do. What does Prometheus do?" But then he went further than the person of Prometheus: "What does the liver mean, the live-her—the doctor said it's a female disease, cancer of the livery." And the Liver he saw or projected in his talk as the Mother Liver. "Then you are in the House of the Mother Liver" I said, and that, as I do, I see him always ahead along the way (the way or quest of what those of us who set out in 1950 with a mission in poetry were promised to).[69]

Olson's feminizes his liver as an odd combination of something like mother Earth and a feminized forbidden knowledge (more like Pandora than Prometheus). A mere six months after the Stonewall riots, he makes common cause with his most devoted fellow poet, the openly gay Duncan, who recognizes in Olson both a friend and a father figure. However grandiose (but not without irony) Olson's choice of Prometheus over Zeus may be, he once again envisions himself as a tragic bearer of knowledge, rather than as someone fully in control of knowledge. Later in the exchange, Olson goes even further in allegorizing his own failing body:

> "This is a civilization, the whole state of things," he said pointing to his guts. It was only towards the close of the séance that I began to realize that

half his body had indeed been shaved and half shaggy hairy man, visually as schizophrenic an emblem as the hermaphrodite. The liver for sure is on the right hand side. He was concerned to tell me that he had done his work. "I have only Miss Live-er to do now"—"The liver won't de.... DE ... it won't de," he couldn't find the word, "De contaminate" I suggested, not very sure in it. "No," he tried again, "they've got a right word for it. Won't de ... de ...," he couldn't get it.[70]

Seemingly searching for the word "detoxify" or "detoxicate," Olson is left without access to information. The man who had embodied information now seems effeminized and disembodied by his illness. The anthropomorphization is a total one—Olson guts are to America as America is to Olson's guts, both are sick and dying. The "pejorocracy" has done its worst: no detox is possible. Prometheus meets Pandora as all the information in the world is released, only to consume the consumers.

It is Olson's influential words to Ed Dorn—pronounced in telegraph-style Poundese—that may best convey his tragically ambivalent relation to information:

PRIMARY DOCUMENTS: And to hook on here is a lifetime of assiduity. Best thing to do is to dig one thing or place or man until you yourself know more about that than is possible to any other man. It doesn't matter whether it's Barbed Wire or Pemmican or Paterson or Iowa. Saturate it. Beat it.

And then U KNOW everything else very fast: one saturation job (it might take fourteen years). And you're in, forever.[71]

The trouble is that it might take much longer than fourteen years. And Dorn might not "KNOW everything else very fast."[72] And he might be out, not "in, forever." Olson's emphasis on primary documents—like that of modernists such as Pound, Williams, Zukofsky, Dos Passos, or Benjamin, to name merely a few—could not by itself produce and sustain a comprehensive body of knowledge. The "saturation job" has necessarily to be selective. Fragmented knowledge (or so the metaphor runs) remains, like the individual, severed from the collective. In 1946 Olson speaks of not having time to present to Pound in person his idea for a "book on the Human Body. A record in the perfectest language I can manage of the HEART, LIVER, BRAINS, KIDNEY, the organs, to

body them forth, to give a full sense of the instrument of the organism, approached on the simplest of premises: viz., the BODY is the first and simplest and most unthought of fact of a human life."[73] If the body was "the first and simplest . . . fact," it was also the first and simplest limitation. Olson never wrote "the book on the Human Body"; but in another sense, *The Maximus Poems* are that book. Nearly everything Olson wrote was suffused, or saturated, with a thirst for knowledge so great that it threatened to undermine the very collectivities—his family, Gloucester, Black Mountain—that meant so much to him. George Butterick describes the famous and troubling conclusion to *The Maximus Poems* as "a catalogue of losses."[74] The conclusion might also be read as a retraction—an apology for a masculinist reduction of the world to tangible goods: "my wife    my car    my color    and    myself."[75] At the end of Maximus's exhaustive account of four hundred years of local history, as well as millennia of mythographical history, it is a paltry list, not worthy even of more than one typographical line. The attempt to build the polis, to achieve a "heterogeneous" cosmopolitan Gloucester, has failed. "But it doesn't matter—all goes back to the ONE JOB," the saturation job.[76] Olson is at his most humanistic in valuing learning—colossal, eclectic, and mythical—above all else. We should continue to be wary of Olson's masculinism and his primitivism, but neither of these terms, as applied to Olson, should be understood in their conventional senses.

Carla Billitteri has recently proposed that we read Olson in the context of what she calls his "poetics of transnational utopia."[77] Olson knew that, on the face of things, Gloucester had little in common with the ancient Phoenician city of Tyre—linking the two was not a matter of gratuitous esotericism, but rather a sweeping attempt to find imaginative correspondences between two seemingly unrelated cultures at opposite ends of the Atlantic. As Eugene Vydrin describes it, "Proprioception offers a phenomenology of perception whose seat is the individual body, whose testing ground is language, and whose horizon is human movement across the Earth."[78] As a model for the acquisition of knowledge, proprioception insists on an immediacy of engagement between mind and body, body and polis, as well as body and planet. In stressing movement on a global scale, Olson foregrounds migration as the central driving force of historical change. *Maximus* is not an epic of place, but of space. As Jonathan Skinner has noted, Olson rejects the American narrative of the conquest of wilderness.[79] Stephen Fredman, drawing a

line of influence from Emerson and Thoreau, suggests that Olson's privileging of primary facts responds to a pervasive sense of "groundlessness": "Olson and Thoreau use the epistemological imperative that one find out the facts for oneself as a primary approach to the problem of groundlessness, an approach that can be adopted as spiritual discipline, as political program, and as poetics.... As a political program, it proposes that an individual who locates the true facts of his or her own condition can be of tremendous use to the community as a resistant factor, sustaining the value of the local and the actual against the state, the universal, and the eternal."[80] A primary fact, unlike received wisdom, can be rearranged and made into an obstacle to the smooth operation of an ideology. Though Olson's transhistorical speculations may strike contemporary readers as humanist or universalist in their claims, there is also a strong case to be made that Olson's continual linking of discrete "occasions" destabilizes universalist presuppositions. As he put it, his goal was to combat "The Big False Humanism / Now On."[81]

This inimitable run-on sentence from *The Bibliography on America* in many respects epitomizes Olson's relation to scholarly knowledge: "So far as 'scholarship' might, it will disclose the intimate connection between person-as-continuation-of-millennia-by-acts-of-imagination-as-arising-directly-from-fierce-penetration-of-all-past-persons, places, things, and actions-as-data (objects)—not by fiction to fiction: our own 'life' is too serious a concern for us to be parlayed forward by literary antecedence."[82] Olson's hyphenated list draws on a Jungian rhetoric at the same time that it refuses to align itself with any singular cultural tradition. "Literary antecedence," for Olson, speaks to a kind of nationalist partiality. Olson demands that we think on a larger scale—both spatially and temporally—in terms that could be considered analogous to those articulated by the "big history" movement.[83] His metaphors are pervasively masculinist (e.g., "fierce-penetration"), but his metaphors of inclusiveness also stubbornly refuse to sequester knowledge from an engagement with the immediacy of perception. Olson's star rises and falls on whether or not we as readers are willing to contemplate "all-past-persons, places, and actions-as-data." To consider all persons, places and actions as objects of *knowledge* is different from considering them as *data*. To consider people and things as data is to recognize our own role in a continuing process; we, too, are data "to be parlayed forward." In emphasizing the reciprocal nature of perceiver and perceived, Olson

echoes both Whitehead's *Process and Reality* and Wiener's notion of feedback loops. For Olson, data is not necessarily or even primarily quantitative, but rather elemental in the physical sense: the basic building material of poetic perception as well as of historical inquiry.

Recent scholarship on Olson has increasingly emphasized ecocritical, transatlantic, and anticapitalist dimensions of his writing.[84] The recurrent motif of "The-man-with-the-house-on-his-head," which runs through the later *Maximus* poems, suggests the difficulty of balancing *polis*, *oikos* (household), and individual *bios* (living being). Olson's most elaborate rendering (or arguably plagiarizing) of the "man-with-the-house-on-his-head" story, which he found in Charles Godfrey Leland's *Algonquin Legends*, begins with the single word "chockablock" in the left margin.[85] *Chock-a-block*, according the *OED*, is a nautical term "said of a tackle with the two blocks run close together so that they touch each other—the limit of hoisting; *transf.* jammed or crammed close together; also of a place or person, crammed *with*, chock-full *of*." Olson found the legend "chock-a-block" with detail, and he correspondingly abridged Leland's version. "Chock-a-block" can also refer to the overall form of *The Maximus Poems*. Keeping in mind the latter of half of the *OED* definition, Gloucester could be described as having a "chock-a-block" history, and Olson himself could be described as a "chock-a-block" person—both are burdened by the weight of a tangled history that nonetheless remains on the move.

Daniel Belgrad, in common with Friedlander, has argued that in order to appreciate Olson's poetry we must approach it as a complete body of work, as a total life project. Belgrad champions Olson's politics by way of the sum of activities: "In Olson's poetic act, the texts of his poems must . . . be seen as inseparable from the little magazines he supported, the school he ran, the lectures and readings he gave, and the correspondences he maintained. All these acts contributed to his effort to combat the hegemonic sway of corporate capitalist attitudes and of advertisements touting technological progress and white American ethnocentrism. His life's work was a rearguard action against their effort at closure, their monopolization of Americans' attention."[86] Olson's "chock-a-block" learning—his theory of Mayan glyphs, for instance—will often not stand up to the scrutiny of specialized scholarship. Robert von Hallberg is right to point out that "part of the price he paid for his influence was an abiding temptation to achieve literary success as a poet by indulging

in what he knew to be loose scholarship."[87] Olson's goal, however, was precisely not to be a specialized scholar. In Belgrad's terms, this would have made him a far less effective critic of postwar American society. As early as 1973 in the then-new (and Olson-inspired) journal *boundary 2*, Catherine Stimpson sought to counter the misconception that "Olson, at his most irritating, is like a computer overloaded with modern thought and ancient culture."[88] The sheer quantity of learned allusion in Olson's writing may lead us to the conclusion that such learning is idiosyncratic, perhaps even solipsistic. Though there may be some justice in the charge that Olson's self-sacrifice to learning was self-serving, ultimately it was Olson's aim, achieved in part through his lifelong intake of information, to get beyond the "myself" with which he ends his epic.

# 4

# "WHEN INFORMATION RUBS/AGAINST INFORMATION"

## POETRY AND INFORMATICS IN THE EXPANDED FIELD IN THE 1960S

TO WRITE POETRY TODAY IS TO ATTEMPT TO COMMUNICATE OVER A VERY NOISY CHANNEL . . . IN THEORY IT IS POSSIBLE TO COMMUNICATE EVEN OVER A CHANNEL OF NEARLY UNLIMITED NOISE WITH SUITABLE METHODS OF CODING    HOW IF THE NOISY CHANNEL IS ALSO IN OUR OWN HEAD.

—David Antin, *some/thing*

This chapter explores the interplay of poetry and informatics in the late 1960s and early 1970s writings of John Cage, Bern Porter, Hannah Weiner, and Bernadette Mayer. These poets take an *informatic turn* away from the New American and concrete poetry of the 1950s and early 1960s toward a poetry increasingly concerned with informatic motifs, found materials, and the exhaustive recording of everyday experience. Other writers and artists who characterize this informatic turn in the mid to late 1960s include Vito Acconci, David Antin, Carl Andre, Dan Graham, Andy Warhol, Adrian Piper, Lucy Lippard, and the Art & Language group. Writing of the turn toward an aesthetic of information in the art of the late 1960s, Eve Meltzer argues, "Considered together, the aesthetic of 'information' and 'information' in the technological sense of the word gave rise to the following notion: the world itself had become an information system. And with the exigencies of [the] contemporary political scene, the exhibition announced the desperate

realisation that if the world was an information system then its subjects must be information-subjects; like the pattern of digital data, all were irreversibly alienated from the signified."[1] Informatic themes and procedures in the 1960s have received considerable attention from art historians; my focus here is on less well-known poetic texts that are equally representative of these concerns. The poets I discuss here may find themselves "irreversibly alienated from the signified," but they also show themselves to be keenly interested in representing and mimicking the emergent patterns of a society increasingly dominated by information.

The third and final issue of the journal *Joglars* (1966), edited by Clark Coolidge, contains two significant discussions of the globalization of information and communications—one by John Cage, the other by Stan VanDerBeek. Cage's piece, the first section of "Diary: How to Improve the World (You Will Only Make Matters Worse)," would reappear in a significant location, the Spring 1967 issue of *Aspen* magazine, and would appear again in an even more significant setting, the Fall 1968 debut issue of *The Whole Earth Catalog*.[2] VanDerBeek had known Cage as a student at Black Mountain College in the 1950s, and collaborated with him on several projects during the 1960s.[3] VanDerBeek's contribution to *Joglars*, "'Culture: Intercom' and Expanded Cinema" (versions of which were to appear in a number of other contemporaneous journals), introduced the term "expanded cinema." The term would later be taken for the title of Gene Youngblood's influential 1970 book, and would take on another afterlife with the publication of Rosalind Krauss's much-cited "Sculpture in the Expanded Field" (subsequently adapted by Barrett Watten in his essay "Poetry in the Expanded Field"). As the means of print production and distribution are often thematized in this writing, it is important to note the technologies—such as the mimeograph, photocopier, and Selectric typewriter—which made much of this writing possible. *Joglars* is, in many respects, a characteristic journal of the mimeograph revolution.[4] Co-edited with Michael Palmer for its first two issues, *Joglars* was created on an IBM Selectric, then mimeographed (or photocopied) and side-stapled. In format as well as in content, *Joglars* has much in common with the better-known *o To 9*, edited by Bernadette Mayer and Vito Acconci, which began a year following the third issue of *Joglars*, and to which Coolidge was a frequent contributor.[5]

The influence of Marshall McLuhan can be widely felt in the writing under discussion here, although other important precursors include Jackson Mac Low and Fluxus. Cage often reiterated how central McLuhan

was to his later work, going so far as to suggest in 1967 that "not a moment passes without my being influenced by him and grateful to him."[6] McLuhan is quoted on the first page of Cage's *Joglars* contribution, while VanDerBeek's essay–manifesto is suffused with McLuhanisms. McLuhan was himself deeply interested in visual poetry, and his works had a special appeal to poets interested in what Dick Higgins (also in 1966) termed "intermedia." In 1967, Higgins's Something Else Press would publish McLuhan's *Verbi-Voco-Visual Explorations*. Something Else also published Cage (including the third installment of "Diary" in 1967) as well as publishing Bern Porter, and in 1966 producing the first reprint of Stein's *Making of Americans*.

McLuhan's *Verbi-Voco-Visual Explorations* raises the issue of information overload in relation to its effects on artists and on artistic media, and suggests an opposition between "The Artist and the Bureaucrat." But even as McLuhan writes, this distinction seems to break down— after the "electronic revolution" we are all, bureaucrats and poets, held captive by information, and in particular by television, advertising, and newspapers. According to McLuhan, "Toward the end of the last century . . . as all kinds of information flowed from many quarters of the world in greater volume and at greater speed, so similar varieties of knowledge about the inner and outer life of man and society began to co-exist even in semi-literate minds. Biological metaphors of change and existence are necessary means of processing and unifying large bodies of data."[7]

The artist–hero's struggle with the bureaucrat–conformist is a frequent theme in McLuhan's writings; in "The Artist and the Bureaucrat," McLuhan describes Sherlock Holmes as an artist and suggests that much of Holmes's appeal derives from his struggle with the bureaucracy of Scotland Yard. McLuhan seems to suggest that such artistic and intellectual resistance is still possible, and yet at the bottom of the page, set off from the main text in Futura, is the following factoid: "The Secretariat building of the U.N. is the largest filing cabinet in the world." "The big file," it would seem, has become increasingly irresistible, and artists and writers have little choice but to adapt. As in much of McLuhan's writing, information in abundance is both overwhelming and radically liberatory. The key point for McLuhan would seem to be whether artists and intellectuals can use the new information available to them to challenge "the ordinary mind devoid of simultaneous modes of awareness or observation."

VanDerBeek's "'Culture: Intercom' and Expanded Cinema: A Proposal and Manifesto" takes McLuhan's rhetoric to greater extremes. It begins as follows:

> It is imperative that we quickly find some way for the entire level of world human understanding to rise to a new human scale.
> This scale is the world . . .
> The risks are the life or death of this world.
> The technological explosion of this last half century, and the implied future are overwhelming . . .[8]

Despite its apocalyptic rhetoric, "Culture: Intercom" is, on the whole, a utopian expression of avant-garde film's potential to effect radical social change. In a manner strikingly reminiscent of the cosmopolitan ambitions of the 1920s avant-garde before the introduction of sound film, VanDerBeek argues that filmmakers must "invent a non-verbal international picture language." He proposes the creation of "movie-dromes" or "image libraries" as a means by which to "effect the maximum information use of the maximum information devices that we now have at our disposal." According to VanDerBeek, "Certain things might happen . . . if an individual is exposed to an overwhelming information experience." VanDerBeek is not specific about what these things may be, and his manifesto echoes the shock aesthetics of earlier avant-gardists such as Eisenstein and Brecht.

Where VanDerBeek differs from earlier film theorists is in his emphasis on the revolutionary effects of the instantaneous global transmission of information. His proposal sounds uncannily like a prefiguration of the Internet (ARPANET first went into operation in 1969; the term "Internet" was adopted in 1974):

> By satellite, each [movie-]drome could receive its images from a world wide library source, store them and program a feedback presentation to the local community that lived near the center, this newsreel feedback, could authentically review the total world image "reality" . . .
> "Intra-Communitronics," or dialogues with other centers would be likely, and instant reference material via transmission television and telephone could be called for and received at 186,000 m.p.s. . . . from anywhere in the world.

VanDerBeek's "movie-drome" draws on a range of technologies and media forms—some new, such as video and satellite communication, and others not so new, like the newsreel. VanDerBeek anticipates a centralized image library connected to a distributed network, although it should be noted that his proposal does not specifically mention computers as the central means by which such a network would be facilitated. He might have derived his notion of the movie-drome in part from the writings of J. C. R. Licklider, who had, as early as 1960, proposed a global network of "thinking centers" which would "incorporate the functions of present-day libraries together with anticipated advances in information storage and retrieval."[9]

VanDerBeek was uniquely well positioned in 1966 to survey the rapid evolution of new information technologies. From 1964 to 1967, he collaborated with Ken Knowlton of Bell Labs to produce some of the earliest computer animation films, a remarkable series of eight films titled *Poem Field* (Cage would provide the soundtrack for *Poem Field* no. 7), created on an IBM 7094 mainframe computer. Those films demonstrate well expanded cinema's ambitious attempt to fuse word and image on-screen. The *Poem Field* films also speak to the direct influence of Cage and of Olson's field poetics. As Marjorie Perloff has written in her *Radical Artifice: Writing Poetry in the Age of Media*, "The importance of Cage for postmodern poetics cannot be overestimated, for it was Cage who understood, at least as early as the fifties, that from now on poetry would have to position itself, not vis-à-vis the landscape or the city or this or that political event, but in relation to the media that, like it or not, occupy an increasingly large part of our verbal, visual, and acoustic space."[10] VanDerBeek's manifesto is redolent of the language of "the happening" (Cage staged the first "happening" at Black Mountain in 1952). For both Cage and VanDerBeek, by 1966 the "happening" had taken on global dimensions; the movie-drome does not speak to a particular place or audience so much as it aspires to address itself to an increasingly globalized (and potentially networked) community of viewers.

## How to Worsen the World (You Will Only Make Matters Better): John Cage and Information

JOAN RETALLACK: You talk very beautifully about "brushing" the source text.

JOHN CAGE: Yes. That term comes from Marshall McLuhan, you know, "brushing information against information." And that this is our only work now. Do you know that? Yes, work is obsolete. All we do is brush information against information.[11]

Nearly twenty-five years after writing the first installment of "Diary: How to Improve the World," Cage once again evoked the McLuhan quote from *The Medium Is the Massage*. His response speaks forcefully to the increasingly informational character of the global economy. The phrase "When information is brushed against information" first appeared in McLuhan's 1963 essay "The Agenbite of Outwit" in a strikingly prophetic passage: "Man in the electronic age has no possible environment except the globe and no possible occupation except information gathering. By simply moving information and brushing information against information, any medium whatever creates vast wealth. The richest corporation in the world—Atlantic Telephone and Telegraph—has only one function: moving information about."[12] Nearly the same phrase adorns the Quentin Fiore designed poster of "Diary" that appeared in the fourth issue of *Aspen*, except that "When information is brushed against information" is instead "When information rubs / against information." In *The Medium Is the Massage* the quote is juxtaposed with a close-up of a woman's legs clad in fishnet stockings. On the following page, the sentence continues: "The results are startling and effective. The perennial quest for involvement, fill-in, takes many forms."[13] Including, apparently, the form of involvement with women's bodies, since the turn-of-the-page accompanying image is of a model wearing a "LOVE" dress.

We might dismiss this sequence out of hand merely as crude 1960s objectification (which it is), were it not that McLuhan, as early as the 1951 *Mechanical Bride*, was critical of the ways in which advertising represented the female body. Writing of an ad for woman's nylons, he claims, "To the mind of the modern girl, legs, like busts, are power points which she has been taught to tailor, but as parts of the success kit rather than erotically or sensuously. She swings her legs from the hip with masculine drive and confidence. She knows that 'a long-legged gal can go places.' As such, her legs are not intimately associated with her unique self but are merely display objects like the grill work on a car. They are date-baited power levers for the management of the male

audience."[14] McLuhan's rhetoric is fraught and implicitly sexist, but he does raise several important considerations, which are articulated more fully in *Understanding Media* and *The Medium Is the Massage*. For McLuhan, the most exaggerated aspects of femininity are closely tied to reversing masculine power, and to controlling a flow of information: rather than information being immaterial or transcending culture, for McLuhan information is closely tied to advertising and to social roles. For the McLuhan of 1951, the objectification of the female body is analogous to the "grill work on a car." By 1967, the register is not the industrial excesses of automobile design, but rather the informatic patterns of the global media system. The stocking-clad legs of the woman are, we might say, overdetermined, signifying a range of social relations and symbolic exchanges between men and women.[15]

Cage's "Diary" is a uniquely hybrid work; its nearest formal analog might be Cage's lectures or mesostic poems, but it departs significantly from those models. For the most part "Diary" consists of quotations, but it also contains original writing. Although its title suggests that it is a chronological life record, it is constructed more like a constrained commonplace book than a conventional diary. Published in ten sections (spread across three books) between 1967 and 1982, the "Diary" would ultimately be recorded in its entirety by Cage shortly before his death. The "Diary" is, to my mind, a significant work deserving of greater critical attention. Here, I restrict myself to the opening section. Importantly, Cage drew attention to the mediated nature of the text from the beginning: the *Joglars* version is written in twelve different typefaces on a Selectric typewriter; the *Aspen* version adds color to those fonts. Composing the text on a Selectric must have been a laborious undertaking, since each change of font would have required swapping out the famous golf-ball-shaped type head. Cage claimed in the headnote to the *Year from Monday* version that the choice of typeface as well as margins was determined by chance operations. Each line was to have fewer than forty-three characters (coincidentally or not, the Selectric type ball featured forty-four characters).

The "Diary" is a utopian text, immediately proposing "getting rid of ownership" and the "disappearance of power politics" in its opening lines. It is also a work centrally concerned with the acquisition and dissemination of information. A number of Cage's lectures feature him in pursuit of autodidactic knowledge. This quest for knowledge often takes

the form of telephone calls to libraries, as in "Lecture on the Weather" or, on a smaller scale, in the "Mushroom Haiku." On its first page, the "Diary" incorporates one such motif of information gathering. Cage describes a transformative experience in 1964 (which elsewhere he suggests led him to begin the diary)[16] that impressed on him the need to think globally:

> April '64: U.S.
> State Department man gave Honolulu
> talk—"global village whether we
> like it or not"—cited fifty-five
> services which are global in extent.[17]

A year and a half later, Cage attempts to track down the fifty-five services, only to find:

> When I
> Said, "Fifty-five global services,"
> California Bell Telephone man replied
> (September '65), "It's now sixty-one."[18]

Cage has in effect witnessed the rapid growth of electronic bureaucracy. No one seems to know what the specific nature of the "global services" are, and yet everyone seems confident that they exist. Cage continues the motif, and implies that an unspecified interlocutor is giving him advice about how to find the information he is seeking:

> "Write to Center for the Study
> of Democratic Institutions: they'll
> know about the global services."
> did. They answered they knew nothing,
> suggested writing to State Department.
> Books one formerly needed were hard to
> locate. Now they're all out in
> paperback. Society's changing.
> Relevant information's hard to come
> by. Soon it'll be everywhere, unnoticed.[19]

In effect, Cage is tracking an epochal shift from information scarcity to information abundance. Cage draws heavily on the paradoxical rhetoric of McLuhan and Fuller—but by means of the constrained nature of "Diary," he also manages to maintain something of a deadpan distancing from their more direct pronouncements. Cage seems to suggest that despite the unprecedented impact of new communications technologies, not much has changed in terms of our ability to access "relevant information." To a self-identified anarchist such as Cage, the uncontrolled growth of mysterious governmental institutions ought to be implicitly anathema. Ever the optimist, however, Cage was to remark in the same late interview from which my epigraph is taken, "Life is abundant. People are polyattentive."[20] Cage was too sophisticated to attribute his artistic practices exclusively to changing media and communications systems. His music, art, and writing could well be described as polymediatic. As the subtitle to Brandon Joseph's *Beyond the Dream Syndicate: Tony Conrad and the Arts After Cage* indicates, Cage exerted an extraordinary influence over later artists and writers working across multiple media. Thanks in part to Cage, as the sixties progressed information practices and motifs would play an increasingly prominent role in poetic (and visual poetic) writing. In *Silence*, Cage writes:

If we set out to catalogue things

.

.

.

today, we find ourselves rather

.

.

.

endlessly involved in cross-

.

.

.

referencing.[21]

Information rubbing against information, to push the metaphor further, could be construed as analogous to cultural cross-referencing. And information rubbing against itself could now serve as a metaphor not

only for advertising and telecommunication, but also for artistic and poetic creation.

## "'Info' Man, Are You There?": Bern Porter's Founds and the Culture of Information

Bern Porter is the only postwar American poet to have merited a retrospective at the Museum of Modern Art. An eccentric who could perhaps be classified as an "outsider" artist, Porter is best known for his "founds," or found visual poems. He was a physicist by training, but he was also an artist, writer, publisher, and polymath. He worked on the Manhattan Project and on the Saturn V rocket. He met and worked with Albert Einstein, J. Robert Oppenheimer, and Wernher von Braun. He never owned a car or a television. Though he lived without many modern conveniences, he also polemicized starkly, "Obsolescence revolts me."[22] Porter was deeply conflicted about the effects of technology, but he was also committed to using applied science to expand the realms of art and poetry. According to his biographer James Schevill, Porter was centrally "concerned with revealing how science and technology can combine with art and poetry to show us a world so loaded with new information that it is almost impossible to catalog it completely."[23] The books of found poems that Porter created in the 1960s took as their material all manner of textual and visual material—from advertisements to computer printouts from the Saturn V rocket project. So eclectic are Porter's materials that it is difficult to trace the origins of many of his appropriations. The founds, which are deeply skeptical of American consumerism and mass culture, also parody an increasingly informatic, bureaucratized society.

Porter echoes William Blake in his call for a liberation of the senses by means of visual poetry. Porter considered radio, tape recording, and film all to hold considerable potential for poetic innovation. In 1959, he called for a "scipoe" in which

> Physics projects poetry beyond the typographical entrapment
> traditionally circumscribing it as a visually read experience.
> Physics provides a method, principle, terminology, spirit and advance to
> be incorporated into poetics for enrichment and extension.
> Enhancement is further possible with electronic recording in the pure
> word state by microphone, tape, record and loudspeaker for
> transmission by ear.[24]

By 1975, Porter was describing this co-relation between energy and language in terms of "data bits," and continuing to insist on the possibility of overcoming the limitations of the five senses: "The pulsating, expanding, contracting vibrant energy plasma which I call intelligence, sends, receives, assimilates, manages and controls energy data bits within the confines of a present five-sense system."[25] Porter's books of found poems tend to be sparing in their manner of collaging together materials. By contrast to the tradition of Dada photomontage or even of early pop art collage (such as the work of Richard Hamilton), Porter tended to use only one, or at most several, sources per page. Porter composed his founds on the scale of the book as well as on the scale of the page (or page spread), and each book typically constrains itself to a sequence of texts and images on a given theme. Porter's 468B: Thy Future (Figure 10) is the most austerely informatic of Porter's books; the entirety of it consists of appropriated computer code. It is almost impossible to read in a conventional manner; 468B: Thy Future contains no deliberately constructed sentences in human language. The human future, it would seem, is opaquely numbered and coded—468B is a transmission from inside the military–industrial–space complex that seemingly has no addressee.

```
 23  -    TUBE ASSY          1 R N D                        65B80191-1   22140104     0078  C
401 Z    *DESCR. UNAVAILABLE* 1 R N F   1234567890          1A57885-1    22340104     0098  U
403 Z    *DESCR. UNAVAILABLE* 1 R N F   1234567890          11M00001-1   22440101     007B  C
405 Z    *DESCR. UNAVAILABLE* 1 R N D                       1A57883-1    22340103     0098  U
407 Z    *DESCR. UNAVAILABLE* 1 R N D                       G7820042     22240102     0088  P
     -    BRKT ASSY          1 R N D                        G7820041     22240101     0088  P
     -    BASE               1 R N D                        G7820064     22240108     0098  [
     -    BASE               1 R N D                        G7820065     22240109     0098  [
     -    GUSSET             1 R N D
     -    SUPPORT HALF       1 R N D
 1   -    SUPPORT HALF       1 R N D
 3   -    SUPPORT HALF       1 R N D
     -    BRKT ASSY          1 R N F   1234567890
     -    BASE               1 R N F   1234567890
     -    BASE               1 R N F   1234567890
     -    GUSSET             1 R N F   1234567890
     -    GUSSET             1 R N F   1234567890
     -    SUPPORT HALF       1 R N F   1234567890
 1   -    SUPPORT HALF       1 R N F   1234567890
 3   -    SUPPORT HALF       1 R N F   1234567890
 5   -    RADIUS FILLER      1 R N F   1234567890
     -    INSERT             1 R N F   1234567890
     -    INSERT (CONTINUED) 1 R N F   1234567890
```

Figure 10. Bern Porter, from 468B: Thy Future.

*The Wastemaker, 1926–1961*, Porter's first major book of founds, presents a fascinating cross-section of recycled texts and images, many of them presumably found in the trash at his local post office. As its title suggests, *The Wastemaker* recycles the detritus of consumer news and information. Like the print advertising that had come of age by the 1920s, *The Wastemaker* is detached from any sense of individuated, localizable meaning. Lists, formulae, and charts appear seemingly at random. Figure 11 shows a characteristic juxtaposition; on the left page, what seems to be a portion of an ad asks the question "'Info' Man, Are You There?" On the right hand page is a Greek inscription taken from H. Rider Haggard's popular novel *She*. "'Info' Man" would seem to harbor a litany of physical disorders associated with information anxiety: from the expected (headache and eyestrain) to the not so expected (hemorrhoids). "'Info' Man" gives no answer to the question posed to him; presumably he is too busy dealing with the maladies induced in him by information overload. Porter's later *Book of Dos* (1982) also contains a suggestive found advertisement (Figure 12). Like many of Porter's appropriations, the ad takes the form of an imperative statement: we are ordered to "Beat the Data Explosion," but in the absence of specifics, the free-floating ad can

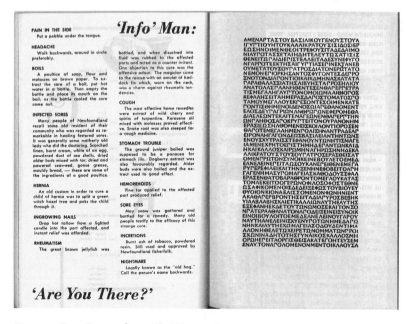

*Figure 11. Bern Porter, from* The Wastemaker.

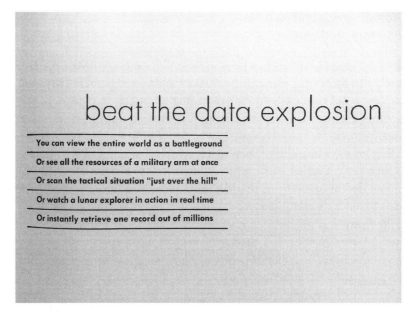

*Figure 12.* Bern Porter, from *The Book of Dos.*

seemingly only contribute to the data glut. The ad seems to suggest that whatever product or service it aims to sell can help us overcome a tendency to "view the world as a battleground." At the same time, the ad seems to traffic in a corporate survival-of-the-fittest rhetoric: we must master information or information will master us.

Porter's books—and in particular works such as *468B: Thy Future* and *The Manhattan Telephone Book*—often explore themes of remediation, to the extent that the books themselves function as long meditations on the disconnection of words and images from everyday experience. Each of Porter's found books in effect presents a cross-section of the commercial graphic design of a specific era. The founds reconstitute a world of lost ephemera to the extent that his biographer claims, "In the end, Porter himself becomes a Found."[26] In common with Hannah Weiner, Porter often imagines himself not as a source of poetic writing, but rather as a perceiving body within (and sometimes upon) which writing is received and processed (or left as unprocessed data). Porter's found books are scrapbooks of their time, but they are also explorations of a world in which there are too many messages for us to be able to identify the senders and the recipients of those messages.

## Resisting Technicized Memory: Bernadette Mayer from
*Memory* to *Studying Hunger*

Before being published in a book version, Bernadette Mayer's *Memory* took the form of a multimedia installation of 1,200 color snapshots accompanied by a 7.5-hour tape recording of roughly 200 pages of text written during the month of July, 1971. In moving from *Memory* to her next project, *Studying Hunger*, Mayer describes a shift in her writing: "You see, the whole thing [*Studying Hunger*] had already had a beginning with a project called MEMORY which turned into a show which turned into a dream or returned to a dream that enabled me to walk. Before this I couldnt walk, I had street fantasies like any normal prostitute."[27] Like Andy Warhol's 1968 *a, A Novel* or Kenneth Goldsmith's 1995 *Soliloquy*, Mayer's *Memory* is a "project of attention," a constrained record of a span of time. And like those projects, *Memory* suggests a voyeuristic engagement with intimate details of daily life. In describing *Memory* as a "project of attention," I am drawing on the work of Michael Sheringham and Andrew Epstein. Projects of attention typically involve the recording of everyday experience over specific periods of time. Sheringham describes a project as a "commitment to midterm actions—implies a preoccupation with the domain of practice."[28] Georges Perec's "Attempt to Exhaust a Place in Paris," which took place over three days, is an exemplary "project of attention." Sheringham also cites the examples of Henri Lefebvre, Raymond Queneau, and the Situationists. Epstein applies the term to Ron Silliman's *BART*, in which Silliman describes the experience of 5.5 hours spent traveling to every station on the Bay Area Rapid Transit system. A number of works by authors under discussion in this book could be described as projects of attention: Cage's *Diary*, Goldsmith's *Soliloquy*, Lin's ambient and index poetics. Mayer's *Memory*, by the standards of projects of attention, is extremely involved and seemingly unconstrained. *Memory* and *Studying Hunger* could also be described as "projects of distraction"; by way of a proliferation of fragmentary memory they point to the variability of attention and to the irreducible richness of sensory experience.

Both *Memory* and *Studying Hunger* are sprawling works that contain multiple references to coding and to data accumulation. Whereas *Memory* was in effect a multimedia project that depended on audio recording and photography, *Studying Hunger* confines itself to text. Mayer's description of her practice deserves to be quoted at length:

I had an idea before this that if a human, a writer, could come up with a workable code, or shorthand, for the transcription of every event, every motion, every transition of his or her own mind, & could perform this process of translation on himself, using the code, for a 24-hour period, he or we or someone could come up with a great piece of language/information.

Anyway
When I began to attempt the month-long experiment with states of consciousness, I wrote down a list of intentions. It went like this: First, to record special states of consciousness. Special: change, sudden change, high, low, food, levels of attention.[29]

The title *Studying Hunger* refers not so much to the bohemian artist's starved existence as it does to Mayer's attempt to record as many of the ambient details (and desires) of everyday life as possible—without, I would suggest, allowing those details, alone or in the aggregate, to define her. The motif of hunger becomes a kind of catchall metaphor for desire and for the memory of desire. Ostensibly, *Studying Hunger* is a life record provided by Mayer to her psychoanalyst. It is, however, a record so exhaustively detailed that it is difficult to see how it could be of much therapeutic value to the analyst.

From its opening, *Studying Hunger* announces its intention "to do the opposite of 'accumulate data,' oppose MEMORIES, DIARIES, find structures."[30] Rather, Mayer seeks

a language . . . that stays on the observation/notes/leaps side of language border which seems to separate, just barely, observation & analysis. But if the language must resort to analysis to "keep going," then let it be closer to that than to "accumulate data." Keep going is a pose; accumulate data is a pose.
Also, to use this to find a structure for MEMORY & you, you will find out what memory is, you already know, what moving is
And, to do this without remembering[31]

Mayer's challenge is not unlike the one described by Stein in "Composition as Explanation" and "What Are Masterpieces": how to reconfigure memory so as to be able to think "without remembering"—that is, to reveal underlying structures of memory so as to resist static patterns of recollection. To do the opposite of accumulating data, it is paradoxically

necessary for Mayer to obsessively record states of consciousness—not to seek "a great piece of language," but rather to find new ways of absorbing, encoding, and perhaps even erasing recorded data.

If both *Memory* and *Studying Hunger* are confessional in nature, they do not seem to be primarily about guilt, but rather a cathartic engagement with "language/information." Mayer's prose is alternately laconic and opinionated, and her punctuation is deliberately haphazard. In passing, she discusses with an unspecified interlocutor the pressures of the mass media:

> How much information is contained in it for individual message nut-quality needs, if you now know what I mean. Incorporation of the lost object—ingestion as introjection, or, an injection of milk as sense of humor. And then as the ego rejoins the id in sound sleep. In the previous (above) story, try to distinguish signal from noise. Thank you very much. Is this elation-writing? Is this a woman writing? Is this person a woman? Is this woman elated? Is this a woman's elation? The hunger situation is the deepest point of fixation in the depressions, a model for the later, and famous: "threatened loss of love."[32]

Mayer's digressive headlong style parodies a reductive Freudianism. The floating sentence "Thank you very much" would seem to pay homage to Stein. Each "introjection" in the paragraph could be analogous to a lost object that cannot be reclaimed. The series of questions Mayer poses about elation and women's writing would seem to be unanswerable: the writer's psychic states cannot be reduced to any single message. Linda Russo writes that "*Memory* retrieves history-making *for* the collective *from* the individual."[33] By obsessively recording the omnipresent mundaneness of desire, *Memory* and *Studying Hunger* prevent us from becoming fixated on Mayer herself—in effect, the accumulation of data continually redirects the reader away from depth psychology. While she was at work on *Studying Hunger*, Mayer was also at work on her extensive collaboration with Clark Coolidge, *The Cave* (1972–78). Coolidge has said of this period, "We were all interested in writing a thousand pages a day";[34] "We wanted endless works, that would zoom on & on and include everything ultimately, we'd talk about the 'Everything work' which would use every possible bit flashing through our minds."[35] Much

of what Mayer and Coolidge wrote (together and separately) during the early 1970s went unpublished or did not appear in book form. Both writers were prolific, but they also edited carefully and published selectively. The original *Studying Hunger* (1975) was only seventy pages long; the complete *Studying Hunger Journals* cover more than 450 pages. Comparing the two versions reveals that Mayer rewrote the raw journal material extensively.

Both versions of *Studying Hunger* are more anti-confessional than confessional; both overwhelm with detail and with indeterminate states of consciousness. It can be difficult to tell whether the author is awake or dreaming, and everyday banalities can quickly slide into surreal exaggeration. *Studying Hunger* echoes Gene Youngblood's 1970 declaration in *Expanded Cinema* that "the accumulation of facts is no longer of top priority to humanity."[36] Mayer's 1977 book *Eruditio Ex Memoria* would continue to pursue questions of lived, personal memory and its relation to recorded, stored memory.[37] Essentially a compendium of factoids remembered from throughout her education, *Eruditio* offers a skeptical take on rote memory. "I know all this information is wrong because it was taught to me by Catholics," she observes.[38] Like its predecessors *Memory* and *Studying Hunger*, *Eruditio* thematizes the difficulty of giving significance to the author's abundant memories. Speaking to an imagined reader, Mayer writes, "I expect something and I think you know exactly where I am and what I'm doing and it might not be so. I have a memory and a backlog of knowledge and information that is not necessarily complete for you."[39] Both poet and reader are lost in the backlog— it is difficult for Mayer to know what her reader does and does not know about her. In a particularly Steinian sentence from *Memory*, she writes, "There are no secrets here, there's a part of my memory's a picture show & then I think what do I do next: next to memory running with memory motion information & design design a motion design forward motion design style let me save you the trouble, let me repeat: I could design style conceals, let me add simply add & you accumulate cause you come close like the dreams & pictures all over the walls & floor."[40] Here again would seem to be the tension between "keep going is a pose" and "accumulating data is a pose." Since everything is a pose, however, there is also nothing that needs to be concealed. Accumulation becomes a kind of antistyle that refuses to keep secrets. As in Poe's "Purloined Letter,"

the safest place to conceal something may be in plain view, especially if the view is crowded. In one of *Studying Hunger*'s more paranoid moments, Mayer muses as to whether "the police, with special photographic techniques, would decipher something from this writing if I commit a homicide."[41] What would save her from detection, she concludes, would be the sheer quantity of information she has left behind: "But how would they know that it was this page, out of all the hundreds of pages of writing, this page that was to be studied at the lab."[42] By making public so great a quantity of memories, Mayer refuses to privilege one kind of memory (personal/expressive) over another (public/restrained).

Externalized or technicized memory, particularly in the context of poetry, has been a concern within Western philosophy at least since Plato's *Ion* and *Phaedrus*. This concern seems to have gained new relevance in the 1960s with the rise of McLuhan and the publication of works such as Jacques Derrida's 1966 *Of Grammatology*. Mayer's memory projects do not directly theorize their relation to new technologies of recording—but it can hardly be a coincidence that Mayer rebels against "accumulating data" at a time, the late 1960s and early 1970s, when portable technologies (such as those used in the *Memory* exhibition) made it possible to record one's own life in ever more exhausting detail. The most famous instance of involuntary memory in twentieth-century literature is the petit madeleine episode in *Swann's Way*; the sheer volume of Mayer's memories makes it impossible to place so much significance in any single object or phenomenon. Nor does Mayer place much confidence in the totality of personal memory. Like Joe Brainard's nearly contemporaneous *I Remember* (the first installment of which was published by Angel Hair in 1970), Mayer's memory projects refuse strict chronology, just as they refuse to assign hierarchical importance to individual memories. Both writer and reader cannot help but be overwhelmed by detail. Paradoxically, the abundance of recollection returns us not to the past, but rather to the continuous present.

## Words I See: Clairvoyance and Informatics in the Poetry of Hannah Weiner

Hannah Weiner's remarkable "Trans-Space Communication" immediately follows a series of visual poems by Bern Porter in the July 1969 sixth issue of *o To 9*. In her most important poetic statement before she

began to write clairvoyantly, Weiner describes her interest in "exploring methods of communication that will be understood face to face, or at any distance, regardless of country or planet or origin."[43] Alluding to her recent code poem performances, she recounts that her "explorations have dealt with the use of minimal clues: how much information can be received, and how accurately, through how little means."[44] Weiner then goes on to directly situate her writing in the context of information overload:

> The amount of information available has more than doubled since World War II. In the next ten years it will double again. How do we deal with it?
>
> 1. Do we use more than the 5% of the brain we now use?
> 2. Do we process quicker?
> 3. Do we decode information more and put it in another form (not language) so that the present brain can handle it?
> 4. Is there a change in the neural circuits of the brain?[45]

Weiner's subsequent writing, in effect, attempted to answer all four of these questions in the affirmative. By its incorporation of multiple voices, her clairvoyant writing is able to reveal, as well as to overcome, the limitations of the single brain working in isolation.

Weiner's clairvoyant practice is too complex for me to detail adequately here, but I would align myself with Judith Goldman, Patrick Durgin, and Joyelle McSweeney in suggesting that we not conflate Weiner's clairvoyance "with either illness or a supernatural gift of fortune-telling."[46] As Linda Russo writes, "Weiner's clairvoyant writing reveals the female subject to be a surface available for the projection of (often conflicting) aural and visual texts."[47] Like Porter, Weiner routinely recorded imperative commands; those commands point to a collective group mind, which is both empathetic and troubling, as much as they are targeted to individuals and/or to Weiner herself. "Living with these words is like living under orders," she writes in the preface to *Clairvoyant Journal*.[48] Those orders come at rapid-fire speed. One of the most striking aspects of the audio recordings of *Clairvoyant Journal* is the fast pace at which Weiner and her fellow performers read.[49] "The four years of this manuscript," she continues, "document my experience and changes in perception. I continue writing as a collaborator with WORDS I SEE. Sometimes I struggle as I don't ENJOY all their interruptions."[50] Weiner's syntax here

even suggests that "WORDS I SEE" is a kind of person—as with so much in Weiner's clairvoyant writing, it raises fascinating questions with regard to private and public voices, and the nature of poetic inspiration.

Mayer and Wiener were close friends and mutual influences during this period, and the first page of *Clairvoyant Journal* (Figure 13) invokes Mayer's example. Wiener describes Mayer as an important precursor in "doing pre thought thinking." The disjointed syntax of Weiner's text shows her exchanging thoughts and voices with her clairvoyant interlocutors (one of whom is represented by capital letters, the other by italics): "Bernadette's MAYER EXPERIMENTS this book is mind controlled the WALK Bernadette language *ex communicate her words so through* it goes through The way I QUOTE to destroy a word is to change its *litters*."[51] Weiner's interlocutor could here even be referring to the walk of the prostitute described in *Studying Hunger*. Presumably the "mind controlled" book Weiner refers to is her *Clairvoyant Journal*, but this could also refer to Mayer's books (it is the second voice that specifies "MAYER EXPERIMENTS," not Weiner herself). Fascinatingly, it is not Wiener alone who makes the statement "The way I QUOTE to destroy a word." Rather, "I QUOTE" is a clairvoyant statement, a quotation that may have been received visually, aurally, or even telepathically. The very ambiguity of the reception/transmission of the statement would seem to remove it from the category of verifiable knowledge. In effect, to take Weiner "at her word" is to acknowledge the profoundly social nature of language, which can of course take many forms other than direct utterance. By "ex communicating" language, Weiner seems to suggest, Mayer makes visible underlying structures of memory and feeling that cannot otherwise be expressed.

Weiner frequently thematizes her own inability to record accurately and completely the clairvoyant messages she sees and hears. She both welcomes and resents "when all these interruptions keep arriving."[52] Her use of informatic motifs would culminate in her *The Zero One* (1985), whose title surely must refer to the binary basis of computer languages. Largely composed of anecdotes regarding the case of Leonard Peltier and the struggles of the American Indian Movement, *The Zero One* is an entropic text that progressively dissolves into seemingly random numbers. The anecdotes or fragments that Weiner records are continually interrupted by number sequences, as in the poem's opening: "There are other ways to write 01234 . . ."[53] As the poem goes on, it increasingly

GO FOR A SAMADHI
*feel different*

1st CHAKRA                      BEGIN
                                BEGIN WITH ME

*Hooray*  GET OUT is a JOE musical not an order  COME SOON  NO  I PASS
NO  pass the *paper* wine  YOU HAVE ORDERS *fix the page* WRONG BAR
*Too late u met* Michael at the Tin Palace  PARTY free pass OMIT to La Mama
*good night Bernadette*  BEGIN  Going backwards:  QUARTER TO TEN:
see GO OUT  WHERE  YOU TRY SOBOSSEKS FIRST.  *agent London*
ACTION.  *dont hesitate* MISS TIN PALACE SEE MICHAEL  GO WORDS
He knows an agent WOW*get linoleum* TALK TO MARJORIE see Joe, hello to
Bob *conscious person* at NO
NOW  SINGLE  DONUTS eat the glazing NO  DOUBLEDAY POPULAR
SO ELSE  WOW*ie* DRUNK  *leave more space*  dont underline *that's an*
order  SO WHAT

          *serious now*  *dont hesitate*  tonight followed *all wrong go to bed*
no periods  orders  go to bed  glad get out is *New* York  *dont repeat*  3 *months*
*dont sit down*  *dont perspire*  *dont do it*  *leave*  *get it*  get it at door no*ney*
*mother's word*  *be careful drunk also* HERE  where?  *bed alright*  *dont per-*
*spire*  *hear shout* NO *dont explain* GO TOMORROW  *Explain the interference*
it stops you from *bed doing* what the other words tell you *omit*  DONT GO
BE A FOOL  It's 7  1ST CHAKRA  see clock DONT EXPLAIN THE CHAK-
RAS NOW RHYS KNOWS FOUR GO TO BERNADETTE'S  it's 7  WOW
BEGIN  Going to Phil Glass concert  POPULAR WIFE  GO TOMORROW
Tomorrow is Joe's musical and a party  DONT GO BOTH  This is silly
2 MOS  *dont comment yourself*  SO  HUMBLE ENOUGH  Rosemary is
back in town *No more periods* , Read THINK Einstein's definition of thinking  *Bernadette* doing
pre thought thinking  SO AM I says the refrigerator in the pink bulb GET OUT
Change the bulb  Bernadette's MAYER EXPERIMENTS this book is mind con-
trolled the WALK *Bernadette* language *ex communicate her words*  so through it
goes through  The way I QUOTE to destroy a word is to change its *litters too*
*heavy*  Systematically derange the SIS  I MUST DO IT  *cut it short* SLOW
I QUOTE Pick any word at random let mind play around until ideas pass try this *through*
*with so* SO WITH  RHYS it's CHARMING'S word  *He behave*
*yourself* SAW ME  YOUR NOVEL CUT IT SHORT PLEASE PASS THE PAGE

*Figure 13.* Hannah Wiener, from *Clairvoyant Journal*, 2/28. By permission of
Charles Bernstein in trust for Hannah Weiner.

```
Objec  or0I2  subje  I0I23  am0I2  entir  irres
A0I23  moder  army0  suppl  by0I2  theOI  Unite
State  andOI  Israe  blaze  a0I23  trail  of0I2
DidOI  you0I  do0I2  a0I23  lotOI  in0I2  your0
Myrtl  Poor0  BearO  signe  a0I23  third  affid
Stres  theOI  reali  of0I2  theOI  word0  0I234
Gunme  repor  dress  in0I2  Guate  Army0  unifo
What0  you0I  seeOI  is0I2  what0  you0I  getOI
I9760  Leona  Pelti  wasOI  arres  in0I2  Canad
ThatO  I0I23  am0I2  runni  outOI  of0I2  sente
Trail  of0I2  scorc  earth  massa  andOI  decim
You0I  could  have0  taken  two0I  aspir  0I234
WeOI2  share  theOI  spiri  of0I2  theOI  creat
Poetr  funct  is0I2  to0I2  rekin  langu  to0I2
Parti  of0I2  theOI  leftO  wasOI  rende  impos
I0I23  have0  a0I23  frien  named  JoeOI  I0I23
TheOI  cry0I  of0I2  priso  activ  priso  refor
Offic  verse  cultu  is0I2  more0  a0I23  celeb
Inten  death  squad  attac  andOI  kidna  of0I2
YouOI  canOI  quote  me0I2  I0I23  dontO  wantO
Trans  to0I2  anoth  priso  where  weOI2  canOI
TheOI  twent  or0I2  asOI2  later  from0  colla
Bodie  wereO  aband  on0I2  July0  60I23  on0I2
ThenO  I0I23  would  justO  write  a0I23  norma
InOI2  your0  lette  beOI2  sure0  you0I  menti
Break  itOI2  langu  awayO  from0  itsOI  enfor
TheOI  massO  based  labor  andOI  peasa  organ
So0I2  weOI2  wentO  to0I2  theOI  cafe0  in0I2
Hospi  facil  consi  of0I2  a0I23  bareO  steel
THEOI  enlar  sente  howev  allow  asOI2  a0I23
Mexic  soldi  total  destr  allOI  food0  suppl
HeOI2  wasOI  watch  TV0I2  he0I2  gotOI  a0I23
Stand  DeerO  Recha  andOI  mysel  haveO  beenO
Beate  witho  provo  Stand  DeerO  is0I2  620I2
OneOI  or0I2  moreO  THEsO  have0  beenO  usedO
Force  under  while  lastO  month  theOI  entir
```

155
```

*Figure 14.* From Hannah Wiener, *Written In/The Zero One*. By permission of Charles Bernstein in trust for Hannah Weiner.

3/10

How can I describe anything when all these interruptions keep *arriving* and then
tell me I dont describe it well   WELL *forgive them* big ME   COUNTDOWN
got that for days and yesterday it didn't stop GO TO COUNTDOWN  GO TO
COUNTDOWN  CALL DAVIDs  get COUNTDOWN finally GO TO COUNT-
DOWN at the door so OK I go see these maroon velvet pants I'm not BUY $40
pants BLOOMINGDALES all over again I leave GO TO COUNTDOWN: refuge,
get in a taxi, start for home, no peace, get out GO TO COUNTDOWN ok it's only
money go back and buy the pants it's better than seeing GO TO COUNTDOWN
for the rest of my life *peace* so they fit well   UNTIL   MICHAEL COOPER
For a while I tried to get away with *negative*  COUNTING   by counting down
10, 9, 8, 7   while breathing GO TO  MAKE CLEARer   FAR OUT
B   at the door RHYS  RHYS IMPORTANT  (notes)  HAVE A DOUBLE
L      image of pink embroidered pillow case appears on blanket, get it out
I
S     GO NOW *girlfriend* *negative* MOTHER made it when I was 2
S     JANA      she's fasting TRY HARDER across her chest and
F
U                DRESS WARM across Charlemagne's groin   Joan's
L                head says LAUGHS as she   QUINK THICK   SAY IT
      Rhys *rhythm*   VERY IMPORTANT says radio   LY
      DESCRIBE *go ahead* in Charlemagne's white pants WOOL white hat
      IMITATED Hawai JOAN   ARAKAWA  (more notes going back 3 days)
YOU WONT OBEY   PORK CHOP  BUY THEM pig in pork chop color along
the edge of                               NOT APPLE PIE in pink and white sash
*frying*   ORGASM *deaf* *don't go to a museum*

                                          CANT GET THE SPACING
          JUNK                            it's a nice arc
   get       grapefruit
              IT W R I T E S
                        I
                        T
                        S
Try praying: Our father who art *be right over*   E
A song: Here we go round the mulberry bush the      L  F
*grapefruit John* the mulbery *mush* GIVE UP
GRAPEFRUIT IS THE NAME OF Yoko Ono's book, APOLOGIZE is on a Ringo
Star2 record 2 r's  Call Jerry MISS ROTHENBERG MISS DAVID ANTIN
SNOWING IN VERMONT *delightful*  JOHN  Dream about Jason Epstein very huge
loud SHUT UP in hs office, *I rejoice* laugh  DESCRIBE CHARLEMAGNE
*how old 33 spiritual discipline*
      *not in dollars  not too negative*
                  *no money*       MONEY

*Figure 15.* Hannah Wiener, from *Clairvoyant Journal*, 3/10. By permission of
Charles Bernstein in trust for Hannah Weiner.

resembles a garbled transmission, until at the poem's end (Figure 14), the text has become as much as half made up of numbers, and the poem has become divided into seven columns of five characters each. Seemingly direct political and metapoetic statements are interrupted and overwritten, creating fascinating juxtapositions: "Poetr funct iso12 too12 rekin langu too12 . . ." or "Offic verse cultu iso12 moreo / Inten death squad attac ando1 kidna ofo12 / Youo1 cano1 quote meo12 . . ."[54] Although Weiner, or perhaps an interlocutor, gives us permission to quote her here, the very construction of *The Zero One* makes it almost impossible to quote in discrete units. Like the writings of Cage, Porter, and Mayer from this period, Weiner's poetry cultivates an overdetermined aesthetic. The March 10 entry of the journal (Figure 15), for instance, features "COUNTDOWN" as a repeated word. Although the writing purports to write itself, this happens only with great difficulty, as evidenced by the diagonal positioning of the text "IT WRITES ITSELF," juxtaposed with "CAN'T GET THE SPACING / it's a nice arc."[55]

In *Clairvoyant Journal*, voices take on a mediated and overlapping interdependence. The most famous deleted words of modernist poetry are Eliot's "HE DO THE POLICE IN DIFFERENT VOICES" from the typescript of *The Waste Land*, crossed out by Pound and returned through the mail. Weiner's voice is continually interrupted by different voices, but just as often she interrupts the voices she hears, ignoring the demand that she "SHUT UP." Weiner's writing is both polyphonic and abrasively dissonant. Weiner—again in common with Cage, Porter, and Mayer—describes the experience of being inundated with information in all its forms. This is a source of great concern—it is also a source of an ambitious poetics that attempts to envision new forms of communication and information sharing.

# 5

# PARADISE AND INFORMATICS

## LYN HEJINIAN, BRUCE ANDREWS, AND THE POSTHUMAN ADAMIC

Form does not necessarily achieve closure, nor does raw materiality provide openness. Indeed, the conjunction of form with radical openness may be what can offer a version of the "paradise" for which writing often yearns—a flowering focus on a distant infinity.

> —Lyn Hejinian, "The Rejection of Closure"

Artist never fell.

> —Robert Grenier, "Tender Buttons"

Paradise figures prominently as a motif in the work of a number of Language writers—especially during the early to mid-1980s in the writing of Lyn Hejinian, Ron Silliman, and and Bruce Andrews—and to a lesser extent also in the writing of Bob Perelman, Charles Bernstein, and Jean Day.[1] Bob Perelman demonstrates succinctly the many political levels on which the metaphor could operate in his 1988 *Captive Audience*:

> But do we at least agree
> that the human body is paradise
> and that the United States
> of America is not?[2]

Or as Bruce Andrews deploys the conceit with implications that are no less sweeping: "Paradise is a total repertoire of possibilities."[3]

To oversimplify at the outset, I make the case here that the conflicting notions of paradise deployed in 1980s Language writing respond to three revolutions (or so-called revolutions): the sexual revolution, the Reagan revolution, and the information revolution. Although these are of course very different kinds of "revolutions," in a generalized sense all three could be said to be aftereffects of cultural changes that began in the 1960s. Of these three related yet distinct revolutions, it is the nascent information revolution on which I focus primarily here—and in particular on Hejinian's and Andrews's attempts to resist what Donna Haraway was to characterize in 1985 as the "informatics of domination."[4]

The recent publication of the ten-volume *Grand Piano: An Experiment in Collective Autobiography* has greatly expanded our knowledge of the San Francisco Language writing scene in the late 1970s. Ted Pearson describes San Francisco at the time as "hardly paradise, but it was the city in which we arrived, through which we flowed, and from which we dispersed."[5] The effects of the sexual revolution (the designation is problematically general) can be felt throughout *The Grand Piano*, from Steve Benson's description of coming out amid the "Gay Revolution"[6] to Ron Silliman's suggestion, "As for sex in my poetry—it sometimes seems to me that it's everywhere."[7] In volume 6, the theme of which is "the body," Kit Robinson describes a play called *Paradise Now* at the Living Theater in New Haven in 1969. His account stands in well as a microcosm of the success and failure of late-1960s liberationist ideals. The play "began with the players roaming the aisles and shouting slogans ('I can't travel without a passport') ('I'm not allowed to smoke marijuana') and ended with audience members in various stages of undress cavorting with the players, by now naked, on stage."[8] Such a paradise was profoundly generative for artists and writers, but it did not last. The pre-AIDS San Francisco of *The Grand Piano* might be described as a comparative paradise in terms of its sexual mores. But by the mid-1980s, with the arrival of AIDS, the Reagan presidency, and the 1986 *Bowers v. Hardwick* Supreme Court decision, that paradise had been lost. From Hejinian's perspective, "Within a few months of Reagan's taking office, a half century of social progress was on the way out."[9] In *The Grand Piano*, Hejinian describes the end of the kind of 1960s idealism described by Robinson: "While the 60s may have foreseen the ending of the Cold War, they also mark the point from which global capitalism as we know it began its momentous surge. . . . Left political counterculture was bent on bringing

alternative practices into the American sociopolitical experience. But corporate America soon discovered the means to coopt, commercialize, and mainstream the signifiers and signifying systems of the counterculture, banalizing its most visible forms of self-representation."[10] The basic outlines of the 1960s as a lost paradise persist in popular accounts of the period.

This narrative has been challenged by, among others, Thomas Frank, who in his *Conquest of Cool* argues that corporate culture was in fact deeply involved in the creation of the counterculture from the late 1950s onward.[11] Like Frank, Hejinian is careful to note that the sixties were not only host to a liberatory populism, but also witness to an intensified American consumerism.

With respect to consumerism and sexuality, the writing of the Language writers strongly bears witness to the post-1960s changes described by Joel Dinerstein: "In a sense the Enlightenment utopia of the mind— as the rational host of self-control, self-mastery, and perfectibility—has shifted to the body. As self-actualization now seems possible through technological advance, the body has become the locus of consumer desire and the (literal) base for layers of technological prosthetics. . . . As late as the 1970s, the utopian ideals of technological transformation tended more toward the national (transportation networks, nuclear energy, NASA) and even the domestic (consumer appliances, television) than the personal."[12] Dinerstein's account maps well on to the challenges faced by left-leaning writers in the wake of the 1960s. The pursuit of paradise, to adapt Dinerstein's narrative slightly, shifted after the 1960s from a collective undertaking to a personal one. Dinerstein names the individualist pursuit of body-centered perfection the "posthuman Adamic," and suggests that "the concept of the Adamic is invested in recuperating an Edenic purity earned through virtuous work."[13] Increasingly supplementing the body's capacity for work in the postwar period, personal and prosthetic technologies promoted a happiness to be found through physical and technological perfectionism. As Dinerstein writes of the paradise of personal technologies, "Since the early 1980s, the consumer fruits of the electronic and computer revolutions have stirred every younger generation to a faith in the peaceful, plentiful, groovy future made possible by technological fables of abundance."[14] In diagnosing what is wrong with this scenario, Dinerstein argues that "posthuman escapism is based in the fear of understanding the human organism as a multiethnic, multicultural, multigenetic construction created through

centuries of contact and acculturation . . . In other words, *the posthuman is an escape from the panhuman.*"[15]

The critique of the "posthuman Adamic" takes perhaps its strongest form in Donna Haraway's 1985 "Cyborg Manifesto." Acknowledging her debt to Haraway's term "the informatics of domination," N. Katherine Hayles defines "informatics" as "technologies of information as well as the biological, social, linguistic, and cultural changes that initiate, accompany, and complicate their development."[16] Haraway rejects outright any kind of equation of informatic technology with a paradisal future or a paradisal past: "A cyborg body is not innocent; it was not born in a garden; it does not seek unitary identity and so generate antagonistic dualisms without end (or until the world ends); it takes irony for granted. One is too few, and two is only one possibility. Intense pleasure in skill, machine skill, ceases to be a sin, but an aspect of our embodiment. We can be responsible for machines; *they* do not dominate or threaten us."[17] The figure of the posthuman Adam—Dinerstein offers the examples of the 1984 film *The Terminator* and the 1986 film *RoboCop*—has typically taken the form of a white male whose innate powers are supplemented by technological means. Haraway's cyborg attacks such ideological creations by way of a technophilic irony, but Haraway is careful to reject technological determinism. Above all, she insists, "cyborg writing must not be about the Fall, the imagination of a once-upon-a-time wholeness before language, before writing, before Man."[18] Though the Language writers were influenced by, and sympathetic to, Haraway's project (volume 5 of *The Grand Piano* begins with an epigraph by her), they often violate her prohibition on invoking paradisal visions of language. Given that the Language writers' critique of language's capacity to resist ideological contamination was so severe, this is perhaps surprising. These paradisal notions of language were not deployed uncritically, but rather, I want to suggest, were intended to negotiate how poets might interact with a system of signification (taken in the broadest sense: advertising, news, political speech, education) that they had come to mistrust in the wake of the 1960s.

In order to overcome the flood of ideology, so to speak, Language writers created their own flood of language—often suffused with "proto-semantic" paradisal notions of communication, as well as with competing "post-semantic" paranoid notions of language without reference. According to Barrett Watten, "The central problem of reference in [Language]

writing may be seen in a context as directly related to the administration of information about the War on the part of the government and media."[19] Disillusionment over the Vietnam War is central to the politics of Language writing, and yet the war had ended by the time most of the Language writers were actively publishing. Watten's claim is particularly well suited to Andrews, whose Harvard Ph.D. dissertation investigated the escalation of the Vietnam War.[20] What is particularly interesting about Watten's phrasing is his invocation of the "administration of information." At the end of an era in which the counterculture had increasingly made available hitherto-taboo information about the body, as well as about the secret workings of the United States government, Richard Nixon was reelected in 1972. Neither the Freedom of Information Act (passed in 1966) nor the new sexual freedoms could by themselves do much to achieve the kind of social change the Language poets sought. My point here is not to rehearse familiar postwar history, but rather to demonstrate the ways in which sexuality, referentiality, and information abundance are intertwined in the politics and poetics of the Language poets.

## "Paradise, Radius Parade": Lyn Hejinian and the Gendering of Memory Storage

In her 1986 *The Cell*, Hejinian writes:

> The romanticization of limping, of
>     sea-shells, of tenderness as
>     erotic curiosity, of battered paper,
>     of the paternal typewriter
> Motherhood is so much information.[21]

The section from which I am quoting begins by describing "world-wide attention," but soon suggests that such attention will not extend to the maternity ward. The "paternal typewriter," it would seem, ignores the information-saturated condition of modern motherhood. As in her *Writing Is an Aid to Memory* and her better-known *My Life*, the technicization of memory figures prominently in the metaphorics of *The Cell*. These three works resist a paradise of total memory at the same time that they demonstrate a consistent attraction to an encyclopedic knowledge

that is no longer off-limits to women, and is no longer burdened by taboo. In engaging the power of domestic, private memory, Hejinian upsets the traditional privileging of public, authoritative knowledge—and yet she rejects a paradise of personal memory. As she describes, "My motives in composing *Writing Is an Aid to Memory* were contrary to those of reminiscence; the work is neither anecdotal nor diaristic. I was aiming for something encyclopedic; I was interested in epistemology: in consciousness, in knowledge, in the ways that knowledge is organized and structured."[22] Hejinian's use of personal memory, as well as her radically associative and disjunctive style, could well be described as meta-autobiographical. In the face of an abundance of memories, Hejinian offers her readers too many choices. There can be no personal paradise, no retreating to an idealized life account. In the fittingly titled "The Person," she writes:

> There is no outside
> position
>
> Paradise, radius
> parade[23]

If there is a paradise to be found, Hejinian would seem to suggest that it won't be a regaining, nor will it be found in isolation.

Jacob Edmond's essay "The Closures of the Open Text: Lyn Hejinian's 'Paradise Found'" discusses the figure extensively in Hejinian's writing, and what follows is indebted to his account. My approach here is somewhat more general than Edmond's, in that I discuss broader themes concerning technology and information, and somewhat more specific, in that I link the figure of paradise more closely to historical events. Edmond suggests that Hejinian offers "two apparently antithetical paradises—paradise as language and paradise as totalizing, transcendent closure."[24] According to Edmond, "Hejinian's writing exhibits a striking preoccupation with total linguistic transparency, correspondence between language and world, epistemological closure, and perfect understanding, all of which she associates with the term *paradise*. Her essay 'The Rejection of Closure' (1984), her long poem *The Guard* (1984), and her later essay 'La Faustienne' (1998) all grow, directly or indirectly, out of this preoccupation. In these texts, paradise, as complete closure and perfect

knowledge, partakes in a formal and thematic dialectic such that the reemergence of the desire for paradise always accompanies its repudiation."[25] To this account, I would add that Hejinian also associates the idea of paradise with perfect memory (retrospective "perfect knowledge") as well as with an erotics of language. "It's erotic to say everything," she writes in *The Guard*.[26] Edmond quotes a journal entry that illustrates explicitly the dilemma of the two paradises he describes within her writing: "Language is the guard of paradise. It doesn't let one in. Then too it might be the garden of paradise."[27] To put this in slightly different terms, a language of Adamic naming would convey perfect information. Hejinian rejects such a possibility, and yet the "metaframe" (as Edmond calls it) of a poem such as *The Guard* continually reintroduces the notion of a liberated language that paradoxically obstructs access to a transparent politics of liberation. A language of posthuman Adamic naming might, in other words, convey an unlimited amount of unprocessable data.

Hejinian's recurrent interest in the encyclopedic is closely related to her interest in the workings of memory. "My head is a shelf that holds encyclopedias," she writes in *The Guard*.[28] For Hejinian, the technicization of memory suggests a kind of completion or closure that is at odds with poetic creation. She notes retrospectively that writing is a hindrance as well as an aid to memory: "Much as I enjoy the 'list poems' of Ted Berrigan, Bernadette Mayer, or Jack Collom, *Writing Is an Aid to Memory* bears no relation to one, I don't deny being attracted to sheer data—but sheer data is like a lexicon, and though one wants to know as many words as possible, the essential thing is to put them together. Experience suggested that writing is indeed an aid to memory, but not solely, or even most significantly, because it can serve as a replacement for memory (which is what a list does)."[29] Writing is disembodied memory; writing presents us with a profusion of possibilities. Too many memories at once, resequenced and reduced for an external audience, are perhaps no longer "authentic" memories. Hejinian's writing emphasizes the radical selectivity of memory. As she writes in "The Rejection of Closure," "What stays in the gaps, so to speak, remains crucial and informative. Part of the reading occurs as the recovery of that information (looking behind) and the discovery of newly structured ideas."[30] As she writes in *My Life*, "What follows a strict chronology has no memory."[31] The list presents an inhuman (or perhaps a posthuman) illusion of order; the role of the poet is to counteract this illusion of order.

One way Hejinian gets beyond the impasse of the dichotomy of paradise-as-idealized-language/paradise-as-totalizing-closure is to insist on the importance of drawing attention to classificatory structures: "If in the Edenic scenario we acquired knowledge of the animals by naming them, it was not by virtue of any numinous immanence in the name but because Adam was a taxonomist. He distinguished between the individual animals, discovered the concept of categories, and then organized the various species according to their different functions and relationships in the system. What the 'naming' provides is structure, not individual words."[32] The "encyclopedic impulse," as she calls it, presents a false paradise where structure has been overcome, where total memory overwhelms any ability to sift through experience. "The encyclopedic impulse" recollects passively; it privileges mind over body; it refuses to reclassify. Following Gertrude Stein, Hejinian insists on a pragmatic present-tense engagement with knowing: "Knowledge, like speaking or writing, is not an entity but a function—it would best be called 'knowing'—and the purpose of that function is to contextualize—to contextualize in the profoundest sense, so that knowledge is not only knowing of (which is experience in potentia) and knowing that (which generates propositions) but also knowing how."[33] Our "desire to possess knowledge," she claims, "is wasteful of uncertainty."[34] So, too, is our desire for complete life records, for inclusive chronological accounts, as she writes in "The Person": "Self-consciousness is discontinuous / The very word 'diary' / embarrasses me."[35]

For Hejinian, to privilege the encyclopedic impulse is to normativize a white, bourgeois subject position. She grapples with the difficulty of resisting a corporeal determinism at the same time that she insists on grounding experience in the individual body: "I am my thoughts, not my body. If I truly feel this, it is a product of gender-liberating, and now age-defiant, willfulness or white middle-class privilege? A or B? C. In any case, my thoughts are not all my own. And shouldn't I have gotten over the mind–body dichotomy by now? Isn't privileging the mind over the body just that—precisely a matter of privilege, the privilege of someone with a purportedly unmarked body?"[36] In choosing C, Hejinian in a sense overcomes mind/body dualism and is able to retain imaginative agency while placing in doubt her own class privilege. "Money is the memory of my class," she writes in My Life, gesturing to the ways in which memory is inextricably tied to the legitimization of the existing

family and class structure. An important role of the politically engaged writer would be to cast suspicion on conventional patterns of personal and collective memorialization. Alluding to Stein's claim that "a sentence is not emotional a paragraph is," Hejinian pairs paradise with paragraphs which presumably convey emotion: "Paradise and paragraphs / They can be indifferent / under the pink skin of distribution."[37] Paradise presumes equality, or perhaps even enforces a vision of equality, regardless of present inequalities.

The most insistent inequality of all, that between men and women, Hejinian notes, is deeply inscribed within Western epistemology. In the myth of Faust, "the female element . . . is not the knower but the site of knowledge, its object and embodiment—that which is to be known."[38] In a characteristic reversal, Hejinian muses on a Faustienne rather than a Faust. By reversing the gaze, the Faustienne is able to attain a different kind of self-consciousness—without pushing the metaphor too far, one might even suggest that the Faustienne is able to achieve a kind of "double consciousness" of which Faust is incapable—since she is able to be both knower and known. In a work such as *The Cell*, Hejinian radically collapses the difference between viewer and viewed, as well as between the unitary (the cell) and the collective (the organism comprising cells). Hejinian describes the pleasure of a kind of partial knowledge, which does not renounce information, but rather questions the forms it takes:

> The information is like a
>      balmy palpitation
> I like everything at a
>      level below its name[39]

To "like everything at a / level below its name," we might surmise, is to reject the certainty of Edenic naming. Charles Bernstein deploys a similar metaphorics in his 1991 poem "The Kiwi Bird in the Kiwi Tree": "I want no paradise only to be / drenched in the downpour of words, / fecund with tropicality."[40]

For both Hejinian and Bernstein, "the downpour of words" suggests a communicative paradise that might help to resist the post-1970s paradise of personal consumption. In "The Culture Industry," Adorno and Horkheimer write, "The paradise offered by the culture industry is the

same old drudgery. Both escape and elopement are pre-designed to lead back to the starting point. Pleasure promotes the resignation which it ought to help to forget."[41] In *My Life in the Nineties*, Hejinian continues to write of such a consumer paradise: "They were having the subjectivity of consumers, lacking objectivity amid abundant objects."[42] The job of the poet is to redistribute facts in order to get "under the pink skin of distribution." This is not necessarily to fictionalize facts, but rather to question the acculturated force of purportedly neutral facts. In creating paratactic, nonchronological biographical accounts, Hejinian insists that "there are no unequal facts."[43] "Facticity consists in being at origin (speaking here not of the original how but of the original why) inexplicable (a fact has original inexplicability: that's a fact, bingo! No fact is flat)."[44] Facts imply points of origin, but no fact is innocent or guilty. Hejinian champions an epistemological model that places primary importance on collective rather than individual perception. As she writes in *My Life in the Nineties*, "We perceive nothing but relationships—perception itself is that."[45]

For Hejinian, a comprehensive understanding of our relations to others might come as close as we are to get to paradise. This can perhaps only be achieved through representing consciousness as discontinuous, and extending the span of our attention: "The desire to tell within the conditions of a discontinuous consciousness seems to constitute the original situation of the poem. The discontinuity of consciousness is interwoven through the continuity of reality—a reality whose independence of our experience and descriptions must be recognized. In response, the poetic impulse, attempting (never successfully) to achieve the condition that the phrase 'language and "paradise"' names, seeks to extend the scope and temporal continuity of consciousness."[46] Hejinian does not posit that there is a "level . . . below the name," a proto-semantic (or perhaps post-semantic) layer to which we can ascribe a kind of continuity of meaning. If mass culture and technological memory give us the illusion of continuity, it is the role of poetry to disabuse us of that illusion. Hejinian cautions us against modernist attempts at total meaning: "What of the inclusive impulse—'all of it'—which is so characteristic of modernist approaches to comprehension and control? If we accept the notion that knowledge is always and only embedded, always and only situated, we must give up the aspiration to 'know everything.'"[47] In the face of a society of control, we might even surmise that Hejinian's writings

ask us to lose control, to forget some things, to remain unfocused—at least some of the time.

The intricate conclusion to *Writing Is an Aid to Memory* brings together themes related to information, attention, and perception—at the same time that it refers back to the poem's enigmatic beginning. The opening line of the book is "apple is shot nod," which Hejinian has noted refers to William Tell. The apple could also refer to the forbidden fruit of knowledge. The poem transitions rapidly—beneath the level of the "new sentence" as a unit—as if to represent the consistently shifting processes of immediate consciousness:

> think is shot
> motion is debate to the eye
> I have got a foothold and a doubt
> of talk trucks distraction of a visit glass
> understanding comes forgiveness thinks
> disclosure
> unable is not to concentrate mostly
> limb
> mind on minded put
> bit supported the other deaths drawn of a distraction
> the situation is in fast with fast evidence
> it is not a rarity
> I glance toward what the eye can pronounce aside
> an addition of information must fly[48]

Despite the seeming randomness of its thematics, the poem mentions distraction twice, and with the line "unable is not to concentrate mostly" it would seem to mimic the phenomenon of "continuous partial attention" described in chapter 1. The negative "unable is not" as well as the qualifying "mostly" make it almost impossible to focus on the "fast evidence" of the continual "addition of information." In fact, the method of the poem would seem to be mostly subtractive rather than additive. The poem's dominant constraint is to indent the beginning of each line according to the position of the first letter's place in the alphabet (thus "apple is shot nod" is fully left justified). At its conclusion, it is almost as if information has flown out of the poem. Information, no matter how abundant, cannot restore us to Eden, the poem seems to be saying.

"Time is storage," she writes in *The Cell*.[49] There is no escape from the perpetual process of remembering and forgetting—our experiences are inscribed and erased at every instant. As she writes earlier in the book:

> ideas move and move the thinker
>     more parted, pasted dog up
> in return far of the information.[50]

## The Poetics of Overdeterminacy: Bruce Andrews and the Libidinal Economics of Information

In *Lip Service*, his epic modeled on Dante's *Paradiso*, Andrews poses a fascinating, and perhaps unanswerable question: "Is it even remotely conceivable / that a woman could have written this?"[51] Without answering this question directly, Barbara Cole has suggested that the predominant reason Andrews's writing "is not better known [is] because it is written by a man."[52] Cole argues provocatively that Andrews is an

> exemplary practitioner of *écriture feminine*—doing what so many of his female contemporaries have not dared to do: to break syntactic convention . . .
>     What we can't digest in Andrews's poetry is what the speakers themselves have trouble swallowing. These voices—or perhaps more aptly, these lip syncers—repeat what every hole has already absorbed. But what transforms these lip synced sound bites beyond mere ventriloquism is the genius of *Lip Service's* fluid vibrations and stop-cut undulations. The sexuality—in content and form—is undeniable at every step of the way but, certainly, this is a cerebral sexuality. Indeed, Andrews gives new meaning to the notion of "giving head."[53]

Cole suggests that although Andrews is "an exemplary practitioner of *écriture feminine*," he also "forces us to consider the essentialist fallacy of *écriture feminine*."[54] As Hélène Cixous makes clear in "The Laugh of the Medusa," one does not have to be a woman in order to write in opposition to *écriture patriarchal*.[55] Given the plurality of voices in Andrews's work—and that Andrews admits discomfort with some of what those voices (typically in sound bite form) have to say—it is difficult to assign the kind of agency to his writing that we typically depend on an "author function" to provide. The polyvocalism of Andrews's writing

makes it almost impossible to know who is speaking, much less to assign gender roles.

Overdetermination has arguably become so standard within the contemporary critical lexicon that we neglect both the history and the implications of the term. Coined by Freud in *The Interpretation of Dreams*, "overdetermination" took on a new political urgency in the 1960s. Consider the use of the term by Norman O. Brown (whom Andrews has cited as an influence) in the 1966 *Love's Body*: "A vast pun, a free play, with unlimited substitutions. A symbol is never a symbol but always polysymbolic, overdetermined, polymorphous. Freedom is fertility; a proliferation of images, in excess. The seed must be sown wastefully, extravagantly. Too much, or not enough; overdetermination is determination made into chance; chance and determination reconciled. Too much meaning is meaning and absurdity reconciled."[56] Andrews has consistently rejected aleatory procedures, but his work in many ways both embodies and resists the kind of liberation championed by Brown. In claiming that "Power is the surplus of the sign," Andrews would seem to suggest that all language is overdetermined.[57] But overdetermination in Andrews's writing, rather than sowing confusion and doubt, becomes celebrated for its potential to free us from repression. Louis Althusser's account of overdetermination in his 1965 *For Marx* (it is worth nothing that Andrews was in Paris shortly after the events of May 1968) is far bleaker than Brown's:

> Ideology . . . is the expression of the relation between men and their "world," that is, the (overdetermined) unity of the real relation and the imaginary relation between them and their real conditions of existence. . . . It is in this overdetermination of the real by the imaginary and of the imaginary by the real that ideology is active in principle, that it reinforces or modifies the relations between men and their conditions of existence, in the imaginary relation itself. It follows that this action can never be purely instrumental; the men who would use an ideology purely as a means of action, as a tool, find that they have been caught by it, implicated by it, just when they are using it and believe themselves to be the absolute masters of it.[58]

Key to Althusser's account is the claim that ideology is not merely false consciousness, but inheres in all social relations under capitalism. Because ideology has so many input causes, it is impossible to get at the

"real conditions of existence." Ideology, according to Althusser, "does not just refer to apparently unique and aberrant historical situations (Germany, for example) but is universal."[59] For Althusser, we are all (poets and philosophers included) subject to overdetermination.

Andrews's writings could be said (in an appropriately overdetermined fashion perhaps!) to operate according to Brown's favorable account of overdetermination at the same time that they also operate according to Althusser's far more grim account. In the 1977 "Text and Context," Andrews writes:

> Engulfment, flooding of signifiers without predetermined signification. Instead, the clichés of existentialism—freedom, surplus of signifiers, choice as constitutive & we do it ourselves.
>
> Politics not concealed any longer.[60]

Paradise as "a total repertoire of possibilities" suggests that acknowledging and appropriating the power of overdetermination might be a way to resist predetermined outcomes. In order to achieve effects which put into practice ideology critique at the same time that they question the efficacy of liberatory discourses, Andrews continually returns to a poetics of surplus signification, and he does so in what is perhaps the most consistently disjunctive manner of any of the Language writers.

Andrews's writing is supremely indicative of Language writing's alternating love–hate relationship with the power of language-in-excess to liberate as well as to obfuscate. Carla Billitteri has recently offered a reading of post-Olsonian American poetics which suggests that Cratylism (a model of language which has much in common with Judeo-Christian notions of paradisal Adamic naming) is central to the politics of Language writing. Billitteri argues that

> neo-Cratylism as a political program is put forward most exuberantly by Andrews . . . While affirming consistently that language is not natural but socially constructed, that meaning is not inherent to words but the function of a rule-governed system, that language refers to an external reality only by convention, and that the relationship between language and social order is indirect, Andrews again and again expresses a Cratylist desire for a form of writing that can engage language prior to social construction, for a nonsyntactical writing of meaning-embodied words, for an instantiation

of the real within writing, and for a direct effect on the social order through poetic practice.[61]

It is perhaps counterintuitive to label Andrews a Cratylist, given how difficult it can be to assign fixed meaning to his writings. Consider the following passage, for instance:

> With this, purchase paradise
> > helps it sublimer wish not want
> > so then give me a ring attached
> releases the subjectivity of destroyed subjects—
> > > > > mass cloak dial-a-tribe[62]

We are confronted here by too much and not enough information. Perhaps "this" with which to purchase paradise is the *paradiso* we have presumably purchased and are holding in our hands—but this would seem to lead in a circle, as would releasing the "subjectivity of destroyed subjects."[63] The flip side of engaging language "prior to its social construction" could be engaging language after its social destruction.

Peter Quartermain has suggested forcefully that *Lip Service* should be read as a critique of the degraded language that surrounds contemporary sexuality and its commercialization:

> The portrayal of the Beloved in *Lip Service* runs savagely counter to the myth of women and sexuality purveyed in the market place and the entertainment industry (to say nothing of the *Paradiso*), yet at the same time it clearly reflects it: by and large, women in this poem—and especially in the first five sections—are, like women in advertisements, unreflective and largely uncritical creatures whose major interests and passions revolve around cosmetics, breast implants, sexual performance and social standing; vain, manipulative, inconstant, they seem by and large to participate more or less willingly in a life which is, by any standards, undesirable and indeed dehumanised—as the poem proceeds, its title comes among other things to suggest joyless oral sex. This paradise is a Hell in which women are more or less willingly complicit in their own damnation.[64]

Quartermain acknowledges that Andrews may well be writing in the persona of a woman—but he also notes that the poem, as its title would

suggest, makes it impossible to assign direct, sincere agency. The poem could well be described as a compendium of sexually taboo language. The net effect is to inspire disgust. Sianne Ngai has suggested that "no contemporary American poet has continued the modernist avant-garde's project of decoupling art from beauty, or developed the negative aesthetic already latent in Kant's definition of the disgusting as the end-point of mimetic art, as consistently or aggressively as Andrews."[65]

One would not typically associate exuberant Cratylism with a poetics of disgust. What accounts for Andrews being simultaneously a laureate of Cratylism and a laureate of disgust is his insistence on a poetics grounded in the body. Andrews's writing is replete with bodies with organs but without identities. His interest in the commodification of the eroticized body, and the ways in which bodies are modified, supplemented, and marketed, suggests a profound interest in issues of biopower (a term first popularized in English by Foucault's 1978 *History of Sexuality*). Bob Perelman has situated Andrews's interest in the body at the core of his work, arguing that it provides him with a point of reference from which to attack the ubiquitous language of capital. According to Perelman:

> As markets become saturated there is a steady demand for flashier items that are also firmly saleable. The processes of commodification are ubiquitous and can make the segue from Jackson Pollock to new Formica patterns seem as inevitable as the seasons.
>
> In attempting to avoid such aesthetic innocuousness, Andrews pins his hopes on the body. It is not the site of identity or self-expression; rather, it is something of a utopian counterweight to the various registers of false rhetoric he feels surrounded by.[66]

Andrews's emphasis on the body (and the bawdy) represents an attempt to achieve "paradise," a place beyond signification and ideology, and perhaps also beyond gender and class identity. But this potentially paradisal place of authentic communication is subject to something like an infinite regress given the conditions of artificial desire and artificial meaning imposed by late capitalist societies. There would seem to be no place for the unconscious in Andrews's poetry. Even if there is an individuated, non-commodified unconscious, Andrews's writing places in question whether it is possible to liberate the unconscious without a more radical questioning of the entire realm of signification.

Jerome McGann has written that "nothing is more obdurate than the writing of Bruce Andrews."[67] In the sense that Andrews's writing stubbornly refuses a personal paradise through an insistence on the artificiality of the consumer paradise, it is unparalleled in its obduracy. But it might also be said that Andrews's writings—and here *Lip Service* and *Love Songs* are exemplary—demand that we acknowledge the vulnerability of docile bodies: deeply flawed, leaking bodies with which no one is ever satisfied. These are not perfected posthuman specimens. These are the bodies of victims and victimizers. In the 1979 "Writing Social Work and Political Practice," Andrews writes of his poetics as "an antisystemic detonation of settled relations, an anarchic liberation of energy flows. Such flows, like libidinal discharges, are thought to exist underneath & independent from the system of language. That system, an armoring, entraps them in codes & grammar. Normative grammar—a machine for the accumulation of meaning seen as surplus value & for territorializing the surface relations among signifiers by converting them into an efficient pointing system."[68] As much as Andrews insists on the power of libidinal excess to reconfigure social relations, his writings, through their tireless invocation of libidinal excess, demonstrate that such energy flows exist *within*, as well as *beneath*, the system of language. Andrews's fierce and uncompromising attack on the "efficient pointing system" implies that a more libidinally liberated language may not necessarily offer a more accurate representation of social relations.

In his essay "Be Careful Now You Know Sugar Melts in Water," Andrews offers perhaps his fullest account of the role of sexuality within his writings. He describes a pervasive technologization of the body, which overwhelms our ability to access and liberate our genuine desires:

> technology may be an extension of the body. here, it suggests an interior technologizing of bodily desires which extend, or rivet, them right back inside. so escapes from social fixity by means of precipitation look more & more inadequate as a response to this near-inclusive set tossed over our wants & needs. to assume that we face a model of repression could encourage us simply to loosen the bonds of constraint. but if we face a mode of activation of sex, of harnessed desublimation, of privatized socialization, what is left but to recognize (to rewrite) the rules, the roles, & the stereotypes.[69]

We cannot "simply . . . loosen the bonds of restraint" without considering how even our most intimate desires may be influenced by the techno-cratic consumerist society in which we live. In order to function smoothly, capitalism requires noise-reduction devices. In response, voices of resis-tance need to become "building blocks of noise." Andrews suggests that the most effective opposition might take the form of collective noise—not necessarily of the vuvuzela variety, but rather "noise as wayward, unregimented sound. Or seemingly meaningless, random fluctuations in data—not the 'managed data' that defines information. Too irregular, or pumped up with excess timbral richness, its overtones untameable in harmonic terms, undercutting expectations of determinate pitch (or, in our case, of a representational determinacy and bolstering)."[70] To resist "managed data," in this formulation, is to suggest that the orderly operations of consumer capitalism can be challenged by interrupting the patterning of data, and by extension music. Given how total the grip of ideology is over contemporary society, noise in this model is not only a necessary countermeasure, but also comparatively determinate in that it does not allow for the further spread of ideology (or misinformation).

If it is difficult to assign individual agency to the sound bite voices in Andrews's writing, it is even more difficult to discern distinct temporal or narrative markers. A traditional feature of lyric poetry is its invoca-tion of personal time or of powerful recollected memory—a poem such as "Tintern Abbey" reflects on the passage of five years in the life of its author. But it is difficult to find an Andrews poem in which the poet reflects directly on the passage of personal time. In a sense, we might say that there can be no innocence in Andrews's writing because there is no sense of a personal before or after. Andrews minimizes the intrusion of a lyric voice by working extensively with collaged material. More specifi-cally, he works from a voluminous supply of slips of paper.[71] These slips often predate the composition of his poems by years, or even decades. I would propose that, contrary to the Romantic model of spontaneous inspiration from internalized memory, Andrews is working for the most part with exteriorized memory. Bernard Stiegler draws a distinction between exteriorized or technicized memory, which he calls *hypomnesis*, and *anamnesis*, which he uses "to designate the embodied act of remem-bering."[72] Andrews's writing largely precludes the Wordsworthian act of anamnesis, instead plunging us into an anarchic, atemporal world of found language, remembered only through technical means. According

to Stiegler, "Human life is no longer simply biological: it is a technical economy of desire sustained by hypomnesic technical milieus, symbolic milieus in which drives find themselves submitted to a principle of reality that requires the postponement of their satisfaction. As a result of this symbolic mediation, an economy arises through which the energy of the drives is transformed into libidinal energy, that is, into desire and sublimation."[73] It is here perhaps that Andrews and Hejinian converge: both are centrally concerned with the "technical economy of desire." Writing is an aid to desire. Is that an archive in your pocket or are you just happy to see me? Everyday language, and everyday practices of memory, are suffused with languages of desire that are not our own. The posthuman Adam is a figure who denies history; he only imagines he creates his own language. The posthuman Eve cannot name, but only rename. Perhaps freed of their traditional gender roles they might seek, on their own or together, a version of the "'paradise' for which writing yearns—a flowering focus on a distant infinity."[74] Paradise, it should be noted, is placed in quotes.

# 6

## VANGUARD TOTAL INDEX

### CONCEPTUAL WRITING, INFORMATION ASYMMETRY, AND THE DATA GLUT

Ubu usurps much usufruct. Ubu sums up lump sums.

—Christian Bök, *Eunoia*

Why is an index dear to him. He has thousands of gesticulations.

—Gertrude Stein, "Advertisements"

The past decade has seen a proliferation of works of constrained and appropriated writing that incorporate the forms of the index, the database, and the catalog. These forms embody what Lev Manovich describes as "the database logic" of new media.[1] Manovich asks, "How can our new abilities to store vast amounts of data, to automatically index, link, search, and instantly retrieve it, lead to new kinds of narratives?"[2] If one replaces the word "narratives" with "poetry," that question could be considered the central theme of this chapter. Conceptual writing's appropriation strategies, I suggest, offer some preliminary answers. Robert Fitterman maintains that conceptual writing's distinguishing feature is its use of appropriated texts "in large, unmodified chunks—a paragraph, a page, a whole book," in order to "reframe works that already exist in new contexts . . . which, in turn, instigates new ways to potentially realize our place as text artists in a network culture."[3] According to Kenneth Goldsmith, "In the face of an unprecedented amount of digital text, writing needs to redefine itself in order to adapt to the new environment of textual abundance."[4] Flarf poetry, by contrast to conceptual poetry, is composed of smaller, more discrete textual fragments, and is

said to more closely resemble earlier poetic appropriation strategies that allow poets greater agency in the selection of source materials.[5]

I make the case here that by adopting strategies of *passive indexing*, conceptual writing demonstrates considerable self-reflexivity with respect to the conditions of its own existence and dissemination in an era of instantaneous global information flows. Moreover, this writing points to distinctive changes in the nature of the global economy over the past two decades, highlighting the emergence of what Ulrich Beck terms the "risk society," or what Jacob Hacker calls "the great risk shift," wherein financial risk has shifted from governments and corporations to individuals (in the form, for instance, of privatized retirement plans).[6] All the works surveyed in this chapter thematize in some manner the relation of a writer to a data set—raising important questions concerning matters of privacy, authenticity, identity, and information asymmetry. These works are not, for the most part, directly prescriptive of social change. They more often take the form of parodic compendia. Rather than refusing conventional syntax at the level of the sentence in the manner of the Language poets, these works for the most part operate by restructuring and reframing aggregate data.

Broadly speaking, I am construing conceptual writing concerned with the nature and structure of information systems as indexical in form. In using the term index, I am referring more to the bureaucratic forms taken by large quantities of information than to the linguistic sense of indexicality developed by Charles Sanders Peirce.[7] Indexes are the ultimate archival form—no library, not even a Borgesian one, can ever purport to be absolutely complete. Indexical art and writing presents tricky theoretical questions with regard to originality, translation, and transcoding. Indexes can be used to measure almost anything—including, perhaps, the impossibility of "getting outside" the institutions of late capitalist bourgeois culture. Financial, bibliographic, biomedical, and demographic indexes all bear witness to the forms taken by the bureaucratic mechanisms of contemporary capitalism—to which conceptualism bears an uneasy relation. The writer or artist herself is often subject to the index. The index fund, a comparatively recent financial innovation, exemplifies this phenomenon. Most knowledge workers, poets included, participate in retirement plans that own index funds which passively track stock and bond markets. Does this mean that poets, too, are owners of Apple, the world's largest corporation by market capitalization?

This is not the place for an extensive consideration of the ethics of investment: my point here is simply that every index in some sense begs the question of the total index. To change the course of capitalism, the Language poets tirelessly suggested, it is necessary to consider one's position (or "positionality") within the system of political economy as a whole. By adopting the form of the index, conceptual writing investigates the place of the writer within global networks of aesthetic and economic valuation.

Although indexes are often taken to be passive accumulations of data, they inevitably reflect the values and biases of their creators. Much indexical writing is clearly dystopian in its critique of information systems, but indexical writing is also in some sense literally utopian in that it is often of "no place"; it substitutes categorical appropriation for local expression. The author is not dead; the author, like the electronic investor, inhabits multiple locations at once. The author as "content provider" or "data processor" exists as a function rather than as a physically or geographically locatable source of meaning. Perloff has recently suggested that "only by adopting the language of the library and the database—the language of facts, dates, historical ledger, map, dictionary, biographical entry, literary quotation—can the contemporary poet create what is paradoxically a new poetic sphere."[8] Conceptual writing places in question our notions of individual agency, and our ability to sequester ourselves from the global. This returns us to the question of the poet's place within the index, database, or catalog. Words now travel, for better and worse, instantaneously across borders. We are all being indexed all the time. Rodrigo Toscano writes somewhat facetiously that "all poetic installments must index the wiles (as well as vagaries) of current global class struggle as currently acted out in the (writer's) text-designer's actual locale of habitation."[9] As Toscano, who describes himself as having "grown up on the borderlands of California," well knows, the writer's "actual locale" is often in flux, and the writer's place of residence may be far less significant than her institutional setting.

Institutional critique is among the most important concerns of conceptual art and writing, and is closely related to conceptual writing's emphasis on practices of classifying, storing, and disseminating information.[10] Lucy Lippard's *Six Years*, perhaps the most influential historical account of conceptual art, is itself an indexical sampling of a movement characterized by sampling. The long, eighteenth-century-esque subtitle of the book is an essay unto itself: "The dematerialization of the art

object from 1966 to 1972: a cross-reference book of information on some esthetic boundaries: consisting of a bibliography into which are inserted a fragmented text, art works, documents, interviews, and symposia, arranged chronologically and focused on so-called conceptual or information or idea art with mentions of such vaguely designated areas as minimal, anti-form, systems, earth, or process art, occurring now in the Americas, Europe, England, Australia, and Asia (with occasional political overtones), edited and annotated by Lucy R. Lippard."[11] The title is all encompassing at the same time that it refuses to commit to any one of its multiple slogans. Only Africa and Antarctica are left out of the book's totalizing purview, and yet the book advertises itself in self-deprecatingly bureaucratic terms as merely a "cross-reference book of information" and a "bibliography." Sol LeWitt famously declared in 1966 that "the serial artist does not attempt to produce a beautiful or mysterious object but functions merely as a clerk cataloging the results of his premise."[12] *Six Years* might best be described as a catalog, although the word (perhaps because of its associations in the art world with the gallery system) is absent from Lippard's title.

Numerous examples of 1960s conceptual artworks concerned with the indexing and cataloging of information could be cited here. Craig Dworkin has recently suggested that "the guiding concept behind conceptual poetry may be the idea of language as quantifiable data."[13] The same could be said of a number of conceptual works from the 1960s— such as On Kawara's *One Million Years* or Vito Acconci's list poems or the index-based works of the Art & Language group. Like *Six Years*, the 1970 *Information* show at the Museum of Modern Art aspired to be global in scope.[14] The show emerged out of an attempt by MoMA to placate the Art Worker's Coalition, among whose members was Dan Graham, who in a 1969 statement declared, "What does the artist have in common with his friends, his public, his society? Information about himself, themselves, and all ourselves—which is not reduced to ideas or material."[15] Throughout the late 1960s, Graham was centrally concerned with information systems. Eve Meltzer's description of the *Information* show serves also as a useful overview of Graham's concerns during the period: "'This is the dream of the information world', they [the *Information* artists] seem to be telling us. A dream (indeed a nightmare for many) of the world as a total sign system, where even language has been stripped of affect and pared of everything save the bones of its infrastructure; a

dream that sometimes promises revolution, but just as often threatens to completely dissociate cause and effect, sign and referent, subject and world."[16] Of his works, Graham's "Schema" perhaps most fully accomplishes the stripping of affect and intentionality from language, leaving behind only the "bones of its infrastructure." In notes on "Schema," Graham explicitly states his goal of reducing (or expanding) the "poem" to convey the most basic, but also context-variable, information regarding its execution:

> A page exists each time as in-formation (information): its subject matter is in-formation.
>
> It takes place as in-formation in terms of the base (constituents) of place.
>
> As it takes place, its in-formation structure appears to uphold its decomposition (simultaneously as it is composed in the same process) in terms of the base constituents of (its) place.
>
> [. . .]
>
> Systems of in-format seem to exist somewhere half-way between material and concept, without being either of these (categories).[17]

For Graham, information can both mark place as well as erode its specificity. His 1969 "INCOME (Outflow) PIECE" situates the artist amid not merely the art market, but larger financial markets as well. Graham proposed to sell stock in himself—or rather in "Dan Graham, Inc."—as a means to make the process of creating and selling his art more transparent. In a series of newspaper ads, Graham quite literally inserted himself into the marketplace for ideas. In describing "his object (motive)," Graham wrote that he wanted "to make public information on social motives and categorization whose structure upholds, reveals in its functioning, the socio-economic support system of media."[18]

Much changed between the 1960s and the 2000s, of course, but in terms of conceptual practices centered on questions of information and informatics, the rise of the personal computer and the Internet are (unsurprisingly) of paramount importance. Detractors of conceptual writing have suggested that the four-decade lag between the emergence of conceptual art and conceptual writing results either from the desire of conceptual writers to draw on the prestige of the art world, or from a willful ignorance of the achievements of 1970s and 1980s writers working with appropriation techniques.[19] Proponents of conceptual writing,

on the other hand, have frequently emphasized that conceptual writing responds to an utterly transformed media landscape. Dworkin writes that "in a world of increasingly capacious and inexpensive storage media, the proliferation of conceptual practices comes as no surprise ... Conceptual poetry, accordingly, often operates as an interface—returning the answer to a particular query; assembling, rearranging, and displaying information; or sorting and selecting from files of accumulated language pursuant to a certain algorithm—rather than producing new material from scratch. Even if it does not involve electronics or computers, conceptual poetry is thus very much a part of its technological and cultural moment."[20] By functioning both like, and as, an interface, conceptual poetry draws renewed attention to the ways in which information is conveyed and categorized. Conceptual art of the 1960s, though it was centrally concerned with the forms taken by large data sets, was produced during the era of the mainframe, before powerful distributed information networks were widely available to individual users. The term "data base," according to the *OED*, was first used in 1962; the term "metadata" in 1969. Conceptual artists in the 1960s could only begin to envision the emergence of a world in which among all members of the G7 group of developed nations, upward of "70% of Gross Domestic Product depends on intangible goods, which are information related, not on material goods."[21]

The first indexed stock fund, introduced by Vanguard in 1976, has subsequently grown to become the world's largest mutual fund. The strategy of passive indexing emerged as a result of Burton Malkiel's 1973 *A Random Walk Down Wall Street*, which demonstrated that most professional money managers (and their actively managed funds) could not outperform a randomly chosen index of stocks or bonds. Though probably unknown to most conceptual writers, *A Random Walk* may be the most influential investment book written in the second half of the twentieth century. "The logic behind this strategy [of indexing]," according to Malkiel, "is the logic of the efficient market theory."[22] Regardless of whether the investor necessarily believes in the market's ability to price assets efficiently or ethically, the assumption is that over time stock and bond markets in the aggregate will provide greater returns than conventional savings accounts or government retirement programs. Malkiel's simple hypothesis resulted in the "passive allocation" of trillions of dollars over the past three decades. In part, the index fund

responded to the problem of "information asymmetry" (a term which came into circulation in the 1970s with the rise of information economics).[23] Given that corporations could devote far greater resources to researching the market, the individual investor would likely always be at a disadvantage in terms of allocating capital. Rather than buy into one part of the system of capital, in the form of an individual stock or bond, investors could now in effect buy into the market as a whole.

In the wake of the 2008 financial crisis, the "efficient market hypothesis" came under increasing scrutiny. Eugene Fama, considered "the father of the efficient market hypothesis," offers this definition: "It says prices reflect all available information . . . one of the founding principles of capitalism is that prices provided good signals for the allocation of resources, and that's basically the principle of efficient markets."[24] The difficulty in 2008, of course, was that prices did not reflect all available information. Even the most well-informed (or purportedly well-informed) market participants and observers claimed that they did not understand the nature of derivatives and other complex financial products. A postcrisis article in *The Economist* went so far as to claim that the crisis had been caused by "big data": "During the recent financial crisis it became clear that banks and rating agencies had been relying on models which, although they required a vast amount of information to be fed in, failed to reflect financial risk in the real world. This was the first crisis to be sparked by big data—and there will be more."[25] Of course, not everyone was on the wrong end of information asymmetry, and many corporations and hedge funds profited handsomely. And even at corporations that failed, many executives received extraordinary compensation. The previously obscure term "moral hazard" (borrowed from the insurance industry) soon entered the popular lexicon. According to Paul Krugman, "moral hazard" refers "to any situation in which one person makes the decision about how much risk to take, while someone else bears the cost if things go badly."[26] By socializing private losses on a massive scale in the wake of the crisis, governments around the world largely absolved corporations and their executives of "moral hazard." In the United States at least, attempts to mitigate risk for lower-income individuals and families, by contrast, were largely ineffective.[27] From Hurricane Katrina to the subprime crisis, the federal government showed itself to be increasingly unwilling to mitigate individual risk.[28] While the 1930s and 1960s saw unprecedented expansions of the social safety net in the

United States, the 1980s saw much of the safety net dismantled, and the 1990s and 2000s saw further erosions. Upon his reelection in 2004, President George W. Bush's first pledge was to privatize social security. After the collapse of Lehman Brothers in September 2008, such a move became politically untenable even on the far right, and yet there were few signs that the shifting of risk from governments to individuals had slowed. Information might have become more abundant than ever, but the onus was increasingly on individuals (and/or families) to ensure that they used that information to procure the right mortgage, the right insurance, or the right retirement plan—or else face personal financial disaster.[29]

I offer this brief overview of the financial crisis to underscore three salient points concerning conceptual works that feature indexical appropriation: (1) the strategy of passive indexing mimics the informatization as well as the financialization of the global economy; (2) indexical appropriation typically implies the embeddedness of the writer within the economy and/or the mass media; and (3) indexical appropriation raises important issues related to the ownership of information and the consequences of asymmetric information.[30]

A number of critics, including Charles Bernstein, Joshua Clover, and Christopher Nealon, have considered the ramifications of the financial crisis for American avant-garde poetry.[31] Charles Bernstein parodies both the data glut and the financial crisis to great effect in his mock address "Poetry Bailout Will Restore Confidence of Readers," delivered, appropriately enough, in late 2008 at the release of the year's *Best American Poetry* volume. According to Bernstein, "The glut of illiquid, insolvent, and troubled poems is clogging the literary arteries of the West. These debt-ridden poems threaten to infect other areas of the literary sector and ultimately to topple our culture industry."[32] Poetry is, in effect, caught in a liquidity trap: "The risks poets have taken have been too great; the aesthetic negligence has been profound."[33] There are too many poems and not enough readers; the literary establishment, like the banking system, can no longer inspire confidence: "What began as a subprime poetry problem on essentially unregulated poetry websites, has spread to other, more stable, literary magazines and presses, and contributed to excess poetry inventories that have pushed down the value of responsible poems."[34] Bernstein wittily plays on his insider/outsider status: as both an academic and a purveyor of avant-garde poetry that, in effect, has no market value. Bernstein's address is perhaps

at its most sincere when he suggests that "when the literary system works as it should, poetry and poetry assets flow to and from readers to create a productive part of the cultural field."[35] Bernstein's playful polemic, though not altogether new, has additional resonance in the continuing midst of the Great Recession.

Dworkin, too, has invoked the rhetoric of economic crisis in relation to the glut of poetry, arguing that "poetry faces a Malthusian limit. Bound by discrepant rates of production and consumption, the readerly economy of poetry in the twenty-first century cannot avoid a catastrophic calculus: the rate of consumption quickly hits an arithmetic limit (any one person can only read so much), but the rate of production is increasing geometrically."[36] Like Bernstein, Dworkin advocates a broader field for poetry, recognizing that making poetry more "accessible" will do little to attract readers as opposed to writers. Dworkin proposes a Franco Moretti–inspired reorienting of poetry criticism: "Instead of attempting to account for individual books, the task would be to graph and model the complex poetic ecosystem itself, or to map data in ways that their composite assembly would reveal new information. Rather than look at discrete texts, criticism would turn to charting the relations among texts and visualizing those networks themselves."[37] This description could also serve as an overview of many of the concerns of a poetry that draws on the index form to offer a critique not only of existing systems of literary value, but of larger systems of economic and informational valuation. The index poem itself could be described as a "complex poetic ecosystem" that maps the ambient data of a society increasingly centered on the production and consumption of information.

Two list poems anthologized in *Against Expression*, Charles Bernstein's "My/My/My" and Alexandra Nemerov's "First, My Motorola," exemplify the increasingly commodified nature of everyday life. First published in 1975, Bernstein's poem begins:

my pillow
my shirt
my house
my supper
my tooth
my money
my kite[38]

The simple structure of Bernstein's poem points to the multiplicity of ways in which one can claim to possess something. The "my _____" format primarily lists objects, but also occasionally feelings and sometimes persons. There are no proper names in Bernstein's poem. Presumably Bernstein has exercised authorial agency over the ordering of his list. Nemerov's poem, by contrast, employs nearly the same structure, but lists only brand names in the order in which she encountered them throughout the course of a day:

First, my Motorola
Then my Frette
Then my Sonia Rykiel
Then my Bulgari
Then my Asprey
Then my Kohler[39]

The poem pursues this list for six pages and concludes once again with her Motorola. Bernstein's and Nemerov's work are list poems as opposed to wholly appropriated indexes, but both can be read as indexes of the frequency with which items or names appear. Nemerov's poem reveals a great deal about her consumption habits in the aggregate. With nearly every brand name she mentions, we can infer a product; those inferences cumulatively result in a kind of self-portrait in a mirror of product preference. Two of the brand names that appear most frequently in Nemerov's poem are Apple and Google. "First, My Motorola" is thus a one-day "project of attention" that is a chronicle of product usage as well as a chronicle of information consumption.[40]

Among American poets of the post-Language generation, Tan Lin has perhaps devoted the most attention to the index as a poetic form. Lin describes his method as follows: "*In BlipSoak01*, my impulse was to initiate a random sampling technique or device that would transpire, as it were, within a time-based composition, and that would seem 'self-operating,' i.e. a series of endlessly mutating literary styles no different form various surface effects, most notably the rhythms of a post-capitalist marketplace marked by flexible accumulation and the replacement of durable goods with transitory information structures as the principal commodity, which are in turn indistinguishable from various authors: Riding, Spicer, Oppen, Rakosi, etc."[41] In juxtaposing the work of poets—

particularly poets hostile to capitalism such as the four he cites—with the ambient data of corporate mass culture, Lin makes it difficult to source the information contained in his indexical poems. The effect, he suggests, is one of erasure, which mimics a larger cultural amnesia: "The aim of the work is to erase the database as an impenetrable impediment to the poetic and render the monumental inconsequential and relaxing, with the most relaxing data being those things that have already been forgotten in a culture that exists *in order to be forgotten*."[42] *BlipSoak01* relentlessly times itself—offering down-to-the-second measurements of the time of its articulation in its margins. It becomes difficult, and often impossible, to disentangle the separate sources and discursive forms found within Lin's ambient writing.

In his more recent *Seven Controlled Vocabularies and Obituary, 2004: The Joy of Cooking*, Lin again returns to the index as a primary form—interspersing photographs, found text (which typically consists of "relaxing data"), and what are probably best described as short essays on various aspects of mass culture. In a passage titled "AMERICAN STANDARD CODE for INFORMATION EXCHANGE," Lin writes of the television show *The Apprentice*: "Rather than contemplate the working class, the contestants on *The Apprentice* examine themselves, or more particularly, their fantasies about their working lives and the administered workspace—which is transformed into a TV game show. Or to put it in terms that both working viewer and working contestant can relate to: the ultimate fantasy island is the self-mediated workspace with only one survivor—a boss introjected [as oneself]."[43] Lin alternates between passages of targeted ideology critique (such as the preceding) and more abstract meditations on the nature of poetry and books. Both reality TV and avant-garde poetry, Lin implies, share a common basis in conforming to the informational channels of their time and context. Literary theory would seem to conform to yet another informational channel, as instanced by Lin's borrowing of the complete index to Barthes's *Image–Music–Text*. The "AMERICAN STANDARD CODE," though reductive in the extreme, cannot be bypassed. The ambient work, rather than attempting a direct attack on mass culture, attempts something of a sneak attack, camouflaging itself in standardized informatic patterns. It is metadata (a term played upon in the book's cover design) that matters most in determining whether something is identified as art: "[Today] a work of architecture [or film] or [poem] or [painting] or [novel] should have as

fluid and standardized an ID [OBJECT ID™ SYSTEM] as possible and function like a waiting area, time slot, universal market/currency or metadata standard [square brackets in original]."[44] Lin offers a critique of consumer culture, but he does not suppose that poetry is immune from simplistic forms of classification such as those found in popular shows such as *The Apprentice*. The contestant who fantasizes of a "self-mediated workspace," like the academic poet, partakes of the bureaucratic sublime. Self-mediation of information or aesthetic value would seem to lead to an ideological impasse wherein the viewer or reader chooses sameness rather than difference. Invoking Stein's *Tender Buttons*, Lin writes, "Increasingly, goods and the information about those goods will come to mean one and the same thing. The difference is contracting."[45]

Conceptual works featuring indexical forms often confront the standardization of consumption, as well as the standardization of knowledge production.[46] Rob Fitterman's *Sprawl: Metropolis 30a* operates as a metadata index of the Indian Mound Mall in Heath, Ohio, which Fitterman connects to the Cahokia Mounds in Collinsville, Illinois. Fitterman appropriates the mall's directory, which is overwhelmingly dominated by chain stores, and then proceeds to sample online customer reviews for every store in the mall. Fitterman also includes a promotional statement for the mall that concludes by largely erasing the effects of European conquest on the landscape inhabited by Native Americans: "Despite its hard-luck reputation, the Cahokia site feels immensely peaceful today. There's no whiff of angst from an unsettled spirit world, no sense that anything awful happened here. So feel free to roam the grounds, bring your camera, and show the children the mystery of the Native American Indians that they won't soon forget!"[47] While such appropriation techniques carry with them a strong whiff of kitsch, they also often bring with them social critique—of standardization, of suburbanization, and of hyperconsumerism. Appropriation strategies such as Fitterman's are in some sense profoundly realist in that they accurately depict present realities with a minimum of authorial interference. The poem "Directory," for instance, which appeared in the special "Conceptual and Flarf" section of *Poetry* magazine, is an extremely straightforward index both of the mall's constituent parts, as well as of the numbing experience of knowing in advance what products and services will be found in each:

Macy's
Circuit City
Payless Shoe Source
Sears
Kay Jeweler's[48]

The poem (if it is a poem) is utterly banal, but that is its point. It mimics the rhythms of everyday life in a consumer society; it reproduces redundancy through wholesale serial copying. Similarly emphasizing the effects of corporate homogenization, Rachel Zolf's *Human Resources* deploys a complex blend of appropriated texts in order to present a critique of management culture. While it follows no single constraint consistently, *Human Resources* frequently makes use of word count and search query rankings—often including Arabic numerals within its text. In the following passage, Q stands for search engine queries. Not surprisingly, profane and sexualized keywords top the rankings, and yet political keywords (Bush, America, War) also appear: "Mass affluent consumers' key satisfaction drivers aspirational by most common queries of most-common-English-words engine: fuck Q1 sex Q2 love the shit god i penis cunt a ass jesus dog Q13 pussy hate busy john me hello vagina america bitch cat dick you war yes."[49] The language of personal investment figures prominently in *Human Resources*—interspersed with invocations of Bataillean general economy: "Align this process as it evolves I want everything overlaid with Bataille's catastrophes as cleansing acts, rebalancing the planet. Just like your portfolio, tweaking the delicate equilibrium among asset mix, time horizon and risk tolerance."[50] The implied "you" in this passage would seem to be the individual worker/consumer/investor who is implicated in "the great risk shift." Poetry, too, is involved in this total investment scheme: "Ensconced in the academy pleasuring in the beautiful excess of the unshackled referent, poetry can't stock food banks, warm bodies or stop genocide from affecting my RSP."[51] An RSP, or Retirement Savings Plan, is the Canadian equivalent of an IRA, or Individual Retirement Account. Inverting the expected concern that her RSP's investments will sanction genocide, Zolf worries grimly that genocide will adversely affect her own personal economic interests.

Zolf makes it difficult if not impossible to extract the language of the personal from the language of the corporate or even of the state. *Human*

*Resources* suggests the disturbing interconnectedness of institutions and individuals, and invokes the bureaucratic sublime to suggest that anyone and anything can be reduced to a numerical equivalent. Of the use of numbers and numerology in *Human Resources*, Christian Bök has written, "These cryptograms based upon 'word-rank' . . . call to mind index values or stock prices—or perhaps (because of the Hebraic mystique of gematria), the penal codes at Auschwitz; however, Zolf also suggests that, perhaps, poetry might constitute a kind of encryption that renders us 'illegible' to such capitalist mechanisms."[52] Bök's reading is perhaps overly optimistic, given that Zolf casts doubt on the ability of "the unreadable [to] drive the reader from consuming to producing."[53] Zolf implores us to "look through the mirror, it's the Information Age," suggesting that we can only see ourselves through information.[54] Whereas the dominant mechanisms of capitalism force us to translate all aspects of our lives into numerical data, Zolf insists we do the opposite and translate quantities back into a language capable of bearing ethical content. There is little hope on Zolf's part, however, that re-encryption in itself can effect social change.

Bill Kennedy and Darren Wershler-Henry's 2006 *Apostrophe* likewise uses search engine results to depict the contemporary experience of drowning in data, interpolating its readers within the global catalog of the World Wide Web. Playing on the notion of poetic apostrophe, the poem harnesses Internet search engines to create variations on phrases that take the form "you are _____." So, for instance, a representative section titled "(feeling quite overwhelmed you must say)" runs as follows: "you are a failure ◆ you are able to divine how people are feeling about you ◆ you are continually on trial to prove that your opinions and actions are correct ◆ you are not upset ◆ you are finding this situation can go on for weeks, months or even years."[55] The reader cannot help but be exhausted by what are most often unflattering, if not aggressive, apostrophes. Drawing on the nearly infinite textual reserves of the web, "you" can be almost anyone or anything. In an afterword, Kennedy and Wershler-Henry write, "As a figure of speech, apostrophe implicates the reader in the production of excess information."[56] This excess information takes on the form of a catalog, which, like an index, is radically selective, but also potentially radically generative of associations: "The catalogue is a form that struggles with excess. Its job is to be reductive, to squeeze all of the possibilities that a world of information

has to offer into a definitive set—not just the Greeks, but these Greeks. Its poetic effect, however, is the exact opposite. A catalogue opens up a poem to the threat of a surfeit of information, felt most keenly when the reader wonders, politely, 'How long can this go on?'"[57] The answer is of course dependent on the reader, and/or on what the reader considers "a definitive set." Like Raymond Queneau's *One Hundred Million Million Poems*, the poem can easily outlast its reader's ability to read it in a conventional manner.

Much of the work of Kenneth Goldsmith, perhaps the best known and most influential of conceptual writers using appropriation techniques, can be read as indexical in its wholesale adoption of bureaucratic data. *Day*, a retyping of an entire day's *New York Times*, includes some two hundred pages of stock market quotes. *Soliloquy*, an exact record of every word spoken in a week by Goldsmith, includes many conversations concerning the use of computers circa 1996 (Goldsmith at the time was operating a web design business). Darren Wershler-Henry has written that "the weather in [Goldsmith's] *The Weather* serves as an index of the national mood." Goldsmith's current work-in-progress, *Capital*, is a "rewrite" of Walter Benjamin's *Arcades Project* set in New York City in the twentieth century.[58]

Goldsmith's equation of poetry with "managing language in the digital age" presents many critical conundrums.[59] Although a work such as *Soliloquy* could be described as "oblique autobiography," what are we to make of a project like *Day*, the content of which is entirely predetermined?[60] Consider, for instance, the following passages (I am quoting a large chunk in part because of Goldsmith's insistence on the chunkiness, so to speak, of conceptual appropriation):

HOW AMAZON USES INFORMATION Amazon.com, the No. 1 Internet retailer, has revised its privacy policy, and in doing so has provided a window into how much it uses the customer data it collects to help it and other companies sell more. In the new policy, Amazon has disclosed that it has started sending e-mail marketing messages on behalf of other companies. It also added to a long list of data it collects about users, including financial information, Social Security numbers, product searches and the telephone number from which a user calls Amazon's customer service line. And for the first time, Amazon disclosed it can buy information about customers from outside databases. And if the new initiatives do not help

stem Amazon's huge losses and the company is put up for sale, the new policy says, anyone who buys Amazon will get its customer data.[61]

There would seem to be little need here to worry much about what the New Critics called "the biographical fallacy" (the excessive reading of biography into a literary work), since Goldsmith gives no indication that this passage is any more or less interesting than the hundreds of other pages in either direction. This can only be "news that stays news" if a reader (or a community of readers) finds some kind of significance in it. In a sense, the material of *Day* is a journalistic cross-section of material that hasn't been processed into history worth remembering. While some newspaper readers may feel like they read the entire paper on a given day, in fact they read in a highly selective manner. Some of the oddest sections in *Day* are the pages of stock quotes (the *New York Times* stopped printing such material in 2006). Consider this uncannily Steinian moment, which seems as if it might have been drawn from an alternate version of "Patriarchal Poetry":

> Baxter 1.16 1..4 35 15587 85.63 82.13 83.25–1.50 16.94 6.56 BayView .40 4.1
> 14 4W 9.94 9.38 9.75+0.25
> Continued on Next Page
> The same way my father made it.
> The same way his father made it.
> The same way his father made it.
> The same way his father made it.
> The same way his father made it.
> The same way his father made it.
> The same way his father made it.
> The same way his father made it.
> BELVEDERE
> VODKA
> IMPORTED[62]

The most obvious variable in Goldsmith's retyping is the move from newspaper page to book page—in which Goldsmith tends to ignore most, but not all, of the paper's original formatting. Goldsmith could have lineated this page very differently without doing anything more

than merely retyping. The stock quotes, no longer in neatly ordered columns, devolve into seemingly arbitrary strings of numbers. An advertisement, such as the one for Belvedere Vodka, would typically be set off from the main columns of news. *Day's* reduction of the entire paper to a single typeface and a uniform prose formatting foregrounds the textual disconnect of a vodka ad placed in the midst of a page of what are in effect obsolete prices.

In a short essay that serves as a kind of manifesto for *Day*, Goldsmith writes, "I'm interested in a valueless practice. Nothing has less value than yesterday's news (in this case yesterday's newspaper—what could be of less value, say, than stock quotes from September 1, 2000?)."[63] Elsewhere, however, Goldsmith has given strong indications that his practice is not "valueless." In "The Day" (not to be confused with *Day*), for instance, which was printed in a special conceptual section of *Poetry* magazine edited by Goldsmith, he chose two brief selections from the September 11, 2001, *New York Times*. By a strange process of recirculation, the *Times* even reprinted one of those poems, "Metropolitan Forecast" (the title is self-explanatory), on the ten-year anniversary of the 9/11 attacks, crediting the poem to Goldsmith and ambiguously noting that the poem had appeared in *Poetry* magazine, although presumably the *Times* remained the copyright holder. Paired with Goldsmith's poem in the *Times* on the ten-year anniversary was a more conventional article from November 2001 describing the unseasonably warm autumn.[64] In effect, the *Times* was (re)appropriating its own content.

Goldsmith's other poem for "The Day" further reveals him struggling to conduct a valueless practice (again I quote a large chunk):

Islam

E2 THE NEW YORK TIMES, TUESDAY, SEPTEMBER 11, 2001 ARTS

ABROAD

Continued From First Arts Page

On Islam, Mr. Houellebecq went still further, deriding his estranged

mother for converting to Islam and proclaiming that, while all mono-

theistic religions were "cretinous," "the most stupid religion is Islam."

And he added: "When you read the Koran, you give up. At least the

Bible is

Sexual tourism

and inflammatory
remarks about
Palestinians.
very beautiful because Jews have an extraordinary literary talent." And
later, noting that "Islam is a dangerous religion," he said it was condemned
to disappear, not only because God does not exist but because it was
being undermined by capitalism.[65]

The words at the center of the selection, set off from the main text and
lineated like verse, are not Houellebecq's. The article in question does
mention that Houellebecq's recent novel features a sexual tourist as
its protagonist—but nowhere do the words "inflammatory / remarks
about / Palestinians" appear in the text of the original article.[66] Gold-
smith's interjection puts Houellebecq's xenophobia into even sharper
relief—the very act of selecting this passage demonstrates that Gold-
smith's aims, even if they are primarily ironic or parodic, are not free of
value judgments.

Though Goldsmith's writings have attracted considerable attention,
perhaps his most influential accomplishment has been his role in the
creation of *UbuWeb*, arguably the world's largest online archive of avant-
garde writing, music, and film.[67] *UbuWeb* exemplifies what the concep-
tual artist Seth Price has termed the phenomenon of "dispersion" during
"the last few decades of global corporate sprawl."[68] According to Price,
"Distributed media can be defined as social information circulating
in theoretically unlimited quantities in the common market, stored or
accessed via portable devices."[69] Price's description has much in com-
mon with descriptions of the goals of the relational aesthetics move-
ment in aspiring to a more democratic system of circulation.[70] Price's
most extensive work of conceptual writing, *How to Disappear in Amer-
ica*, takes the form of an ambivalent handbook on said topic. Largely
appropriated from a single online source, the book indulges fantasies
of escape only to relentlessly demonstrate how difficult it in fact would
be to step outside the bureaucratic oversight of contemporary society.
*How to Disappear in America* presents a paranoid vision of a world in
which our every action leaves some trace of our presence.

Price's *How to Disappear in America* foregrounds the disappearance
of its author in complex ways. Price acknowledges that the book is

mostly appropriated, but he also claims to have spent considerable time editing and writing it. Price rearranges and adds to his main source, an online text available at SkepticTank.org. The complexities do not end there: in 2006, the German artist Susanne Bürner published substantially the same source text(s) under the title *Vanishing Point: How to Disappear in America Without a Trace*.[71] Both Price's and Bürner's texts are distributed by the New York–based Printed Matter, although I can find no other institutional relationship between the two works. Bürner's version predates Price's, but the two artists seem to have been independently attracted to the same source. When I asked a salesperson at Printed Matter about the relation between the two books, she replied, "That's the trouble with appropriation," implying that it made little difference if appropriation artists independently drew on the same texts. In another sense, however, the troubling fluidity of (re)appropriation could be part of the point: the writer/artist is dispersed into an amorphous, ahistorical mass of textuality. Fascinatingly, the original author of the text, Fredric Rice, has accused Seth Price of violating his copyright (Rice does not seem to be aware of the earlier Bürner text).[72] According to Rice, his work is to be used for noncommercial purposes only. Ironically, then, Price's appropriation has commercialized (under the copyright imprimatur of the Leopard Press) what was before a universally available free online work. Rice's original intention, so far as I can tell, was to write an imaginative how-to guide for people trying to escape cults or abusive relationships. When reframed by Price and Bürner, much of Rice's deliberately cartoonish writing comes off as more paranoid and delusional than it in fact is.

Importantly, all three incarnations of the *How to Disappear in America* text conclude with an eloquent court ruling written by Montana State Supreme Court Justice James C. Nelson. Like other recent conceptual works such as Christian Bök's *Xenotext Experiment*, Sarah Jacobs's *Deciphering Human Chromosome 16: Index to the Report*, and Kim Rosenfield's *re: evolution*, the *How to Disappear* text is particularly focused on issues of bioinformatics (the storage, retrieval, and interpretation of biological data).[73] Justice Nelson's ruling contains the following statement:

We are a throw-away society. My garbage contains the remains of what I eat and drink. It may contain discarded credit card receipts along with

yesterday's newspaper and junk mail. It might hold some personal letters, bills, receipts, vouchers, medical records, photographs and stuff that is imprinted with the multitude of assigned numbers that allow me access to the global economy and vice versa.

My garbage can contains my DNA.[74]

Despite his concern, the judge ruled that evidence collected from a suspect's trash was not eligible for Fourth Amendment protection. The irony then in concluding with this ruling is that it stands as a futile critique of the system of criminal data collection. The text seems to be saying, in effect, that there is no way to disappear in America, no way to step outside the total index of governmental and corporate data systems.

Matthew Timmons's *Credit* (2009) similarly engages the inescapability of data collection systems.[75] Praised by Craig Dworkin and Vanessa Place, *Credit* consists of eight hundred pages of financial documents addressed to its author. *Credit* so far exists only in three copies, and its author notes that he himself is not able to afford its $199 cost on the print-on-demand site Lulu.com. Since I, too, am unable to access or afford this book, I will quote from Dworkin's description: "Documenting the social and economic space defined by the writing that falls between bulk mailing and fine print (full color and some of it very fine indeed), CREDIT appropriates direct mail credit card solicitations and advertisements in order to explore the nature of disclosure in a series of plays between display and censorship, see-thru windows and security envelopes, financial promise and legal threat.... Testing the limits of publishing—CREDIT is the largest and most expensive book publishable via Lulu—Timmons' book is well beyond most readers' means."[76] Although much of the personal information is redacted, *Credit* nonetheless would seem to reveal much about how individual borrowers are interpolated by a system of massive redundancy. Despite (or perhaps because of!) his credit woes, Timmons, according to Vanessa Place, received twenty-six credit card offers within a span of three weeks. There would seem to be little hope that even the most vigilant consumer could ever wholly resist, ignore, or understand such a fantastically complex array of financial opportunities and risks. The bourgeois investor may contemplate the ethics of his or her retirement investments; the indebted consumer is forced to trust corporations whose fine print cannot possibly be comprehended.

Perhaps the most troubling conceptual inventory yet to appear is Vanessa Place's *Statement of Facts*. First published on *UbuWeb* and now available as a Lulu.com volume released under the imprint of Blanc Press, *Statement of Facts* reproduces legal documents (with names redacted) obtained by Place, who is a criminal appellate attorney specializing in the defense of sexual offenders. *Statement of Facts* is the first of a three-part trilogy called *Tragodía*; two further installments, *Statement of the Case* and *Argument*, are forthcoming. The Blanc Press version of *Statement of Facts* mimics the appearance of the Princeton University Press Charles Singleton translation of *The Divine Comedy*—but there is no redemption (*purgatorio*) or transcendence (*paradiso*) within Place's tragic epic of suffering, guilt, and violence. *Statement of Facts* showcases the *Rashomon*-like effects of conflicting testimony, and makes its readers question the factuality of criminal documents—opening a window on to the bureaucratic mechanisms of the criminal justice system.

Despite Place not having written a word of the 430 pages of *Statement of Facts*, the perspective of the author can hardly be neutral, given that Place has written extensively on rape law in her critical book *The Guilt Project: Rape, Morality, and Law*. Both *The Guilt Project* and *Statement of Facts* make for extremely difficult reading. While *Statement of Facts* purports to passively index court documents, *The Guilt Project* offers a sophisticated and well-argued account of the hypocrisies and injustices of contemporary rape law. Place does not mount a comprehensive socioeconomic critique in *The Guilt Project*, but she does repeatedly emphasize that poverty contributes greatly to the justice system's fundamental lack of fairness. From the perspective of issues having to do with information classification and data excess, *Statement of Facts* could be taken to suggest that no amount of documentation will necessarily give us an objective account of disputed events. It is not possible to evaluate Place's provocative claims here; however, I would note that *The Guilt Project* insists on the culpability of society as a whole. Place emphasizes that contemporary media culture plays a role in shaping notions of guilt and innocence, and she foregrounds her own role within the system: "There's no getting out from under the calloused thumb, because in today's Western world, even artists abrogate their artistic identity, and authors their authority, and it's all big business, or big business writ small, for even indie's corporate-lite, and where there once was a thirst for culture, now there's not much left but a gag effect. . . . I work

for the guilty. I am guilty."[77] Place's rhetoric is extreme, and her prognosis bleak. The conditions she describes, importantly, take place in a world where "we live engulfed in images, and there is no transcendence."[78]

The works described so far in this chapter (with the possible exception of Bernstein's "My/My/My") passively index in whole or in part an existing data set. By contrast, a poem such as Paul Violi's "Index" actively indexes a fictional biography.[79] First published in *Harper's* in 1982, the poem has no direct link to the famous "Harper's Index," which was introduced in 1984. Violi's "Index" is a chronology of the life of a fictional painter named Sutej Hudney, which begins at childhood and ends with "last words." The poem performs an intriguing retrospective indexing, but it is distinctly "un-conceptual" by comparison to the writing of Lin, Place, or Goldsmith. Violi's poem is arguably more a work of short fiction than one of appropriation—interested more in an ironic displacement of the self than in a critique of information or classification systems.

Thanks in some measure to the promotional tactics of its practitioners, conceptual writing has too often been read as a literature of exhaustion rather than as a literature of engagement. While exhaustion may indeed be a goal of conceptual writing (which Place and Fitterman describe in terms of an allegory of failure), it can also be the case that many of the works just described can be placed in a realist, or even socialist realist, tradition.[80] The works described above conform well to Mitchell Whitelaw's description of indexical data art. Whitelaw describes recent works which "construct a notion of data—of its capacities, qualities, and significance—in the ways that they use it. Data is here first of all indexical of reality. These works gather existing data from the network, drawing together thousands of elements that are already, unproblematically, 'out there.' This reinforces the sense of collapsed indexicality; these data points have causes (authors) of their own that in some sense guarantee their connection to reality, or at least defer the question of connection."[81] Rather than post-individualist cross-sections of random data, works of conceptual writing can be read as realistic depictions of how "we spend our lives engaged with data systems."[82] We are data; data is us—whether in terms of bioinformatics or in terms of the bureaucratic sublime's fusion of the personal and the corporate, or the personal and the academic. As Derek Beaulieu writes, "The Internet is not something that challenges who we are or how we write, it is who we are and how we write."[83] Whitelaw suggests that one of the goals of data art is

the construction of a new "data subjectivity." Conceptual writing helps us counter the myth of the anarchic Internet, of the self-created digital subject, of the poet as a figure of retreat to a time before the information society. By a seeming paradox, conceptual writing may be the most creative, most technologically aware writing now being found, generated, and lost in the vastness of electronic textuality. Artists and writers can no more easily chose to opt out of the information society than they can chose the era in which they live. For the generation of poets that came of age in the 1990s and 2000s, data excess is a fundamental precondition for new (and recycled) writing. As Price puts it kitschily in *Dispersion*, "With more and more media readily available through this unruly archive [the Internet], the task becomes one of packaging, producing, reframing, and distributing; a mode of production analogous not to the creation of material goods, but to the production of social contexts, using existing material. Anything on the internet is a fragment, provisional, pointing elsewhere. Nothing is finished. What a time you chose to be born!"[84]

# "PROLIFERATING RAW DATA"

## ROBERT GRENIER IN THE EXPANDED FIELD OF NEW MEDIA POETICS

Technē belongs to bringing-forth, to poiēsis; it is something poietic.

—Martin Heidegger, "The Question Concerning Technology"

When you work on the computer, you work inside the prison house of the language of the computer. And it's endlessly fascinating and is opening up new vistas all the time, but you never get beyond the immediate relation with the machine.

—Robert Grenier, in conversation with Ramsey Scott

Only in the past few years has the poet Robert Grenier owned a computer.[1] Since the late 1980s, the bulk of his work has taken the form of poems drawn by hand. One of the few typed poems in the 1991 collection *What I Believe: Transpirations/Transpiring: Minnesota* reads:

```
C O M P U T E R
c o m p
u t e r
w i t o
r a t e ? ?
*
c o m p
u t e r
l i t e
w h a t ?
? [2]
```

The poem would seem something of a dubious nonresponse to the seemingly benign question, Are you computer literate? But the poem deserves closer attention. The poem depends on mono-spaced type (largely made obsolete by the word processor) to achieve its four-letter-per-line symmetry on the page. Highly conscious of its appearance on the page, the poem ends with a handwritten question mark. The word "computer" is never misspelled, but presumably "literate" is misspelled twice, introducing the possibility of several puns within the lineation of the words (or parts of compound words) "rate" and "lite." Could the poem be spoken in an Elmer Fudd voice? Or could this even be the voice of Randolph Dud, the self-deprecatory figure who elicited Grenier's 1971 pronouncement "I HATE SPEECH," which Ron Silliman and others have cited as the inaugural slogan of Language writing? Considering that Grenier was primarily mounting a tongue-in-cheek critique of "voice-based" poetics, it might be overreaching to read too much into the persona of R. Dud. On the one hand, "C O M P U T E R" could be read as a protest against the introduction of the word processor—especially given that Grenier's poems have consistently been extraordinarily self-conscious of their hand- and typewritten materiality on the page. On the other hand, perhaps the poem is suggesting that to resist computerization is to be a dud.

On occasion I have envisioned an updated version of Randolph Dud writing "I HATE SCREENS"—a sentiment (albeit typically delivered in less emphatic terms) that I hear routinely from students and colleagues. There is a greater abundance of poetry readily accessible than ever before, and yet I find it unappealing to read poetry on my laptop or on an e-reader, despite the fact that I use both regularly. Many of Grenier's 1970s and 1980s poems seem almost to require the characteristic look and feel of the IBM Selectric's Courier font. To publish poetry now in Courier would perhaps seem affected or nostalgic—yet it is difficult to imagine Grenier's *Phantom Anthems* (1986) or *A Day at the Beach* (1984) in any other typeface.[3]

One poem in particular from *A Day at the Beach* epitomizes the issues raised in this book. The poem is part of a sequence, and its meaning is intimately related to its presentation, and so I reproduce the page spread in full (Figure 16). *A Day at the Beach* is divided into three sections: morning, midday, and evening. Each page of the book is

correspondingly divided into three parts. The book's frontispiece and endsheet feature photographs of the poet writing the word "sand" in sand. The poem (or section of the sequence) most relevant to my discussion here reads:

```
PROLIFERATING RAW DATA
rising level of generalization

abandoned object actually except as example
```

In some sense, the poem could stand in for the entire project of trying to create a one-to-one correspondence between the book of poems and the experience of being at the beach. The book is replete with mundane details of going to the beach—from sand lice to pelicans—and is radically episodic and spare in its details. The aggregate data of the poems (literally letter by letter and word by word) proliferates, without necessarily taking the form of a conventional lyric of self-discovery. Though located at the *locus classicus* of the liminal (or littoral) poem, the seaside, the book does not operate along the lines of the traditional romantic lyric. *A Day at the Beach* does not build to a crisis or denouement. There is no speaker who suggests that there is a "rising level of generalization," and follows this with "abandoned object actually except as example." Nor are there definite or indefinite articles to introduce these statements. We are seemingly reading the equivalent of field notes. The poet seems content to let raw data speak for itself.

But raw data does not speak for itself, and Grenier's spatialization of the poems on the page does much to contribute to their meaning.[4] The poet himself has written that in "*A Day at the Beach*, set of six things on a page where two 'columns' stacked 3-each, everywhichway, maintain [*sic*] a 'story-line' in various directions—'purely the possible'— while maintaining a sturdy 'narrative line' throughout, leaning on the top-to-bottom/left to right 'development' of the 'thrice-told' seventy-two frames.... Written or not, the sledgehammer contemplation of things with clumsy orders of verbiage—& printing of same, if that route, impressing paper—is a furious, fortuitous, foolish & noble act."[5] In equating narrative and attention, Grenier seemingly de-emphasizes the importance of plot, instead emphasizing the role of the media by

WRITING INSTRUMENT

warmth of the page

with the fingers in hand

SHAPES

shape only

subadjacent to

chaos expanding

forming shapes

FOOL

madman though ye beem

*Figure 16.* Robert Grenier, from *A Day at the Beach* (1984).

PROLIFERATING RAW DATA

rising level of generalization

abandoned object actually except as example

BUUUHH

end of the next
shift the
smoke stacking

the steamstack
the swing shift
getting off

and through which the poem is conveyed, as well as emphasizing the
role of sense perception (or immediate cognition) in the production
and reception of the poem. Time of day becomes the narrative structure
of the sequence. For Grenier, "All writing is essentially 'narrative'—not
only storytelling/prose—but any combination of letters, that moves in
time."[6] In Grenier's own terms, A Day at the Beach is a multidirectional
narrative, highly conscious of the mediation between the poet's thoughts
and experiences and their ultimate "realization" on paper. Elsewhere
Grenier has written of his handwritten poems, "The graphic qualities
have no interest in themselves."[7] The goal, rather than to produce an
aesthetically pleasing work of visual art, is to undertake a "conjuring act,
groping toward phenomena with the apparatus of the hands making
marks + entirely preoccupied w/moving fingers—as if that participated
in the World At Large in some direct way that was both significant to it/
called forth by it."[8] This quote, it should be noted, is transcribed from
a handwritten essay. Grenier takes the verb "to draw" literally in the
sense of sketching, but also in the sense of drawing forth the most basic
units of language itself, the very shapes of letters. At an even more basic
level, Grenier draws attention to the individual lines that make up letter-
forms. Like Blake's illuminated books, Grenier's poetry over the past
two decades rejects typographic representation in favor of hand-drawn
letters. Grenier is, in some ways, a font unto himself, sacrificing conven-
tional legibility in the interests of a gestural, embodied script.

Barrett Watten (importantly Grenier's co-editor of the journal This,
in which the famous "I HATE SPEECH" proclamation first appeared) has
recently argued that emergent media technologies should lead us to con-
sider "poetics in an expanded field." Grenier's writing, which has appeared
in many media formats—letterpress, offset, poster, handwriting, inter-
views, index cards, JavaScript, e-mail, Giclée prints, and even sand—is
an exemplary case of such a poetics in an expanded field. Tim Wood
writes that "Grenier's poetry isn't nostalgic nor is it the work of a lud-
dite.... Grenier's poetry proleptically embraces recent technological
advances, anticipating a future that has now arrived."[9]

The beach would traditionally be considered among the most poetic
and least mediated of all locations: its very sublimity overwhelms medi-
ation, requiring a different kind of attention to data. By focusing on
the smallest possible units of meaning, A Day at the Beach operates
as an interface between the human and the natural landscape, between
meaning-making and raw sense-data—as well as between poet and

reader. For Alexander Galloway and Eugene Thacker, "data does not come into being fully formed and whole but instead is inflected with shape as the result of specific social and technical processes. Interface is how dissimilar data forms interoperate."[10] One of the index cards from Grenier's *Sentences* reads in its entirety:

interoperoptatative[11]

Grenier's portmanteau could suggest that it is one card between (*inter*) other similarly sized poem works (*opera*) meant to optimize a fluid nonsequential interaction between writer and reader. This single-word poem, like much of Grenier's writing, pushes the boundaries of what is recognizable as poetry—it attempts *to be what it says* by interoperating on its readers. It can be read either in its original context within a box of five hundred five-by-eight index cards (Figure 17), or in its later web-based JavaScript incarnation (Figure 18), in which the order of the cards is randomized.

The word "interoperoptatative" is also located conspicuously near the center of Grenier's poster poem CAMBRIDGE MASS (Figure 19),

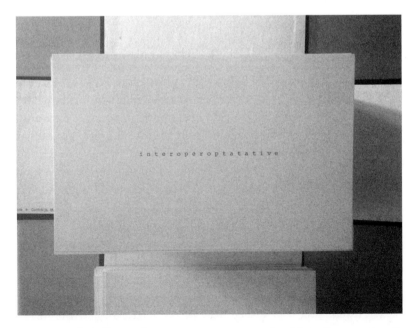

*Figure 17.* Robert Grenier, "interoperoptatative," from *Sentences* (1978).

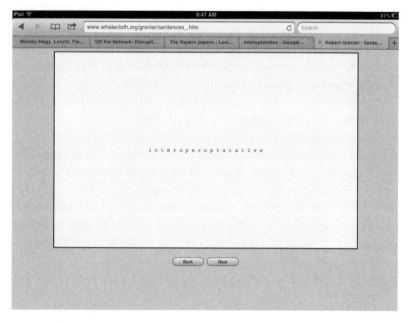

*Figure 18.* "i n t e r o p e r o p t a t a t i v e," from *Sentences* (2003 web version, written in JavaScript, viewed on an iPad 2 in Safari browser).

which includes approximately 275 poems, some selected from *Sentences.*[12] The word is thus literally shared between two (or arguably three) of Grenier's works. Printed by Lyn Hejinian's Tuumba Press in 1979, the poster poem (Figure 20) is described in a contemporaneous brochure from the press as "a mind's eye view of Cambridge, Mass. & environs." Grenier denies that there is any inherent order to the spatialization of the poems on the poster, but he also describes the work "as a rough and subjective map of the Boston area, centered on Cambridge, spreading out in the topography of memory. . . . The black of the right margin would be the Atlantic Ocean, and the middle of the black edge at the top Ipswich Bay, Cape Ann the upper right and Connecticut the lower left—a map of mental relations."[13] In her important early essay "The Rejection of Closure," Hejinian pairs CAMBRIDGE M'ASS with Bruce Andrews's "Love Songs," and categorizes both as

"Field work," where words and lines are distributed irregularly on the page . . . in which the order of the reading is not imposed in advance. Any

reading of these works is an improvisation; one moves through the work not in straight lines but in curves, swirls, and across intersections, to words that catch the eye or attract attention repeatedly.[14]

I would add to this that CAMBRIDGE M'ASS is not only a subjective poem–map drawn from memory, it is also an information-rich visual work that makes strong demands on the reader/viewer. Each word, phrase, or sentence is, so to speak, inseparable from the "mass" of text that surrounds it. The word "i n t e r o p e r o p t a t a t i v e," for instance, might allude to Louis Zukofsky's emphasis on *optics* in his definition of objectivism—especially as Zukofsky's definition is alluded to elsewhere in the poster.[15] The word "i n t e r o p e r o p t a t a t i v e" might also refer obliquely to the opening chapter of Harvard professor F. O. Matthiessen's *American Renaissance*, which is titled (after Whitman) "In the Optative Mood." This one neologism is polyvalent in its associations—and its different print and electronic contexts only add to its allusive complexity.

Grenier's poetry, like that of his contemporary Aram Saroyan, is often categorized as minimalist (a term Grenier disavows). On their own, Grenier's poems may be minimalistic, but in the aggregate they are anything but—they revel in a non-serial simultaneity. There can be no singular focal point to CAMBRIDGE M'ASS, just as there can be no consistent sequence to *Sentences*. CAMBRIDGE M'ASS overloads the reader with details of everyday life—much as the modern city-dweller (e.g., Leopold Bloom) is continually exposed to a barrage of textuality in the form of signage, much of which only serves to constitute an ambient background to everyday life. A map, especially one drawn from memory, is always perspectival and always mediated. Grenier's poems typically emerge from the simplest of production techniques and media, and yet in that very simplicity they continually refer back to the forms of mediation (type, codex, pen, screen, scanning) that make them possible in their final incarnations. Liz Kotz suggests in her reading of the relation of text and image in conceptual art that "1960s artists recurrent obsession with the most minimal, redundant, and empty of messages can be seen as an effort to foreground the channels of transmission and the conditions of reception in . . . new communications media."[16] Craig Dworkin makes a similar case in his recent *No Medium*, in which he argues that media "consist of analyses of networked objects in specific social settings," and

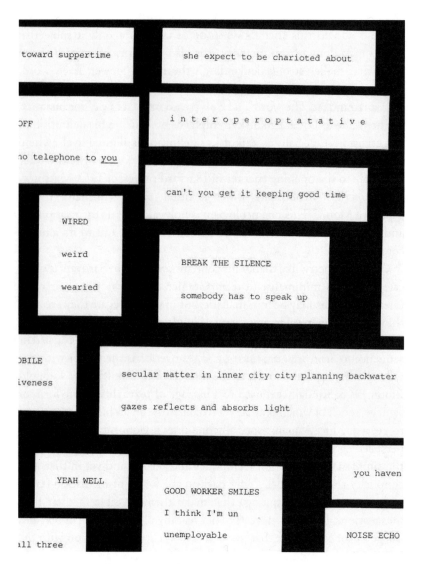

*Figure 19.* Robert Grenier, detail from CAMBRIDGE M'ASS (1979).

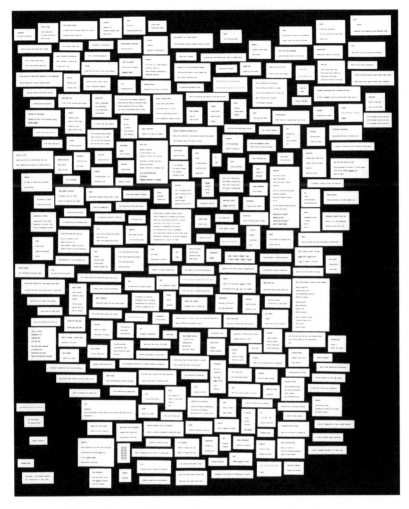

*Figure 20.* Robert Grenier, full view of CAMBRIDGE M'ASS (1979).

"are not merely storage mechanisms somehow independent of the acts of reading or recognizing the signs they record."[17]

Speaking of his close friend Larry Eigner, Grenier insists on the centrality of the typewriter and of various media forms to Eigner's poetics: "It's tempting to think of [Eigner] as one of the very first (almost 'interactive,' since the U.S. Mail came fairly quickly, not like letters in the 19th century) 'Virtual Reality' American persons—'all by themselves,' yet bound up intimately and actively (in their minds), in very

significant 'contact' with other persons 'on screen' (PBS television and otherwise, continuingly, FM radio—what he heard and saw via these media was an element of 'what there was'/probably extraordinarily 'real,' for him, to which he often 'reacted' in his poems."[18] Grenier's critical prose, like his poetry, insists on an im*media*cy of communication. According to Grenier, Eigner's physical limitations are an advantage in terms of his ability to experience more fully a world increasingly mediated by radio, television, and computers. Grenier's poetry, like Eigner's, is interactive without the use of a digital interface—or rather his poetry is "i n t e r o p e r o p t a t a t i v e." Mark Hansen has recently claimed that "mediation forms the very basis of human existence. Human beings literally exist in the mediation of the world, which is to say, in a medium that has always been technical."[19] Grenier's writing helps us see that poetry as a medium, no less than any other literary genre, continues to have an important role to play in a world of proliferating raw data— both on-screen and off.

# ACKNOWLEDGMENTS

It was my good fortune to have Ursula Heise as my dissertation adviser, as I first encountered many of the themes of this book in her Poetry/ Technology graduate seminar. The other members of my dissertation committee—Michael Golston, Brent Hayes Edwards, Bruce Andrews, and Lytle Shaw—also deserve special thanks. Michael Golston has taught me more about poetry and poetics than anyone else—his scholarly generosity is beyond compare. Craig Dworkin has been a central influence on my work; his comments on this project in its early stages were crucial to its genesis. Bruce Andrews kindly discussed his work with me on multiple occasions. I did not know either Tan Lin or Robert Grenier when I set out to write about their work, but both have since become good friends, and I thank them for their commentary.

At Bard College, I had the exceptional luck to have Robert Kelly, Ann Lauterbach, Joan Retallack, and Michael Ives as colleagues. Michael Ives in particular has been a key interlocutor, tirelessly commenting on my works in progress.

Much of this book was written under the auspices of a junior/postdoctoral fellowship at the Fox Center for Humanistic Inquiry at Emory University. While at Emory, Benji Kahan read and commented on much of my work. Michael Moon, James Mulholland, and Christina Hanhardt offered instructive criticism on an early version of chapter 6.

Craig Saper and Michael North kindly responded to my Bob Brown queries. Phoebe Brown, Christopher Perry Brown, and Rory Brown generously discussed Brown with me in person. Parts of this book were presented as papers at the Columbia/Penn Poetics Conference, the American Comparative Literature Association Conference, the Society

for Textual Studies Conference, the Modernist Studies Association Conference, and the Bruce Andrews Symposium at Fordham University. Library research was conducted at UCLA Special Collections, Emory University's Danowski Archive, the Beinecke Library at Yale, the Berg Collection at the New York Public Library, the Fales Collection at NYU, the Charles Olson Research Collection at the University of Connecticut, Stanford University Special Collections, and the Columbia University Rare Book and Manuscript Library.

The following is a partial list of those who commented on the book at various stages: Ondrea Ackerman, Michael Aird, Chris Alexander, Andrea Andersson, Doug Armato, Melissa Watterworth Batt, Paul Benzon, Charles Bernstein, Jen Bervin, Sebastian Campos, Sarah Cole, Seamus Cowan, Kenneth Crews, Douglas Davey, Katherine Finkelstein, Robert Fitterman, David Foote, Kristen Gallagher, Michael Gallagher, Drew Gardner, Kenneth Goldsmith, Alicia Gomez, Robert Grenier, Emily Hamilton, Cole Heinowitz, Lyn Hejinian, Ryan Howe, Danielle Kasprzak, Charley Lanning, Tan Lin, Trisha Low, Alan Lucey, Simon Morris, Karla Nielsen, Justin Parks, Bergen Pierson, Alexander Provan, Jean-Michel Rabaté, Natalie Robehmed, Kim Rosenfield, Judah Rubin, Athena Ryno, Matthew Sandler, Andrew Shurtz, Danny Snelson, Stefanie Sobelle, Carol Stephens, Mike Stoffel, Dennis Tenen, Nick Thurston, Jenelle Troxell, Sam Truitt, Eugene Vydrin, Charles Walls, Erin Warholm, Robert Weston, Tim Wood.

Forsyth Harmon deserves an honorary Ph.D. for all the editing she did on this project.

If I hadn't already dedicated my dissertation to my mother, Sarah Stephens, this book would be dedicated to her.

# NOTES

## Preface

1. According to Pelle Snickars and Patrick Vonderau, the pocket phone was in fact first proposed not long after the original Bloomsday: "The American journalist Robert Thompson Sloss (1872–1920) in 1908 envisioned the future of mobile media in his contribution to the German book *Die Welt in hundert Jahren*. Over a century before the iPhone was launched, Sloss rightly predicted the advent of a 'wireless century' marked by the availability of 'pocket phones' that would allow instant and worldwide connections between individuals or even groups, for personal conversations from the North Pole as much as for conference calls to New York City; for transmitting sounds and music, moving images and written documents; and even for making bank payments." Pelle Snickars and Patrick Vonderau, eds., *Moving Data: The iPhone and the Future of Media* (New York: Columbia University Press, 2012), 5.

2. Some objects in Bloom's pocket, such as money, are implied but not specifically recorded. Bloom's budget for June 16, for instance, is revealed in the "Ithaca" chapter (17.1455ff.). James Joyce, *Ulysses*, ed. Hans Walter Gabler (New York: Vintage, 1986), 584.

3. Tom Standage, *The Victorian Internet: The Remarkable Story of the Telegraph and the Nineteenth Century's Online Pioneers* (New York: Walker, 1998), 102.

4. F. T. Marinetti, *Critical Writings*, ed. Günter Berghaus and trans. Doug Thompson (New York: Farrar, Straus and Giroux, 2006), 14. For a critique of the claim that information and communications technologies result in the "death of distance," see Vincent Mosco, "Loose Ends: The Death of Distance, the End of Politics," in *The Digital Sublime: Myth, Power, and Cyberspace* (Cambridge, Mass.: MIT Press, 2004), 85–116. Leo Marx notes that the metaphor of the annihilation of space and time predates the Industrial Revolution: "No stock phrase in the entire lexicon of progress appears more often than 'the annihilation of space and time,' borrowed from one of Pope's relatively obscure poems ('Ye

Gods! annihilate but space and time . . .')." *The Machine in the Garden: Technology and the Pastoral Ideal in America* (New York: Oxford University Press, 1964), 194. The metaphor is particularly resonant in Karl Marx's *Grundrisse*, which argues that "capital by its nature drives beyond every spatial barrier. Thus the creation of the physical conditions of exchange—of the means of communication and transport—the annihilation of space by time—becomes an extraordinary necessity for it. Only in so far as the direct product can be realized in distant markets in mass quantities in proportion to reductions in the transport costs, and only in so far as at the same time the means of communication and transport themselves can yield spheres of realization for labour, driven by capital; only in so far as commercial traffic takes place in massive volume—in which more than necessary labour is replaced—only to that extent is the production of cheap means of communication and transport a condition for production based on capital, and promoted by it *for that reason*. All labour required in order to throw the finished product into circulation—it is in economic circulation only when it is present on the market—is from capital's viewpoint a barrier to be overcome." *Grundrisse: Foundations of the Critique of Political Economy*, trans. Martin Nicolaus (London: Penguin, 1973), 524–25.

5. Roger E. Bohn and James E. Short, *How Much Information? 2009 Report on American Consumers*, Global Information Industry Center, University of California, San Diego, http://hmi.ucsd.edu/pdf/HMI_2009_ConsumerReport_Dec9_2009.pdf.

6. Luciano Floridi, *Information: A Very Short Introduction* (Oxford: Oxford University Press, 2010), 6.

7. Ibid.

8. For an intelligent overview of information overload metaphors, see Mark D. Bowles, "Liquefying Information: Controlling the Flood in the Cold War and Beyond," and in particular the section of the essay titled "Water as Control Metaphor in the Cold War," in *Cultures of Control*, ed. Miriam Levin (New York: Routledge, 2000), 225–46.

9. James Gleick, *The Information: A History, a Theory, a Flood* (New York: Pantheon, 2011).

10. This statistic (or earlier variants of it) has been reported, for instance, by Matt Richtel in "Read This and Cost Your Company Dough," *New York Times*, December 22, 2008, http://bits.blogs.nytimes.com/2008/12/22/read-this-and-cost-your-company-dough; as well as by Andrea Coombes, "Don't You Dare E-mail This Study," *Wall Street Journal*, May 17, 2009, http://online.wsj.com/article/SB124252211780027326.html.

11. Samuel R. Delany, *Stars in My Pocket Like Grains of Sand*, 20th anniv. ed. (Middletown, Conn.: Wesleyan University Press, 2004).

12. Bernard Stiegler, "Within the Limits of Capitalism, Economizing Means Taking Care," *Ars Industrialis*, n.d., http://www.arsindustrialis.org/node/2922.

13. Barack Obama, "Remarks by the President at Hampton University Commencement," *The White House*, May 9, 2010, http://www.whitehouse.gov/the-press-office/remarks-president-hampton-university-commencement.

14. For more on Hejinian's phrase, see Alan Golding, "'Isn't the Avant-Garde Always Pedagogical': Experimental Poetics and/as Pedagogy," *Iowa Review* 32, no. 1 (2002): 64–71.

15. Jay David Bolter and Richard Grusin define "remediation" as "the representation of one medium in another medium." *Remediation: Understanding New Media* (Cambridge, Mass.: MIT Press, 1999), 45. As W. J. T. Mitchell and Mark B. N. Hansen note, this definition is "itself, fundamentally, a remediation of McLuhan" and his claim that "the 'content' of any medium is always another medium." *Critical Terms for Media Studies* (Chicago: University of Chicago Press, 2010), xiv. Transcoding is a competing, overlapping term, which would seem to be slightly less sweeping in its implied denunciation of content. According to Lev Manovich, "In new media lingo, to 'transcode' something is to translate it into another format." *The Language of New Media* (Cambridge, Mass.: MIT Press, 2004), 47.

16. Brian Reed, "Visual Experiment and Oral Performance," in *The Sound of Poetry/The Poetry of Sound*, eds. Craig Dworkin and Marjorie Perloff (Chicago: University of Chicago Press, 2009), 284.

17. Ibid.

18. William Carlos Williams, "Asphodel, That Greeny Flower," *Collected Poems, Volume II: 1939–1962*, eds. A. Walton Litz and Christopher MacGowan (New York: New Directions, 1986), 318. Copyright 1944 by William Carlos Williams. Reprinted by permission of New Directions Publishing Corporation.

## Introduction

1. Sara Janius has made a parallel argument with regard to the modernist novel, and notes that poetry would be an equally appropriate genre for exploring modernism's relation to technological change. Janius argues that "modernist aesthetics from Marcel Proust to James Joyce is an index of a technologically mediated crisis of the senses, a perceptual crisis that ultimately cuts across the question of art as such. . . . The modernist era coincides with the historical period that saw the emergence of, among other things, phonography, chronophotography, cinematography, radiography, telephony, electricity, and technologies of speed. Yet traditional accounts of modernism, marked as they often have been by an antitechnological bias, have obscured this coexistence. . . . This makes the high modernist novel, along with poetry, an exceptionally appropriate field for the study of the relations of technology and aesthetics, since it is precisely in this domain that the incompatibility between the two has been most strongly asserted." *The Senses of Modernism: Technology, Perception, and Aesthetics* (Ithaca, N.Y.: Cornell University Press, 2002), 1–2. For comparable accounts of the interrelationship

of technology and modernist poetics, see Tim Armstrong, *Modernism, Technology, and the Body* (Cambridge: Cambridge University Press, 1998), and Julian Murphet, *Multimedia Modernism: Literature and the Anglo-American Avant-Garde* (Cambridge: Cambridge University Press, 2009). For a comparable study of postwar American fiction in relation to information overload, see John Johnston, *Information Multiplicity: American Fiction in the Age of Media Saturation* (Baltimore: Johns Hopkins University Press, 1998). Malcolm McCullough's *Ambient Commons: Attention in the Age of Embodied Information* (Cambridge, Mass.: MIT Press, 2013) offers an excellent overview of what he calls urban informatics, or the ubiquitous display of text and information in public spaces.

2. Mitchell Whitelaw, "Art Against Information: Case Studies in Data Practice," *fibreculture: internet theory + criticism + research* 11 (2008), http://www.journal.fibreculture.org/issue11/issue11_whitelaw.html.

3. Victoria Vesna, ed., *Database Aesthetics: Art in the Age of Information Overflow* (Minneapolis: University of Minnesota Press, 2007), 114.

4. Tim Wu, *The Master Switch: The Rise and Fall of Information Empires* (New York: Norton, 2010).

5. See Richard Ohmann, *Selling Culture: Magazines, Markets, and Class at the Turn of the Century* (New York: Verso, 1996).

6. Mark Morrisson, *The Public Face of Modernism: Little Magazines, Audiences, and Reception, 1905–1920* (Madison: University of Wisconsin Press, 2001), 3.

7. Walter Benjamin, "One-Way Street," in *Selected Writings, Vol. 1: 1913–1926*, eds. Marcus Bullock and Michael Jennings (Cambridge, Mass.: Harvard University Press, 1996): 456.

8. Ibid.

9. Ibid., 457.

10. Kenneth Goldsmith, "A Week of Blogs for the Poetry Foundation," in *The Consequence of Innovation: 21st Century Poetics*, ed. Craig Dworkin (New York: Roof Books, 2008), 148. Goldsmith is not the first to draw attention to Stein's *Making of Americans* as a point of origin for a poetics of exhaustion or unreadability; his championing of *The Making of Americans* draws on the Language writers' interest in Stein's writing, which in turn owes a debt to the interest of 1960s writers such as Dick Higgins, whose Something Else Press republished *The Making of Americans* in 1966. Despite (or perhaps due to) its legendary unreadability, *The Making of Americans* has a fascinating history as a performance text. From 1975 to 2000, the Paula Cooper Gallery in New York hosted annual marathon readings attended by artists and writers such as Alison Knowles and John Cage. In 2012, the journal *Triple Canopy* revived this tradition with considerable success. A complete reading takes approximately forty-eight hours.

11. Mark Goble, *Beautiful Circuits: Modernism and the Mediated Life* (New York: Columbia University Press, 2010), 88.

12. Gertrude Stein, *A Primer for the Gradual Understanding of Gertrude Stein*, ed. Robert Bartlett Haas (Los Angeles: Black Sparrow, 1971), 29.

13. The writing of Stein and Brown's "Readies," like much of the writing discussed in this book, largely defies New Critical techniques of close reading—techniques that have often been criticized for sequestering poetry from politics and history. New Critical close reading has also come under attack for privileging a small canon of lyric poetry—put in different terms, New Criticism might also be described as sequestering poetry from the information glut of the expanded canon of world literature. Franco Moretti has proposed a program of "distant reading" as a way to reorient literary scholarship away from close reading. For Moretti, "the trouble with close reading (in all of its incarnations, from the new criticism to deconstruction) is that it necessarily depends on an extremely small canon. This may have become an unconscious and invisible premise by now, but it is an iron one nonetheless: you invest so much in individual texts only if you think that very few of them really matter. Otherwise, it doesn't make sense. And if you want to look beyond the canon (and of course, world literature will do so: it would be absurd if it didn't!) close reading will not do it. It's not designed to do it, it's designed to do the opposite. At bottom, it's a theological exercise—very solemn treatment of very few texts taken very seriously—whereas what we really need is a little pact with the devil: we know how to read texts, now let's learn how not to read them. Distant reading: where distance, let me repeat it, is a condition of knowledge: it allows you to focus on units that are much smaller or much larger than the text: devices, themes, tropes—or genres and systems." "Conjectures on World Literature," *New Left Review* 1 (January–February 2000), http://www.newleftreview.org/A2094.

14. See Hannah Higgins and Douglas Kahn, *Mainframe Experimentalism: Early Computing and the Foundations of the Digital Arts* (Berkeley: University of California Press, 2012). For more on the emergence of digital poetries during this period, see Christopher Funkhouser, *Prehistoric Digital Poetry: An Archaeology of Forms* (Tuscaloosa: University of Alabama Press, 2007).

15. Lyn Hejinian, *My Life* (Los Angeles: Green Integer, 2002), 70.

16. David M. Goldes and Jonathan Spira, *Information Overload: We Have Met the Enemy and He Is Us*, Basex Inc. Corporate Report, New York, 2007, http://www.iorgforum.org/wp-content/uploads/2011/06/InformationOverload.BasexReport.pdf. Geoffrey Nunberg notes that it is impossible to find a definitive source for this frequently recycled claim. See "Farewell to the Information Age," in *The Book History Reader*, 2nd ed., eds. David Finkelstein and Alistair McCleery (London: Routledge, 2006), 509–25.

17. Bertram Gross, *The Managing of Organizations: The Administrative Struggle* (New York: Free Press, 1964). The title of James G. Miller's 1960 article "Information Input Overload and Pyschopathology," *American Journal of Psychiatry* 116 (1960): 695–704, demonstrates an earlier incarnation of the term—several years later, the "input" seems to have become superfluous.

18. Marshall McLuhan, *Understanding Me: Lectures and Interviews*, eds. Stephanie McLuhan and David Staines (Cambridge, Mass.: MIT Press, 2003), 52.

19. See Alvin Toffler, *Future Shock* (New York: Bantam, 1970), 350–64.

20. For a useful survey of the influence of the U.S. military on the development of information technologies, as well as its crucial support of emergent fields such as cognitive science, see Paul N. Edwards, who observes that "World War II nearly drowned in the noise of its own technology." Partially in response, "from the early 1940s until the early 1960s, the armed forces of the United States were the single most important driver of digital computer development." *The Closed World: Computers and the Politics of Discourse in Cold War America* (Cambridge, Mass.: MIT Press, 1996), 210, 43.

21. Ann Blair's *Too Much to Know: Managing Scholarly Information Before the Modern Age* (New Haven, Conn.: Yale University Press, 2010), and Alex Wright's *Glut: Mastering Data Through the Ages* (Ithaca, N.Y.: Cornell University Press, 2007), provide the best overviews of information overload before the modern era. Wright suggests Zenodotus's catalog at the library of Alexandria as a point of origin. Blair does not provide a singular historical point of origin, but importantly suggests that the phenomenon predated printing.

Michael Hobart and Zachary Schiffman similarly argue that "information overload did not so much originate as culminate with printing, which intensified a problem whose intimations surfaced several centuries earlier. Scribal document production in the Middle Ages had already advanced to the point where it required the development of increasingly sophisticated systems for managing information. The earliest of these systems simply involved the physical arrangement of material on a page; later systems applied more and more elaborate taxonomic principles to the problem of information management." *Information Ages: Literacy, Numeracy, and the Computer Revolution* (Baltimore: Johns Hopkins University Press, 1998), 90. Katherine Ellison suggests a later date: "By the late seventeenth century, information emerges as a concept, and almost immediately it is imagined as a physically and psychologically threatening entity, at once material and immaterial, with the capability of overloading the human body and intellect." *Fatal News: Reading and Information Overload in Early Eighteenth-Century Literature* (New York: Routledge, 2006), 1. Innumerable historical examples can be cited, such as this passage from Washington Irving's *Sketchbook*: "The world will inevitably be overstocked with good books. It will soon be the employment of a lifetime merely to learn their names. Many a man of passable information, at the present day, reads scarcely anything other than reviews; and before long a man of erudition will be little better than a walking catalogue." *History, Tales, and Sketches*, ed. James Tuttleton (New York: Library of America, 1977), 114.

It is clearly impossible to specify a distinct point of origin for a phenomenon so complex and so deeply woven into the fabric of communication and data storage—although clearly an exponential growth in both the quantity of data, as well as concern over the saturation of said data, has taken place over the course

of the past 150 years. See also Richard R. Harper, *Texture: Human Expression in the Age of Communications Overload* (Cambridge, Mass.: MIT Press, 2010), Douglas Rushkoff, *Present Shock: When Everything Happens Now* (New York: Penguin, 2013), and Nicholas Carr, *The Shallows: What the Internet Is Doing to Our Brains* (New York: Norton, 2010).

22. As examples of the genre I am calling "information overload self-help," see Richard Saul Wurman, *Information Anxiety: What to Do When Information Doesn't Tell You What You Need to Know* (New York: Doubleday, 1989), Kevin A. Miller, *Surviving Information Overload: The Clear, Practical Guide to Help You Stay on Top of What You Need to Know* (Grand Rapids, Mich.: Zondervan, 2004), and Larry Rosen, *iDisorder: Understanding Our Obsession with Technology and Overcoming Its Hold on Us* (New York: Palgrave Macmillan, 2012). For a slightly more highbrow incarnation of the information overload self-help manual, see William Powers's *Hamlet's Blackberry: A Practical Philosophy for Building a Good Life in the Digital Age* (New York: Harper, 2010).

In *Self-Help, Inc.: Makeover Culture in American Life* (New York: Oxford University Press, 2005), Micki McGee suggests that contemporary self-help books primarily address what she refers to as "belabored selves"—American workers who suffer from increasing pressures on their time. McGee argues that "in describing the nature of work on the self, the literatures of self-improvement offer two distinct options: the path of endless effort and the path of absolute effortlessness. These correspond to the modernist/antimodernist, rational/expressive pairs encountered before. Those experts who are committed to rational self-mastery (for example, Stephen R. Covey, Anthony Robbins, Helen Gurley Brown) propose the effortful life, while those who focus on the expressive dimension (for example, Deepak Chopra, Julia Cameron, Richard Carlson, and Eckhart Tolle) emphasize self-acceptance through a mystical oneness. Despite their apparent opposition, both approaches represent an effort to come to terms with the problem of contingency and vulnerability in both the labor force and life itself" (145).

Self-help books which offer advice on how to combat information overload typically suggest the path of effortful self-control and precise time management. Excessive Internet usage is often described as a particular threat to the productivity and happiness of the individual, and many of these books seem to take knowledge workers as their normative audience. For more on self-help and time management, see also my article (cowritten with Robert Weston), "Free Time: Overwork as an Ontological Condition," *Social Text* 94 (Spring 2008): 135–64.

23. Richard R. John employs "the bureaucratic sublime" in *Spreading the News: The American Postal System from Franklin to Morse* (Cambridge, Mass.: Harvard University Press, 1998); Robert Pepperell, "the information sublime" in "An Information Sublime: Knowledge After *The Postmodern Condition*," *Leonardo* 42, no.

5 (2009), http://www.mitpressjournals.org/toc/leon/42/5; Vincent Mosco, "the digital sublime" in "Loose Ends." For a broad historical account, see David R. Nye, *American Technological Sublime* (Cambridge, Mass.: MIT Press, 1996).

24. Immanuel Kant, *Critique of Judgment*, trans. Werner Pluhar (Indianapolis: Hackett, 1987), 101.

25. Sianne Ngai, *Ugly Feelings* (Cambridge, Mass.: Harvard University Press, 2007).

26. Sven Spieker, *The Big Archive: Art from Bureaucracy* (Cambridge, Mass.: MIT Press, 2008), 5. See also James Beniger, *The Control Revolution: Technological and Economic Origins of the Information Society* (Cambridge, Mass.: Harvard University Press, 1986).

27. Spieker, *The Big Archive*, 8.

28. Jean Baudrillard, *Simulacra and Simulation*, trans. Sheila Faria Glaser (Ann Arbor: University of Michigan Press, 1994), 79.

29. According to the widely used "General Definition of Information" (GDI), information is understood "in terms of data + meaning" (Floridi, *Information*, 20). Information is "understood as semantic content . . . only if . . . the data are well formed . . . and meaningful" (21). Alex Wright offers a simple definition in his *Glut*: "Information is the juxtaposition of data to create meaning" (10). Thus information overload might more accurately be called "data overload," in that what readers are being overloaded by is not necessarily meaning, but rather a flood of data which blocks access to (meaningful) information.

30. David Shields, *Reality Hungers: A Manifesto* (New York: Knopf, 2010), 82.

31. Walter Benjamin, "The Storyteller," in *Selected Writings, Vol. 3*, eds. Howard Eiland and Michael Jennings (Cambridge, Mass.: Harvard University Press, 2002), 147.

32. T. S. Eliot, *Complete Poems and Plays, 1909–1950* (New York: Harcourt Brace, 1971), 96.

33. Theodor Adorno and Max Horkheimer, *The Dialectic of Enlightenment: Philosophical Fragments*, trans. Edmund Jephcott and ed. Gunzelin Schmid Noerr (Stanford, Calif.: Stanford University Press, 2002), 139. Daniel Headrick offers a succinct, less polemical, version of what could be called the "dialectic of information": "We have so much information, and yet the 'betterment of humankind' still escapes us. Nevertheless, we still want information—more than ever, faster than ever. If this seems like a conundrum, it is because we confuse two meanings of progress: the instrumental and the moral. Instrumental progress relates to the means of achieving a given goal: getting from place to place, communicating with someone far away, destroying a city. Moral progress judges the goal. In ethical terms, the human race has made little or no progress in the past three centuries. But the instrumental progress in information systems . . . has been phenomenal. And no one would want it otherwise." *When Information Came of Age: Technologies of Knowledge in the Age of Reason and Revolution, 1700–1850* (Oxford: Oxford

University Press, 2002), 12. As Headrick's last sentence shows, although complaints about information inundation may be frequent, outright refusals of the instrumental progress afforded by information technology are rare.

34. See Siegfried Kracauer, *The Mass Ornament: Weimar Essays*, trans. and ed. Thomas Levin (Cambridge, Mass.: Harvard University Press, 1995), and Walter Benjamin, *The Work of Art in the Age of Its Technological Reproducibility and Other Writings on Media*, eds. Michael Jennings et al. and trans. Edmund Jephcott et al. (Cambridge, Mass.: Harvard University Press, 2008).

35. A more recent version of this argument is provided in Theodore Roszak's *The Cult of Information: A Neo-Luddite Treatise on High-Tech, Artificial Intelligence, and the Art of True Thinking* (Berkeley: University of California Press, 1994): data glut is not some unforeseen, accidental fluctuation of supply, like a bumper crop of wheat. It is a strategy of social control, deliberately and often expertly wielded. It is one of the main ways in which modern governments and interest groups obfuscate issues to their own advantage; they dazzle and distract with more raw data than the citizenry can hope to sort through (164).

It is difficult to prove Roszak's claims empirically—although the American populace's general failure to sort through the "raw data" surrounding the lead-up to the 2003 invasion of Iraq could be cited as a prime example. The communications scholar Susan J. Douglas writes that "the great irony of our time is that just when a globe-encircling grid of communications systems indeed makes it possible for Americans to see and learn more than ever about the rest of the world, Americans have been more isolated and less informed about global politics." "The Turn Within: The Irony of Technology in a Globalized World," in *Rewiring the "Nation": The Place of Technology in American Studies*, eds. Carolyn de la Peña and Siva Vaidhyanathan (Baltimore: Johns Hopkins University Press, 2007), 71–72. Given the pervasiveness of this sentiment, it is difficult to explore in detail here.

36. For more on modernism and mass culture, see Andreas Huyssen, *After the Great Divide: Modernism, Mass Culture, Postmodernism* (Bloomington: Indiana University Press, 1987), Mark Wollaeger, *Modernism, Media, and Propaganda: British Narrative from 1900 to 1945* (Princeton, N.J.: Princeton University Press, 2006), Thomas Strychacz, *Modernism, Mass Culture, and Professionalism* (Cambridge: Cambridge University Press, 1993), Allison Pease, *Modernism, Mass Culture, and the Aesthetics of Obscenity* (Cambridge: Cambridge University Press, 2009), and Goble, *Beautiful Circuits*.

37. T. S. Eliot, *The Sacred Wood: Essays on Poetry and Criticism* (London: Methuen, 1920), 9.

38. Ezra Pound, *Guide to Kulchur* (New York: New Directions, 1952), 23.

39. Ezra Pound, *ABC of Reading* (New York: New Directions, 1960), 17.

40. I. A. Richards, "Mr. Eliot's Poems," in *T. S. Eliot: The Contemporary Reviews*, ed. Jewel Spears Broker (Cambridge: Cambridge University Press, 2004), 138.

41. Ezra Pound, *Ezra Pound Speaking: Radio Speeches of World War II*, ed. Leonard Doob (Westport, Conn.: Greenwood Press, 1978), 172.

42. T. S. Eliot, *Selected Essays, 1917–1932* (New York: Harcourt Brace, 1932), 247.

43. Many of modernism's canonical figures depict taking time out from their overloaded schedules in order to carry out their true vocation as poets: T. S. Eliot at Lloyd's Bank; Wallace Stevens at an insurance company; William Carlos Williams at his medical practice. Eliot himself would write to his patron John Quinn in 1921, "The chief drawback to my present mode of life is the lack of *continuous* time, not getting more than a few hours together for myself, which breaks the concentration required for turning out a poem of any length." *Letters of T. S. Eliot: Vol. 1, 1898–1921*, ed. Valerie Eliot (New York: Houghton Mifflin, 1988), 557.

44. See Joanne Yates, *Control Through Communication: The Rise of System in American Management* (Baltimore: Johns Hopkins University Press, 1993), and Alan Liu, *Laws of Cool: Knowledge Work and the Culture of Information* (Chicago: University of Chicago Press, 2004) and "Transcendental Data," in *Local Transcendence: Essays on Postmodern Historicism and the Database* (Chicago: University of Chicago Press, 2008), 209–36.

45. See Ian Burn, "The 'Sixties: Crisis and Aftermath (or the Memoirs of an Ex-Conceptual Artist)," in *Conceptual Art: A Critical Anthology*, eds. Alexander Alberro and Blake Stimson (Cambridge, Mass.: MIT Press, 1999), 392–409.

46. For more on poetry in the workplace in the postwar period, see Jasper Bernes, "John Ashbery's Free Indirect Labor," *Modern Language Quarterly* 74, no. 4 (2013): 517–40.

47. Robert Fitterman, *Rob the Plagiarist: Others Writing by Robert Fitterman* (New York: Roof Books, 2009), 10–11.

48. *Oulipo Compendium*, eds. Alastair Brotchie and Harry Matthews (London: Atlas Press, 1998), 14.

49. "Author's Introduction" to *The Wedge*, in *Collected Poems, Volume II*, 54.

50. Raymond Queneau, "Wealth and Limit," in *Letters, Numbers, Forms: Essays, 1928–1970*, trans. Jordan Stump (Urbana: University of Illinois Press, 2007), 45.

51. Ibid., 46.

52. Ibid., 45.

53. Marjorie Perloff, *Radical Artifice: Writing Poetry in the Age of Media* (Chicago: University of Chicago Press, 1991), 19.

54. Bruce Sterling, "The Life and Death of Media," in *Sound Unbound: Sampling Digital Music and Culture*, ed. Paul D. Miller (Cambridge, Mass.: MIT Press, 2008), 75. Recent books championing "the Whig theory of technological history" not surprisingly tend to downplay or ignore information overload; instead, they often tout the benefits of collaboration and of the wiki model of knowledge production. See for instance Cass R. Sunstein, *Infotopia: How Many Minds Produce Knowledge* (New York: Oxford University Press, 2006), Clay Shirky,

*Here Comes Everybody: The Power of Organizing Without Organizations* (New York: Penguin, 2008), Don Tapscott and Anthony Williams, *Wikinomics: How Mass Collaboration Changes Everything* (New York: Portfolio, 2006), and Clive Thompson, *Smarter Than You Think: How Technology Is Changing Our Minds for the Better* (New York: Penguin, 2013). The legal scholar Cass Sunstein is particularly notable within this group, since he headed the Obama administration's Office of Information and Regulatory Affairs (established by the Paperwork Reduction Act of 1980).

55. Edward R. Tufte, *Envisioning Information* (Cheshire, Conn.: Graphics Press, 1990), 50–51.

56. Steven Johnson, *Interface Culture: How New Technology Transforms the Way We Create and Communicate* (New York: Basic Books, 1997), 237.

57. Alexander Galloway's *Protocol: How Control Exists After Decentralization* (Cambridge, Mass.: MIT Press, 2004) offers a particularly stringent critique of what might be called the ideology of the transparent interface. Galloway contests the tendency "for contemporary critics to describe the Internet as an unpredictable mass of data—rhizomatic and lacking central organization. This position states that since new communication technologies are based on the elimination of centralized command and hierarchical control, it follows that the world is witnessing a general disappearance of control as such" (8). Against the notion that the web is an anarchic mass which it is possible to navigate through neutral interfaces, Galloway proposes that rather than conceiving of the structure of the Internet as decentralized, we should conceive of it as distributed: "The Net is not simply a new, anarchical media format, ushering in the virtues of multiplicity and diversity, but is, in fact, a highly sophisticated system of rules and regulations (protocol)" (69). Galloway takes no position on information overload, but he does suggest that "it is *through* protocol that one must guide one's efforts not against it" (17). See also Galloway's *The Interface Effect* (London: Polity, 2013).

58. Yohai Benkler, *The Wealth of Networks: How Social Production Transforms Markets and Freedom* (New Haven, Conn.: Yale University Press, 2007), 172.

59. Ibid., 174. Eli Pariser's *The Filter Bubble: What the Internet Is Hiding from You* (New York: Penguin, 2011) argues convincingly that although the rise of personalized Internet content delivery strategies (on the part of Google, Facebook, Apple, and others) may counter the effects of the information glut, those same strategies also threaten to put unprecedented control over media content and personal information in the hands of a small number of corporations. Pariser also expresses considerable concern about what he calls "The Adderall Society" (discussed below).

60. Ibid., 235.

61. Richard Foreman et al., "Discussion of *The Pancake People; or, The Gods Are Pounding My Head*," *Edge: The Third Culture*, n.d., http://www.edge.org/3rd _culture/foreman05/foreman05_index.html.

62. Ibid.

63. Ibid.

64. Ibid.

65. Mark Poster, *Information Please: Culture and Politics in the Age of Digital Machines* (Durham, N.C.: Duke University Press, 2006), 52.

66. Ibid., 154.

67. Jonathan Crary, *Suspensions of Perception: Attention, Spectacle, and Modern Culture* (Cambridge, Mass.: MIT Press, 2001), 13.

68. Ibid., 35–36. In the discussion that follows, I use both the designations ADD and ADHD, although I prefer the current term ADHD, which replaced ADD in the DSM-III-R introduced in 1987. Many humanists, including Crary, have continued to use the designation ADD long after it has gone out of use within the psychiatric literature.

69. Ibid., 37.

70. Thomas E. Brown, *Attention Deficit Disorder: The Unfocused Mind in Children and Adults* (New Haven, Conn.: Yale University Press, 2006), 246.

71. Torkel Klingberg, *The Overflowing Brain: Information Overload and the Limits of Working Memory* (Oxford: Oxford University Press, 2008), 19, 39.

72. Bernard Stiegler, *Taking Care of Youth and the Generations*, trans. Stephen Barker (Stanford, Calif.: Stanford University Press, 2010), 87, 89.

73. Betsy Sparrow, Jenny Liu, and Daniel M. Wegner, "Google Effects on Memory: Cognitive Consequences of Having Information at Your Fingertips," *Science* 333 (2011): 778.

74. Ibid.

75. N. Katherine Hayles, "Hyper and Deep Attention: The Generational Divide," *Profession* (2007): 187. See also Hayles, *How We Think: Digital Media and Contemporary Technogenesis* (Chicago: University of Chicago Press, 2012), and Cathy Davidson, *Now You See It: How the Brain Science of Attention Will Transform the Way We Live, Work, and Learn* (New York: Viking, 2011). See also Karen Littau, *Theories of Reading: Books, Bodies and Bibliomania* (Cambridge: Polity, 2006).

76. For an excellent (if somewhat alarmist) introductory overview of questions surrounding technology and distraction in the classroom, see "Digital Nation: Life on the Virtual Frontier," a special episode of the PBS television show *Frontline*, n.d., http://www.pbs.org/wgbh/pages/frontline/digitalnation/.

77. Georges Perec, *Species of Spaces and Other Pieces*, trans. John Sturrock (London: Penguin, 1997), 182.

78. Tan Lin, *plagiarism/outsource, Notes Towards the Definition of Culture, Untitled Heath Ledger Project, a history of the search engine, disco OS* (Canary Islands: Zasterle Press, 2010), n.p.

79. "The Tortoise and the Hare: Dale Smith and Kenneth Goldsmith Parse Slow and Fast Poetries," *Jacket 2* 38 (Fall 2009), http://www.jacketmagazine

.com/38/iv-smith-goldsmith.shtml. See also Smith's "Slow Poetry: An Introduction," *Big Bridge*, 2009, http://www.bigbridge.org/BB14/SLOWPO.HTM.

80. "The Tortoise and the Hare."

81. Ibid.

82. John Ashbery, *Collected Poems, 1956–1987*, ed. Mark Ford (New York: Library of America, 2008), 280.

83. Joshua Clover, "'A Form Adequate to History': Toward a Renewed Marxist Poetics," *Paideuma* 37 (January 2010): 326.

84. Sue Currell, "Streamlining the Eye: Speed Reading and the Revolution of Words, 1870–1940," in *Residual Media*, ed. Charles Acland (Minneapolis: University of Minnesota Press, 2007), 350.

85. The slow versus speed reading debate has taken a number of forms. Lindsay Waters (the influential executive editor of Harvard University Press) has recently advocated a return to slow reading. See Waters's "Time for Reading," *Chronicle Review* 53, no. 23 (2007), http://chronicle.com/article/Time-for-Reading/10505, in which he takes Franco Moretti to task for being a kind of destroyer of literature. In order to do so, Waters somewhat misrepresents Moretti's case for "distant reading." Moretti does not call for speed reading or an end to reading, but for a more systematic scholarship. So far as I am aware, Moretti has made no programmatic attempt to influence the reading habits of non-scholars. Moretti frames the issue of "distant reading" in terms of canonicity—which is also to say, in terms of the epistemological question: How can any scholar be expected to have a comprehensive knowledge of a field so broad as world literature? Waters wants to read Moretti as reducing literature to a utilitarian function, but in terms of Moretti's larger project this seems beside the point. The problem, in other words, is not Moretti's supposedly philistine reading program; the problem is where and when to find "time for reading" the vast quantity of literature at the scholar's disposal. For more on distant reading, see note 13, as well as Moretti's *Distant Reading* (London: Verso, 2013). For a compelling overview of how reading practices have changed in the past few decades, see the collection *I Read Where I Am: Exploring New Information Cultures*, ed. Mieke Gerritzen, Geert Lovink, and Minke Kampman (Amsterdam: Graphic Design Museum, 2011).

86. For more on the history of reading machines and their influence on twentieth-century literature, see Terry Harpold, *Ex-foliations: Reading Machines and the Upgrade Path* (Minneapolis: University of Minnesota Press, 2008).

87. Joan Retallack, *The Poethical Wager* (Berkeley: University of California Press, 2003), 192.

88. Ibid.

89. Jonathan Beller, "Paying Attention," *Cabinet* 24 (Winter 2006–7), http://www.cabinetmagazine.org/issues/24/beller.php.

90. Herbert Simon, *Administrative Behavior: A Study of Decision-Making Processes in Administrative Organizations*, 4th ed. (New York: Free Press, 1997), 22–23.

91. Herbert Simon, "Designing Organizations for an Information-Rich World," in *Computers, Communication, and the Public Interest*, ed. Martin Greenberger (Baltimore: Johns Hopkins University Press, 1971), 40–41.

92. See Daniel Kahneman, *Thinking, Fast and Slow* (New York: Farrar, Straus and Giroux, 2011). For a fascinating reading of Frank O'Hara's poetry in the context of Tversky and Kahneman's choice theory, see Michael Clune, *American Literature and the Free Market, 1945–2000* (Cambridge: Cambridge University Press, 2010), 53–76.

93. Barry Schwartz, *The Paradox of Choice: Why More Is Less* (New York: Harper Perennial, 2005).

94. Richard Lanham, *The Economics of Attention: Style and Substance in the Age of Information* (Chicago: University of Chicago Press, 2007), 21.

95. Mihaly Csikszentmihalyi, *Flow: The Psychology of Optimal Experience* (New York: Harper and Row, 1990), 28–29.

96. In *The Attention Economy: Understanding the New Currency of Business* (Boston: Harvard Business School Press, 2001), John Beck and Thomas Davenport give a condensed history of all human progress through the lens of attention: "Every business is an engine fueled by attention. In the farms and fields of primitive societies, and in the factories of the Industrial Revolution, physical manpower drove the economy. In the information era, knowledge was power—the more a company had, the more successful it could be. But now, as flows of unnecessary information clog worker brains and corporate communication links, attention is the rare resource that truly powers a company. Recognizing that attention is valuable, that where it is directed is important, and that it can be managed like other precious resources is essential in today's economy" (17).

97. Anson Rabinbach, *The Human Motor: Energy, Fatigue, and the Origins of Modernity* (Berkeley: University of California Press, 1992), 300.

98. H. G. Wells's 1937 "The World Brain" is often cited as an early example of the global brain metaphor. For a general overview, see "The Electronic Brain" chapter of Douwe Draaisma and Paul Vincent, *Metaphors of Memory: A History of Ideas About the Mind* (Cambridge: Cambridge University Press, 1995), 142–51. For more on the development of human computer metaphors, see David Alan Grier, *When Computers Were Human* (Princeton, N.J.: Princeton University Press, 2007).

99. Peter Shillingsburg, *From Gutenberg to Google: Electronic Representations of Literary Texts* (Cambridge: Cambridge University Press, 2006), 165.

100. Kenneth Golsdmith, *Uncreative Writing* (New York: Columbia University Press, 2011), 218.

101. John Ashbery, *The Tennis Court Oath* (Middletown, Conn.: Wesleyan University Press, 1962), 15.

102. Jasper Bernes has convincingly read Ashbery's poetry, and especially his 1956 poem "The Instruction Manual," as commentaries on office work in the postwar era. See "John Ashbery's Free Indirect Labor."

103. Jacques Derrida, *Archive Fever: A Freudian Impression*, trans. Eric Prenowitz (Chicago: University of Chicago Press, 1996), 7.

104. There is a considerable literature (most of it nonacademic) on the noosphere and/or "noetic consciousness." For an overview see David Pitt and Paul Samson, eds., *The Biosphere and Noosphere Reader: Global Environment, Society, and Change* (New York: Routledge, 1999).

105. Klingberg, for instance, asserts, "The brains with which we are born today are almost identical to the those with which Cro-Magnons were born forty thousand years ago. . . . The same brain now has to take on the torrent of information that the digital society discharges over us. A Cro-Magnon human met in one year as many people as you and I meet in one day. The volume and complexity of the information we're expected to handle continues to increase" (*Overflowing Brain*, 10–11).

106. Nicholas Carr's recent *The Shallows: What the Internet Is Doing to Our Brains* argues that the Internet has begun to affect the physiology of our brains. Research in this area remains inconclusive at best.

107. Mel Nichols, "I Google Myself," *Poetry* 194, no. 4 (2009): 318–19.

108. For more on this, see Rodrigo Qian Quiroga, *Borges and Memory* (Cambridge, Mass.: MIT Press, 2012).

109. Jorge Luis Borges, *Collected Fictions*, trans. Andrew Hurley (New York: Penguin, 1998), 118.

110. Freud also insists that "our mental apparatus . . . has an unlimited capacity for new perceptions and nevertheless lays down permanent—even though not unalterable—memory-traces of them." "A Note on the Mystic Writing-Pad," in *The Archive*, ed. Charles Merewether (Cambridge, Mass.: MIT Press, 2006), 21.

111. This claim is informed by Ursula Heise's discussion of the overpopulation debate and its effect on writers such as John Cage from the late 1960s onward. See "Among the Everywheres: Global Crowds and the Networked Planet," in *Sense of Planet and Sense of Place: The Environmental Imagination of the Global* (Oxford: Oxford University Press, 2008), 68–90. Fred Turner's *From Counterculture to Cyberculture: Stewart Brand, the Whole Earth Network, and the Rise of Digital Utopianism* (Chicago: University of Chicago Press, 2008) details the fascinating interplay between Stewart Brand and figures such as Paul Ehrlich (author of the 1968 *Population Bomb*) and Gregory Bateson, both of whom were professors of Brand's.

112. Nicolas Bourriard, *Postproduction* (New York: Lukas and Sternberg, 2002), 13. According to Bourriard, "Postproduction is a technical term from the audiovisual vocabulary used in television, film, and video. It refers to the set of processes applied to recorded material: montage, the inclusion of other visual or audio sources, subtitling, voice-overs, and special effects" (ibid.). Drawing on Bourriard, the art critic John Kelsey has recently suggested that the "relational

aesthetics" movement was succeeded by a "hyperrelational aesthetics" movement which "emerged between 9/11 and the credit crisis and so can be squarely situated in relation to the collapse of the neoliberal economy." "Next-Level Spleen," *Artforum* 51, no. 1 (2012): 413. Kelsey explicitly links the rise of hyperrelational aesthetics to the advent of ubiquitous portable computing: "For most artists today, the laptop and phone have already supplanted the studio as primary sites of production. Early signs of this shift were evident in what became known as relational aesthetics, which in retrospect, seems wrongly defined as a practice in which communal experience became the medium. It is more properly understood, rather, as a capitalist–realist adaptation of art to the experience economy, obviously, but also to the new productive imperative to go mobile, as a body and a practice" (412).

113. Michel Foucault, *The Archeology of Knowledge*, trans. A. M. Sheridan Smith (New York: Vintage, 1972), 130.

114. Craig Dworkin, "Hypermnesia," *boundary 2*, vol. 36, no. 3 (2009): 95.

115. Friedrich Nietzsche, *Unfashionable Observations*, trans. Richard T. Gray (Stanford, Calif.: Stanford University Press, 1995), 116.

116. Ibid., 110.

117. Ibid., 109.

118. Quoted in Friedrich Kittler, *Discourse Networks, 1800/1900*, trans. Michael Metteer and Chris Cullens (Stanford, Calif.: Stanford University Press, 1990), 200.

119. As Viktor Mayer-Schönberger notes in his recent *Delete: The Virtue of Forgetting in the Digital Age* (Princeton, N.J.: Princeton University Press, 2009), "Through cheap storage technology, keeping digital information has become not only affordable, but frequently cheaper than taking the time to selectively delete some of it" (91).

120. Bernard Stiegler, "Memory," in *Critical Terms for Media Studies*, eds. Mark Hansen and W. J. T. Mitchell (Chicago: University of Chicago Press, 2010), 67–68.

121. Jacques Derrida, *Paper Machine*, trans. Rachel Bowlby (Stanford, Calif.: Stanford University Press, 2005), 17.

122. Gertrude Stein, *The Making of Americans* (Normal, Ill.: Dalkey Archive, 1995), 175.

123. Quoted in Lucy Lippard, *Six Years: The Dematerialization of the Art Object from 1966 to 1972* (Berkeley: University of California Press, 1973), 252.

124. Gustave Flaubert, *Bouvard and Pécuchet*, trans. Mark Polizzotti with an introduction by Raymond Queneau (Urbana, Ill.: Dalkey Archive, 2005), x.

125. Ibid., 318.

126. Craig Dworkin, "Introduction," in *Against Expression: An Anthology of Conceptual Writing*, eds. Craig Dworkin and Kenneth Goldsmith (Evanston, Ill.: Northwestern University Press, 2011), xlvi.

127. Flaubert, *Bouvard and Pécuchet*, 280.

128. Ibid.

129. Ibid., 316, 280.

130. *Against Expression*, xviii.

131. Ibid.

132. Marcus Boon, *In Praise of Copying* (Cambridge, Mass.: Harvard University Press, 2010), 47.

133. Ibid., 76.

134. Ann M. Blair, *Too Much to Know: Managing Scholarly Information Before the Modern Age* (New Haven, Conn.: Yale University Press, 2010), 55.

135. "Hypermnesia," 85.

136. *Archive Fever*, 68.

137. Stein, *The Making of Americans*, 185.

138. For the fullest articulation of this position, see Kittler's *Optical Media* (Cambridge: Polity, 2010).

139. Friedrich Kittler, *Gramophone, Film, Typewriter*, trans. Geoffrey Winthrop-Young and Michael Wutz (Stanford, Calif.: Stanford University Press, 1999), 263.

## 1. "Reading at It"

1. Gertrude Stein, *Writings, 1932–1946*, eds. Catherine R. Stimpson and Harriet Chessman (New York: Library of America, 1998), 823.

2. Ibid.

3. Ibid.

4. For an overview of the rise of information overload in the immediate postwar period, see Bowles, "Liquefying Information."

5. Gertrude Stein, "Off We All Went to See Germany," *Life*, August 6, 1945, 54–58.

6. Vannevar Bush, "As We May Think," *Atlantic Monthly* 176 (July 1945): 108.

7. Ibid.

8. For a more extensive reading of the Memex and its context, see Harpold, *Ex-foliations*, 15–44, 70–72.

9. Bush, "As We May Think," 101.

10. Albert Borgmann, *Holding on to Reality: The Nature of Information at the Turn of the Millennium* (Chicago: University of Chicago Press, 2000), 9.

11. Norbert Wiener, "Men, Machines, and the World About," in *New Media Reader*, eds. Noah Wardrip-Fruin and Nick Montfort (Cambridge, Mass.: MIT Press, 2003), 66.

12. Barbara Will, *Gertrude Stein, Modernism, and the Problem of "Genius"* (Edinburgh: University of Edinburgh Press, 2000), 55.

13. Gertrude Stein, *Everybody's Autobiography* (Cambridge, Mass.: Exact Change, 1993), 99.

14. Ngai, *Ugly Feelings*, 253.

15. *Making of Americans*, 3.

16. Ngai, *Ugly Feelings*, 253.

17. Ibid. The idea that Stein's writings induce fatigue and exhaustion in readers is not new and predates B. F. Skinner's "Has Gertrude Stein a Secret," *Atlantic Monthly* 153 (January 1934): 50–57. Ezra Pound claimed in 1930 that "the best criticism of Miss Stein known to me has been unconsciously recorded ... In a list of notes on contributors we find that Miss Stein took 'postgrad' work in psychology at Johns Hopkins, giving special attention to 'fatigue and unconscious responses.'" "Small Magazines," *English Journal* 19, no. 9 (1930): 699. Whereas recent commentators such as Ngai have championed Stein's ability to induce fatigue in readers, Pound's implication is strongly dismissive.

18. For more on Americanitis, see Greil Marcus, "Where Are the Elixirs of Yesteryear When We Hurt?" *New York Times*, January 26, 1998, http://www.nytimes .com/1998/01/26/arts/one-step-back-where-are-the-elixirs-of-yesteryear-when -we-hurt.html.

19. Annie Payson Call, *Power Through Repose* (Cambridge, Mass.: Roberts Brothers, 1891).

20. The *OED* cites the earliest use of the term as an 1882 article in the *Gentleman's Magazine* of London.

21. William James, *Writings, 1878–1899*, ed. Gerald E. Myers (New York: Library of America, 1992), 832.

22. Crary, *Suspensions of Perception*, 94.

23. Ibid., 13–14.

24. George Miller Beard, *American Nervousness: Its Causes and Consequences* (New York: G. P. Putnam's Sons, 1881), 34.

25. Ibid., 20.

26. Ibid., 18.

27. James, *Writings, 1878–1899*, 833.

28. Ibid.

29. Maria Farland, "Gertrude Stein's Brain Work," *American Literature* 76, no. 1 (2004): 142.

30. Hugo Münsterberg, *Psychology and Industrial Efficiency* (Boston: Houghton Mifflin, 1913), 211.

31. Gertrude Stein, "Cultivated Motor Automatism: A Study of Character in Its Relation to Attention," *Psychological Review* 5, no. 3 (1898): 299.

32. *Writings, 1932–1946*, 272.

33. Leon Katz was the first to explore the influence of *Sex and Character* on Stein's writing. See "Weininger and *The Making of Americans*," *Twentieth-Century Literature* 24, no. 1 (1978): 8–26.

34. See, for instance, Mark Niemayer's "Hysteria and the Normal Unconscious: Dual Natures in Gertrude Stein's 'Melanctha,'" *Journal of American Studies*

28, no. 1 (1994): 77–90; see also Lisa Ruddick's chapter "Melanctha: The Costs of Mind Wandering," in *Reading Gertrude Stein: Body, Text, Gnosis* (Ithaca, N.Y.: Cornell University Press, 1990), 12–54.

35. Leon M. Solomons and Gertrude Stein, "Normal Motor Automatism," *Psychology Review*, September 1896, 511.

36. Ibid., 494.

37. Ibid., 511.

38. *Writings, 1932–1946*, 271.

39. Steven Meyer, *Irresistible Dictation: Gertrude Stein and the Correlations of Writing and Science* (Stanford, Calif.: Stanford University Press, 2001), 79.

40. Ibid., 80.

41. Gertrude Stein, *Writings, 1903–1932*, ed. Catherine R. Stimpson and Harriet Chessman (New York: Library of America, 1998), 3.

42. Ibid., 8.

43. Tom Lutz, *American Nervousness, 1903: An Anecdotal History* (Ithaca, N.Y.: Cornell University Press, 1993), 279.

44. *Writings, 1903–1932*, 6.

45. Ibid., 16, 40.

46. Ibid., 46.

47. Ibid.

48. *Writings, 1932–1946*, 389.

49. *Everybody's Autobiography*, 63.

50. *Writings, 1932–1946*, 505.

51. *The Making of Americans*, 47.

52. Will, *Gertrude Stein, Modernism, and the Problem of "Genius,"* 51.

53. *Everybody's Autobiography*, 251.

54. Ibid., 122.

55. Barrett Watten, *The Constructivist Moment: From Material Text to Cultural Poetics* (Middletown, Conn.: Wesleyan University Press, 2003), 119–20.

56. Ibid., 124.

57. *Writings, 1903–1946*, 811.

58. For this argument, I am indebted to Jenelle Troxell's "Shock and Contemplation: 'Close Up' and the Female Avant-Garde" (Ph.D. diss., Columbia University, 2009), which argues that Stein, along with other female contributors to the film journal *Close Up*, proposed a contemplative aesthetic in response to the shock effects championed by theorists such as Siegfried Kracauer and Walter Benjamin.

59. Gertrude Stein, *How to Write* (New York: Dover, 1975), 8.

60. Gertrude Stein, *Stanzas in Meditation: The Corrected Edition*, eds. Susannah Hollister and Emily Setina (New Haven, Conn.: Yale University Press), 191.

61. Ellen Berry, *Curved Thought and Textual Wandering* (Ann Arbor: University of Michigan Press, 1992), 18.

62. Will, *Gertrude Stein, Modernism, and the Problem of "Genius,"* 25.

63. *The Making of Americans,* 815.

64. Quoted in Gary Small and Gigi Vorgan, *iBrain: Surviving the Technological Alteration of the Modern Mind* (New York: Harper, 2009), 18.

65. Ibid., 18.

66. James, *Writings, 1878–1899,* 216.

67. Ruddick, *Reading Gertrude Stein,* 38.

68. James, *Writings, 1878–1899,* 223; Stein, *Writings, 1903–1932,* 344.

69. Meyer, *Irresistible Dictation,* 33.

70. James, *Writings, 1878–1899,* 219.

71. Will, *Gertrude Stein, Modernism, and the Problem of "Genius,"* 30.

72. Ronald Martin, *American Literature and the Destruction of Knowledge: Innovative Writing in the Age of Epistemology* (Durham, N.C.: Duke University Press, 1991), 179.

73. For the fullest account of Taylorism in relation to modernist literature, see Martha Banta, *Taylored Lives: Narrative Productions in the Age of Taylor, Veblen, and Ford* (Chicago: University of Chicago Press, 1993).

74. Münsterberg, *Psychology and Industrial Efficiency,* 208.

75. Gertrude Stein, *Useful Knowledge* (Barrytown, N.Y.: Station Hill, 1988), 28. Used by permission of Station Hill of Barrytown.

76. Ibid., 29.

77. Joan Retallack, *The Poethical Wager* (Berkeley: University of California Press, 2004), 151.

78. Gertrude Stein, *How Writing Is Written,* ed. Robert Bartlett Haas (Los Angeles: Black Sparrow, 1974), 89.

79. Ibid., 91.

80. *Writings, 1932–1946,* 303.

81. *A Primer for the Gradual Understanding of Gertrude Stein,* 33.

82. Ibid., 22.

83. For more on Stein's relation to her own fame and to publicity, see Goble, *Beautiful Circuits,* 85–148, and Katherine Biers, "Gertrude Stein Talking," in *Virtual Modernism: Writing and Technology in the Progressive Era* (Minneapolis: University of Minnesota Press, 2013), 173–99. For more on Stein's interest in radio, see Sarah Wilson, "Gertrude Stein and the Radio," in *Broadcasting Modernism,* eds. Debra Rae Cohen et al. (Tallahassee: University Press of Florida, 2009), 107–23.

84. *Writings, 1932–1946,* 298.

85. *How Writing Is Written,* 157. For more on Stein's attitudes toward mass culture, see Alyson Tischler, "A Rose Is a Pose: Steinian Modernism and Mass Culture," *Journal of Modern Literature* 26, nos. 3–4 (2003): 12–27.

86. *Everybody's Autobiography,* 55.

87. Ibid., 101.

88. Ibid., 102.

89. *How Writing Is Written*, 155.

90. *Writings, 1932–1946*, 286.

91. Meyer, *Irresistible Dictation*, 320.

92. Ibid., 16.

93. *Stanzas in Meditation*, 248.

94. Crary, *Suspensions of Perception*, 46.

95. Ibid., 22–23.

96. Ibid., 24–25.

97. *Writings, 1932–1946*, 303.

98. Ibid., 294.

99. Gertrude Stein, "American Language and Literature," in *Gertrude Stein and the Making of Literature*, eds. Shirley Neuman and Ira B. Nadel (Boston: Northeastern University Press, 1988), 231.

100. Ibid., 228–29.

101. Ibid., 229.

102. For more on the movement of language in Stein's writings, see Jonathan Levin's "Gertrude Stein and the Movement of Words," in *The Poetics of Transition: Emerson, Pragmatism, and American Literary Modernism* (Durham, N.C.: Duke University Press, 1999), 145–66.

103. William Carlos Williams, *Imaginations*, ed. Webster Schott (New York: New Directions, 1970), 350.

104. Ibid., 349–50.

105. Quoted in Meyer, *Irresistible Dictation*, 227.

106. Quoted in ibid., 321–22.

107. Ibid., 326.

108. See Marjorie Perloff, *The Poetics of Indeterminacy: Rimbaud to Cage* (Princeton, N.J.: Princeton University Press, 1981).

109. "Reflection" MS, Yale Collection of American Literature, Beinecke Rare Book and Manuscript Library. For a useful overview of Stein's manuscript practices, see Gabrielle Dean, "Grid Games: Gertrude Stein's Diagrams and Detectives," *Modernism/Modernity* 15, no. 2 (2008): 317–41.

110. Barbara Will, *Unlikely Collaboration: Gertrude Stein, Bernard Faÿ, and the Vichy Dilemma* (New York: Columbia University Press, 2011).

111. Barbara Will, "Gertrude Stein, Bernard Faÿ, and the Ruthless Flowers of Friendship," *Modernism/Modernity* 15, no. 4 (2008): 663.

112. John Whittier-Ferguson, "The Liberation of Gertrude Stein: War and Writing," *Modernism/Modernity* 8, no. 3 (2001): 423.

113. Stacy Lavin, "The Globe Is All One: *Wars I Have Seen* as Proto-network Narrative," *Digital Humanities Quarterly* 5, no. 2 (2011), http://www.digitalhumanities.org/dhq/vol/5/2/000096/000096.html.

114. Gertrude Stein, *Mrs. Reynolds* (Los Angeles: Sun and Moon, 1988), 57.

115. Goble, *Beautiful Circuits*, 238.

116. Barbara Wineapple, "The Politics of Politics; or, How the Atomic Bomb Didn't Interest Gertrude Stein and Emily Dickinson," *South Central Review* 23, no. 3 (2006): 37–38.

117. McLuhan, *Understanding Me*, 47.

118. Alice B. Toklas, *What Is Remembered* (New York: Holt, Rinehart and Winston, 1963), 173.

119. Gertrude Stein, *Wars I Have Seen* (New York: Random House, 1946), 170.

## 2. Bob Brown, "Inforg"

1. *Readies for Bob Brown's Machine* (Cagnes-sur-Mer, France: Roving Eye Press, 1931), 154. There are three distinct incarnations of the "Readies" project. The first incarnation appeared in *transition: an international quarterly for creative experiment* ("Spring-Summer Number," June 1930): 167–73; for ease of reference, I refer to this version as "The Readies," and I quote from the version republished in the anthology *In transition: Writing and Art from transition Magazine, 1927–1930* (New York: Anchor Books, 1990), 59–65. The second incarnation, published in 1930, is the version republished and edited by Craig Saper (Houston: Rice University Press, 2009). The third incarnation is the full anthology *Readies for Bob Brown's Machine* published in 1931, which in subsequent notes I refer to as *The Readies*. Saper's afterwords to "The Readies" and *Words* serve as excellent introductions to Brown's work. Saper has also produced a useful simulation and overview of the reading machine, available at http://www.readies.org/.

2. Floridi, *Information*, 9.

3. Goldsmith, "A Week of Blogs for the Poetry Foundation," 143.

4. *Laws of Cool*, 4.

5. Jerome McGann, *Black Riders: The Visible Language of Modernism* (Princeton, N.J.: Princeton University Press, 1993), 89.

6. Craig Saper is in the process of writing a biography of Brown.

7. Michael North, "The Movies, the Readies, and the 'Revolution of the Word,'" *Modernism/Modernity* 9, no. 2 (2002): 216.

8. Michael North, *Camera Works: Photography and the Twentieth-Century Word* (New York: Oxford University Press, 2005), 61–82.

9. By Brown's own account, Ezra Pound "thought my writing wasn't so bad, although a bit on the 'pink popcorn' side." "Autobiographical Fragment," TS, Bob Brown Archive, UCLA Special Collections. Brown's correspondence with Stein reveals a distinct lack of interest in his writing on her part. See "Letters of Gertrude Stein," *Berkeley: A Journal of Modern Culture* 8 (1951): 1–2, 8.

10. Craig Dworkin points out that "in addition to the racism, misogyny and homophobia which are all too familiar to readers of early twentieth-century literature, the readies also reflect the male modernists' often literal phallocentrism."

"'Seeing Words Machinewise': Technology and Visual Prosody," *Sagetrieb* 18, no. 1 (1999): 59–60. Dworkin is right to point out these features of the readies, but I would suggest that he underemphasizes the degree of satire and parody embedded in Brown's overall project. The readies texts are frequently racist and sexist, and their publisher (the collection was published by Brown's Roving Eye Press but edited by Hilaire Hiler) should rightly be held to account for their content. According to Dworkin, however, "Modernist technophilia was rarely as unconflicted as Brown's" (60). In this Dworkin overstates the case, and later contradicts himself when he points out that "'The revolution of the word' . . . was to take place against 'the industrialization of expression' (Jolas)" (83). Dworkin astutely draws attention to Jolas's larger project, but he does not sufficiently take into account that Brown, too, is fighting "the industrialization of expression" with more industrialization—and this cannot help but be a parodic undertaking.

11. I am thinking here of Douglas Mao and Rebecca Walkowitz's collection *Bad Modernisms* (Durham, N.C.: Duke University Press, 2006).

12. Brandon Joseph, *Beyond the Dream Syndicate: Tony Conrad and the Arts After Cage* (New York: Zone Books, 2008), 54.

13. Ibid., 51.

14. Marjorie Perloff, "The Avant-Garde Phase of American Modernism," in *Cambridge Companion to American Modernism*, ed. Walter Kalaidjian (New York: Cambridge University Press, 2005), 196.

15. Augusto de Campos, introduction to the Brazilian edition of *1450–1950*, reprinted in A MARGEM DA MARGEM (AT THE MARGIN OF THE MARGIN) (São Paulo: Companhia das Letras, 1989), 126–41.

16. North writes, "For a good part of his life, Brown was little more than a hack writer, turning out jingles, advertisements, news stories, and popular novels, one of which, *What Happened to Mary*, was perhaps the very first film novelization, adapted from the very first movie serial, issued by Edison in 1912. In the latter part of his life, Brown turned to cookbooks like *The Complete Book of Cheese* or *Let There Be Beer!* In between these two stints in the netherworld of popular journalism, Brown became one of the more intriguing of the eccentric writers filling out the edges of the transatlantic avant-garde" (*Camera Works*, 214).

17. Bob Brown, *Words*, ed. Craig Saper (Houston: Rice University Press, 2009), 48.

18. Bob Brown, *1450–1950* (New York: Jargon Books, 1959).

19. *Readies*, 204.

20. Ibid., 160.

21. Ibid., 168.

22. Ibid., 166.

23. Ibid., 168.

24. N. Katherine Hayles, *How We Became Posthuman: Virtual Bodies in Cybernetics, Literature, and Informatics* (Chicago: University of Chicago Press, 2003), 13.

25. *Readies*, 168.

26. Ibid., 159.

27. "Readies," 59.

28. *Readies*, 161.

29. Ibid., 185.

30. Bob Brown, "The American Writer's Plight," *International Literature* 11 (1935): n.p.

31. Ibid.

32. Global English is a complex topic: I am thinking here in particular of Jonathan Arac's essay "Anglo-Globalism," *New Left Review* 16 (July–August 2002), http://www.newleftreview.org/II/16/jonathan-arac-anglo-globalism. For an excellent overview of Global English in relation to machine translation, see Rita Raley, "Machine Translation and Global English," *Yale Journal of Criticism* 16, no. 2 (2003): 291–313.

33. *Readies*, 113.

34. Ibid., 182–83.

35. Rebecca Walkowitz, *Cosmopolitan Style: Modernism Beyond the Nation* (New York: Columbia University Press, 2006), 77.

36. Simon Dentith, *Parody* (London: Routledge, 2000), 9.

37. Walkowitz, *Cosmopolitan Style*, 2–3.

38. John Dewey, "Americanism and Localism," in *The Middle Works, 1899–1924, Volume 12: 1920*, eds. Jo Ann Boydston and Ralph Ross (Carbondale: Southern Illinois University Press, 1982), 15.

39. Bob Brown, *Globe-Gliding* (Diessen, Germany: Roving Eye Press, 1930), 1; later republished as *Nomadness* (New York: Dodd, Mead and Company, 1931). Used by permission of Phoebe Brown.

40. Paul Virilio, "Continental Drift," in *The Virilio Reader*, ed. James der Derian (Oxford: Blackwell, 1998), 193.

41. "Salute to All the Bob Browns," unpublished poem, Box 67, Bob Brown Archive, UCLA Special Collections. Used by permission of Phoebe Brown.

42. Bob Brown, *Let There Be Beer!* (New York: H. Smith and R. Haas, 1932), 287.

43. Ibid., 197.

44. Ibid., 198–99.

45. Bob Brown, *Gems: A Censored Anthology* (Cagnes-sur-Mer, France: Roving Eye Press, 1931), 29.

46. *Readies*, 114. Reprinted by permission of New Directions Publishing Corp.

47. Ibid. Reprinted by permission of New Directions Publishing Corp.

48. Ibid., 185.

49. Ibid., 114. Reprinted by permission of New Directions Publishing Corp.

50. Ulla Dydo, *Gertrude Stein: The Language That Rises* (Evanston, Ill.: Northwestern University Press, 2003), 387.

51. *Readies*, 100.

52. *Paper Machine*, 23.

53. Jacques Roubaud, *Poetry, etcetera: Cleaning House*, trans. Guy Bennett (Los Angeles: Green Integer, 2007), 24–25.

## 3. Human University

1. For an overview of the rise of information overload in the immediate postwar period, see Bowles, "Liquefying Information." For more general historical accounts of information overload, see Wright, *Glut*, and Borgmann, *Holding on to Reality*. Norbert Wiener's *Cybernetics* notes, "There is a well-known tendency of libraries to become clogged by their own volume; of the sciences to develop such a degree of specialization that the expert is often illiterate outside his own minute specialty. Dr. Vannevar Bush has suggested the use of mechanical aids for searching through vast bodies of material." *Cybernetics; or, Control and Communication in the Animal and the Machine* (Cambridge, Mass.: MIT Press, 1948), 158. Olson likely would have been aware of Bush's well-publicized Memex, which Wiener alludes to here.

2. Steve McCaffery, "Blurb," n.d., *University of Arizona Poetry Center Newsletter*, http://poetry.arizona.edu/newsletter/0908/charles-olson.

3. Olson was not the first to use the term "postmodern," but according to Perry Anderson, "It was [within Olson's writing] that the elements for an affirmative conception of the postmodern were first assembled." *The Origins of Postmodernity* (London: Verso, 2005), 12.

4. Charles Olson, *The Maximus Poems*, ed. George Butterick (Berkeley: University of California Press, 1983), 473.

5. For a recent account of Pound and Olson's attitudes toward higher education, see Alan Golding, "From Pound to Olson: The Avant-Garde Poet as Pedagogue," *Journal of Modern Literature* 34, no. 1 (2010): 86–106.

6. Robert von Hallberg, *Charles Olson: The Scholar's Art* (Cambridge, Mass.: Harvard University Press, 1978), 1.

7. William Carlos Williams, *The Embodiment of Knowledge* (New York: New Directions, 1974), 6–7.

8. Ibid., 66.

9. Ibid., 6.

10. *Collected Poems, Volume II*, 54.

11. William Carlos Williams, *Paterson*, ed. Christopher MacGowan (New York: New Directions, 1992), 6.

12. For a useful recent overview of Olson's politics in the immediate aftermath of the war, see James Ziegler, "Charles Olson's American Studies: Call Me Ishmael and the Cold War," *Arizona Quarterly: A Journal of American Literature, Culture, and Theory* 63, no. 2 (2007): 51–80.

13. Don Byrd, *Charles Olson's Maximus* (Urbana: University of Illinois Press, 1980), 16.

14. Charles Olson, *Collected Poems*, ed. George Butterick (Berkeley: University of California Press, 1997), 89–90. Reprinted with permission of the University of California Press.

15. Ibid., 89.

16. Quoted in Ralph Maud, *Charles Olson at the Harbor* (Vancouver: Talonbooks, 2008), 129.

17. *Cybernetics*, 28, 29.

18. Ibid., 39.

19. See also Mark Hansen, *New Philosophy for New Media* (Cambridge, Mass.: MIT Press, 2006), and *Bodies in Code: Interfaces with Digital Media* (London: Routledge, 2006).

20. *How We Became Posthuman*, 19.

21. Bernadette Wegenstein, "The Body," in *Critical Terms for Media Study*, eds. J. T. Mitchell and Mark B. N. Hansen (Chicago: University of Chicago Press, 2010), 34; *How We Became Posthuman*, 83.

22. Charles Olson, *Selected Letters*, ed. Ralph Maud (Berkeley: University of California Press, 2000), 8.

23. *The Embodiment of Knowledge*, 48.

24. Ibid.

25. Ibid., 105.

26. Charles Olson, *Selected Writings*, ed. Robert Creeley (New York: New Directions, 1966), 82.

27. Ibid.

28. Don Byrd, "Curriculum for the Coming of the New Polis," talk given at the OlsonNow Conference, 1995, http://www.epc.buffalo.edu/authors/olson/blog/.

29. Borgmann, *Holding on to Reality*, 9.

30. In addition to Borgmann, for useful overviews of the emergence of information theory in the late 1940s, see Bruce Clarke, "Information," in *Critical Terms for Media Studies*, eds. Mark Hansen and J. T. Mitchell (Chicago: University of Chicago Press, 2010), 19–34, as well as Floridi, *Information*, Gleick, *The Information*, Hansen, *New Philosophy for New Media*, and Hayles, *How We Became Posthuman*.

31. Borgmann, *Holding on to Reality*, 9.

32. *Charles Olson and Robert Creeley: The Complete Correspondence*, Vol. 7, ed. George Butterick (Los Angeles: Black Sparrow, 1987), 238.

33. The metaphor of the human computer had already gained considerable currency by 1951. Edmund C. Berkeley's *Giant Brains; or, Machines That Think* (New York: Wiley and Sons, 1949) had recently appeared, and *Time*'s January 23, 1950, cover featured a mainframe computer with human eyes and limbs. For a general overview of the political implications of computers in the early cold war era, see Edwards, *The Closed World*.

34. *Charles Olson and Robert Creeley*, 238.

35. See Ralph Maud, *Charles Olson's Reading: A Biography* (Carbondale: Southern Illinois University Press, 1996). Maud's book provides one of the fullest accounts of a postwar American poet's reading habits, and offers a fascinating window into Olson's methods and sources.

36. *Charles Olson and Robert Creeley*, 238.

37. Quoted in Maud, *Charles Olson at the Harbor*, 121.

38. Charles Olson, *Collected Prose*, eds. Donald Allen and Benjamin Friedlander (Berkeley: University of California Press, 1997), 157.

39. *Charles Olson and Robert Creeley*, 238–39.

40. *The Maximus Poems*, 249. For more on Stiegler's distinction between hypomnesis and anamnesis, see his article "Memory."

41. *Collected Prose*, 155–56.

42. Charles Olson, "A Draft Plan for the College, September 1, 1956," *Charles Olson Journal* 2 (Fall 1974): 23. Olson's invocation of "spam" in this context is uncannily predictive of the continued proliferation of not-so-hot news.

43. For the fullest account of the genesis of the *Maximus* poems, see George Butterick, *Guide to the Maximus Poems of Charles Olson* (Berkeley: University of California Press, 1980), xix–xlv.

44. Charles Olson, "West and the Long Poem," 1948–49, TS, Box 36, Charles Olson Research Collection, University of Connecticut, Storrs.

45. Ibid.

46. "Post West," 1953, TS, Box 34, Charles Olson Research Collection, University of Connecticut, Storrs.

47. *Selected Writings*, 83; "Post West."

48. "Poetry and Criticism," n.d., TS, Box 34, Charles Olson Research Collection, University of Connecticut, Storrs.

49. *Collected Prose*, 172. As Butterick notes, "If Maximus reflects the poet's life, it is as a personality seeking completeness; as an allegorical figure, it must be on the order of Man-becoming-all-that-he-might-become." *Guide to the Maximus Poems of Charles Olson*, xxix.

50. *The Maximus Poems*, 6.

51. Ibid., 17.

52. *Collected Prose*, 297.

53. *The Maximus Poems*, 100.

54. Charles Olson, *Letters for Origin, 1950–1956* (New York: Cape Goliard Press, 1970), 9–10.

55. *Collected Prose*, 168.

56. Benjamin Friedlander, "Introduction," in *Olson's Prose*, ed. Gary Grieve-Carlson (Newcastle: Cambridge Scholars, 2007), viii.

57. *Selected Writings*, 130.

58. Paper delivered at the OlsonNow Conference, 2006, http://www.olson now.blogspot.com/2006/05/benjamin-friedlandercharles-olson-now.html.

59. *Collected Prose*, 181.

60. *The Maximus Poems*, 185.

61. Charles Olson, *Muthologos: The Collected Lectures and Interviews*, Vol. 1, ed. George F. Butterick (Bolinas, Calif.: Four Seasons Foundation, 1978), 99–100.

62. *The Maximus Poems*, 32.

63. Ibid., 582.

64. *Muthologos*, 100.

65. Ibid., 22.

66. *The Maximus Poems*, 576.

67. Michael Davidson, *Guys Like Us: Citing Masculinity in Cold War Poetics* (Chicago: University of Chicago Press, 2003), 36. Rachel Blau du Plessis and Libbie Rifkin have offered trenchant critiques of Olson's gender politics. Du Plessis suggests that "the opening words [of 'Projective Verse'] (re)claim poetry for masculine discourse, making poetry safe for men to enter, making poetry a serious discourse of aroused, exploratory manhood." *Blue Studios: Poetry and Its Cultural Work* (Tuscaloosa: University of Alabama Press, 2006), 84. She is particularly critical of Olson's treatment of Frances Boldereff, who was his central interlocutor in the years before he began his extensive correspondence with Robert Creeley. Du Plessis writes that "Olson proposes a posthumanist and post-Graeco-Roman examination of the world. Yet he also does so by primitivist investments in the Noble Mayan and by masculinist investments in helpmeet ears" (93). For more, see Du Plessis, 72–136, and Rifkin, *Career Moves: Olson, Creeley, Zukofsky, Berrigan, and the American Avant-Garde* (Madison: University of Wisconsin, 2001), 13–71, as well as Sharon Thesen's introduction to the Olson/Boldereff correspondence, *Charles Olson and Frances Boldereff: A Modern Correspondence*, eds. Ralph Maud and Sharon Thesen (Middletown, Conn.: Wesleyan University Press, 1999).

The performance artist Carolee Schneeman's account of a visit to Olson in 1963 contains an exceptionally vivid anecdote that bears on Olson's gender politics and on his understanding of embodiment in relation to gender: "Olson asked about my work, and I explained I wanted to take painting into real time and lived actions, even using fragments of language. In this context he said, 'Remember, when the cunt began to speak [when women were finally allowed to perform], it was the beginning of the end of Greek theatre'—he meant the introduction of the actual feminine onto the Greek stage and weakened the pure concepts of language and mythology" (53; bracketed text is by Schneeman). It is unclear to what moment specifically in the history of Greek theater Olson is referring, and it may be that something has been lost in transcription. (Women did not perform on the Athenian stage in antiquity; Olson may be referring to the character of Clytemnestra.) It is also unclear the extent to which Schneeman takes offense to Olson's crude, quasi-Nietzschean account of the decline of Greek theater. To whatever extent she was offended by Olson's reductive declaration, she

considered it an important turning point in her career: "At that moment I considered that I must belong to the realm of 'cunts'—about to enter my culture in motion and speaking. Was there something I could destroy?" (53). What had initially drawn Schneeman to Olson's work, she claims, was "the sense of the body as the instrument of available sensation . . . something I recognized in the *Maximus* poems." Schneeman, *Imagining Her Erotics: Essays, Interviews, Projects* (Cambridge, Mass.: MIT Press, 2002), 52.

68. *The Maximus Poems*, 635.

69. Robert Duncan, "Letter to Jess After His Last Visit to Olson in New York Hospital, 1970," *Charles Olson Journal* 1 (Spring 1974): 5.

70. Ibid., 5–6.

71. *Collected Prose*, 307.

72. Ibid.

73. *Charles Olson and Ezra Pound: An Encounter at St. Elizabeth's*, ed. Catherine Seelye (New York: Grossman, 1975), 82.

74. Butterick, *Guide to the Maximus Poems of Charles Olson*, 751.

75. *The Maximus Poems*, 635.

76. Ibid., 14, *Collected Prose*, 307.

77. Carla Billitteri, "Charles Olson's Poetics of the Inactual," *Worcester Review* 31, nos. 1–2 (2010): 83–92.

78. Eugene Vydrin, "Open Field Scholarship in Charles Olson's Proprioception," in *Olson's Prose*, ed. Gary Grieve-Carlson (Newcastle: Cambridge Scholars, 2007), 177.

79. See Jonathan Skinner, "'Going Widdershins': Into the Woods with Charles Olson," paper delivered at the OlsonNow Conference, 2010, http://www.olsonconference.com/.

80. Stephen Fredman, *The Grounding of American Poetry: Charles Olson and the Emersonian Tradition* (Cambridge: Cambridge University Press, 1993), 34.

81. *The Maximus Poems*, 379.

82. *Collected Prose*, 301.

83. For more on "big history," see David Christian, *Maps of Time: An Introduction to Big History* (Berkeley: University of California Press, 2004). In that book's introduction, William McNeill locates the origins of the big history movement in Fernand Braudel's notion of the *longue durée*, first proposed in 1958. Braudel, like Olson, was concerned about information saturation and its effects on historiography. Braudel's famous essay "History and the Social Sciences: The *Longue Durée*" begins, "There is a general crisis in the human sciences: they are all overwhelmed by their own progress, if only because of the accumulation of new knowledge." *On History*, trans. Sarah Matthews (Chicago: University of Chicago Press, 1980), 25.

84. I am thinking here especially of the recent OlsonNow conferences, and in particular of the talks cited in this essay by Skinner, Billitteri, and Friedlander.

See also Joshua Corey, "'Tansy City': Charles Olson and the Prospects for Avant-Pastoral," *Comparative American Studies* 7, no. 2 (2009): 111–27.

85. *The Maximus Poems*, 201. A side-by-side comparison of Olson's version and Leland's "The Story of a Partridge and His Wigwam" reveals that Olson borrowed verbatim, cleverly embellishing the story by subtracting details. Olson may have been playing on the sentence in Leland that immediately precedes the partridge tale: "If any modern poet had depicted this incident in so like a style, every critic would have called out plagiarism." Charles Godfrey Leland, *Algonquin Legends of New England* (Boston: Houghton Mifflin, 1884), 290.

86. Daniel Belgrad, *The Culture of Spontaneity: Improvisation and the Arts in Postwar America* (Chicago: University of Chicago Press, 1998), 134.

87. Robert von Hallberg, "American Poet–Critics Since 1945," in *Reconstructing American Literary History*, ed. Sacvan Bercovitch (Cambridge, Mass.: Harvard University Press, 1986), 296.

88. Catherine Stimpson, "Charles Olson: Preliminary Images," *boundary 2*, vol. 2, nos. 1–2 (1973): 151.

## 4. "When Information Rubs/Against Information"

1. Eve Meltzer, "The Dream of the Information World," *Oxford Art Journal* 29, no. 1 (2006): 126.

2. For more on the far-reaching influence of *The Whole Earth Catalog*, see Fred Turner, *From Counterculture to Cyberculture: Stewart Brand, the Whole Earth Network, and the Rise of Digital Utopianism* (Chicago: University of Chicago Press, 2008). In a 2006 introduction to the collected issues of *0 To 9*, Acconci playfully recalls, "I remember, in 1968, you [Bernadette Mayer] were obsessed with *The Whole Earth Catalog* (and so was I), and wasn't that the same as the Internet?" *0 To 9: The Complete Magazine, 1967–1969*, eds. Vito Acconci and Bernadette Mayer (Brooklyn, N.Y.: Ugly Duckling Presse, 2006), 7. By the fall of 1968, when the first issue of *The Whole Earth Catalog* appeared, *0 To 9* had already printed its first four issues.

3. See Stan VanDerBeek, *The Culture Intercom* (Cambridge, Mass.: MIT List Visual Arts Center, 2011), 84.

4. For a concise overview of the mimeograph revolution, see Stephen Clay and Rodney Phillips, *A Secret Location on the Lower East Side: Adventures in Writing, 1960–1980* (New York: Granary Books, 1998), 9–56; and on *Joglars* specifically, 237.

5. For an overview of *0 To 9* and its importance, see Gwen Allen, *Artists' Magazines: An Alternative Space for Art* (Cambridge, Mass.: MIT Press, 2011), 69–89.

6. John Cage, "McLuhan's Influence," in *John Cage*, ed. Richard Kostelanetz (New York: Praeger, 1970), 171.

7. Marshall McLuhan, *Verbi-Voco-Visual Explorations* (New York: Something Else Press, 1967), n.p.

8. Stan VanDerBeek, "'Culture: Intercom' and Expanded Cinema: A Proposal and Manifesto," *Joglars* 3 (1966), n.p.

9. J. C. R. Licklider, "Man-Computer Symbiosis," in *The New Media Reader*, eds. Noah Wardrip-Fruin and Nick Montfort (Cambridge, Mass.: MIT Press, 2003), 78.

10. *Radical Artifice*, xiii; for more on Cage's influence on artists working with text and image in the 1960s, see Liz Kotz, *Words to Be Looked At: Language in 1960s Art* (Cambridge, Mass.: MIT Press, 2007), 13–98.

11. John Cage, *Musicage: Cage Muses on Words, Art and Music*, ed. Joan Retallack (Middletown, Conn.: Wesleyan University Press, 1992), 51.

12. Marshall McLuhan, "The Agenbite of Outwit," *Location* 1, no. 1 (1963): 44.

13. Marshall McLuhan, *The Medium Is the Massage: An Inventory of Effects* (New York: Bantam, 1967), 79.

14. Marshall McLuhan, *The Mechanical Bride: Folklore of Industrial Man* (Berkeley, Calif.: Gingko Press, 2011), 98.

15. For a useful overview of McLuhan's collaborative work with Quentin Fiore and Jerome Agel in the 1960s, see Adam Michaels and Jeffrey T. Schnapp, *The Electronic Information Age Book: McLuhan/Agel/Fiore and the Experimental Paperback* (New York: Princeton Architectural Press, 2012).

16. "An experience I had in Hawaii turned my attention to the work of Buckminster Fuller and the work of Marshall McLuhan.... Fuller's world map shows that we live on a single island. Global village (McLuhan), Spaceship Earth (Fuller). Make an equation between human needs and world resources (Fuller). I began my 'Diary: How to Improve the World: You Will Only Make Matters Worse.' Mother said, 'How dare you!'" "An Autobiographical Statement," http://johncage.org/autobiographical_statement.html.

17. *A Year from Monday* (Middletown, Conn.: Wesleyan University Press, 1967), 4.

18. Ibid., 5.

19. Ibid., 8.

20. *Musicage*, xvii.

21. John Cage, *Silence: Lectures and Writings* (Middletown, Conn.: Wesleyan University Press, 1961), 195 (spaces in original).

22. Bern Porter, *I've Left* (New York: Something Else Press, 1971), 1.

23. James Schevill, *Where to Go, What to Do, When You Are Bern Porter: A Personal Biography* (Gardiner, Maine: Tilbury House, 1992), 319.

24. *I've Left*, 45.

25. Bern Porter, *Sounds That Arouse Me: Selected Writings*, ed. Mark Melnicove (Gardiner, Maine: Tilbury House, 1993), 131.

26. Schevill, *Where to Go, What to Do, When You Are Bern Porter*, 271.

27. Bernadette Mayer, *Studying Hunger* (New York: Adventures in Poetry/Big Sky, 1975), 9.

28. Michael Sheringham, *Everyday Life: Theories and Practices from Surrealism to the Present* (New York: Oxford University Press, 2006), 388. See also Epstein, "'Pay More Attention': Ron Silliman's *BART* and Contemporary 'Everyday Life' Projects,'" *Jacket* 39 (2010), http://www.jacketmagazine.com/39/silliman-epstein-bart.shtml.

29. *Studying Hunger*, 7.

30. Bernadette Mayer, *Studying Hunger Journals* (Barrytown, N.Y.: Station Hill Press, 2011), 2.

31. Ibid., 2–3.

32. *Studying Hunger*, 42.

33. Linda Russo, "Poetics of Adjacency: *0–9* and the Conceptual Writing of Bernadette Mayer and Hannah Wiener," in *Don't Ever Get Famous: Essays on New York Writing After the New York School*, ed. Daniel Kane (Normal, Ill.: Dalkey Archive, 2006), 142.

34. Clark Coolidge and Bernadette Mayer, *The Cave* (New York: Adventures in Poetry, 2009), vii.

35. Quoted in Maggie Nelson, *Women, the New York School, and Other True Abstractions* (Iowa City: University of Iowa Press, 2007), 100.

36. Gene Youngblood, *Expanded Cinema* (New York: Dutton, 1970), 82.

37. Emma Kay's 1999 *Worldview*—in which she recollects everything she can about the history of the world—employs a similar constraint as *Eruditio*, and makes for an interesting comparison.

38. Bernadette Mayer, *Eruditio Ex Memoria* (New York: Angel Hair, 1977), n.p.

39. Ibid.

40. Bernadette Mayer, *Memory* (Plainfield, Vt.: North Atlantic Books, 1975), n.p.

41. Mayer, *Studying Hunger Journals*, 141.

42. Ibid.

43. Hannah Weiner, "Trans-Space Communication," *0 To 9*, vol. 6 (July 1969): 100.

44. Ibid.

45. Ibid., 100–101.

46. Hannah Weiner, *Hannah Weiner's Open House*, ed. Patrick Durgin (Chicago: Kenning Editions, 2007), 16. See also Judith Goldman, "Hannah=hannaH: Politics, Ethics, and Clairvoyance in the Work of Hannah Weiner," *differences: A Journal of Feminist Cultural Studies* 12, no. 2 (2001): 121–68, and Joyelle McSweeney, "Disabled Texts and the Threat of Hannah Weiner," *boundary 2*, vol. 36, no. 4 (2009): 123–32.

47. Russo, "Poetics of Adjacency," 146.

48. *Hannah Weiner's Open House*, 63.

49. A number of audio recordings of Wiener are available on PennSound: http://writing.upenn.edu/pennsound/x/Weiner.php.

50. *Hannah Weiner's Open House*, 64.

51. Ibid., 65.

52. Ibid.

53. Ibid., 148.

54. Ibid., 155.

55. Ibid., 65.

## 5. Paradise and Informatics

1. In addition to the works cited in this chapter, I am thinking of Ron Silliman's *Paradise* (Providence: Burning Deck, 1984), and Jean Day's poem "Paradise and Lunch," published in *In the American Tree*, ed. Ron Silliman (Orono, Maine: National Poetry Foundation, 1986). Peter Quartermain offers a useful list of Language writers who rework Dante's *Paradiso*, and suggests that in part they do so in response to Pound: "Andrews is not the only so-called Language Poet to draw on and rework Dante in a quest for a poetic mode which will bring to an end our exiled condition in language, bring readers home again: one section of Ron Silliman's long serial project *The Alphabet*, for example, is called *Paradise*; Lyn Hejinian has in her critical writing come back again and again to the nature and possibility of achieving paradise through and in writing, language; one finds it a recurrent theme in the work of Susan Howe and Rosmarie Waldrop. It may very well be that such interrogations of Paradise derive, in their more or less immediate ancestry, from Ezra Pound's famous conclusion in *The Cantos*, 'le paradis n'est pas artificiel.' Pound was pointing, first, to the futility of believing that we have any life other than this one, and second to the actual possibility of the individual achieving, however momentarily, a sense of paradise. Moments of coherence are unstable and transitory, but they are in Pound's view nevertheless paradisal and actual; if they manifest the transcendent, that transcendence is secular and earthbound." Peter Quartermain, "Paradise as Praxis: A Preliminary Note on Bruce Andrews's *Lip Service*," in *Stubborn Poetries: Poetic Facticity and the Avant-Garde* (Tuscaloosa: University of Alabama Press, 2013), 251–52.

2. Bob Perelman, *Captive Audience* (Great Barrington, Mass.: The Figures, 1988), 56.

3. Bruce Andrews, *Paradise and Method: Poetics and Praxis* (Evanston, Ill.: Northwestern University Press, 1996), 268.

4. Donna Haraway, *Simians, Cyborgs, and Women: The Reinvention of Nature* (London: Routledge, 1991), 161.

5. Rae Armantrout et al., *The Grand Piano: An Experiment in Collective Autobiography*, 10 vols. (Detroit: Mode A, 2006–11), 10:14–15.

6. Ibid., 6:24.

7. Ibid., 6:13.

8. Ibid., 6:48.

9. Ibid., 2:72.

10. Ibid., 7:56.

11. Thomas Frank, *The Conquest of Cool: Business Culture, Counterculture, and the Rise of Hip Consumerism* (Chicago: University of Chicago Press, 1998).

12. Joel Dinerstein, "Technology and Its Discontents: On the Verge of the Posthuman," in *Rewiring the "Nation": The Place of Technology in American Studies*, eds. Carolyn de la Peña and Siva Vaidhyanathan (Baltimore: Johns Hopkins University Press, 2007), 19–20.

13. Ibid., 21.

14. Ibid., 29.

15. Ibid., 37.

16. *How We Became Posthuman*, 29.

17. Haraway, *Simians, Cyborgs, and Women*, 180.

18. Ibid., 176.

19. Quoted in Silliman, *Paradise*, 197.

20. Bruce Andrews, "Empire and Society: Toward a Contextual Explanation of American Aims and Policy in Vietnam" (Ph.D. diss., Harvard University, 1975).

21. Lyn Hejinian, *The Cell* (Los Angeles: Sun and Moon, 1992), 41.

22. *The Grand Piano*, 7:57.

23. *The Guard* (Berkeley, Calif.: Tuumba, 1984), 148.

24. Jacob Edmond, "The Closures of the Open Text: Lyn Hejinian's 'Paradise Found,'" *Contemporary Literature* 50, no. 2 (2009): 250.

25. Ibid., 241–42.

26. *The Guard*, 30.

27. Quoted in Edmond, "The Closures of the Open Text," 253.

28. *The Guard*, 21.

29. *The Grand Piano*, 3:56–57.

30. *The Language of Inquiry* (Berkeley: University of California Press, 2000), 46.

31. *My Life*, 16.

32. *Language of Inquiry*, 53.

33. Ibid., 223.

34. Ibid., 222.

35. Ibid., 46.

36. *The Grand Piano*, 5:131.

37. *Language of Inquiry*, 157.

38. Ibid., 240.

39. *The Cell*, 31.

40. Charles Bernstein, *Rough Trades* (Los Angeles: Sun and Moon, 1991), 11.

41. *Dialectic of Enlightenment*, 113.

42. *My Life in the Nineties* (New York: Shark Books, 2003), 28.

43. Ibid., 47.

44. Ibid.

45. Ibid., 33.

46. *Language of Inquiry*, 77.

47. Ibid., 224.

48. Lyn Hejinian, *Writing as an Aid to Memory* (Los Angeles: Green Integer), sec. 41.

49. *The Cell*, 85.

50. *Writing as an Aid to Memory*, sec. 7.

51. Bruce Andrews, *Lip Service* (Toronto: Coach House Books, 2001), 256.

52. Barbara Cole, "Bruce Andrews's Venus: Paying Lip Service to *Écriture Feminine*," in *The Consequence of Innovation: 21st Century Poetics*, ed. Craig Dworkin (New York: Roof Books), 94.

53. Ibid., 99.

54. Ibid., 98.

55. Hélène Cixous, "The Laugh of the Medusa," *Signs* 1, no. 4 (Summer 1976): 875–93.

56. Norman O. Brown, *Love's Body* (New York: Vintage, 1966), 249.

57. *Paradise and Method*, 229.

58. Louis Althusser, *For Marx*, trans. Ben Brewster (New York: Pantheon, 1969), 234.

59. Ibid., 113.

60. *Paradise and Method*, 13.

61. Carla Billitteri, *Language and the Renewal of Society in Walt Whitman, Laura (Riding) Jackson, and Charles Olson: The American Cratylus* (New York: Palgrave Macmillan, 2009), 160.

62. *Lip Service*, 101.

63. Ibid.

64. Quartermain, "Paradise as Praxis," 246–47.

65. Ngai, *Ugly Feelings*, 348.

66. Bob Perelman, *The Marginalization of Poetry: Language Writing and Literary History* (Princeton, N.J.: Princeton University Press, 1996), 98.

67. Jerome McGann, "'The Apparatus of Loss': Bruce Andrews's Writing," *Aerial* 9 (1999): 183.

68. *Paradise and Method*, 17.

69. Ibid., 132.

70. Bruce Andrews, "Praxis: A Political Economy of Noise and Information," in *Close Listening: Poetry and the Performed Word*, ed. Charles Bernstein (New York: Oxford University Press, 1998), 75.

71. In an unpublished interview, Andrews gives an extensive account of his compositional practice: "At some point in the late '70s . . . I bought a paper cutter, which was the major technological shift in my work, much more significant than word processors, for instance. All my work since . . . yeah, basically in the last 30 years now, has been composed on small pieces of paper—8.5/11″ sheets of paper

cut into 6. Everything I write, pretty much—essays, shopping lists, phone numbers, things I need to do, as well as poetry that I collect and create—is all done on that size. . . . This separates the reading and the writing, or the writing and the editing of this work, sometimes *by years*. I'll often be editing words that I composed, or a couple of words, on thousands of little pieces of paper—years before. So I don't have any relationship with my prior state of mind, when I wrote these things, and I don't remember the epiphany that led to some vision or something, like poets often feel, and I can be much more mobile and flexible in editing. . . . There's something about operating at the micro-text level of the sign that is something you could produce at the moment, there's something that lends itself to sitting down and generating things at this micro level, and having all the possibilities more readily available to you. And I don't think that's true with discourse. If you're operating with discursive material I don't think discursive materials of the variety, of the complexity, of the vividness that you want to end up with, are all generateable in the moment. But, what I discovered was that they're *collectable*. So the difference to me . . . the micro materials, these raw materials, are things that you could produce on the spot without any fear that you're being way too limited, you know, that you could imagine all the possibilities of the alphabet, and the combinations of the letters and sounds, and things and you could work through those . . . with discourse you *can't*—but it lends itself to a kind of gradual accumulation in the same way that collecting does. . . . And that becomes my relationship to discursive materials—not that I'm expected to sit down at the typewriter and come up with my personalized version of discursive materials, which is what then becomes a poem, but that I can work with editing a *vast* body of material that I accumulate and collect *over time* that I wouldn't have otherwise been able to do." Bruce Andrews, unpublished interview with Dennis Büscher-Ulbrich, New York City, September 27, 2010.

72. Stiegler, "Memory," 65.

73. Ibid., 73.

74. *Language of Inquiry*, 42.

## 6. Vanguard Total Index

1. Manovich's claim that "database and narrative are natural enemies" (*Language of New Media*, 225) has been much critiqued elsewhere. See, for instance, Victoria Vesna's collection *Database Aesthetics*, and in particular Weinbren's essay "Ocean, Database, Recut," 61–85.

2. *Language of New Media*, 237.

3. *Rob the Plagiarist*, 15.

4. *Uncreative Writing*, 24.

5. For more on the distinction, see Goldsmith, "Flarf and Conceptual Writing," *Poetry* 194, no. 4 (2009): 315–16. Conceptual art's emergence is usually dated to the early to mid-1960s; it is not until forty years later that the term conceptual

writing—first popularized by Craig Dworkin's 2003 *UbuWeb Anthology of Conceptual Writing*—came into circulation. Though primarily composed of 1960s writing, Dworkin's primer implied a strong correlation between conceptualism and information technology by placing works such as the computer-generated *RACTER* (1984) under the banner of conceptualism. For overviews of conceptual writing as a movement, see Fitterman and Place, *Notes on Conceptualisms* (Brooklyn: Ugly Duckling Presse, 2009), Dworkin and Goldsmith, *Against Expression*, and Bergrvall et al., *I'll Drown My Book: Conceptual Writing by Women* (Los Angeles: Les Figues Press, 2012). For the most thorough scholarly account of Flarf to date, see Brian Reed, *Nobody's Business: Twenty-First-Century Avant-Garde Poetics* (Ithaca, N.Y.: Cornell University Press, 2013), 88–120.

6. See Ulrich Beck, *Risk Society: Towards a New Modernity* (London: Sage, 1992), and Jacob Hacker, *The Great Risk Shift: The New Economic Insecurity and the Decline of the American Dream* (Oxford: Oxford University Press, 2006). For an account of the risk society in relation to recent narrative fiction, see Ursula K. Heise, *Sense of Place and Sense of Planet: The Environmental Imagination of the Global* (Oxford: Oxford University Press, 2008), 119–59.

7. For a useful overview of the place of indexes and indexicality in contemporary film and art, see the special "Indexicality: Trace and Sign" issue of *differences: A Journal of Feminist Cultural Studies* 18, no. 1 (2007), edited by Mary Ann Doane. Indexes can also fall under the purview of metadata schemes. For more, see my article "From the Personal to the Proprietary: Conceptual Writing's Critique of Metadata," *Digital Humanities Quarterly* 6, no. 2 (2012), http://www.digitalhumanities.org/dhq/vol/6/2/000124/000124.html. Johanna Drucker has recently written that "metadata schemes must be read as models of knowledge, as discursive instruments that bring the object of their inquiry into being, shaping the fields in which they operate by defining quite explicitly what can and cannot be said about the objects of a particular collection or online environment." *SpecLab: Digital Aesthetics and Projects in Speculative Computing* (Chicago: University of Chicago Press, 2009), 11.

8. Marjorie Perloff, *Unoriginal Genius: Poetry by Other Means in the New Century* (Chicago: University of Chicago Press, 2010), 122.

9. Rodrigo Toscano, "Formulas of Constraint for Text Making (or De-Liberating Freedoms in Transit I)," in *The Noulipian Analects*, eds. Matias Vieneger and Christine Wertheim (Los Angeles: Les Figues Press, 2007), 91.

10. For a useful overview of institutional critique, see Alexander Alberro and Blake Stimson, eds., *Institutional Critique: An Anthology of Artists' Writings* (Cambridge, Mass.: MIT Press, 2009).

11. Lucy Lippard, *Six Years: The Dematerialization of the Art Object from 1966 to 1972* (Berkeley: University of California Press, 1973). For more on the importance of *Six Years*, see Catherine Morris and Vincent Bonin, eds., *Materializing Six Years: Lucy R. Lippard and the Emergence of Conceptual Art* (Cambridge, Mass.: MIT Press, 2012).

12. Sol LeWitt, "Serial Project #1," *Aspen* 5–6 (1966), n.p.

13. *Against Expression*, xxxvi.

14. For more on the *Information* show, see Edward Shanken's "Art in the Information Age: Technology and Conceptual Art," in *Conceptual Art: Theory, Myth and Practice*, ed. Michael Corris (Cambridge: Cambridge University Press, 2004). Shanken argues that the conventional art historical distinction between Conceptual and Art and Technology movements is untenable, suggesting that conceptual writers were more centrally interested in information technology than has been recognized.

15. Dan Graham, *Works and Collected Writings*, ed. Gloria Moure (Barcelona: Ediciones Poligrafa, 2009), 94.

16. Meltzer, "The Dream of the Information World," 132.

17. Graham, *Works and Collected Writings*, n.p.

18. Other 1960s artists, such as Les Levine, Robert Morris, Ed Kienholz, and Hans Haacke, also extensively explored financial themes within their work. For a contemporary overview, see Jean Lipman, "Money for Money's Sake," *Art in America* 58, no. 1 (1970): 76–84.

19. See in particular Ron Silliman's response to the *Open Letter* special issue on Kenneth Goldsmith, February 27, 2011, http://epc.buffalo.edu/authors/gold smith/silliman_goldsmith.html. See also Drew Gardner's more playful "I'll Steal Your Poets Like I Stole Your Bike," *Harriet Blog*, April 19, 2010, http:// www.poetryfoundation.org/harriet/2010/04/ill-steal-your-poets-like-i-stole-your -bike, and Johanna Drucker's "Beyond Conceptualisms: Poetics After Critique and the End of the Individual Voice," *Poetry Project Newsletter* 231 (April–May 2012): 6–9.

20. *Against Expression*, xlii.

21. Floridi, *Information*, 5.

22. Burton Malkiel, *A Random Walk Down Wall Street* (New York: Norton, 1973), 356.

23. For a concise account of the history of information economics as a field, see Joseph Stiglitz's "The Contributions of the Economics of Information to Twentieth-Century Economics," *Quarterly Journal of Economics* 115, no. 4 (2000): 1441–78. The inaugural text of information economics is usually taken to be George Akerlof's 1970 "The Market for Lemons: Quality Uncertainty and the Market Mechanism," *Quarterly Journal of Economics* 84, no. 3 (1970): 488–500.

24. Quoted in Justin Fox, *The Myth of the Rational Market: A History of Risk, Reward, and Delusion on Wall Street* (New York: Harper, 2010), 223.

25. "Data, Data Everywhere," *The Economist*, February 25, 2010, http://www .economist.com/node/15557443.

26. Paul Krugman, *The Return of Depression Economics and the Crisis of 2008* (New York: Norton, 2008), 66.

27. The collapse of the housing bubble had particularly adverse affects for African Americans and Latinos. According to the Pew Charitable Trust, "From

2005 to 2009, inflation-adjusted median wealth fell by 66% among Hispanic households and 53% among black households, compared with just 16% among white households." "In 2009, the typical white household had $113,149 in wealth, while the typical Hispanic household had $6,325, and the typical black household just $5,677." Rakesh Kochhar, Richard Fry, and Paul Taylor, "Wealth Gaps Rise to Record Highs Between Whites, Blacks, Hispanics," Pew Research: Social and Demographic Trends, July 26, 2011, http://www.pewsocialtrends.org/2011/07/26/wealth-gaps-rise-to-record-highs-between-whites-blacks-hispanics/.

28. See Peter Gosselin, *High Wire: The Precarious Financial Lives of American Families* (New York: Basic Books, 2008) for a comprehensive overview of the increasing precarity faced by American families.

29. In 2008 alone, over one million American homeowners, including a disproportionate number of African Americans and Latinos, lost their homes due to foreclosure. Many borrowers did not understand the terms of their mortgages; fewer than 10 percent of homeowners facing foreclosure received assistance from the federal government. See Sewell Chan, "Inspector Reports That a Program Designed to Help Prevent Foreclosures Has Fallen Short," *New York Times*, July 22, 2010, http://query.nytimes.com/gst/fullpage.html?res=9E0DE7DE1E31F931A15754C0A9669D8B63.

30. The informatization and financialization of the global economy over the past four decades has elicited a great deal of critical attention. For a general overview, see David Harvey, *The Enigma of Capital and the Crises of Capitalism* (Oxford: Oxford University Press, 2011). For a more specific account of phenomena that have alternately been described as "cognitive capitalism," "semiocapitalism," "post-Fordism," and "disaster capitalism," see Franco Bifo Berardi, "Cognitarian Subjectivation," *Are You Working Too Much? Post-Fordism, Precarity, and the Labor of Art* (Berlin: Sternberg Press, 2011), 134–46.

31. See Christopher Nealon, *The Matter of Capital: Poetry and Crisis in the American Century* (Cambridge, Mass.: Harvard University Press, 2011), and Clover, "A Form Adequate to History."

32. Charles Bernstein, *Attack of the Difficult Poems: Essays and Inventions* (Chicago: University of Chicago Press, 2011), 267.

33. Ibid., 268.

34. Ibid.

35. Ibid., 267.

36. *Consequence of Innovation*, 9.

37. Ibid., 14.

38. *Against Expression*, 89. Originally published in *Asylums* (New York: Asylum's Press, 1975).

39. *Against Expression*, 457.

40. For more on "projects of attention," see the discussion in chapter 4 of this volume.

41. Tan Lin, "New Media Writing: Code vs. Database," *The Noulipian Analects*, eds. Matias Viegener and Christine Wertheim (Los Angeles: Les Figues, 2007), 145–47.

42. Ibid., 146.

43. Tan Lin, *Seven Controlled Vocabularies and Obituary, 2004: The Joy of Cooking* (Middletown, Conn.: Wesleyan University Press, 2010), 122–23.

44. Ibid., 131.

45. Ibid., 86.

46. Brian Reed, for instance, has convincingly interpreted Dworkin's *Parse* as a commentary on the nature of academic labor. He writes, "[*Parse's*] generative constraint—to transcribe a textbook's syntax—proves impossible for a fallible human being to carry out punctiliously. Dworkin shows that the information age has not somehow magically dispelled alienation's negative effects. Content providers, 'creative' or not, must try to fulfill the excruciating demand that they become teratological organisms, that is, monstrously overdeveloped in certain respects and impoverished in others. Worse, they discover that honestly tenaciously pursuing their occupation actually lowers their chances of creating worthwhile art. Purposeless play, as Friedrich Schiller long ago taught—is by definition inefficient. Dworkin suggests that nowadays authentic artistry can only occur when a worker is distracted from or fails at an assigned task." "Grammar Trouble," *boundary 2*, vol. 36, no. 3 (2009): 151–52.

For more on *Parse* and on Dworkin's poem "Dure," see my article "Self-Portrait in a Context Mirror: Pain and Quotation in the Conceptual Writing of Craig Dworkin," *Postmodern Culture* 19, no. 3 (2009), http://pmc.iath.virginia.edu/.

47. Robert Fitterman, *Sprawl: Metropolis 30a* (Los Angeles: Make Now Press, 2010), 14.

48. Robert Fitterman, "Directory," *Poetry* 194, no. 4 (2009): 335.

49. Rachel Zolf, *Human Resources* (Toronto: Couch House, 2007), 36. For a more extensive account of *Human Resources*, see Reed, *Nobody's Business*, 16–26.

50. Ibid., 67.

51. Ibid., 74.

52. Christian Bök, "Late Review 04," *Harriet Blog*, n.d., http://www.poetry foundation.org/harriet/2008/02/late-review-04/.

53. Zolf, *Human Resources*, 74.

54. Ibid., 65.

55. Bill Kennedy and Darren Wershler-Henry, *Apostrophe* (Toronto: ECW Press, 2006), 120.

56. Ibid., 287.

57. Ibid., 286.

58. For an overview, see Kenneth Goldsmith, "Rewriting Walter Benjamin's 'Arcades Project,'" *Harriet Blog*, n.d., http://www.poetryfoundation.org/harriet /2011/04/rewriting-walter-benjamins-the-arcades-project/.

59. For another reading of the contradictions inherent in Goldsmith's practice, see Reed, *Nobody's Business*, 76–87.

60. *Uncreative Writing*, 188.

61. Kenneth Goldsmith, *Day* (Great Barrington, Mass.: The Figures, 2003), 202.

62. Ibid., 246.

63. Kenneth Goldsmith, "Uncreativity as a Creative Practice," n.d., http://epc .buffalo.edu/authors/goldsmith/uncreativity.html.

64. Katherine Schulten, "Poetry Pairing: Crystalline Weather," *New York Times*, September 1, 2011, http://learning.blogs.nytimes.com/2011/09/01/poetry-pair ing-crystalline-weather/.

65. Kenneth Goldsmith, "The Day," *Poetry* 194, no. 4 (2009): 337.

66. Alan Riding, "France's Shock Novelist Strikes Again," *New York Times*, September 11, 2001, http://www.nytimes.com/2001/09/11/books/11ARTS.html.

67. For a more specific discussion of Goldsmith's role in creating *UbuWeb*, see his *Letter to Bettina Funcke* (Ostfildern, Germany: Hatje Cantz, 2011). I raise the topic of *UbuWeb* here in part because its existence points to important changes in the economy of poetry distribution. Whereas many avant-garde books and journals were produced in small editions, *UbuWeb* points toward a new "gift economy" of the web, an indexical future (if not present) in which readers sort through a metaindex, rather than encountering physical texts within the confines of a store, library, or classroom. Most of Goldsmith's texts are freely available online, as well as in print versions. His texts (if indeed they are his) are thus fully searchable, and in effect can be indexed by the user. Like the larger web of which it is a part, *UbuWeb* is a continually growing and continually updated open system. Central to the ethos of conceptual art—as many observers have noted—has been an embrace of open systems that are dynamically responsive to the world around them. Indexical/categorical art, particularly if it theorizes its own systematicity, is often described as open-ended in its structure. By contrast, a finished art object such as a painting—as theorized for instance in Michael Fried's influential 1966 "Art and Objecthood"—would run counter to an open system. A market, in a manner of speaking, is a population of shares, whose prices continually rise and fall. A traditional anthology or exhibition presents a closed catalog of writers or artists. If the *UbuWeb Anthology of Conceptual Writing* did not pretend to be global or comprehensive, the same cannot be said for *UbuWeb* as a whole, which has profoundly expanded the conditions of accessibility for avant-garde art, and has made available films, sound recordings, and texts from dozens of countries and languages. As Siegfried Zielinski notes, "In the internet, all earlier media exist side by side." *Deep Time of the Media: Toward an Archaeology of Hearing and Seeing by Technical Means* (Cambridge, Mass.: MIT Press, 2008), 31. *UbuWeb* makes available a virtual Alexandria of avant-garde film, art, music, and writing. Screen and speakers are its primary

constraints. Unlike conceptual art, which now often commands astronomical sums, conceptual writing is for the most part either free or available in inexpensive editions.

68. Seth Price, "Dispersion," *Dot Dot Dot* 12 (Summer 2006), http://www.distributedhistory.com/Dispersion2008.pdf.

69. Ibid.

70. For a useful introduction to the relational aesthetics movement, see Claire Bishop's anthology *Participation* (Cambridge, Mass.: MIT Press, 2006).

71. Susanne Bürner, *Vanishing Point: How to Disappear in America Without a Trace* (Frankfurt: Revolver and Toastink Press, 2006).

72. For Rice's original text and his repudiation of Price, see the Skeptic Tank website, http://www.skeptictank.org/hs/vanish.htm.

73. See Christian Bök, *The Xenotext Experiment*, 2007, http://www.ubu.com/ubu/unpub/Unpub_022_Bok_Xenotext.pdf, Kim Rosenfield, *re: evolution* (Los Angeles: Les Figues Press, 2008), and Sarah Jacobs, *Deciphering Chromosome 16: Index to the Report* (York: Information as Material, 2006).

74. Seth Price, *How to Disappear in America* (New York: Leopard Press, 2008), 92.

75. Dana Teen Lomax's *Disclosure* (Oakland: Black Radish Books, 2011), and Brian Kim Stefans's *Bank of America Online Banking: A Critical Evaluation* (Los Angeles: Citoyen Press, 2010) bear interesting comparison to *Credit*. Both works extensively reproduce their authors' personal financial records. *Disclosure* consists entirely of official records—ranging from report cards to dental x-rays to bank statements. Stefans's exposé makes no pretense to being poetry or conceptual writing (although its author is included in *Against Expression*), and was first made available for free on Lulu.com. In reviewing the book, Marie Buck praises it for its lack of posturing, and suggests that we might in any case "read the pamphlet as an intervention into the contemporary poetry community of which Stefans is a part." Buck notes, "The pamphlet begins with a Frank O'Hara quotation—'I go on to the bank / and Miss Stillwagon (first name Linda I once heard) / doesn't even look up my balance for once in her life . . . ,' suggesting that Stefans might have poets in mind. And given the pamphlet's avenues of distribution, it's safe to assume many of the people who have read it are poets. (I, for one, started reading it thinking I was beginning some sort of conceptual poem.)"

76. Craig Dworkin blurb for Matthew Timmons's *Credit*, n.d., http://www.arras.net/fscIII/?p=659.

77. Vanessa Place, *The Guilt Project: Rape, Morality, and Law* (New York: Other Press, 2010), 236.

78. Ibid., 239.

79. Paul Violi, "Index," in *Postmodern American Poetry: An Anthology*, ed. Paul Hoover (New York: Norton, 1994), 435–38.

80. Drawing on the examples of Charles Reznikoff and Vanessa Place, Goldsmith has presented a version of this argument in his "Toward a Poetics of Hyperrealism." See *Uncreative Writing*, 83–108.

81. Whitelaw, "Art Against Information," n.p.

82. Ibid.

83. Derek Beaulieu, *Seen of the Crime: Essays on Conceptual Writing* (Montreal: Snare Books, 2011), 6.

84. "Dispersion," n.p.

## Afterword

1. The new media implications of Grenier's work have been discussed by a number of commentators, including Perelman, *The Marginalization of Poetry*, 38–44, Golding "Language Writing, Digital Poetics, and Transitional Materialities," in *New Media Poetics: Contexts, Technotexts, and Theories*, eds. Adalaide Morris and Thomas Swiss (Cambridge, Mass.: MIT Press, 2009), 249–84, and Watten, "Poetics in the Expanded Field: Textual, Visual, Digital . . ." (also in Morris and Swiss), 335–70. Perhaps most polemical of those who have read Grenier's work in the context of information technology is Michael Basinski, who writes, "By the simple act of refusing a type bound culture, by taking charge of his literary creation and not bowing to the imperial nature of words, poetics, and text and book, Grenier has been able to invent a form of poetry that is suitable for the computer era but also moves beyond the stagnancy of text-based poetry, visual poetry and performance poetry. His poems best utilize the capacity of the computer. He does this by not using a computer as a tool to manipulate text but as a medium to present his unique and individualized poetic operations." "Robert Grenier's Opems," *Witz* 7, no. 1 (1999): 32. For perhaps the most extensive consideration by Grenier of his poetic practice, see his online exchange with Charles Bernstein in *Jacket* 35 (2008), http://www.jacketmagazine.com/35/iv-grenier-ivb-bernstein.shtml.

2. Robert Grenier, *What I Believe: Transpirations/Transpiring: Minnesota* (Oakland: O Books, 1991), n.p.

3. For more on Grenier's use of Courier and his transition from typed to drawn poems, see Ondrea Ackerman, "Wandering Lines: Robert Grenier's Drawing Poems," *Journal of Modern Literature* 36, no. 4 (2013): 133–53. Significantly, *The Collected Poems of Larry Eigner* (co-edited by Grenier and Curtis Faville) retains the mono-spaced type of Eigner's typescripts.

4. I am thinking here in particular of Lisa Gitelman's collection *"Raw Data" Is an Oxymoron* (Cambridge, Mass.: MIT Press, 2013).

5. Robert Grenier, *Attention: Seven Narratives* (Buffalo, N.Y.: Institute for Further Studies, 1985), 18.

6. Ibid., 23.

7. Robert Grenier, "[Essay]," in *Poetry Plastique*, eds. Charles Bernstein and Jay Sanders (New York: Granary Books, 2001), 73.

8. Ibid., 71–72.

9. Tim Wood, "Robert Grenier's 'Always/Only/A/ Plenum': A Reaction and a Response," *Action Yes Online Quarterly* 1, no. 12 (2010), http://www.actionyes .org/issue10/wood/wood1.html.

10. Alexander Galloway and Eugene Thacker, *The Exploit: A Theory of Networks* (Minneapolis: University of Minnesota Press, 2007), 144.

11. Robert Grenier, *Sentences* (Cambridge, Mass.: Whale Cloth Press, 1978).

12. Robert Grenier, CAMBRIDGE M'ASS (Berkeley, Calif.: Tuumba Press, 1979), broadside. For the fullest critical treatment to date of CAMBRIDGE M'ASS, see James D. Sullivan, "Book-Length Broadside: Bob Grenier's CAMBRIDGE M'ASS," *Jacket* 2 (March 2013), https://jacket2.org/article/book-length-broadside.

13. Ibid.

14. *Language of Inquiry*, 44–45.

15. The slip reading "I'm a rested phenomenon" from CAMBRIDGE M'ASS almost certainly refers to Zukofsky's notoriously difficult definition of objectification in poetry, which he describes as "a rested totality." Louis Zukofsky, *Prepositions+: The Collected Critical Essays* (Middletown, Conn.: Wesleyan University Press, 2000), 13.

16. Kotz, 223.

17. Craig Dworkin, *No Medium* (Cambridge, Mass.: MIT Press, 2013), 32.

18. Quoted in Larry Eigner, *The Collected Poems*, eds. Robert Grenier and Curtis Faville, 4 vols. (Stanford, Calif.: Stanford University Press, 2010), 3:728.

19. Mark Hansen, "New Media," in *Critical Terms for Media Studies*, eds. Mark Hansen and W. J. T. Mitchell (Chicago: University of Chicago Press, 2010), 177.

# INDEX

PAUL STEPHENS is a knowledge worker living in New York City.